MEXICAN DEVOTIONAL
RETABLOS

FROM THE PETERS COLLECTION

SAINT JOSEPH'S UNIVERSITY

PHILADELPHIA

EDITED BY

JOSEPH F. CHORPENNING, O.S.F.S.

SAINT JOSEPH'S UNIVERSITY PRESS
PHILADELPHIA, PENNSYLVANIA

LIBRARY OF CONGRESS CATALOG CARD NUMBER 94-65556

ISBN 0-916101-19-3 (CLOTH)
ISBN 0-916101-20-7 (PAPER)

PUBLISHED BY
SAINT JOSEPH'S UNIVERSITY PRESS
5600 CITY AVENUE
PHILADELPHIA, PENNSYLVANIA 19131

PRINTED IN THE UNITED STATES OF AMERICA

TABLE OF CONTENTS

Preface

The word *retablo* comes from the Latin *retro tabulum*, meaning "behind the (altar) table." In Spanish, *retablo* usually refers to painted or sculpture retables or altarpieces that first became popular in Europe in the fourteenth century.[1] However, in Mexico, *retablo* not only has the general meaning of altarpiece, but also the specific meaning of a religious image painted in oil on a tin-plated sheet of iron that was produced from the early nineteenth century through the early twentieth century.

This second meaning of *retablo* seems to have developed from the tradition of votive paintings. In the early eighteenth century, *ex-votos* or *milagros*, "miracles," that expressed gratitude to Christ, the Virgin, or one of the saints, for recovery from an illness, accident, or natural disaster, began to be referred to as *retablos*. These votive paintings were usually placed on the walls of a church or a shrine near the retable or altarpiece that depicted the sacred person who had intervened on behalf of the petitioner. It is likely that the name *retablo* was transferred to these *ex-votos* by association. In the early nineteenth century, the *retablo* developed a second form: small paintings of Christ, the Virgin, and saints that were intended as devotional objects for use by ordinary people in the privacy of their own homes. While the *retablo ex-voto* continues to be produced today and to be seen in abundance in shrines and churches in Mexico, the *retablo santo* or devotional *retablo* flourished only until the late nineteenth and early twentieth century, when they were supplanted by inexpensive color lithographs.[2]

In a sense, the devotional *retablo* functioned similarly to the altarpieces in churches. Sometimes in a niche or tin frame, sometimes unframed, it was hung on the wall or propped upon a dresser, creating a sacred space around which other tokens or devotional objects were kept. *Retablo* artists were essentially copyists, who were generally faithful to prescribed iconography. A *retablo* was expected to portray its subject just as it appeared in paintings that the faithful saw in churches. The age of devotional *retablos* corresponded to a troubled period in Mexican history. After winning its independence from Spain in 1821, Mexico was ravaged for decades by civil wars. Perhaps in the turbulence that surrounded the Mexican people, the domestic shrine, of which the *retablo* was the focal point, offered comfort, consolation, protection, and a center of gravity. Father Thomas J. Steele, S.J., a renowned authority on New Mexican *santos*, has observed of the *santeros* (saint-makers): "By making *santos*, the *santeros* enabled the saints to be present at the time and in the place the people needed them. In this way, the *santero* knit together the fabric of a cosmic society that included both Heaven and earth, and thus he helped define the religious and cultural

1. On the origin of the Spanish retable, see Judith Berg Sobré, *Behind the Altar Table: The Development of the Painted Retable in Spain, 1350-1500* (Columbia: University of Missouri Press, 1989).
2. For a succinct introduction to Mexican *retablos*, see Gloria Fraser Giffords, *"Retablos: Santos & Ex-Votos," Latin American Art* 2, no. 3 (Fall 1990): 90-94.

identity that sustained the earthly community through the many shocks—the unpredictable changes and the absurd disasters—that history held for New Mexican Hispanics."[3] The same can be said of the *retablo* artists of Mexico.

One of the hallmarks of Hispanic culture is its acute sense of intimacy with the divine. The great St. Teresa of Ávila (1515-1582) epitomizes this consciousness. The story is often told that once after some misfortune befell her, Teresa said to the Lord: "'If this is the way that You treat Your friends, it's no wonder You have so few of them!'" That same spirit is found in Mexico and in New Mexico. This story from New Mexico, but which could be from anywhere in Latin America, illustrates this point. Following a long drought, some local farmers asked the parish priest to allow them to parade a statue of the Christ Child through the fields as a petition for rain. The procession accomplished its purpose, and it began to rain. However, it rained so much that the fields were damaged. The next day, the farmers returned to the parish priest to ask permission to parade the statue of the Blessed Mother. "'Why?'" the priest inquired. "'Didn't you take out the Child yesterday?'" "'Yes,'" the farmers replied, "'but we want to show her what a mess her Son has made!'"[4] As prized objects of veneration, *retablos* were an integral part of this sense of familiarity with the supernatural in Mexico. For example, if a saint withheld a favor, the *retablo santo* might suffer some indignity, such as being put in a drawer or closet. Whatever was done to the image was believed to pass to its prototype.

In the eighteen years that have elapsed between the appearance of the first edition of Gloria Fraser Giffords' pioneering study *Mexican Folk Retablos* (Tucson: Univeristy of Arizona Press, 1974) and the publication of the revised edition (Albuquerque: University of New Mexico Press, 1992), there has been a dramatic growth of interest in *retablos*. The publication of a revised edition of *Mexican Folk Retablos* itself is indicative of a burgeoning interest in this subject. Once the first edition went out of print, copies of it became rare, often selling for as much as three hundred dollars. There are other signs of growth. For several years now, Nancy Hamilton, a professional writer and *retablo* collector, has published the *Retablo Newsletter* on a monthly, sometimes bimonthly, basis. In 1991, a major exhibition of devotional and *ex-voto retablos*, "The Art of Private Devotion: *Retablo* Painting of Mexico," was mounted with venues at The Meadows Museum, Southern Methodist University (Dallas), Field Museum of Natural History (Chicago), The Mexican Museum (San Francisco), The Spencer Museum of Art (Lawrence, Kansas), University of Texas at San Antonio Art Gallery, and Old Jail Art Center (Albany Texas). *Retablos* are found in the catalogues of the

3. Foreword, *New Kingdom of the Saints: Religious Art of New Mexico 1780-1907* by Larry Frank (Santa Fe: Red Crane Books, 1992), xiii.
4. Joseph P. Peters, "The Meaning of Mexican *Retablos*," in *Retablos: Mexican Folk Icons from the Collections of Mr. & Mrs. Joseph P. Peters* (Annapolis: St. John's College, 1983), and *Retablos: Masterpieces on Tin* (Philadelphia: Philadelphia Art Alliance, 1989).

major New York auction houses, such as Christie's and Sotheby's. The Peters Collection, presented to Saint Joseph's University by Joseph and Ruth Peters of Philadelphia, longtime *retablo* collectors and connoisseurs, must be situated within this broad context.

In the intial essay of this catalogue, Joe and Ruth speak for themselves about their *afición* for the *retablo* art of Mexico. I might be permitted, however, to point out that The Peters Collection is a logical step in these collectors' effort to make this art better known, understood, and appreciated. They have loaned pieces from their collection to exhibitions, such as "The Art of Private Devotion" and "Patron Saint of the New World: Spanish American Colonial Images of St. Joseph," held at Saint Joseph's University in Spring 1992. Exhibitions have also been devoted exclusively to their collection. In 1983, the exhibition "*Retablos*: Mexican Folk Icons from the Collections of Mr. & Mrs. Joseph P. Peters" took place at St. John's College Art Gallery in Annapolis. In 1989, a similar exhibition, entitled "*Retablos*: Masterpieces on Tin from the Collection of Mr. & Mrs. Joseph P. Peters," was hosted by the Philadelphia Art Alliance. In 1990, their collection was the subject of a feature article in *The Philadelphia Inquirer Magazine*. It may be coincidence that an article on the Barnes Foundation appeared in the same issue, but it recalls Ruth's study of art at the Barnes with Violette de Mazia and the collection of New Mexican *retablos* that Dr. Barnes himself acquired. As the Barnes and Saint Joseph's University are neighbors, visitors to Lower Merion can view the *retablo* art both of Mexico and of New Mexico, an opportunity not usually available in the East.

A permanent exhibition housed in Regis Hall on the campus of Saint Joseph's University in Philadelphia, The Peters Collection consists of forty-four devotional *retablos*, two nineteenth-century Mexican oil-on-canvas paintings, and two Philippine polychrome wood *bultos* (statues). The fact that Saint Joseph's is a Jesuit university highlights the significance of The Peters Collection in two important and related ways that underscore that Philadelphia's Jesuit university is a most appropriate home for this remarkable collection.

First, the Society of Jesus was among the most positive and enthusiastic supporters of the strategy of using religious images to accomplish the evangelization of the Americas. Two of the essays in this volume, as well as the catalogue commentaries, demonstrate that the iconography of Colonial religious painting and sculpture persists in nineteenth-century Mexican devotional *retablos*. This continuity testifies to the tremendous impact of the strategy advocated and employed so effectively by the Jesuits. Thus, The Peters Collection serves as a reminder of the importance of the Society of Jesus' participation in the evangelization of the New World.

Second, The Peters Collection offers a window not only on the art and piety of a neighboring country and culture, but also on the Jesuit contribution to Catholic devotional life. Many of the *retablos* in The Peters Collection are of saints and of advocations of Christ and of the Virgin Mary that the Jesuits vigorously promoted both in Europe and in the Americas. These include the Sacred Heart of Jesus (Catalogue 4), the Immaculate Conception (Catalogue 8 and 9), Our Lady of Sorrows (Catalogue 10, 11, and 33), Our Lady, Refuge of Sinners (Catalogue 18), St. Joseph (Catalogue 31, 32, and 33), the Archangel Raphael (Catalogue 36), and the Holy Family (Catalogue 44). Viewed from this perspective, The Peters Collection memorializes the major role that the Society of Jesus has played in the development of Catholic piety.

The purpose of this catalogue of The Peters Collection is to advance the scholarly conversation begun by Giffords' *Mexican Folk Retablos* and recently continued by the exhibition catalogue *The Art of Private Devotion: Retablo Painting of Mexico* (Fort Worth: InterCultura/Dallas: The Meadows Museum, Southern Methodist University, 1991) and Fernando Juárez Frías' *Retablos populares mexicanos: Iconografía religiosa del siglo XIX* (Mexico City: Inversora Bursatil, 1991). It seeks to achieve this aim by sharing insights from the collectors into how and why this particular collection came together, in addition to information on the technical and stylistic facets of specific *retablos* in The Peters Collection. This volume also attains its purpose by presenting scholarly research on heretofore neglected artistic and literary sources for a number of devotional *retablo* subjects (St. Jerome in Penitence, the Most Holy Trinity, St. Regina, St. Joseph, the Holy Family, the Powerful Hand, and narrative scenes, such as the Espousal of St. Joseph and the Virgin Mary, the Flight into Egypt, and the House at Nazareth), as well as commentary on each piece of the collection that offers a more detailed discussion of the iconography of devotional *retablo* subjects than is often found in the standard works on Mexican *retablos*. For Saint Joseph's, it is important not only that we have been given The Peters Collection, but also that, in keeping with our mission as a University, we produce scholarship that supports this collection, makes it accessible to our various constituencies, and adds to current knowledge about this art form.

In the Peters' home, their collection of *retablos*, *bultos*, and Colonial Spanish paintings is displayed in carefully arranged groupings. Joe and Ruth readily give credit for this attractive design to their good friend Ernest R. "Bud" Parks, Jr., a New York interior designer, who has also crafted handmade frames for the *retablos* that accord with each painting's

individual character. In preparing the exhibition space for The Peters Collection, we have attempted to re-create the style in which these art works are seen in Joe's and Ruth's home. Joe and Ruth have graciously helped us to achieve this effect by designing the basic arrangement of The Peters Collection as it is exhibited in its new home in Regis Hall.

Finally, I would like to thank the numerous individuals who have helped to make this exhibition and catalogue a reality. A debt of gratitude is owed to Joe and Ruth on three counts: first, for The Peters Collection; second, for their essays written from their individual and unique perspectives; and, thirdly, for allowing the resources of the impressive art library that they have put together to support their collection to be used in the preparation of this volume. I thank Nancy Hamilton for responding so enthusiastically and generously to the invitation to contribute an essay. I am especially grateful to Christopher C. Wilson, who not only prepared an essay but also collaborated on the catalogue of the exhibition. Thanks too to Carmen R. Croce, director of Saint Joseph's University Press, Catherine Orr-Gontarek, and Tom Malone for the design, layout, and production of the catalogue; to Barbara Lang of the Interlibrary Loan office of Drexel Library at Saint Joseph's University for her patient and diligent assistance in locating and borrowing copies of oftentimes obscure books and articles; to Kevin W. Robinson and the Saint Joseph's University Physical Plant staff for the preparation of the exhibition space; to Barbara von Barghahn, Bettina Jessell, and Santiago Sebastián for their counsel and encouragement; to the Metropolitan Museum of Art, National Gallery of Art, Toledo Museum of Art, Jeffrey Blake, Rev. Roland Gauthier, C.S.C., Nancy Hamilton, Ernie and Eddna Martin, Johanna van Nest, and August Uribe for the photographs that appear in this volume.

Joseph F. Chorpenning, O.S.F.S.

MEMORIAL OF BLESSED ANDRÉ BESSETTE, 1994

THE PETERS COLLECTION:
TWO PERSPECTIVES BY THE COLLECTORS

In the category functionally linked with the revealed religion of Christianity and
its anthropomorphized conception of God and His saints, the task facing the creative imagination
of the folk artist was centered around a human figure, which was to be representative of the
characteristics, the activity, or the suffering of the Divine Person and the saints.

Karel Šourek, *Folk Art in Pictures*
(London, n.d.), 175.

APOLOGIA

JOSEPH P. PETERS

When visitors encounter our collection of *retablos* for the first time, they are apt to ask two questions, which is reasonable in light of their unfamiliarity with its subject-matter. The first is to some extent a probing of motives: how did you get started? And the second is more a matter of seeking information: where did you acquire them?

When Father Chorpenning asked my wife and me to write an essay about our collection for this catalogue, we agreed that I would reply to these two questions, with an emphasis on the religious imagery of these artifacts. Ruth, in turn, would explore their artistic content, since her background had not exposed her to such imagery, Catholic or otherwise. In our judgment, the two viewpoints would blend to contribute to a better understanding of what underlies this collection.

I have no doubt that my interest in religious imagery is rooted in my childhood. One of my earliest memories is the "altar" that my mother created in the corner of our kitchen. It contained bits and pieces of objects precious to her—holy pictures, beribboned religious medals, dried flowers left over from some cherished bouquet or boutonniere, and always a shoot of palm twisted in the shape of a cross that was saved from the previous Palm Sunday—all housed on a bracketed shelf. In place of wax candles, she had a tinted glass jar containing cooking oil with a lighted wick floating in it. If the light burned out, it was immediately relighted, for it was important to both my mother and my father, and to me as I grew older, to be vigilant in keeping this hopefully eternal flame alive. Even as a child, one of my few chores was to go to the neighborhood pharmacy to buy a supply of these wicks.

To this day, I do not understand why a pharmacy would stock this item. Nonetheless, this is where my mother always sent me, armed with ten cents, to purchase a package of wicks.

Now I am aware that my mother's altar was simply her variation on the traditional "beautiful corner" venerated in many Catholic homes in southern and eastern Europe. A nineteenth-century observer of Mexican life, Fanny Calderón de la Baca, noted similar small altars with collections of "daubs," which I suspect were *retablos*, and blest palm leaves in the Indian huts she visited in rural Mexico.

The *pièce de résistance* of my mother's assemblage was a framed lithoprint of the head of the suffering Christ crowned with thorns. Even as a child, this picture fascinated me. A sophisticated art lover might sneer at it, because it was undeniably kitsch. But to my mother it was a souvenir of a treasured relationship. She was fond of repeating the story of how she came to possess it. It was the parting gift of a Jewish friend who worked alongside her in the garment industry. I won't repeat the details of my mother's account of how her friend converted to Catholicism and became a Dominican nun. That I still cherish this stained and faded image and that I am looking at it as I write these words may explain much of what has drawn me to these simple *retablos*.

But, this was only a beginning. As a boy hearing Sunday Mass at a local Italian national Catholic church in midtown Manhattan, I was enthralled by the polychrome statues of saints and holy persons which dominated its interior. Even then I recognized that there was something different about these representations. They were unlike the more austere elongated Gothic images that I saw in St. Patrick's Cathedral or the saccharine "Barclay Street art" that was displayed in other churches.

At the entrance to our local church, to the left, there sat a boxed glass container that housed, again in vivid colors, the Holy Souls burning and writhing in Purgatory. The faithful were expected to drop a few coins in a slot at its base and to recite some prayers to lessen the torment of these sinners being cleansed of their sins so that they would qualify for entrance into paradise. The depiction of the Holy Souls in our collection is mild compared to my memory of the one crafted by a twentieth-century anonymous artisan for our church.

My interest in such imagery did not wane over the years; rather, time and broader exposure through museum visits and travel only served to heighten it. El Greco and Georges Rouault were artistic heroes during my college years. They continue to be despite the addition of many more eclectic painters and sculptors to my repertoire of favorites.

Now, some remarks about the sources of our collection. For me, it began on March 26, 1965 (the date recorded on the reverse of my first purchase) in Nogales, Sonora, Mexico. It was a *Nuestra Señora, Refugio de Pecadores*, "Our Lady, Refuge of Sinners," perhaps the most common representation of Mary in Mexican *retablo* art. At the time, however, I regarded it simply as a folk art representation of Our Lady. It was not until I had the great opportunity to meet Gloria Giffords a year later at her home in Tucson that I was introduced to the idiosyncrasies of Latin America iconography. She patiently identified many of the hundreds of *retablos*, *bultos*, and other religious artifacts which were crammed into every nook and corner, including the backs of doors, of her home. Sensing my growing interest, she recommended several books and pamphlets that would supply the background that I so obviously lacked. But Gloria did even more: she whetted my appetite to seek out more images in my future travels throughout Mexico, Central and South America, and the American Southwest. It was only a matter of time until our horde of *retablos*, *bultos*, books, and related items would strain our capacity to house them.

Ernest (Bud) Parks, Jr., also encouraged me, first, by his sensitivity to the artistry of these simple folk *retablos* and, later, by his willingness to frame them in a manner that heightened their beauty and revealed his creative abilities. By then, Ruth had entered the scene, and she and I eventually pooled our acquisitions. But she will tell you more about that.

We never knew where we would locate a purchasable *retablo*. Mexico City was, until about twenty years ago, the prime source. Suddenly, however, all of the hole-in-the-wall antique/junk shops that lined downtown Allende Street closed their doors, and the piles of *retablos*, some badly rusted and scratched, but others more acceptable, separated by sheets of newspaper, disappeared. Benin Gallery in the Zona Rosa was a reliable source—it, too, has closed its doors—but one had to ask specifically to see any *retablos*, which were housed on the third floor, not open to the public. The Gallery specialized in the grander forms of Spanish Colonial art, which unfortunately were not allowed by Mexican law to be removed from that country. This restriction did not apply to *retablos* or to simpler post-Colonial pieces. As a result, we were able to enhance our collection with some unique purchases from Benin Gallery.

Over the years, we uncovered many items in New York City antique shops, rarely, however, in the more exclusive Madison Avenue or 57th Street galleries. Some out-of-the-ordinary examples were unexpectedly unearthed in Carmel (California), Tubac (Arizona), Washington, D.C., Chicago, Santa Fe, Albuquerque, and Querétaro (Mexico), and even at a roadside gift shop outside Oklahoma City. Ruth and I soon learned to be alert to the possibility

that Mexican popular art or souvenir shops anywhere on this continent could be likely sources. Of course, the price one had to pay for searching out collectibles in these tourist traps was the danger of dulling one's artistic sensibilities with mountains of trashy artifacts. The recent popularity and increasing value of *retablos* have diminished the likelihood of finding any of these treasures in such outlets. We no longer waste our time in such ventures.

It was not until we were introduced by Gloria Giffords to L.C. "Fran" Tolland in El Paso, Texas, that our collection really began to soar. Fran is undoubtedly the leading expert on the subject of *retablos*. But he is more than that. He is a longtime lover of Mexican religious imagery. His wife, Luz, supports him with her sincere Mexican piety so necessary for comprehending the subtleties of this devotional art form. About a third of our collection was acquired from Fran. Many of these are part of this exhibition. Ernie Martin of San Antonio has in recent years assumed the role of a major vendor of Mexican *retablos* and other Spanish Colonial artifacts. He was the source of the *Santa Librada*, "St. Wilgefortis" (Catalogue 34), and the *San Acacio*, "St. Acacius" (Catalogue 22), pieces. Both Fran and Ernie have done much to make it possible for an interested beginner to get a headstart in assembling a significant collection. However, Ruth and I still reminisce about those early days when we had to probe diligently for acceptable items. So many of the *retablos* we uncovered were rusted, pitted, scratched, or almost indistinguishable that we only purchased about one item out of every ten that we examined. Even now, we wonder about the eventual whereabouts of these battered relics, which we and other serious collectors declined.

We like to think of these *retablos* as a "poor man's art." The rich could afford grand paintings on canvas, many of which have found their way into museum collections. The poor had to be content, however, with smaller paintings on wood panels or less costly materials. It was not until the late eighteenth century that the metallurgic process of applying a thin coat of tin to a leaf of iron was developed. These tin sheets were inexpensively produced and were used by naive and usually self-taught artists as a ground for oil paintings (*retablos*) for sale to poorer small town and country people.

Although there are great differences in the style and quality of *retablos*, there are many similarities in technique and production. Viewers of this exhibition will notice that, although most of the examples are permeated with devotion, intensity, and a folk stylization, often with a charming naivete, they range from crude and primitive depictions to very skillful representations. Because of these stylistic variations, it is easy to understand their appeal to collectors with differing tastes.

However, we, as modern outsiders, can never really come to terms with the inner spirituality of these images. I realized this sometime ago when I displayed a day's purchase on the bureau of my hotel room somewhere in the Southwest. A Mexican-American maid entered to perform her housekeeping chores. Suddenly, she spotted the *retablo*. Without any regard for whatever I might think, she picked it up and kissed it. To her, it was not simply a holy icon; it was the incarnation of a holy person who merited her love. This, to me, is the true significance of these images. We who do not possess this intimacy with the divine that is so deeply ingrained in the people of Latin America can never completely share her experience. Certainly, few of us would ever think of kissing a holy image. But, as I now recall, my mother and my grandmother often did, and I am perhaps poorer for my inability to do so.

JULY 1993

What These *Retablos* Mean to Me

R U T H P R E N T I S S P E T E R S

Unlike my husband, I did not record the date when I purchased my first *retablo*. However, I do remember some of the details of that incident. It, too, came from a shop in Nogales, Mexico. The shopkeeper described it as a picture of St. Teresa. Later, I learned otherwise. But its identification was of no real consequence to me. My background did not expose me to pictures of saints or to the stories of their lives or accomplishments. To me, most of our *retablos* are simply exquisite jewels, lovingly crafted by anonymous artists imbued with a love of the divine.

By the time I married Joe Peters, my personal collection numbered about two dozen carefully selected pieces. I had no favorites, as I recall—I loved them all, each for its own special artistic appeal. Again, I repeat, the names of the saints depicted were not important. It was not until many years later that I learned that titles or subject-matter are not essential ingredients of a work of art. As a student at the Barnes Foundation, the titles of monumental works of art by Cezanne, Renoir, and other moderns were seldom mentioned when we analyzed the qualities that made them great. Indeed, none of the paintings on view in the Barnes Collection were titled.

There is something special about a work of art that transcends labels, titles, subject-matter, or meaning. Not that these are not taken into account by the artist who crafts the piece, but they are qualities that are superimposed upon more basic matters. Albert C. Barnes warned that "[we] miss the function of a painting if we look to it either for literal reproduction of subject-matter or for information of a documentary character." He continues that good art has the power to move us aesthetically. Sentiment plays little or no role in this system.

However, since I do not bring the childhood experiences that my husband describes to my appreciation of *retablos* nor can I completely separate myself from Dr. Barnes' admonition pertaining to "subject-matter," the Souls in Purgatory or bloody Christs do limit my aesthetic response. Because we all do not like the same things to the same extent, the term "choice" is perhaps the more appropriate word to describe my reaction to such strong imagery. I know that our home would overflow with more such depictions if Joe and I had not long ago agreed that we would make no purchases which were not approved by both of us. Actually, his eye and ability to see beauty in the unusual can at times be quite impressive and far exceeds my own discernment.

I doubt that anyone would describe these tin *retablos* as great works of art. They do, however, have the power to create an aesthetic experience for those who know nothing about their devotional content. Miriam Seidel, after viewing the hundred or so *retablos* from our collection that were exhibited at the Philadelphia Art Alliance in the Fall of 1989, perhaps best explained their dual nature. She wrote in her review in *The Philadelphia Inquirer* that "(p)ictures such as these make us remember that they come from a powerful matrix of belief, and are as much functional objects of devotion as works of art."

That these paintings are able to give spiritual solace or guidance to the unlettered people who hung them on the walls of their simple homes is a quality that, in my judgment, enhances their value. They are "art that moves the onlooker." In my opinion, one should ask nothing more of them. I am certain that Dr. Barnes would agree because scattered throughout his world-famous collection of French Modernists are dozens of New Mexican *retablos* on wooden panels. These are close cousins, albeit more primitive in style, of their Mexican counterparts on tin.

When Joe and I married and relocated in rural Oklahoma, we plastered one wall of a long hall in my family homestead with every *retablo* we jointly owned at the time or subsequently acquired. For some reason which I now find difficult to explain, they did not overflow into our living room, although we did hang several Spanish Colonial paintings in that area. Perhaps my instincts warned me not to overexpose such a display of Catholic religious images in what was basically a fundamentalist Protestant region. I cannot forget the look on the face of a man who knocked on our door one morning, asking to use our phone to request assistance for his car that had broken down near our home. He told us that he was a clergyman of some denomination unfamiliar to us, and it was quite obvious as he passed through the hall that he couldn't wait to escape our house of infamy with its graven images. To this day, he may still be talking about this satanic experience.

In 1984, we moved from a large house in Oklahoma to an apartment in Center City Philadelphia. This move was less a shock to us than it was to our collection, which by then numbered over two hundred *retablos* and possibly a hundred or more *bultos* and various Latin American Colonial and folk art pieces. It was apparent that the collection had to be culled. I was uncertain whether Joe could withstand the pain, for he is the real collector in this partnership. To my astonishment, he saw the light, and so we disposed of about half of our collection. Incidentally, Fran Tolland, who was by then our good friend and advisor, purchased much of this overflow, sight unseen. He tells us that he resold every item with

the exception of a large Guatemalan crucifix with a large silver *tres potencias* halo, which he and his wife Luz have hung on the wall of their living room. Four of the items which Fran purchased have subsequently surfaced in museum exhibition catalogues.

We are now in Philadelphia. We have permitted our collection, more or less restricted to *retablos* and a handful of small *bultos*, to flow into every room of our apartment. There is even one hanging in the kitchen—appropriately, a *San Pascual Bailón*, "St. Paschal Baylon," the saint of kitchens.

A few months ago, in response to the enthusiastic way that Saint Joseph's University had reacted to two pieces that we lent them for their Spring 1992 exhibition of Spanish American Colonial images of St. Joseph, we inquired if the University would accept our contribution of as many *retablos* as could be comfortably housed somewhere on the campus. The University agreed, and the result is depicted in this catalogue.

Once again, the transfer of many of our most treasured pieces to a new site in Regis Hall was not a shock to either of us. In a sense, these *retablos* are our children, and we are proud to know that they have a new home where they will be enjoyed by infinitely more people than would ever see them in our apartment. I believe—and I am sure that many collectors would agree with me—that works of art, even such simple works as *retablos*, are only loaned to us for a brief period. We are indeed fortunate that we have been given the opportunity to determine how and when to part with a number of them according to our desires and to be able to view the results.

JULY 1993

Mexican Devotional Paintings on Tin: Technical and Stylistic Aspects

Nancy Hamilton

The Peters Collection includes forty-four popular religious paintings on tin from nineteenth-century Mexico called *láminas* or *retablos*. They represent a specialized, geographically limited version of a broader artistic heritage, incorporating both European traditions and indigenous interpretations of religious values brought by the Spaniards.

Materials and Techniques

Oil painting was flourishing in Europe by the time of the conquest of Mexico (begun in 1518 and completed in 1521). Accomplished artists stretched canvas on which to paint or, in some instances, painted on sheet copper. Both were expensive. The Spanish crown held a monopoly on linen and had rules for its use.[1] Copper, it was noted, was both durable and took the paint well.

Indigenous artists in Mexico had skills in a number of media at the time the Spaniards arrived. They executed paintings on deer hide prepared for that purpose, as well as crafted delicate feather mosaics. As they were encouraged to imitate the Spanish traditions in painting, and especially in the replication of religious subjects, they turned to available media, painting on cloth and wood.

Tinplate, which was to become the medium of choice for Mexican folk artists, came to Spain from Germany in the seventeenth century. Both Spain and Britain developed the manufacture of this sheet iron thinly coated with tin to retard rust. Tinplate was shipped from Spain to Mexico, where the craft of tinsmithing began probably late in the eighteenth century. By about 1830, sheets of tinplate were manufactured for commercial uses. Much less expensive than sheet copper, this metal was adopted by folk painters for religious works.[2]

The metal sheets were made for commercial purposes, such as stamped ceiling panels, which measured 14 x 10 inches. This was the most common size for paintings of particular saints. The Peters Collection reflects this tendency, with twenty-six of the forty-four *retablos* in this size and four others possibly trimmed from these dimensions.

The sheets were usually cut in half to make smaller sizes, so the next most popular was 10 x 7 inches, with ten of The Peters Collection in that size. Paintings in the largest size (20 x 14 inches) and in the smaller sizes (7 x 5 inches, 3 1/2 x 5 inches, or less) were comparatively rare. The smallest of these paintings measure only 1 5/8 x 2 1/4 inches.

1. Pál Keleman, *Baroque and Rococo in Latin America* (New York: Dover Publications, 1967), 198.
2. Lane Coulter and Maurice Dixon, Jr., *New Mexican Tinwork, 1840-1940* (Albuquerque: University of New Mexico Press, 1990), chapter 1.

Two *retablos* in The Peters Collection are of the rare large size: *El Santo Niño Perdido*, "The Holy Lost Child" (Catalogue 3), measuring 18 1/2 x 13 1/4 inches, and *Santiago*, "St. James the Greater" (Catalogue 40), 17 1/2 x 12 1/2 inches. One of the group, *El Divino Rostro*, "The Divine Face" (Catalogue 1), is of a comparatively rare small size, 6 3/4 x 5 inches.

Tinsmiths in New Mexico, who relied on the Santa Fe Trail trade for materials, reworked cans and other identifiable objects to make frames and sconces. In Mexico, however, new tinplate was readily available to folk artists. Frames and *nichos* imprinted with brand names or that clearly had other uses before being recrafted for religious use are rare. In general, Mexican tinwork was crafted from new sheets of the metal.[3]

The nineteenth-century tinplate used in Mexico was of the thinnest grade available, so that the minimal coating of tin allows "the natural oxidation of the tin surface to begin to expose the dark iron beneath."[4] New tinplate is clear and shiny. The older Mexican pieces show this oxidation and often have rust spots, sometimes encroaching on the art work. Current *retablo* forgeries attempt to conceal the characteristic shininess of new tin by creating rust spots to simulate aging.

Mexican tinsmiths developed elaborate frames for prints and paintings, as well as *nichos* in which paintings or small figures could be placed. The framed painting normally would be covered with glass. The frame characteristically would have corner bosses, a lunette at the top, and leaf or wing-like adornments on the upper corners. Some frames had glass inset, with flowers painted on the underside or with wallpaper or other colorful paper placed under the glass. The painting (or in some cases a print or woodcut) often was soldered into the frame.

The frame for *Nuestra Señora de la Encarnación* or *El Alma de María*, "Our Lady of the Incarnation" or "The Soul of Mary," (Catalogue 13) is an example of highly skilled tinwork, with the popular design of rosettes on the corner bosses. The sides of the frame follow simple lines impressed with intricately worked designs.

ARTISTIC STYLES

Oil paintings brought from Europe introduced to the Mexican people not only religious concepts but elements of artistic expression, especially perspective. The Spanish opened the Academy of San Carlos of New Spain in 1785, with faculty members drawn from Spain and Mexico. Its role as a cultural institution is viewed as important in "the development of an already nascent sense of Mexican national identity."[5] While folk artists were not trained there, they shared in this sense, and the proliferation of *retablo* paintings of saints was a phenomenon reflecting the independence movement of the early nineteenth century.

3. Coulter and Dixon, chapter 7.
4. Coulter and Dixon, 156.
5. Marcus Burke in *Mexico: Splendors of Thirty Centuries* (New York: Metropolitan Museum of Art and Bulfinch Press, 1990), 491.

During the Colonial period, paintings and illustrations brought from Europe served as models for local artists. Local craftsmen were often trained by the clergy in painting on canvas, cotton fabric, wood, and metal, and in executing sculptured figures, *bultos*. The subject-matter for religious works was drawn from Flemish, Italian, and Spanish sources that were woven into the Spanish Renaissance style, with additional stylistic influence of the Baroque in the seventeenth and early eighteenth centuries.[6]

From about 1830 until the end of the century, *retablos* were produced in large quantities before being supplanted by less costly color lithographs. They were found primarily in central and southern Mexico, from Saltillo and Torreón southward to Durango, Zacatecas, San Luis Potosí, Guanajuato, Querétaro, and centers closer to Mexico City such as Toluca. Two areas of concentration are illustrated by art historian Roberto Montenegro in his book on *retablos*: Guanajuato and Mexico City.[7]

Paintings of saints could be commissioned, as were the *ex-votos*, or might be sold door-to-door, or at booths outside churches on Sundays and holy days. Such stands are still to be found in Mexico, offering prints of saints, religious medals, rosaries, and *milagros*, the small metal *ex-votos* depicting body parts, animals or humans.[8] The *milagros* may be placed on the garment of a statue in a church, expressing gratitude for favors granted, as illustrated in *El Santo Niño Perdido* (Catalogue 3). Clearly visible on the Christ Child's garment are an arm, a leg, a pair of crutches, a pair of eyes, and other testimonies to His assistance.

Some artists demonstrated notable talent as well as training in their work. *Nuestra Señora de la Encarnación* or *El Alma de María* (Catalogue 14) is an example of careful imitation of European style, with attention to rules of lighting and anatomy.

Artists worked anonymously, not unusual in the field of folk art worldwide. Like the vast majority of *retablos*, those in The Peters Collection are anonymous. Paintings of saints on copper sheets were, for the most part, signed by recognized artists, but those who painted on tin are largely unknown. At least three of the painters on tin signed full names— Donaciano Aguilar, who worked in the Juchipila Valley from 1861 to 1877; Agustín Barajas, from the state of Querétaro; and Refugio Aguilar, whose provenance is unknown. Gloria Fraser Giffords, a renowned authority on *retablos*, believes that the painting of these images was not limited to men, but that family workshops probably included women as well.[9]

The time involved in painting a signed piece by Donaciano Aguilar is given on the back, June 18 to 29. If he had a workshop, this may have been one of several paintings undertaken at the same time, or Aguilar may have had another job with painting as a sideline, since eleven days is much longer than an artist of his accomplishment should need

6. Gerrit Craig Cone, "Foreword" to *Imágines hispanoamericanas* (Tucson: Tucson Museum of Art, 1976).
7. *Retablos de México (Ex-votos): Mexican Votive Paintings* (Mexico City: Ediciones Mexicanas, 1950).
8. Joseph P. Peters, "The Meaning of Mexican *Retablos*," in *Retablos* (Annapolis: St. John's College Art Gallery, 1983).
9. *The Art of Private Devotion: Retablo Painting of Mexico* (Fort Worth: Intercultura/Dallas: The Meadows Museum, Southern Methodist University, 1991), 54.

in order to complete a small painting. At that rate of production, he could have done at least thirty paintings per year.

Visual evidence suggests that the painters developed workshops, since many *retablos* can be divided into large groupings according to shared stylistic traits. Giffords has classified several workshops by the characteristics of the artists. In assigning dates and areas of production to the painters, she has recourse to a special category of *retablos*, the *milagros* or *ex-votos*, which continued to be painted well into the twentieth century. These are usually small horizontal paintings, sometimes commissioned by the person whose story is depicted on the image. They were executed as offerings expressing gratitude to the saints who intervened on behalf of someone who suffered illness, accident, or natural disaster. The picture shows a person in a situation of peril, with the saint or saints invoked for help hovering above. Below the picture is written, usually in black on a white background, a narrative giving the name of the person, the name of the saint, the date and location of the incident, and the outcome. Artists rarely signed these pieces, although some in the twentieth century have done so. It is assumed that the painters of *ex-votos* also created *retablo santos*, single images of Christ, the Virgin, or saints, like those in The Peters Collection. *Ex-votos* produced by the same hand as *retablo santos*, then, can provide valuable clues about the dates and location of an artist and his workshop. The *ex-votos* are of interest not only in tracing the history of *retablos*, but also in their almost photographic presentation of living conditions in specified times and places.[10]

The most prevalent of the artistic groups identified by Giffords is the Red Bole, so-called for its technique of applying a reddish-brown primer to the tin surface before painting. Bole is a red clay that was often applied over wooden surfaces preparatory to applying gold leaf. When used as a primer on tin surfaces, the burnt-red color becomes visible over the years as the oil painting begins to fade.[11]

Retablos belonging to the Red Bole group are characterized by skilled craftsmanship, attention to detail, and characteristic floral and background details. The faces are of particular interest, since, as Giffords points out, they exhibit "almost identical, strongly modeled features. Eyes are especially distinctive, with heavy, fleshy eyelids; lips are often thick and pursed."[12] *Ex-votos* of this type date from the 1870s into the 1890s. In The Peters Collection, the *retablo* depicting *El Señor de Plateros*, "The Lord of Plateros" (Catalogue 6) exhibits the traits of the Red Bole Group identified by Giffords.

Another painting group named by Giffords is that of the Ball Beard Painter, recognizable by the peculiar manner in which beards are portrayed on male figures. Giffords

10. Giffords, *The Art of Private Devotion*, 50.
11. Giffords, *The Art of Private Devotion*, 53, and *Mexican Folk Retablos*, revised edition (Albuquerque: University of New Mexico Press, 1992), 11.
12. Giffords, *Mexican Folk Retablos*, 12.

observes that "[the] cheeks are shaded, giving a five-o'clock-shadow effect. On the chin the beard is neatly divided in the center with both sections terminating in what appear to be little furry balls."[13] One of the *retablos* of *San José*, "St. Joseph," in The Peters Collection (Catalogue 31) bears these distinctive characteristics. As Giffords has pointed out, so many *retablos* belong to this grouping that the artist was either extremely prolific or worked in a workshop setting.[14] *Ex-votos* in this style were executed in the 1890s.

Giffords has named other painters of *retablos*, such as the Bee-Stung Lip Painter, the Calligraphic Line Painter, and the Skimpy Painter.[15] Future studies, and greater availability of published photographs, will help determine whether any of the *retablos* in The Peters Collection can be assigned to these painters. It should be noted, however, that several paintings in the Collection have striking similarities to other *retablos* that have been published but not yet attributed to a particular artist or workshop. The 1991 exhibition catalogue, *The Art of Private Devotion: Retablo Painting of Mexico*, contains two *retablos* that must have been painted by artists whose works are also represented in The Peters Collection. One of the *retablos* of *San José* in *The Art of Private Devotion* (Catalogue 60) is by the same hand as a depiction of the same subject in The Peters Collection (Catalogue 32). The treatment of Joseph's head, hands, and flowering staff in both images attests to the work of one artist. A second artist painted the *retablo* of *San Expedito*, "St. Expeditus," in the 1991 exhibition catalogue (Catalogue 47) and the depiction of *San Rafael*, "St. Raphael," in The Peters Collection (Catalogue 36). The figures in both of these works exhibit thick, fleshy forearms, thighs, and calves, and the treatment of the faces is nearly identical. Future studies must assign names to these two artists and determine whether other existing *retablos* can be attributed to them.

Giffords has singled out a number of artistic characteristics of *retablos*. Several of these traits stand out in *retablos* of The Peters Collection. One such characteristic is that the Baroque tradition is perpetuated in *retablo* art by "a grand manner setting with a bit of drapery and a piece of furniture, upon which might rest [the saint's] attributes...much the way the grand manner portraitists showed the individual's rank or profession by including the tools of his trade."[16] For example, in *San Anacleto, Papa*, "St. Anacletus, Pope" (Catalogue 23), the papal tiara and a standing crucifix rest upon a draped table, as does a book in *San Francisco de Asis*, "St. Francis of Assisi" (Catalogue 27). The "grand manner" setting is also observable in the drapery and vases of flowers in *retablos* of revered statues such as *El Señor de Plateros* (Catalogue 6), *El Señor de las Penas*, "The Lord of Suffering" (Catalogue 7), *Nuestra Señora del Rosario de Talpa*, "Our Lady of the Rosary of Talpa" (Catalogue 19), and *San Martín*, "St. Martin" (Catalogue 35).

13. *The Art of Private Devotion*, 53.
14. *The Art of Private Devotion*, 53.
15. *The Art of Private Devotion*, 53-54.
16. Giffords, *Mexican Folk Retablos*, 7.

Another characteristic is that *retablo* artists had a penchant for the decorative use of detail, especially in the handling of textiles and other objects that lent themselves to embellishment.[17] This trait is salient in a number of *retablos* in The Peters Collection, including the carefully applied stars on the saint's robe in *San Jerónimo*, "St. Jerome" (Catalogue 30), the flowers on the chasuble of *San Martín* (Catalogue 35), and the monograms "MAR" and "IHS" on the cloak of the Virgin Mary in *Nuestra Señora, Refugio de Pecadores*, "Our Lady, Refuge of Sinners" (Catalogue 18). *San Isidro Labrador*, "St. Isidore the Farmer" (Catalogue 29), includes an abundance of finely executed details: flowers, plowed furrows, birds, even the stonework on the church on the background. The saint's name is carefully lettered at the lower center. In *San Rafael* (Catalogue 36), the archangel wears headdress feathers of red, white, and green, the colors of the Mexican flag, as a subtle political statement on the part of the artist. An extraordinary attention to detail is also evident in the miniature scenes of the story of the Virgin's apparition, in December 1531, to the Indian convert Juan Diego in *Nuestra Señora de Guadalupe*, "Our Lady of Guadalupe" (Catalogue 15), and of the five Sorrowful Mysteries of the rosary in *Nuestra Señora de la Soledad de Santa Cruz*, "Our Lady of Solitude of Santa Cruz" (Catalogue 20).

Yet another trait is that the rules of anatomy and perspective are often unknown or misunderstood.[18] For example, in *San Rafael* (Catalogue 36), the archangel's bodily proportions are imprecise: the arms and the legs do not exactly fit. In *Nuestra Señora de la Encarnación* (Catalogue 13), the Virgin's eyes are not aligned. Similarly, in *Nuestra Señora, Refugio de Pecadores* (Catalogue 18), Mary's nose and mouth are not proportional to her eyes. And, in *Santiago* (Catalogue 40), the heads of the three men are peculiarly distorted.

CONCLUSION

The Peters Collection embraces examples of the best of the world of Mexican tin *retablos* of the nineteenth century, as well as two Mexican paintings on canvas and two Philippine *bultos*, statues of saints. Among the *retablos* are pieces from identified groups as well as works that await attribution. They offer insights into this highly specialized realm of art that flourished during a brief period of time. They express in their own way the spirit of a people, a nation, and a religious devotion unique to their time and place.

17. Giffords, *Mexican Folk Retablos*, 7.
18. Giffords, *Mexican Folk Retablos*, 6.

ART AND THE MISSIONARY CHURCH IN THE NEW WORLD: THE LEGACY OF EVANGELIZATION IN MEXICAN DEVOTIONAL *RETABLOS*

CHRISTOPHER C. WILSON

Only recently have Mexican devotional *retablos* begun to attract the scholarly attention they merit, giving rise to compelling questions about the artists, style, and iconography of these remarkable paintings.[1] Gloria Fraser Giffords, for example, has addressed the problem of attribution.[2] Given that most *retablos* are unsigned, how can we identify a body of artists and assign specific works to them? Giffords suggests that the first step may be to isolate stylistic peculiarities, such as a particular treatment of the forehead or beard, shared by *retablos* that may have been produced by one artist or within the same workshop. Based on her observations of these distinctive features, Giffords has assigned names to individual painters or groups of artists, e.g., the Bee-Stung Lip Painter or the Red-Bole Group. Fernando Juárez Frías has contributed valuable information on the iconography of *retablos*, especially regarding popular advocations of Christ and the Virgin that flourished in nineteenth-century Mexico, such as *El Santo Niño de Atocha*, "The Holy Child of Atocha," and *Nuestra Señora del Patrocinio de Zacatecas*, "Our Lady of the Patronage of Zacatecas."[3]

Although these pioneering scholars and others have made significant contributions to our knowledge of *retablos*, one area of inquiry remains largely unaddressed: What are the artistic sources for *retablos*, and, specifically, how are these paintings linked to Spanish and Flemish prototypes that arrived in the New World during the Colonial period? Scholarship on *retablos* has tended to emphasize the impact of nineteenth-century lithographs imported from Europe, while only briefly mentioning the enduring legacy of such artists as Francisco de Zurbarán (1598-1664) and Peter Paul Rubens (1577-1640) in Mexican art of the Colonial period and in *retablos*.[4] True, some *retablos*, those of Our Lady of Lourdes for example, must have derived from nineteenth-century European lithographs. Many others, however, adopted representations of Christ, the Virgin, and saints that were first propagated by the religious Orders in the Spanish colonies during the seventeenth century, and that continued to be produced throughout the Colonial period for the decoration of churches, monasteries, and private homes.

1. For studies of Mexican *retablos*, see Gloria Fraser Giffords, *Mexican Folk Retablos*, revised ed. (Albuquerque: University of New Mexico Press, 1992); "Retablos: Santos & Ex-Votos," *Latin American Art* 2, no. 3 (Fall, 1990): 90-94; Giffords et al, *The Art of Private Devotion: Retablo Painting of Mexico* (Fort Worth: InterCultura/Dallas: The Meadows Museum, Southern Methodist University, 1991); and Fernando Juárez Frías, *Retablos populares mexicanos: Iconografía religiosa del siglo XIX* (Mexico: Inversora/Bursatil, 1991).
2. Giffords, "The Art of Private Devotion," 50-54.
3. See Juárez Frías, 172-187, 74.

This essay explores how Mexican *retablos* continued the imagery that was disseminated centuries earlier throughout the Spanish colonies, when the religious Orders preached their message of salvation to the Native peoples of the New World. The Spanish conquest of the Americas presented the Roman Catholic Church with the challenge of converting an entire indigenous population from non-Christian beliefs to the Christian faith. Art served as an indispensable means of conveying the Christian message to the Indians. In view of the vital role of art in the work of evangelization, a number of important questions need to be addressed for a fuller understanding of the extraordinary legacy we have in *retablos:* Why were certain representations especially valuable for the missionary effort, and why was the impact of these images so great that they persisted in nineteenth-century Mexican art? What are the European artistic sources for these images, how did the sources arrive in the Spanish colonies, and how did the resulting compositions survive, almost unchanged, for nearly three centuries? To begin answering these questions, I will focus on three *retablos* from The Peters Collection: *St. Jerome in Penitence, The Holy Trinity*, and *St. Regina*.

THE ROLE OF ART IN SPAIN'S MISSION IN THE NEW WORLD: THE EXAMPLE OF ST. JEROME

For an understanding of how art assisted Spain's mission in the New World, we must return to sixteenth-century Europe, where the Catholic Church set a precedent for the use of images as a means to combat heresy and to promote orthodoxy. For the Church at this time, paintings and sculptures were powerful weapons in the battle against the spread of the Protestant Reformation. Countering John Calvin's condemnation of the use of religious images in worship, the Catholic Church reaffirmed art as a means of strengthening adherence to the "true faith." In 1563, the Council of Trent, while defining the agenda of the Counter-Reformation, declared that the people should be "instructed" by art, and "excited [by it] to adore and love God and to cultivate piety."[5] Ecclesiastical patrons in Spain, Italy, Flanders and other predominately Catholic regions commissioned artists such as El Greco (1541-1614) and Rubens to create dramatic, stirring images that emphasized Catholic doctrine and at the same time stimulated the viewer emotionally and spiritually.

Works of art produced during the Counter-Reformation often portrayed those elements of Catholicism that were directly under attack by the Protestant Reformers. One of the subjects most frequently depicted in Spanish art of the late sixteenth and seventeenth centuries was the image of a penitent saint. The representation of a figure atoning for his or her sins through meditation, prayer, and mortification of the flesh glorifies the Catholic

4. For discussions of nineteenth-century lithographs as a source for Mexican *retablos*, see Yvonne Lange, "The Impact of European Prints on the Devotional Tin Paintings of Mexico: A Transferal Hypothesis," in *The Art of Private Devotion*, 64-71, and Giffords, "*Retablos: Santos & Ex-Votos*," 92. Giffords mentions the influence of Zurbarán and Rubens on Mexican Colonial art in *Mexican Folk Retablos*, 173.
5. Quoted in Julius S. Held and Donald Posner, *17th and 18th Century Art* (Englewood Cliffs, NJ: Prentice-Hall/New York: Harry N. Abrams, 1972), 70.

emphasis on works, as exemplified by penitential efforts, while at the heart of Protestantism is the doctrine of justification by faith alone. And while the Calvinists denounced the sacrament of confession, arguing that no amount of penance could alter the individual's preordained destiny, the Catholic Church, in response, placed a renewed emphasis on the importance of meditating on one's sins, confessing them properly to a priest, and performing the prescribed penance. Ardent defenders of Catholicism commissioned numerous images of figures such as the apostle St. Peter, St. Mary Magdalen and St. Jerome, tearfully contemplating their sins, confessing them to God in prayer, and sometimes performing harsh physical penance for their misdeeds.

THE PENITENT ST. JEROME IN SPANISH PAINTING OF THE GOLDEN AGE

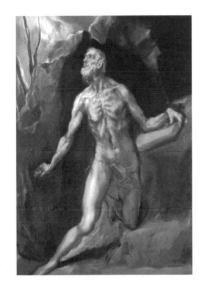

El Greco's painting *St. Jerome in Penitence* (ca. 1610-1614) epitomizes the artistic aims of the Counter-Reformation (Plate 1).[6] One of the four Latin Fathers of the Church, St. Jerome (ca. 345-420) is best known for his work of translating the Bible into Latin. Jerome was frequently represented in Renaissance art as a scholar working in his study, poring over Scripture or writing at a small lectern, as in Albrecht Dürer's engraving of 1514. During the period of the Counter-Reformation, however, increased preference was given to the image of the saint as an emaciated desert hermit, absorbed in meditation and punishing his flesh with a rock.[7]

Plate 1.
El Greco,
*St. Jerome
in Penitence,*
ca. 1610-1614.
Washington, D.C.,
National Gallery
of Art,
Chester Dale
Collection.

Jerome's desires for penance arose from the conflict he felt between his life as a Christian and his love for classical secular literature. As a student, he attended a Roman school of rhetoric, where he was trained in the art of public speaking and debate, the usual preparation for a career in law or civil service.[8] In the course of his studies, Jerome was instructed in the pagan literature of ancient Rome, and he developed a deep admiration for authors such as Virgil, Plautus, and Cicero. One night during Lent, probably in the year 374, Jerome dreamed that he was summoned before Christ, the supreme Judge. "What condition of man are you?" the Judge asked him. "I am a Christian," replied Jerome. The Judge responded angrily: "You lie. *Ciceronianus es, non Christianus*: you are a Ciceronian, a disciple of Cicero, not a Christian. 'Where your treasure is, there your heart is also.'" Christ the Judge ordered him to be flogged, whereupon Jerome cried out for the Lord to have pity, and

6. El Greco's *St. Jerome in Penitence* is an unfinished work. For information about the technical aspects of the work, its provenance, and iconography, see Jonathan Brown and Richard G. Mann, *Spanish Paintings of the Fifteenth through Nineteenth Centuries*, The Collections of the National Gallery of Art Systematic Catalogue (Washington, D.C.: National Gallery of Art, 1990), 56-60.
7. For a discussion of Catholic attitudes toward St. Jerome during the Counter-Reformation, see Eugene F. Rice, *Saint Jerome in the Renaissance.* (Baltimore: The Johns Hopkins University Press, 1985), 143-172. According to Rice (75-79), the portrayal of Jerome as a penitent in the wilderness emerged in Italian art of the early 15th century.
8. Jerome's biography is discussed in Rice, 1-22.

the bystanders joined in his pleas, begging the Judge to forgive Jerome for his youthful errors and to allow him to do penance. Jerome then swore, "Lord, if ever again I possess worldly books, if ever again I read them, I shall have denied You." He awoke from the dream with tears in his eyes, his shoulder visibly bruised and swollen from punishment inflicted by the supreme Judge.[9]

Badly shaken by the dream, Jerome traveled to the Syrian desert, where he took a vow of solitude and settled to do penance for his sinful ways, determined to fulfill his oath to Christ the Judge. He clothed himself in sackcloth and slept on the bare ground. Jerome described his two or three years in the desert in the following passage:

> When all else failed, I lay down at Jesus' feet, watered them with my tears, and wiped them with my hair. I subdued my rebellious flesh with weeks of fasting...I remember crying out for days and nights together; and I beat my breast without stopping until the Lord vouchsafed me some tranquillity. Filled with stiff anger against myself, I went out into the desert alone. Wherever I found a deep valley or rough mountainside or rocky precipice, I made it my place of prayer and torture for my unhappy flesh. The Lord himself is my witness, after many tears, I fixed my eyes on Heaven and seemed to find myself among the angelic hosts. Then, full of joy and happiness, I would sing out: "I run after you in the fragrance of your perfumes."[10]

In the painting now in the National Gallery of Art, Washington, D.C., El Greco depicted a full-length figure of St. Jerome, kneeling on his left leg in front of the mouth of a cave. Naked except for a ragged loincloth, Jerome clutches the Scriptures in his left arm, and in

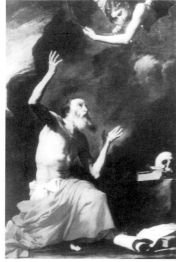

Plate 2. Jusepe de Ribera, *St. Jerome and the Trumpet of the Last Judgment*, 1626. Naples, Museo e Gallerie Nazionali di Capodimonte.

his blood-covered right hand holds a rock, the instrument of his self-flagellation. His hollowed cheeks and protruding ribs are evidence of severe fasts. El Greco has followed the recommendations of sixteenth-century hagiographers, such as Johannus Molanus and Loys Lassere, who advised that the saint be represented as a penitent, mortifying his flesh, since this image rouses the viewer to repent and to imitate Jerome's example.[11]

A variation on the theme of Jerome in the wilderness was painted a few years later, in 1626, by Jusepe de Ribera (1591-1652), a Spaniard who worked in the city of Naples (Plate 2).[12] The source for the composition is Ribera's own

9. The text of Jerome's letter, in which he recounts the dream of being punished by the Supreme Judge, is quoted in Rice, 3.
10. Rice, 7.
11. Rice, 153, 160.
12. For information on the life and work of Jusepe de Ribera, see Jonathan Brown, *The Golden Age of Painting in Spain* (New Haven: Yale University Press, 1991), 179-196.

etching of the subject, which had been completed in 1621 (Plate 3).[13] Like El Greco, Ribera painted Jerome as a hermit, his body mortified by ascetic practices, and placed him in rocky terrain, with the Scriptures nearby. While El Greco portrayed Jerome wearing a small loincloth, Ribera placed a brilliant red drapery over the saint's legs, alluding to the long tradition of depicting Jerome dressed in the red robes of a cardinal. Jerome was given the title of cardinal anachronistically, since no such office existed during his lifetime. In ranking the four Latin Fathers of the Church, medieval Christians placed Gregory the Great first, because he had

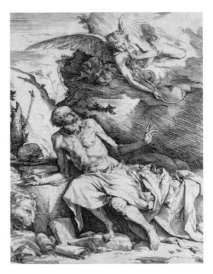

Plate 3.
Jusepe de Ribera,
St. Jerome and
the Trumpet
of the
Last Judgment,
1621, etching.
New York,
Metropolitan
Museum of Art.
Gift of Junius S.
Morgan, 1919.
(19.52.15)

been a pope. Ambrose and Augustine had been bishops. After the Sacred College of Cardinals took institutional shape in Rome at the end of the eleventh century, Jerome was assigned an ecclesiastical dignity, that of cardinal, which ranked between the offices of bishop and pope.[14]

On a ledge rests a human skull, attesting to Jerome's meditations on the brevity of human existence. Ribera has heightened the dramatic intensity of El Greco's composition by introducing an angel, blasting a trumpet and descending from the upper right corner of the picture. The image emphasizes that Jerome hears the trumpet of the Last Judgment, and that the saint's penance is fueled by his knowledge of the inevitable day when the good will enter paradise and the wicked will be cast into hell.

Ribera's painting is only one example of numerous seventeenth-century depictions of the penitent Jerome hearkening to the trumpet of the Last Judgment.[15] Beginning in the tenth century, Jerome was credited with the discovery of a text entitled *The Fifteen Signs before Doomsday*, a brief work describing the events of the Last Judgment. In the early fourteenth century, the text was condensed into a statement of five lines, attributed to Jerome: "Whether I am drinking or eating or sleeping or doing anything else at all, I seem to hear that terrifying voice resound in my ears, saying, 'Arise ye dead and come to judgment.'" In some variants of the text, the word *tuba* replaces *vox*: "I seem to hear that terrifying trumpet resound in my ears." Portrayals of St. Jerome listening to the trumpet, like Ribera's, rely directly or indirectly on this text.[16] The image is a call to the faithful, urging them to imitate Jerome's example and to embrace penance as a means of achieving salvation, and a warning to heretics who must prepare to meet the Judge.

13. Brown, *Golden Age*, 182. Brown notes that Ribera created two influential prints of this subject in 1621 (196). For further information on the two etchings and their influence in European Baroque art, see Jonathan Brown, *Jusepe de Ribera: Prints and Drawings* (Princeton: Princeton University Press, 1973), 26-27, 41-56.
14. Rice, 36-37.
15. The image of St. Jerome hearing the trumpet of the Last Judgment originated in Italy around the year 1400: see Rice, 162-172. In seventeenth-century Spain, Zurbarán (San Diego, Fine Arts Gallery) and Antonio de Pereda (Madrid, Museo del Prado), among other masters, portrayed this subject.
16. Rice, 161-62.

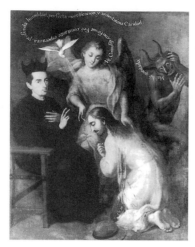

Plate 4.
Good Confession,
Mexico,
17th c.
Mexico City,
La Profesa.

For Catholics of Counter-Reformation Europe, saints were not only models for imitation, but also powerful friends and protectors, who, from their place in Heaven, were in a position to assist those on earth. Since the early Renaissance, the cult of St. Jerome had been a popular devotion, and the saint was perceived as an advocate for the penitent individual who strives to turn away from sin and to lead a virtuous life. Prayers addressed to St. Jerome appear in books of prayer compiled for use by the laity from the fourteenth century on.[17] A book of prayers copied for Claude de France between 1511 and 1514, for example, contains the following passage: "Great lover of Christ, famous, glorious Jerome! Help us live uprightly and love God as you have taught us to in your books. Lover of chastity, whose purity of heart shaped a life of purity, make us chastise our body and weep for our sins. *Ora pro nobis, gloriose Hieronime.*"[18] Prayers could be offered before images of saints, and seventeenth-century Spanish representations of Jerome as a penitent and witness to the Last Judgment must have aroused the viewer not only to follow the saint's example but also to seek his assistance in securing salvation.

Devotion to St. Jerome was fostered in the Iberian peninsula by the Hieronymite Order, which had been founded in Spain during the fourteenth century. The Spanish Hieronymites grew and expanded rapidly. By the year 1415, at the time of its first general chapter, the Order comprised twenty-five houses.[19] In the sixteenth century, with the support of the Hapsburg monarchs, the Hieronymites enjoyed increased success. The Holy Roman Emperor Charles V retired to a Hieronymite monastery in Yuste, and his son,

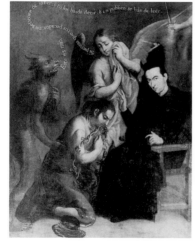

Plate 5.
Bad Confession,
Mexico,
17th c.
Mexico City,
La Profesa.

Philip II, included a Hieronymite monastery as part of his palace at the Escorial, begun in 1563.[20] The Hieronymites also settled in the New World, and members of the Order must have played a key role in carrying the image of St. Jerome across the Atlantic to the Spanish colonies, and in propagating his iconography there.[21]

ST. JEROME IN COLONIAL ART OF THE AMERICAS

Art which furthered the aims of the Counter-Reformation in Europe was well-suited to the needs of the Church in the

17. Rice, 81.
18. The prayer appears on folio 40 of the book of prayers created for Claude de France and is quoted by Rice, 81.
19. Rice, 70.
20. Barbara von Barghahn, "From the Tower of David to the Citadel of Solomon: Mirrors of Virtue for a Viceregal 'Silver Age,'" in *Temples of Gold, Crowns of Silver: Reflections of Majesty in the Viceregal Americas,* edited by Barbara von Barghahn. (Washington: D.C.: The George Washington University, 1991), 161.
21. The best-known Mexican Hieronymite is the extraordinary author Sor Juana Inés de la Cruz (1651-1695), who resided at the Convent of Santa Paula of the Order of San Jerónimo, founded in Mexico City in 1586.

New World. Just as ecclesiastical patrons in Spain, Flanders, and Italy commissioned images that reaffirmed for the viewer elements of Catholic doctrine, such as the sacrament of Penance, so the religious Orders in the Spanish colonies decorated their churches with art that communicated the tenets of Catholicism to a Native American audience. A pair of seventeenth-century paintings from Mexico, for example, illustrate *Good and Bad Confession* (Plates 4 and 5) [22] In the image portraying *Good Confession*, a sinner kneels before a Jesuit priest and admits his faults. The repentant figure is guarded by an angel, and rays of divine light are cast upon him

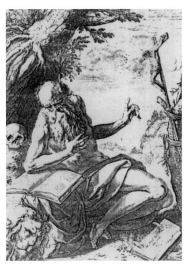

Plate 6.
Hendrik Goltzius
after
Palma il Giovane,
*St. Jerome
in Penitence,*
1596, engraving.

by the dove of the Holy Spirit. A devil flees in terror, repelled by the sight of a good confession. In the image of *Bad Confession*, however, the kneeling figure does not acknowledge his sins. Snakes pour from his mouth, an angel weeps, and the Jesuit priest looks out accusingly toward the viewer, as if warning others not to follow this miserable example. A devil grips the unrepentant figure and declares, "*Éste es mío,*" 'This one is mine.'

Like the representation of a repentant figure making a good confession, the iconography of St. Jerome in Penitence highlights the necessity of meditating on one's sins, of confessing them properly to a priest, and of performing penance in order to progress along the path toward salvation. Because of its instructional purpose, the image of the penitential Jerome, contemplating his faults and punishing his flesh, was a frequent subject in Colonial art of the Americas. A 1586 engraving by Hendrik Goltzius (Plate 6), based on a painting by Palma il Giovane, served as a model for several Spanish Colonial depictions of St. Jerome in Penitence, including an eighteenth-century Ecuadoran work (Plate 7).[23] In this painting,

Jerome sits in a rocky landscape with a cross and a skull set up on a nearby ledge. He is naked, except for a piece of red drapery falling across his legs. The trumpet of the Last Judgment, which the Ecuadoran artist has added to the upper right corner of the composition, rouses the saint to intensify his penance.

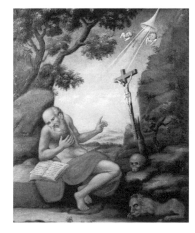

Plate 7.
*St. Jerome
in Penitence,*
Ecuador,
18th c.
Quito,
Museo
Filanbanco.

Jusepe de Ribera's treatment of the subject also may have exerted an impact in the Americas. As previously noted, this artist worked in the city of Naples, at the time a Spanish

22. Santiago Sebastián discusses the Mexican portrayals of *Good and Bad Confession* in "The Diffusion of Counter-Reformation Doctrine," in *Temples of Gold, Crowns of Silver*, 23. For a survey of the iconography of Spanish Colonial art, including an analysis of the impact of Counter-Reformation imagery in the New World, see Sebastián, *El barroco iberoamericano: Mensaje iconográfico* (Madrid: Ediciones Encuentro, 1990).

23. Sebastián states that an engraving by Justus Sadeler influenced several depictions of St. Jerome in penitence produced in the Colonial Americas. While Henrik Goltzius' print was based on a painting by Palma il Giovane, the engraved version by Sadeler, according to Sebastián, was based on a work by Palma il Vecchio. See Sebastián, *El barroco iberoamericano*, 91. For a reproduction of Sadeler's engraving, see Pál Keleman, *Baroque and Rococo in Latin America*, 2 vols. (New York: Dover, 1967), 2: plate 190, g.

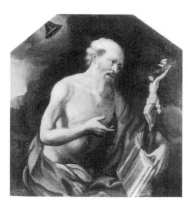

territory, and his works were imported to Spain by viceroys and other individuals who had lived in Italy.[24] Jonathan Brown has observed that of all Ribera's works, the composition most imitated by Spanish artists was his depiction of *St. Jerome and the Trumpet of the Last Judgment.*[25] Seventeenth-century Spanish paintings of this subject, based on Ribera's admired composition, may have been shipped to the colonies, at a time when European works of art were in great demand for the decoration of churches and monasteries in the New World. During the seventeenth century, paintings by El Greco, Zurbarán, Bartolomé Esteban Murillo (1617-1682), Juan Valdés Leal (1622-1690), and other Spanish masters arrived in the Americas, and helped shape the development of Spanish Colonial art.[26] In addition, Ribera's own etchings of *St. Jerome and the Trumpet of the Last Judgment* may have been sent to the colonies, and may have provided the inspiration for subsequent Spanish American portrayals of the penitent saint.

A seventeenth-century painting from Mexico carries forward the iconography of St. Jerome in Penitence that was favored in European art of the Counter-Reformation (Plate 8). The emaciated saint holds the Scriptures, and, gazing at a crucifix, participates in a prayerful dialogue with Christ. A trumpet emerges from the sky in the upper left portion of the composition, alerting the saint and the viewer to the impending approach of the Last Judgment. An eighteenth-century work, produced in Ecuador, stresses Jerome's harsh physical penance (Plate 9). The saint leans on a stone ledge, and in front of him lay not only his books, pens and inkwell, but also a rock and a rope scourge, instruments used for mortification of the flesh.[27]

In the foreground of the Ecuadoran picture rests a lion, an attribute frequently included in European and Colonial Spanish representations of the penitent saint. The animal's presence is explained in the *Plerosque Nimirum*, a ninth-century text containing the earliest known account of an episode that occurred later in Jerome's life, when he retired to a monastery he founded in Bethlehem:

24. Brown, *Golden Age*, 195.
25. Brown, *Golden Age*, 196, and *Jusepe de Ribera*, 44-56.
26. See José de Mesa and Teresa Gisbert, *Historia de la pintura cuzqueña*, 2 vols. (Lima: Fundación Augusto N. Wiese, 1982), 1:116-118; Teresa Gisbert, "Andean Panting," in *Gloria in excelsis: The Virgin and Angels in Viceregal Painting of Peru and Bolivia* (New York: The Center for Inter-American Relations, 1986), 25; Christopher Chadwick Wilson, "St. Teresa of Ávila's Holy Patron: Teresian Sources for the Image of St. Joseph in Spanish American Colonial Art," in *Patron Saint of the New World: Spanish American Colonial Images of St. Joseph*, edited by Joseph F. Chorpenning, O.S.F.S. (Philadelphia: Saint Joseph's University Press, 1992), 14; and Francisco Statsny, "Zurbarán en América Latina," in *Presencia de Zurbarán* (Bogotá: Banco de República, 1988), 21-43.
27. Another version of this same composition exists in the Barbarosa-Stern Collection. See Pedro Gjurinovic Canevaro et al, *Viceregal Peruvian Art: Barbarosa Stern Collection* (Washington, D.C.: Museum of Modern Art of Latin America, 1989), 27.

Late one afternoon, when blessed Jerome sat reading and explaining Scripture to his brother monks, as is customary in monasteries, a huge lion limped into the courtyard on three legs, holding the fourth up in the air. Some of the brothers, overcome by human frailty, fled in terror; but St. Jerome went boldly to meet him, as though the lion were his guest. The lion, because it could not speak, silently held out its wounded paw to the holy man. Jerome called the brothers back and asked them to wash the lion's paw and find out why he limped. When they examined the paw, they found thorns embedded in it. Once the wound was cared for and the lion fed, he quickly recovered. Not only that: he laid aside his brutish wildness and from then on remained tamely with the monks, a tranquil domesticated animal.[28]

Spanish American artists were often very inventive in their portrayal of Jerome's lion. Lions were unknown in the Americas, and painters tended to depart from European artistic models for depicting the animal, preferring instead to give their lions anthropomorphic features. The lions in the two Ecuadoran works discussed earlier, for example, have noses and eyes that resemble those of humans (Plates 7 and 9). In some nineteenth-century images painted in New Mexico, the lion is transformed into a monster, restrained under Jerome's feet, implying that Jerome trampled evil through his penance in the desert (Plate 10).[29]

ST. JEROME AS A SUBJECT OF *RETABLO* ART

In nineteenth-century Mexico, when tin *retablos* were purchased for honored spaces within private homes, the consumer must have wanted images of saints that resembled, at least in their iconography and composition, those which were commonly seen on the walls of local churches. While *retablos* were usually painted in a more "vernacular" style than either their European or Spanish Colonial prototypes, they meticulously reproduced representations of sacred personages that had become standard in Mexican art. Like Colonial religious paintings, *retablos* functioned as windows into Heaven, illustrating figures whose virtues should be imitated, and whose assistance can be invoked for the faithful on earth. In order for these images to be effective, it was a basic requirement

Plate 10.
St. Jerome in Penitence, New Mexico, late 19th c. Colorado Springs, Taylor Museum for Southwestern Studies, Colorado Springs Fine Arts Center.

28. Quoted in Rice, 37. The iconography of St. Jerome in the wilderness conflates Jerome's stay in the desert (374-76) with the taming of the lion, an episode that happened years later in the saint's life.
29. William Wroth, *Christian Images in Hispanic New Mexico* (Colorado Springs: Colorado Springs Fine Arts Center, 1982), 208.

that they be iconographically correct. In other words, *retablos* had to resemble the familiar representations that were venerated in public places of worship.

The *retablo* of *St. Jerome in Penitence* in The Peters Collection certainly follows this requirement (Catalogue 30). The painting looks back to a manner of depicting Jerome which, as we have seen, predominated in the art of Spain and of the New World. Clothed only in a piece of red drapery, Jerome practices penance in the rocky setting of the wilderness. He clasps a crucifix in his right hand, and in his left, holds a rope scourge with which he chastises his flesh. The Scriptures lie open beside him, and in the background rests a lion with anthropomorphized nose and eyes. In the upper right corner, emerging from a group of white clouds, is the trumpet of the Last Judgment, thundering its warning in Jerome's ear. Like the examples of this subject produced in Spain during the Counter-Reformation and in Latin America during the Colonial period, the painting must have incited the viewer to follow Jerome's example by taking up penance as a means of overcoming sin and to seek the saint's help in attaining salvation.

ONE GOD, THREE PERSONS:

THE HOLY TRINITY AS THREE IDENTICAL MEN IN MEXICAN DEVOTIONAL *RETABLOS*.

From the fourth century, when the formulation of "one God in three persons" was clearly established in Church teaching, the doctrine of the Trinity has been at the very center of faith for the vast majority of Christians. Through the centuries, Trinitarian language and imagery has provided a window into the nature of God and an expression of God's saving activity in the world. Presentation of the Trinity, both in the language of the creeds and in church art, has long been viewed as central to the proclamation of the Christian message. A *retablo* of *The Holy Trinity* in The Peters Collection is a visual summary of teaching about God as Father, Son, and Holy Spirit that dates back to the early Church (Catalogue 5). The three persons are depicted as identical men, triplets, each of the same age and size. Symbols on the figures' chests reveal the identity of each person: the Father, in white, bears a sun disklike badge; the Son, with wounds on His hands, clothed in a brown robe and wrapped in a blue mantle, has a lamb on his chest; and the Holy Spirit, in red, is marked by a dove. Although the Holy Trinity has been portrayed in other ways in Christian art, it was this visual formula of three identical men that was most widely used as the Roman Catholic Church presented the Gospel to the Native peoples of the New World. Even after Mexico gained independence from Spain in 1821, this iconography continued to flourish in *retablos*.

How did it happen that the God of the New Testament came to be depicted in this way? And why, out of all the possible portrayals of the Trinity, did this image enjoy such popularity in Spanish Colonial art? As the Church faced the tremendous challenge of converting an entire indigenous population to Christianity, the choice of how to depict the true nature of God was no doubt a matter of some urgency and great significance. For an answer to these questions, we must go back to the first centuries of the Christian faith, back to the period of the very first formulations of God as both one and three. We must bear in mind that the task of the early Church as it proclaimed one God in three persons paralleled the challenge of the first Christian preaching in the New World.

THE EARLY CHURCH AND THE DOCTRINE OF THE TRINITY

One of the most significant theological dilemmas in the first centuries of the Church was how to speak of the nature of God.[30] Unlike the Hebrew Scripture, which repeatedly insists upon the absolute oneness of God, the language of the New Testament speaks of three divine persons: God, the Father; Jesus, the Son of God; and the Comforter or Holy Spirit. According to the Gospel of St. John, for example, Jesus prayed to the Father, and, during the Last Supper, Jesus promised that he would send "the Comforter which is the Holy Spirit" (John 14: 26). For many in the early Church, the language of New Testament revelation made it a matter of faith that God be understood as one, yet three. As the Gospel spread, the Church struggled to answer questions that were raised as various claims were made about the nature and relationship of Father, Son, and Holy Spirit. Are the three persons distinct yet somehow united? Are they equal, or are the Son and Holy Spirit subordinate to the Father? If the Son is not fully divine, is salvation assured through Him?

After much controversy and debate, the Council of Nicea, held in the year 325, declared that the Son possesses the same Godhead as the Father. In the year 381, the First Council of Constantinople extended this same true divinity to the Spirit. The resulting proclamation was that salvation, or eternal life, is offered only through God the Father, God the Son, and God the Holy Spirit. By the end of the fourth century, this theological formulation of one God in three persons, who are co-substantial, and of equal dignity and majesty, was established as the heart of the Christian message. This affirmation of co-divinity shaped much theological speculation about the Trinity throughout subsequent Christian history.[31]

In the fifth-century Athanasian Creed, also known as the *Quicumque vult*, or "Whoever Wishes," the Church declared firmly what the faithful must understand and

30. For a discussion of the evolution of the doctrine of the Trinity in the early Church, see R.L. Richard, "Trinity, Holy," *New Catholic Encyclopedia*, 1967.
31. Richard, 295.

accept about the true nature of the Holy Trinity. As the following passage from this creed suggests, salvation is contingent on a true and correct profession of the triune God:

> Whoever wishes to be saved, needs above all to hold the Catholic faith; unless each one preserves this whole and inviolate, he will without a doubt perish in eternity. But the Catholic faith is this, that we venerate one God in the Trinity, and the Trinity in oneness; neither confounding the persons nor dividing the substance; for there is one person of the Father, another of the Son, another of the Holy Spirit; but the divine nature of the Father and of the Son and of the Holy Spirit is one, their glory is equal, their majesty is co-eternal... and in this Trinity there is nothing first or later, nothing greater or less, but all three persons are co-eternal and co-equal with one another, so that in every respect, as has already been said above, both unity in Trinity and Trinity in unity must be venerated. Therefore let him who wishes to be saved think thus concerning the Trinity.[32]

Used originally as an instrument of instruction, the Athanasian Creed remained popular through the centuries, as evidenced by its inclusion in the Roman Breviary.[33] The religious Orders in the New World undoubtedly used this creed in educating Native Americans about the central doctrine of the triune God of the Christian faith.

THE MANIFESTATION OF THE TRINITY TO ABRAHAM

The image of the Trinity as three identical men evolved from depictions of the Old Testament story of Abraham and the three celestial visitors. This episode is recounted in Genesis 18:1-2:[34]

> And the Lord appeared to him in the plains of Mamre: and he [Abraham] sat in the tent door in the heat of the day. And he lifted up his eyes and looked, and, lo, three men stood by him: and when he saw them, he ran to meet them from the tent door, and bowed himself toward the ground .

Abraham asks the visitors to stay as his guests while he fetches water and food. He tells his wife Sarah to prepare three measures of a meal. The text then states that Abraham "took butter, and milk, and the calf which he had dressed, and set it before them; and he stood by them under the tree and they did eat" (Genesis 18:8). The three visitors, identified in the text as "the Lord," promise Abraham that Sarah shall bear a son, even though "Abraham and

32. The full text of the Athanasian Creed may be found in Michael O'Carroll, C.S.Sp., *Trinitas: A Theological Encyclopedia of the Holy Trinity* (Wilmington, Delaware: Michael Glazier, 1987), 29-31.
33. O'Carroll, 31.
34. Adelheid Heimann, "Trinitas Creator Mundi," *Journal of the Warburg Institute* 2 (1938-39): 45.

Sarah were old and well stricken in age; and it ceased to be with Sarah after the manner of women" (Genesis 18:11).

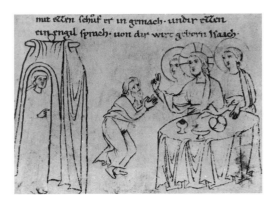

Plate 11.
The Hospitality of Abraham,
miniature from the Millstat Genesis,
1180-1200.
Klagenfurt, Kärntner,
cod. 6/19, fol. 27 r.

One of the four Latin Fathers of the Church, the fourth-century St. Ambrose, Bishop of Milan, wrote in his treatise *On Abraham* that during this episode Abraham beheld the three divine persons of the Trinity.[35] Ambrose also pointed out that although Abraham saw three, he addressed them as one Lord.[36] Similarly, St. Augustine wrote that "Abraham saw three, and he adored one."[37]

Representations of this subject, known in art as the Hospitality of Abraham, exist in Byzantine manuscripts, as well as in illuminated books produced in the West during the High Middle Ages. In some cases, Abraham's three visitors are identified as the three persons of the Trinity. An example may be found in one of the miniatures of the Theodore Psalter, created in the Studios monastery of Constantinople in the year 1066 (London, Brit. Lib., Add. MS 19352, fol. 62v).[38] The image shows Abraham emerging from a door of his house and carrying a bowl of food toward his guests. The three celestial visitors, seated at a round table, are identified by an inscription as *he hagia trias*, "the Holy Three," a term that must mean the Holy Trinity. Another depiction of the Hospitality of Abraham is contained in the Millstat Genesis (Klagenfurt, Kärntner, cod. 6/19), produced in either Salzburg or Corinthia between 1180 and 1200 (Plate 11). The manuscript consists of eighty-seven colored ink drawings that accompany a Middle High German paraphrase of the text of Genesis.[39] In the drawing portraying the three celestial visitors eating at Abraham's table (fol. 27r), the viewer can be certain of the Trinitarian intent of the artist. The head of the central figure is surrounded by a cruciform nimbus which distinguishes him as the Son. The other two male figures are of the same age and size as Christ.

THE TRINITY AS THREE IDENTICAL MEN IN MEDIEVAL AND RENAISSANCE ART

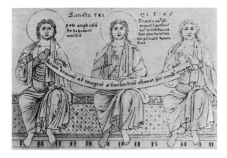

Plate 12.
Herrad of Landsberg,
The Holy Trinity,
miniature from the *Hortus Deliciarum,*
second half of the 12th c.

The iconography of the Hospitality of Abraham gave rise to representations of the Trinity as three identical persons in art of the twelfth century.[40] Often these images show the Trinity in council, deliberating on the creation of

35. St. Ambrose, *De Abraham*, in *Patrologia Latina*, vol. 14, 457: "Deus illi apparuit, et tres aspexit. Cui Deus refulget, Trinitatem videt, non sine Filio Patrem suscipit, nec sine Spiritu sancto Filium confitetur."
36. Ambrose 458: "Tres vidit, et unum Dominum appelavit, ipsius solius se servum fatetur."
37. St. Augustine, *Contra Maximinum Arianorum Episcopum*, in *Patrologia Latina*, vol. 42, 809: "et ipse Abraham tres vidit, et unum adoravit."
38. See Sirarpie der Nersessian, *L'Illustration des psautiers grecs du Moyen Age* (Paris: Editions Klincksiek, 1970), 32 and Figure 101.
39. Kurt Weitzmann and Herbert L. Kessler, *The Cotton Genesis* (Princeton: Princeton University Press, 1986), 23.
40. For a list of depictions of the Trinity as three identical men in art of the twelfth through fifteenth centuries, see Louis Réau, *Iconographie de l'art chrétien*, vol. 2, part 1 (Paris: Presses Universitaires de France, 1956), 23.

Plate 13.
*The Creation of
the Angels
and the Fall of the
Rebel Angels*,
miniature from the
Biblia Historiale,
15th c. Brussels,
Bibliothèque
Royale
de Belgique,
MS. 9001, fol. 19.

humankind. An example may be found in one of the miniatures of the *Hortus Deliciarum*, a manuscript produced by Herrad of Landsberg in the second half of the twelfth century (Plate 12).[41] The three identical bearded men sit in a row, holding a banner bearing the words from Genesis, "Let us make man in our image after our likeness." Above the divine persons is the inscription *Sancta Trinitas*, "Holy Trinity."

The three-man Trinity type continued to be represented in subsequent centuries, as attested by the miniatures in a group of fifteenth-century French manuscripts containing the text of the *Biblia Historiale* by Guyart Desmoulins. In a miniature now preserved in Brussels (Bibliothèque Royale de Belgique, MS. 9001, fol. 19), the composition is divided into six zones (Plate 13).[42] On the upper left is the figure of Wisdom, seated on a throne. Below her are the Trinity, gesticulating as They deliberate on the process of creation. The head of the central figure is distinguished by a cruciform nimbus, like that which surrounds the head of one of Abraham's guests in the twelfth-century Millstat Genesis. In the lower section, the three divine persons are shown blessing the angels whom They have just made. On the upper right, each person of the Trinity points down to the two disastrous scenes below, depicting the fall of Lucifer and the rebel angels into the mouth of hell.

The best-known example of the three-man Trinity type in Western art is that which appears in Jean Fouquet's Book of Hours of Etienne Chevalier (1452-1456). We find this iconography in Fouquet's portrayal of the *Coronation of the Virgin*, and also in his extraordinary

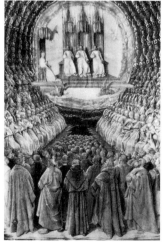

Plate 14.
Jean Fouquet,
*The Heavenly
Court*,
miniature from the
Book of Hours of
Etienne Chevalier,
1452-1456.
Chantilly,
Musée Condé.

depiction of the *Heavenly Court* (Plate 14).[43] In the latter image, the three divine persons, clothed in white, occupy a single throne topped with three canopies. They raise their hands in gestures of benediction. To their right is enthroned the Virgin Mary, Queen of Heaven, and the rest of the composition is crowded with ranks of angels and blessed souls.

During the sixteenth century, Flemish artists sometimes portrayed the Trinity as three identical men in panel paintings of the Coronation of the Virgin. A magnificent example now hangs in the Church of Santa María in Portugalete, Spain (Plate 15).

41. See Herrad of Landsberg, *Hortus Deliciarum*, edited and translated by Aristide D. Caratzao, with commentary and notes by A. Straub and G. Keller (New Rochelle, New York, 1977), and. Heimann, 46.

42. For discussions of this miniature, see Heimann, 47, and L. M. J. Delaissé, *Miniatures médiévales* (Genève: Editions des Deux-Mondes, n.d.), 96.

43. See Jean Fouquet, *The Hours of Etienne Chevalier*, preface by Charles Sterling (New York: George Braziller, 1971), Plates 13 and 27.

It is believed that this work, which forms the central panel of a triptych, was brought to the Iberian Peninsula in the sixteenth century by the Fleming Guyot de Beauregard.[44] The three persons of the Trinity appear as identical bearded men in their early thirties, and they are each dressed in sumptuous costumes with jeweled trim. This Trinity type was occasionally employed by Spanish artists, as in a sepia drawing by the Valencian painter Jerónimo Jacinto de Espinosa (1600-1667) (Plate 16).

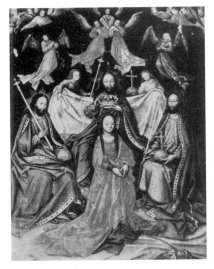

Plate 15.
The Coronation of the Virgin, Central panel of a Flemish triptych, 16th c. Church of Santa María, Portugalete, Spain.

Before turning our attention to art of the New World, we should note that the image of the Trinity as three identical men never acquired the popularity in Renaissance Europe that it would subsequently enjoy for three centuries in the Americas. Despite the Old Testament precedents and theological arguments that justified the three-man Trinity type, most European artists represented the Holy Spirit in the form of a dove. This depiction may be traced to the account of the Baptism of Christ in the Gospels, when the Holy Sprit descended in the form of a dove (Matthew 3:16; Mark 1:10; Luke 3:22). Preference for the dove was doubtlessly rooted in this Scriptural story, and reinforced by New Testament descriptions of the Holy Spirit as the one who will be sent by Christ (John 14:15-31; Acts 1:4), and who descended upon the faithful at Pentecost (Acts 2:1-4).

Arguments in favor of the image of the dove and against that of the three men were made in two treatises that had a great impact on the art of the Spanish Golden Age. The Flemish theologian Johannus Molanus, in his *History of Sacred Images*, first published in 1570, and the Spanish painter and iconographer Francisco Pacheco, in his *Art of Painting* of 1649, both indicated dissatisfaction with representations of the Trinity as three men, though neither went so far as to suggest prohibiting the image.[45] Pacheco argued that the most appropriate depiction of the Trinity is one that shows the Father as "a dignified and handsome old man," Christ as a man of "thirty-three years of age, with the most beautiful countenance," and "the Holy Spirit in the form of a dove."[46] Pacheco then commented that "another depiction of the

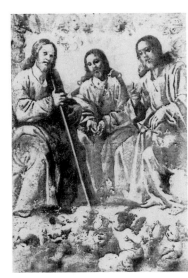

Plate 16.
Jerónimo Jacinto de Espinosa, *The Holy Trinity*, 17th c., drawing. Madrid, National Library.

44. Chandler Rathfon Post, *A History of Spanish Painting*, vol. 9, part 1 (Cambridge, Massachusetts: Harvard University Press, 1947), 14-16.
45. See John B. Knipping, *Iconography of the Counter-Reformation in the Netherlands: Heaven on Earth*, 2 vols. (Nieuwkoop: B. de Graf/Leiden: A.W. Sijthoff, 1974), 2: 476, and Teresa Gisbert, *Iconografía y mitos indígenas en el arte* (La Paz: Talleres Don Bosco, 1980), 89.

mystery is to place three figures seated...with crowns on their heads and scepters in their hands, which are intended to manifest the equality and distinction of the three persons."[47] Pacheco complained that this iconography "is not wholly satisfactory for the ignorant, since he needs a particular sign or attribute by which he can know each person."[48]

THE IMAGE OF THE TRINITY IN ART OF THE NEW WORLD

Today it is difficult to know how the image of the Trinity as three identical men first arrived in the New World, since most works of art shipped to the Americas in the sixteenth century have perished in devastating earthquakes and fires. Nevertheless, a few possibilities may be suggested. Some of the earliest paintings sent to Mexico and to the Andean region of South America were of Flemish origin. Inventories taken in 1546 and 1553 at the Cathedral of Cuzco, Peru, for example, indicate that the interior was decorated with a large quantity of images painted in Flanders.[49] Some of the Flemish paintings that were imported to the colonies may have portrayed the Trinity as three identical men, perhaps resembling the sixteenth-century *Coronation of the Virgin* in the Flemish triptych that now hangs in the Spanish Church of Santa María, Portugalete.

Flemish engravings may have also helped carry this image of the Trinity to the Spanish colonies. During the seventeenth and eighteenth centuries, engravings of religious subjects, printed in Antwerp, were sent to the Americas in large numbers and formed the basis for the composition of many Colonial paintings. John Knipping has observed that during the seventeenth century, engravings were produced in the South Netherlands which portrayed the Trinity as three men, often with the Father carrying a small sun, the Son a

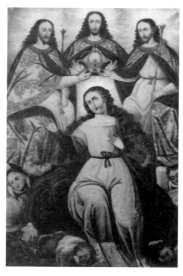

lamb, and the Holy Spirit a dove.[50] This exact iconography predominates in Colonial Mexican images of the Trinity, and subsequently in nineteenth-century Mexican devotional *retablos*.

Once this Trinity type arrived in the Americas, it gained immense popularity and became standard in depictions of members of the Heavenly Court, as in an eighteenth-century *Coronation of the Virgin* produced by an artist of the Cuzco School of Peru (Plate 17).[51] Why the preference for this image of the Trinity in a land where the Christian faith was just being established? The choice is somewhat puzzling given the popularity of the dove image in Europe, and the opposition to

46. Quoted in Gisbert, *Iconografía*, 89.
47. Quoted in Gisbert, *Iconografía*, 89.
48. Quoted in Gisbert, *Iconografía*, 89.
49. For the inventories of the Cathedral of Cuzco, see Mesa and Gisbert, 1: 48-49.
50. Knipping, 2: 476.
51. For a study of Colonial Spanish representations of the Holy Trinity as three identical men, see Santiago Sebastián, "La representación heterodoxa de la Trinidad en Hispanoamérica," *Anales del Instituto de Investigaciones Estéticas* 21 (1968): 70-74.

the three-man image expressed in the writings of Molanus and Pacheco. In fact, the Trinity as three identical men persisted in Latin American art even after Pope Benedict XIV issued an edict in 1745 banning depictions of the Holy Spirit as a human being.[52] Teresa Gisbert has addressed this question, observing that the missionary effort sometimes required the use of images not favored, or even prohibited, in Europe. Gisbert has suggested that Colonial Spanish representations of the Trinity avoided depicting the Holy Spirit in the form of a dove because that image may have suggested animal worship to Native American viewers, a practice forbidden by the European missionaries.[53]

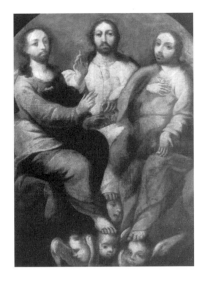

Plate 18.
The Holy Trinity,
Mexico,
18th c.
Mexico City,
Pinacoteca
Virreinal.

An additional answer may be that the Trinity represented as three identical men communicated most clearly to Native Americans a key doctrine of the Church. The Athanasian Creed, we should recall, states that anyone who wishes to be saved must have a clear and correct understanding of the Trinity. The Creed affirms that the three persons are co-equal, co-eternal, and co-substantial. The Trinity as three men stresses the oneness of the three persons, perhaps at the expense of illustrating how each person is distinct. Given that the missionaries had to combat the polytheism of native religions, the Church in the New World may have decided to emphasize an image that proclaims the identity of the three as one. The notion that the Christian God was somehow three different Gods had to be avoided by every means possible. Once this image became firmly established in the lives of the people, it could not be erased, even by Papal edict, and persisted in Mexican art of the eighteenth and nineteenth centuries.

An eighteenth-century painting of the *Holy Trinity* attests to the Mexican preference for clothing the Father in white, the Son in blue, and the Spirit in red (Plate 18). These colors continued to be used in representations of the Trinity on *retablos*, as evidenced by the outstanding example in The Peters Collection. The immediate source for the *retablo* may be a Mexican engraving. During the nineteenth century, copper engravings were produced in Mexico that portrayed the three men sitting on clouds, their heads surrounded by

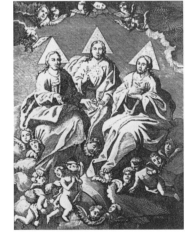

Plate 19.
The Holy Trinity,
Mexico,
1807,
copper engraving.

52. The edict of Pope Benedict XIV is cited in Donna Pierce, "The Holy Trinity in the Art of Rafael Aragón: An Iconographic Study," *New Mexico Studies in the Fine Arts* 3 (1978): 29.
53. Teresa Gisbert, "The Angels," in *Gloria in excelsis*, 62.

triangular haloes, with the symbols of the lamb, the sun, and the dove on each person's chest (Plate 19). These prints, like an example produced in 1807, could be purchased inexpensively, and used in artists' workshops for the production of devotional *retablos*. Thus, engravings enabled artists to continue creating images of the Trinity like the ones that hung on the walls of local churches. Building on centuries of Christian teaching about the nature of God, the makers of *retablos* portrayed God as three men—identical in appearance, equal in stature, harmonious in every way. For the people of nineteenth-century Mexico, this was the image of the Godhead, the mystery of the One who is Three and the Three who are One.

St. Regina, Virgin and Martyr: A Model of Unshakable Faith

A *retablo* in The Peters Collection depicts a female saint clothed in a resplendent white gown and red veil (Catalogue 38). She holds a book, presumably the Scriptures, in her left hand, and a palm frond, symbol of martyrdom, in the other. An inscription identifies the figure as *Santa Regina V. y M.*, "St. Regina, Virgin and Martyr."

According to legend, the early Christian martyr Regina was the daughter of Clement, a pagan citizen of Alise, in Burgundy. Her mother died in childbirth, and Regina was entrusted to the care of a Christian woman, who educated her in the faith. When Clement learned that his daughter had become a Christian, he rejected her, and Regina went to live again with her nurse, working in the fields as a shepherdess. A Roman prefect named Olybrius was attracted to her, and, when he learned of her good birth, sought her hand in marriage. Regina refused, whereupon Olybrius had her locked in a dungeon and tortured. One night in prison, Regina beheld a vision of the cross and heard a voice informing her that her release was at hand. The next day Olybrius ordered her to be tortured and beheaded. During the last moments of her life, a shining dove appeared over Regina and converted many onlookers.

The scene of Regina's martyrdom takes place in the background of the *retablo*. A soldier lifts his sword high into the air, preparing to behead the saint. She kneels, awaiting her release, and is dressed in the same white gown and red veil as in the central portion of the composition. Though painted in the second half of the nineteenth century, this image is in continuity with a long tradition of portraying virgin martyrs in the art of Spain, Flanders, and the New World. How did these depictions reach the shores of the Americas, and why did they attain such prominence in Colonial Spanish art?

54. Clarence Harding, "The Wealth of the Church," in *The Roman Catholic Church in Colonial Latin America*, edited by Richard E. Greenleaf (New York: Knopf, 1971), 178, quoted in *Cross and Sword: An Eyewitness Account of Christianity in Latin America*, edited by H. McKennie Goodpasture (Maryknoll: Orbis, 1989), 43-44.
55. Roberto White, "Historical Preface: Viceregal Mexico," in *Spain and New Spain: Mexican Colonial Arts in Their European Context* (Corpus Christi: Art Museum of South Texas, 1979), 12.

IMAGES OF VIRGIN MARTYRS IN EUROPEAN AND SPANISH COLONIAL ART

While a primary aim of Spanish Colonial art was to teach the Indians about Catholicism, the paintings that hung on church walls also communicated the faith to other segments of the Colonial population, including Spaniards, *criollos* (Spaniards born in the New World), *mestizos* (persons of Indian and Spanish parentage), blacks, and mulattos. We should bear in mind that ecclesiastics accounted for a sizable portion of the population. A 1611 census taken in Lima reported that of the 26, 500 persons living in the Peruvian capital, ten percent were nuns, friars, canons, and priests.[54] By the end of the sixteenth century, there existed over two hundred religious houses in the Viceroyalty of New Spain.[55] One observer, a Carmelite friar who traveled through Mexico, Central America, and Peru between the years 1610 and 1620, reported that Mexico City alone contained sixteen convents of nuns.[56] An important function of art was to inspire religious zeal among the faithful, especially members of religious Orders, the gatekeepers of Christianity in the New World. Like the early Christians, these individuals were responsible for cultivating the faith in a land where the Church was just taking root. It is not surprising, then, that representations of early Christian martyrs abound in Spanish Colonial art.[57] Figures such as St. Sebastian, St. Catherine of Alexandria, and St. Barbara function as models of unshakable faith. Grounded in their commitment to Christ, these individuals faced pagan opposition without fear and welcomed the opportunity to sacrifice their lives in defense of Christianity. Similarly, the religious in the colonies faced the challenge of nurturing and defending the faith in a place where the Church had only recently been introduced.

In seventeenth-century Seville, the port city to the New World, Zurbarán and his workshop painted many images of solitary female martyrs, dressed in sumptuous costumes that convey heavenly splendor and carrying palms of martyrdom or their individual attributes. Often executed in a series, these paintings were intended to be hung in rows on the walls of a church or cloister, where they gave the impression of a heavenly procession of female saints.[58] One of Zurbarán's most impressive works of this type is his representation of *St. Apollonia*, a third-century martyr who lived in Alexandria (Plate 20). During a time of persecution by pagans, Christians fled the city for safety, but Apollonia stayed behind, comforting

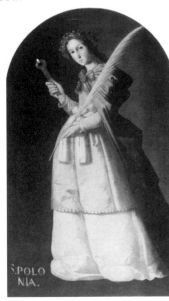

Plate 20.
Francisco
de Zurbarán,
St. Apollonia,
1631-1640.
Paris,
Louvre Museum.

56. Antonio Vázquez de Espinosa, *Compendium and Description of the Indies, c. 1620*, translated by Charles Upson Clark (Washington, D.C.: Smithsonian Institution Press, 1942), 157-159, 161-162, quoted in *Cross and Sword*, 42-43.

57. For discussions of early Christian martyrs in Colonial Spanish art, see Barbara von Barghahn, "Imaging the Cosmic Goddess: Sacred Legends and Metaphors for Majesty," in *Temples of Gold, Crowns of Silver*, 100-103, and Sebastián, *El barroco iberoamericano*, 218-220.

58. Julián Gallego and José Gudiol, *Zurbarán* (London: Alpine Fine Arts Editions, 1987), 43

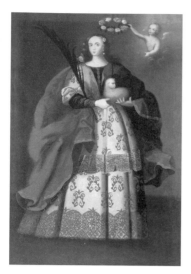

the few Christians who remained, while at the same time preaching and successfully converting many individuals to the faith. When she was ordered to worship a pagan idol, she made the sign of the cross, and the statue burst into pieces. As punishment, Apollonia was tied to a column, and her teeth were pulled out with pincers. She later leapt onto a fire which her persecutors had prepared for her death, surrendering her body to Christ.[59] Zurbarán painted Apollonia carrying the palm of martyrdom in one hand, and in the other, displaying a pair of pincers holding a tooth. She is dressed in an elegant costume of shimmering pink and yellow fabrics, and her pale gray cloak is fastened by a jeweled pin. Apollonia's opulent appearance asserts that her trials on earth earned her an exalted place in the heavenly court.

Beginning in the late 1630s and continuing over the next two decades, Zurbarán and his workshop exported series of paintings for the decoration of churches and monasteries in the Spanish colonies. A contract of 1647 states that the Monastery of the Incarnation in Lima commissioned Zurbarán to execute ten scenes of the life of the Virgin and twenty-four full-length portrayals of female saints. Another document, dated 1649, refers to a shipment of fifty-four canvases bound for Buenos Aires, including representations of virgin martyrs, patriarchs, and kings.[60] Paintings sent from Zurbarán's workshop made a profound impact on the development of Colonial Spanish art, and the Sevillan master's influence is perhaps most evident in Latin American portrayals of virgin martyrs. The tenebristic lighting

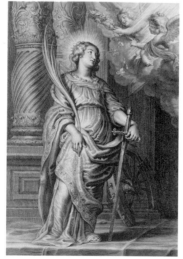

employed in a seventeenth-century Peruvian depiction of *St. Agnes* invites comparison with Zurbarán's portrayals of single female saints (Plate 21). Barbara von Barghahn has attributed this work to the Master of Calamarca, a painter who worked during the second half of the seventeenth century in the Lake Titicaca region, an area now divided between Bolivia and Peru.[61] Agnes is dressed in an elegant costume of rich materials, and holds a lamb and a palm frond. This third-century saint refused to marry the son of a Roman prefect, declaring instead that she was the bride of Christ. Consequently, Agnes was subjected to flames, from which she

59. George Ferguson, *Signs & Symbols in Christian Art* (1954; New York: Oxford University Press, 1961), 105-106. For variations on the story of St. Apollonia's martyrdom, see *Butler's Lives of Patron Saints*, edited and supplemented by Michael Walsh (San Francisco: Harper & Row, 1987), 62; and Fabio Bisogni, "The Martyrdom of St. Apollonia in Four Quattrocento Panels," *Studies in the History of Art* 7 (1975): 44-47.

60. Statsny, 23.

emerged unscathed. Her life finally ended when a Roman soldier cut off her head. Christians came to worship at Agnes' grave, and on one occasion she appeared to them with a lamb, a symbol of Christ, at her side.

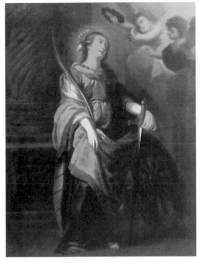

Plate 23.
José de Ibarra
(Mexico),
*St. Catherine
of Alexandria,*
18th c.
Mexico City,
Pinacoteca
Virreinal.

Flemish engravings, based on paintings by Rubens, also contributed to the popularity of virgin martyrs in the art of the New World.[62] A seventeenth-century print by Schelte à Bolswert, after Rubens, portrays *St. Catherine of Alexandria* (Plate 22). Renowned for her preaching abilities, Catherine refused to renounce her belief in Christ, and as punishment her persecutors prepared a spiked wheel for her martyrdom. The wheel, however, flew into pieces before touching Catherine's flesh. She was finally beheaded, the only sure way of eliminating virgin martyrs who remained unharmed by other methods of execution. In the Flemish print, Catherine is dressed in an opulent costume with jeweled trim. She holds a palm and the sword with which her head was severed. Behind her stands the spiked wheel. Unlike Zurbarán, who usually silhouetted his virgin martyrs against a stark background, Rubens included in his background Solomonic columns and a group of angels rushing down to place a wreath on Catherine's head. This engraving provided the basis for several Colonial Mexican paintings, including a magnificent example by José de Ibarra (1688-1756) (Plate 23).

Schelte à Bolswert also executed an etching of Rubens' portrayal of *St. Barbara* (Plate 24) This virgin martyr was imprisoned within a tower by her father, who feared that a male suitor would marry his daughter and take her away. Barbara heard about Christianity and invited a disciple, disguised as a physician, to teach her about the faith. She was converted and baptized. When Barbara revealed to her father that she had become a Christian, he became so enraged that he beheaded his daughter. In the engraving, Barbara stands in front of a tower, dressed in voluminous drapery, including a long veil that cascades down her back. She holds a palm frond, and at her feet lies a sword, the instrument of her martyrdom.

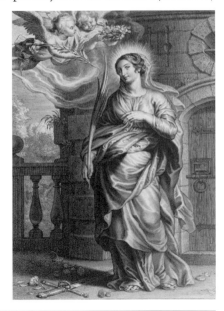

Plate 24.
Schelte à Bolswert
after Rubens,
St. Barbara,
17th c., engraving.
New York,
Metropolitan
Museum of Art,
The Elisha
Whittelsey
Collection,
The Elisha
Whittelsey
Fund, 1951.
(51.501.7153)

61. After studying the *St. Agnes* in the collection of Elvin Duerst, Barbara von Barghahn and I concurred that the painting most resembles the work of the Master of Calamarca. For illustrations of other paintings by the Master of Calamarca, see *Gloria in excelsis*, 8, 18, 60, 68, 69, 71.

62. See Marcus B. Burke, "Mexican Colonial Painting in Its European Context," in *Spain and New Spain*, 32-33.

THE ST. REGINA *RETABLO* IN THE PETERS COLLECTION

The Mexican *retablo* portraying St. Regina displays striking parallels with this engraving, suggesting that the nineteenth-century artist may have had access either to the print, or to a Mexican painting that was inspired by the Flemish composition. Regina's *contrapposto* stance, and the position of her arms, echo similar elements in the Flemish print. Just as Rubens presented an opening in the heavens with two angels rushing down to reward St. Barbara with flowers and a wreath, the Mexican artist depicted beams of divine light, shining on Regina from an upper corner of the picture, with two Cherubim fluttering down toward the standing figure. The artist has simplified Rubens' background considerably, preferring to fill it with masses of clouds. The inclusion of a tiny scene in the background, such as the one depicting the beheading of St. Regina, is a device frequently used in seventeenth-century Flemish art. Also, the Mexican artist has smoothed out the complicated folds of Rubens' drapery, though he did retain the long veil that adorns Barbara's costume in the engraving.

CONCLUSION

There is sufficient evidence to conclude that Mexican devotional *retablos* are directly linked to the religious images propagated in the New World during the Colonial period, when art helped in the process of evangelization. Many of the *retablos*, such as those depicting St. Jerome in Penitence, reproduce portrayals of religious subjects popular in Counter-Reformation Europe. These images were subsequently disseminated in the Spanish colonies, where art communicated Roman Catholic doctrine to Native American viewers. Other *retablos*, such as representations of the Holy Trinity, reveal that ecclesiastical patrons in the New World sometimes preferred iconography that, while not favored in Europe, had an indispensable instructional value for the indigenous population. Still other depictions, St. Regina for example, remind us that art did more than communicate the faith to Native peoples. Art instructed and inspired other segments of the Colonial population as well, such as members of religious Orders who themselves sought models of religious zeal. A full recovery of the history and meaning of the subjects found in Mexican devotional *retablos* will require further investigation of the European and Colonial Spanish precedents for the religious images which continued to inspire the faithful of nineteenth-century Mexico.

I am grateful to Barbara von Barghahn, Jeffrey C. Anderson, Father Joseph F. Chorpenning, and Charles C. Haynes for their valuable comments on earlier drafts of this paper.

THE ICONOGRAPHY OF ST. JOSEPH
IN MEXICAN DEVOTIONAL *RETABLOS*

JOSEPH F. CHORPENNING, O.S.F.S.

In his classic study of religious iconography after the Council of Trent, Émile Mâle characterizes sixteenth-century Spain as "the chosen land of St. Joseph."[1] As evidence to support this assertion, the distinguished art historian cites St. Teresa of Ávila's naming twelve of the seventeen monasteries that she founded during her lifetime for St. Joseph, St. Peter of Alcántara's dissemination of devotion to the earthly father of Christ among the Observant (reformed) Franciscans, and the practice of the Jesuits in Spain of always reserving a chapel in their churches for St. Joseph.[2] However, by the time these developments occurred in the mother country, Mexico had already been the "chosen land of St. Joseph" for several decades. Veneration of this saint was introduced to the Americas within the initial decade after the conquest of Mexico (begun in 1518 and completed in 1521); it was immediately embraced with great enthusiasm by Native Americans, who regarded Joseph, the protector and guardian of the Virgin Mary and Christ Child, as their special patron.[3] In the mid-sixteenth century, Mexico became the first country in Christendom to choose Joseph as its principal patron.[4] The popularity of St. Joseph as a subject in Mexican devotional *retablos* reflects the vigorous cult of this saint that flourished in Mexico since the dawn of the Colonial era. These art works exhibit the rich and varied iconography of Joseph that was developed and popularized by the devotional literature and art of Golden-Age Spain and of Colonial Mexico. Unfortunately, neither this iconography nor its literary and artistic sources have been studied in a systematic or comprehensive fashion in the standard works on Mexican *retablos*.[5] The purpose of this essay is to fill this lacuna in *retablo* scholarship. But before turning to Joseph's iconography and its sources, it would be helpful to review the history of how this saint's vigorous cult was established in Mexico and its primacy in the development of devotion to Joseph in the Universal Church.

MEXICO'S LEADERSHIP IN THE DEVELOPMENT OF DEVOTION TO ST. JOSEPH

Devotion to Joseph was introduced to Mexico by the first Observant Franciscan missionaries who came to evangelize the Americas. Undoubtedly, St. Joseph's appeal and popularity was due to the various roles attributed to him as the story of his veneration among the Franciscans and in Mexico unfolded. Among the roles ascribed to Joseph were:

1. *L'art religieux de la fin du XVIe siècle, du XVIIe siècle et du XVIIIe siècle: Étude sur l'iconographie après le Concile de Trente*, 2nd ed. (Paris: Librairie Armand Colin, 1951), 315.
2. Mâle, 315.
3. Elisa Vargas Lugo, "Comentarios iconográficos," in *Pintura novohispana: Museo Nacional del Virreinato, Tepotzotlán, Tomo 1: Siglos XVI, XVII y principios del XVIII* (Tepotzotlán, México: Asociación de Amigos del Museo Nacional del Virreinato, 1992), 24-27, especially 24-25. While Vargas Lugo emphasizes the popularity of devotion to Joseph among the *criollos* (Spaniards born in the New World) and Indians, adequate attention is not given to the introduction of this cult by European missionaries.
4. John McAndrew, *The Open-Air Churches of Sixteenth-Century Mexico: Atrios, Posas, Open Chapels, and Other Studies* (Cambridge, Massachusetts: Harvard University Press, 1965), 393-97; José Rubén Sanabria, M.J., "La devoción a San José en México en el siglo XVI," *Cahiers de Joséphologie* 25 (1977): 663-76.

model of Franciscan poverty; patron of travellers; patron of the Church Militant and of the evangelization of the Americas; model husband, father, and worker; benevolent father and safe refuge in times of spiritual and physical danger. The name that dominates the story of the introduction of Joseph's cult to the New World is that of the extraordinary lay brother Fray Pedro de Gante (1486-1572).

A modern scholar offers this succinct assessment of Fray Pedro: "an exceptional man who still shines out as a sympathetic European intelligence able to understand many of the problems and to devise humane patterns for the ways of life uneasily evolving in America."[6] Born in Flanders, in a suburb of Ghent, Pedro was either the uncle or great-uncle of Charles V; he was about the same age as Charles' father, Philip the Fair. His education by the Brothers of the Common Life, the best available in his day, prepared him well for the educational work that one day he would carry out in Mexico. Subsequently, Pedro studied at the Louvain, where he was introduced to the thought of the Dutch humanist Desiderius Erasmus (ca. 1466-1536), who had also studied with the Brothers. Fray Pedro's later work reveals that he knew and concurred with Erasmian educational ideals. After completing university studies, Pedro went to court, but soon renounced that life to enter the Franciscan monastery at Ghent. Moved perhaps by the preaching at court of the Dominican friar Bartolomé de las Casas (1474-1566), an ardent defender of the rights of Native Americans, in 1522 Fray Pedro, together with two other Flemish friars, Johann Dekkers and Johann van den Auwera, asked to be sent to Mexico. The three friars embarked for Mexico on May 1, 1523.[7]

Public devotion to Joseph was relatively late in developing in Christian history, lest it detract from the dogmas of Jesus' divine origin and Mary's virginal motherhood. From virtually the inception of the Order, the Franciscans strongly promoted veneration of St. Joseph. As the Jesuit Giuseppe Antonio Patrignani remarks in his *A Manual of Practical Devotion to St. Joseph* of 1709, "[the] Order of St. Francis has been remarkable, from its very infancy, for devotion to St. Joseph."[8] The Franciscans were founded out of the conviction that traditional monasticism had become more of a temporal institution than a spiritual one.[9] To remedy this situation, the Franciscans embraced a radical evangelical poverty not only on the individual but also on the corporate level. No small part of Joseph's appeal must have been that he was a poor man who earned his living and supported Jesus and Mary by the work of his hands as a carpenter. It has been observed that when, on Christmas Eve of 1223 in the Umbrian town of Greccio, St. Francis of Assisi (ca. 1181-1226) presented in

5. See, e.g., *Images of Faith/Imagenes de fe. Religious Art of Mexico: 18th and 19th Centuries* (Chicago: The Mexican Fine Arts Center Museum, 1987); *Colonial Mexican and Popular Religious Art* (San Francisco: The Mexican Museum, 1990); Gloria Fraser Giffords et al., *The Art of Private Devotion: Retablo Painting of Mexico* (Fort Worth: InterCultura/Dallas: The Meadows Museum, Southern Methodist University, 1991); Fernando Juárez Frías, *Retablos populares mexicanos: Iconografía religiosa del siglo XIX* (Mexico City: Inversora Bursatil, 1991); Gloria Fraser Giffords, *Mexican Folk Retablos*, revised ed. (Albuquerque: University of New Mexico Press, 1992). Giffords is the pioneering scholar in the study of Mexican *retablos*; her book *Mexican Folk Retablos* was first published in 1974.
6. McAndrew, 369.
7. McAndrew, 369-70; Leopoldo Campos, O.F.M., "Gante, Pedro de," *New Catholic Encyclopedia*, 1967.
8. Translated and revised by a member of the Society of Jesus (1865; Rockford, Illinois: Tan Books, 1982), 56.

tableau form a living crèche "to relive the radiant poverty of the Nativity," he recreated Joseph's world in which "[the] poor like [Francis] are at home."[10] Francis' young disciple St. Anthony of Padua (1195-1231) also had an affinity with Joseph: Anthony is always represented holding the Child Jesus in his arms "as if he were, in fact, without anyone planning this, the first living icon of the young Joseph."[11]

Early Franciscan literature supports the proposition that the Order looked to Joseph as a model of the evangelical poverty they embraced. For example, in the *Meditations on the Life of Christ*, an influential medieval devotional work that was incorrectly attributed to the great Franciscan theologian St. Bonaventure (1221-1274), the Holy Family, of which Joseph was the divinely appointed head, is consistently portrayed as poor.[12] In Bethlehem Joseph and Mary stayed in "a disused stable, where men might take refuge from the rain. There Joseph, who was a carpenter by trade, may have constructed a shelter."[13] In these circumstances, "the most rigid poverty which was in need of many of the necessities of life," Jesus was born.[14] The Magi's gifts of gold, frankincense, and myrrh were received by the Christ Child as a pauper's alms.[15] The two turtledoves offered for Jesus by Joseph and Mary in the Temple in Jerusalem (Luke 2:24) were "the offering usually made by the poorer classes."[16] In exile in Egypt, Joseph was "diligent . . . in plying his trade of carpenter" to support Mary and Jesus.[17] At Nazareth, "[the] venerable Joseph sought what work he could get as a carpenter."[18] The Holy Family's "exaltation of poverty,"[19] under Joseph's leadership, must have endeared this saint to the Franciscans.

Veneration of St. Joseph acquired official status in the Franciscan Order in 1399, when, at the general chapter held at Assisi, a feast in Joseph's honor, with a Mass and nine-lesson office, was established.[20] In the next century, the tireless Franciscan preacher St. Bernardine of Siena (1380-1444) composed "what is surely the most famous sermon on St. Joseph ever written."[21] Its principal sources were two fourteenth-century texts by Franciscan authors who wrote with special insight on Joseph: Ubertino of Casale's *Tree of Life of the Cross of Jesus* and Bartholomew of Pisa's *Life of the Blessed Virgin Mary*.[22] A glowing description of Joseph's life and virtues, this sermon was delivered in Padua and in Bologna, Bernardine's usual places of residence, as well as in many other cities in Italy. Subsequently, other preachers appropriated his ideas for their own sermons.[23] Today a passage from this sermon is the second reading in the Office of Readings for the Solemnity of St. Joseph.[24] Later in the fifteenth century, probably in the late 1470s, it was a Franciscan Pope, Sixtus IV, who added St. Joseph's feast day (March 19) to the Roman calendar.[25]

9. See M.-D. Chenu, O.P., *Nature, Man, and Society in the Twelfth Century: Essays on New Theological Perspectives in the Latin West*, translated by Jerome Taylor and Lester K. Little (Chicago: Chicago University Press, 1968), 239-69.
10. Andrew Doze, *St. Joseph: Shadow of the Father*, translated by Florestine Audett, R.J.M. (New York: Alba House, 1992), 11-12.
11. Doze, 12.
12. The *Meditations on the Life of Christ*, compiled by an anonymous Franciscan friar, incorporated St. Bonaventure's *Meditations on the Passion*. Bonaventure's authorship of the latter has never been disputed. Because the *Meditations on the Life of Christ* included Bonaventure's *Meditations on the Passion*, eventually the entire compilation was attributed to him.
13. *Meditations on the Life of Christ*, attributed to St. Bonaventure, translated by Sr. M. Emmanuel, O.S.B. (St. Louis: Herder, 1934), 31.
14. *Meditations on the Life of Christ*, 33.
15. *Meditations on the Life of Christ*, 48.

The Franciscans' perception of Joseph as a model for Mendicants was reinforced in 1522, the year before Pedro de Gante left for Mexico, when a friar from another tradition, the Dominican Isidore of Isolanis (ca. 1477-1528) published his *Summa of the Gifts of St. Joseph*. Isidore extolled Joseph as a model of the special virtues to which the friars were committed: the evangelical counsels of poverty, chastity, and obedience. Moreover, he urged Mendicants to venerate Joseph, as well as to dedicate churches and altars to him, for at this time such dedications were rare.[26] Perhaps as a result of Isidore's encouragement, in 1523, the same year Fray Pedro departed from Seville for the New World, the Observant Franciscans of the Flemish Province chose Joseph as their patron.[27]

Fray Pedro's interest in Joseph may have been first awakened during his schooling with the Brothers of the Common Life. The Brothers particularly esteemed and read the writings of one of the earliest advocates of devotion to Joseph, John Gerson (1363-1429), the prolific and eloquent Chancellor of the Sorbonne. Gerson was the author of *Considerations on St. Joseph, Josephina*, a long Latin poem celebrating the saint's virtues and dignity. He is also renowned for his *Sermon for the Feast of the Nativity of the Blessed Virgin Mary*, delivered, on September 8, 1416, to the Fathers of the Council of Constance, whom he urged to invoke Joseph's intercession officially and to institute a feast in his honor in order to obtain unity in the Church, which was then suffering from the Western Schism.[28] The writings of Gerson were well-known to Fray Pedro's Spanish confreres and contemporaries Francisco de Osuna (ca. 1492-ca. 1540) and Bernardino de Laredo (1482-ca. 1540), both of whom wrote short works on Joseph.[29] It seems likely that Fray Pedro was also familiar with Gerson's writings on Joseph.

Whatever devotion to Joseph to which Fray Pedro had been exposed, or even cultivated himself, during his student days would have been reinforced and strengthened when he entered the Franciscans. This was certainly the experience of Laredo. In his *Josephina*, a short treatise on Joseph that is appended to his *Ascent of Mt. Sion* (1535), Laredo expressly states that his devotion to Joseph originated twenty-five years earlier in 1510, the same year he entered the Franciscans.[30]

It has also been speculated that Pope Hadrian VI, to whom Isidore of Isolanis dedicated his *Summa of the Gifts of St. Joseph*, may have sent Fray Pedro a gift of this book shortly before or after he left for Mexico. Hadrian may have known Pedro at the University of Louvain and at court, while the former was Cardinal-Archbishop of Utrecht and confessor and tutor to Charles V. As early as 1521, Hadrian and Charles had corresponded about

16. *Meditations on the Life of Christ*, 52.
17. *Meditations on the Life of Christ*, 65.
18. *Meditations on the Life of Christ*, 85.
19. *Meditations on the Life of Christ*, 48.
20. Blaine Burkey, O.F.M.Cap., "The Feast of St. Joseph: A Franciscan Bequest," *Cahiers de Joséphologie* 19 (1971): 647-80, especially 650.
21. Burkey, 651.
22. See Joseph Dusserre, "Les origines de la dévotion à Saint Joseph," *Cahiers de Joséphologie* 1 (1953): 23-54, 169-96, especially 185-94, and 2 (1954): 5-30, especially 18-25.
23. Burkey, 651.
24. See *The Liturgy of the Hours According to the Roman Rite*, 4 vols. (New York: Catholic Book Publishing Company, 1975-1976), 2:1721-23.

sending Franciscans to Mexico. When Hadrian was elected pope in 1522, he was still in Spain as Regent of Castile.[31]

No real cult of St. Joseph is recorded in Spain earlier than in Mexico. While the Observants and the Observant Franciscan Cardinal-Archbishop of Toledo, Francisco Ximénez de Cisneros (1436-1517), celebrated the saint's feast, they did not promote a public cult as far as is known.[32] That distinction was reserved for their confreres in New Spain (present-day Mexico, Central America, and the Philippines).

In addition to Joseph's primary role as model of the Mendicant life, the saint took on other roles for Fray Pedro and his companions. The Gospels testify that, under Joseph's protection, the Holy Family often travelled, e.g., from Nazareth to Bethlehem for the imperial census (Luke 2:4), to Jerusalem to present the Child Jesus in the Temple (Luke 2:22), to Egypt to save Jesus from the murderous Herod (Matthew 2:14), back to Nazareth when Jesus' life was no longer in danger (Matthew 2:21-23), and from Nazareth to Jerusalem annually for Passover (Luke 2:41). The journey to Egypt was to a pagan land that was hostile to Israelites; there Jesus, Mary, and Joseph were aliens and refugees. Something of Joseph's experience of travel to and residence in Egypt may have resonated in that of Fray Pedro and his companions as they embarked for an unknown, distant, pagan land. It is likely that they invoked Joseph's protection as they sailed across the ocean to evangelize what for Europeans was the New World.[33]

Fray Pedro and the group of friars, the so-called "Twelve," who came to Mexico within a year of his arrival (Fray Pedro's original two companions died shortly after arriving in New Spain) wasted no time in introducing devotion to Joseph to the Americas.[34] In his capacity as husband, father, and worker, Joseph played an important part in the friars' work of evangelization. Fray Pedro consistently proposed Joseph the craftsman and the head of the Holy Family to Native Americans as a role model. To underscore this, in the late 1520s he placed the first school founded to instruct the Indians, not only in Christian doctrine but also in fine arts and crafts, under the saint's protection. "[Fray Pedro] gathered adults there and trained blacksmiths, carpenters, masons, tailors, and cobblers. He formed a whole group of painters, sculptors, and jewelers, who fashioned the statues and retables for the churches and furnished them with ornaments, crosses, candelabra, holy vessels, and the like."[35]

By the end of the same decade, the first place of worship named for Joseph in the Americas, the chapel of "San José de Belén de los Naturales" (St. Joseph of Bethlehem of the Natives) in Mexico City, was built. The primitive version of the chapel was very modest.

25. Burkey, 655.
26. Mâle, 314; McAndrew, 394.
27. McAndrew, 394. For an overview of the history of the Franciscans and of constituent groups of the Order such as the Observants, who, in opposition to the Conventuals, sought to observe the rule in its primitive severity, see Cyprian J. Lynch, O.F.M., "Franciscans," *New Catholic Encyclopedia*, 1967.
28. McAndrew, 394; Francis L. Filas, S.J., *The Man Nearest to Christ: Nature and Historic Development of the Devotion to St. Joseph* (Milwaukee: Bruce Publishing Company, 1944), 114.
29. José Antonio Cifuentes, O.F.M., "Influencias franciscanas en la devoción de Santa Teresa de Jesús a San José," *Estudios Josefinos* 18, nos. 34-35 (1963-1964): 251-300, especially 263-64, 275.
30. Cifuentes, 285.

According to Fray Pedro himself, it was constructed "of thatch, like a poor portico."[36] Bethlehem means "house of bread," and the name that Fray Pedro gave this place of worship suggests that he conceived of it as a new Bethlehem, where Christ would again come into the world, just as He did on the first Christmas in a poor stable in Bethlehem of Judea under Joseph's watchful protection, in the form of the bread of the Eucharist and in a poor place also under Joseph's patronage.[37] Just as Francis of Assisi had done three centuries earlier, Fray Pedro recreated Joseph's world, in which the poor are at home. "San José de Belén de los Naturales" was probably only the second or third church in the world ever dedicated to Joseph.[38] It was also the first parish established for native Americans, and hence has been aptly described as "the cradle of Christianity in the Americas."[39]

According to historians of the Colonial period, the evangelization of the Americas had been entrusted to Joseph by the Franciscans.[40] The dedication to Joseph of the first school founded, the first parish established, and the first place of worship built for the Indians is emblematic of Joseph's role as patron of the evangelization of the Americas. This facet of Joseph's patronage flowed from his title of Patron of the Church Militant, an advocation popularized by Isidore of Isolanis.[41] The basis for this advocation is the correspondence, first perceived by the Fathers of the Church, between the virginal marriage of Joseph and Mary and that of Christ and the Church. As virginal spouse and guardian of the Virgin Mary, who was the archetype of the Church, Joseph was considered to be both a type of Christ, the pope, and bishops, as well as the patron of the Church who protects and propagates the work of salvation.[42]

As the earthly father of Jesus, Joseph was not only a role model for the Indians, he also became *their* father. In Mexico, the missionaries encountered a native population that was torn between the desire to revolt against their conquerors and the desire to find protection from them. For Native Americans, the conquest was an experience of abandonment by their gods, destruction of their temples, razing of their cities, pillage and destruction of their culture, economic devastation and subjugation. Moreover, a sizable segment of the population did not know what it meant to have a father: most *mestizos* knew only their Indian mothers, the common-law wives of the Spanish, but not their fathers. The Church sought to offer the Indians protection and a sense of parenthood.[43] The Virgin Mary, under the title of Our Lady of Guadalupe, became the loving and compassionate mother of the Indians, while Joseph, who rescued the Child Jesus from the tyranny of Herod, became the father of this conquered and oppressed people who would protect and shield them.[44]

31. McAndrew, 394-95.
32. McAndrew, 395. Cf. Burkey, 655.
33. Cf. José Carlos Carrillo Ojeda, M.J., "San José en la Nueva España del siglo XVII," *Cahiers de Joséphologie* 35 (1987): 627-53, especially 631.
34. Robert Ricard, *The Spiritual Conquest of Mexico. An Essay on the Apostolate and the Evangelizing Methods of the Mendicant Orders in New Spain: 1523-1572,* translated by Lesley Byrd Simpson (1966; Berkeley: University of California Press, 1982), 20-21; Rubén Sanabría, 666-67.
35. Ricard, 213.
36. Quoted in McAndrew, 395.

Numerous Colonial Spanish paintings as well as Mexican devotional *retablos* communicate this dimension of Joseph's patronage by showing him not only tenderly holding the Christ Child, but protectively enfolding Him within his cloak (Catalogue 31; Plate 1).[45]

Plate 1.
Gregorio Gamarra
(Bolivia),
*St. Joseph and the
Christ Child,*
ca. 1607-1612.
Philadelphia,
The Chapel of
Saint Joseph,
Michael J. Smith, S.J.,
Memorial,
Saint Joseph's
University.
Gift of Mr. & Mrs.
John P. McNulty '74.
(Photo: Jeffrey Blake)

The image of Joseph as a warm, gracious, and benevolent father figure would have been reinforced by the subsequent arrival in the Americas of other Orders that promoted devotion to this saint. A case in point is the Discalced Carmelites, founded by St. Teresa of Ávila (1515-1582). In the *Book of Her Life* (begun in 1562 and completed in 1565), Teresa recounts that, after she was cured of a crippling illness through Joseph's intercession, she adopted him as her spiritual father and encourages others to do the same.[46] Wherever the Discalced Carmelites went, they labored assiduously that this dimension of the Teresian apostolate be realized.[47]

Devotion to Joseph spread quickly in Mexico. The many open chapels—modeled on "San José de Belén de los Naturales"—built for the Indians were so frequently dedicated to Joseph that "San José" became their familiar name. Indians were more typically baptized José than were Spaniards. The large Franciscan church in Mérida was dedicated to Joseph. He was named patron of the city of Puebla and of a large Indian parish there. His protection from lightening, storms, and earthquakes was considered particularly efficacious.[48] This calls attention to another of Joseph's roles: a powerful intercessor in times of physical and spiritual danger. This role is captured in the title *Refugium peccatorum*, "Refuge of Sinners," which though usually associated with the Virgin Mary, was also one of Joseph's advocations, as an eighteenth-century oil painting on tin *St. Joseph and the Christ Child* (Private Collection), attributed to the Mexican artist Juan Patricio Morlete Ruiz (1713-1772), attests.[49]

Joseph's role as intercessor is also alluded to in the seventeenth-century retable of the parish church of Teabo in the state of Yucatán: the suffering souls in Purgatory implore Our Lady of Sorrows, whose chest is pierced with a large sword, and St. Joseph, who holds the Christ Child and the attribute of the flowering staff, for assistance.[50] (Catalogue 33 was probably intended to be cut into two separate *retablos*. Nonetheless, the Teabo retable

37. One of the comparisons that St. Bernard of Clairvaux (1090-1153) draws between Joseph of Egypt and Joseph of Nazareth is also apposite: "The former laid up wheat, not for himself but for all the people [see Genesis 41:46-57]; the latter received the living Bread from Heaven to guard it, for himself and for the whole world" (quoted in *The Roman Breviary*, edited by Bede Babo, O.S.B., translated by Christine Mohrmann [New York: Benziger Brothers, 1964], 824).
38. Rubén Sanabria, 667; McAndrew, 397.
39. Hermenegildo Ramírez, M.J., "San José en la evangelización de América Latina," *Cahiers de Joséphologie* 39 (1991): 611-35, at 614.
40. Carrillo Ojeda, 632; Ramírez, 614.
41. Guy-M. Bertrand, C.S.C., "La *Summa de Donis Sancti Joseph* d'Isidore de Isolanis, O.P.," *Cahiers de Joséphologie* 8 (1960): 219-49, especially 238; Roland Gauthier, C.S.C., "Joseph (saint) dans l'histoire de la spiritualité," *Dictionnaire de spiritualité*, vol. 8 (Paris: Beauchesne, 1974), 1308-16, especially 1310.

provides an interesting perspective on the pairing of Joseph and the *Mater Dolorosa* in this "double" *retablo*.) The figure of the suffering Virgin represented a sympathetically inclined mother who was filled with compassion for humanity, and who had earned, through her intense participation in the passion of her Son, tremendously efficacious intercessory power. Hence, her assistance was sought for adversities suffered in this life as well as for personal salvation after death.[51] The juxtaposition of Joseph and the Virgin of Sorrows suggests that he was viewed in a similar manner. Joseph had suffered, together with Mary, through the trials and hardships of Christ's infancy and childhood. Teresa of Ávila puts it this way: "For I don't know how one can think about the Queen of Angels and about when she went through so much with the Infant Jesus without giving thanks to St. Joseph for the good assistance he provided them both with."[52] Gerson had emphasized Joseph's powerful intercession: since on earth Jesus and Mary were obedient to Joseph, so in Heaven they grant whatever he desires.[53] This idea is also expressed by Teresa: "[The] Lord wants us to understand that just as He was subject to St. Joseph on earth—for since bearing the title of father, being the Lord's tutor, Joseph could give the Child commands—so in Heaven God does whatever he commands."[54]

One of the earliest testimonies about the devotion to Joseph that flourished in Mexico is found in Laredo's *Josephina*. Laredo records that in the region of Yucatán an indulgence of five hundred days is granted to whomever recites a *Hail Mary* and an *Our Father* in honor of Joseph. Moreover, he discloses that the Bishop of Mexico City, the Franciscan friar Juan de Zumárraga, asked him to send a hundred or more copies of his treatise on Joseph for distribution in Mexico.[55]

On June 29, 1555, at the First Provincial Council of Mexico, held in "San José de Belén de los Naturales," St. Joseph was declared patron of the ecclesiastical Province of Mexico, which included the archdiocese of Mexico City (established as a diocese in 1530, it was raised to an archdiocese in 1546) and its nine suffragan dioceses (all those in Mexico, plus several others, most notably Guatemala and Nicaragua).[56] The conciliar canons reveal that Joseph was chosen as patron for several reasons: the particular favors that God has bestowed upon the Church in the Americas due to Joseph's powerful intercession; the "great devotion" and veneration accorded Joseph by all the faithful, Indians and Spaniards alike; Joseph's protection against natural disasters. In short, Joseph's election represented the *sensus fidelium*.[57] Joseph's feast day was made a holy day of obligation. Thenceforth, it was celebrated with great fervor and solemnity, and with the usual display of fireworks.

42. Bertrand, "La *Summa de Donis Sancti Joseph* d'Isidore de Isolanis, O.P.," 235, and "Joseph (saint): Patristique et Haut Moyen Âge," *Dictionnaire de spiritualité*, vol. 8, 1301-1308, especially 1306; Sheila Schwartz, *The Iconography of the Rest on the Flight into Egypt*, Ph.D. diss., New York University, 1975, 49.

43. Carlos Fuentes, *The Buried Mirror: Reflections on Spain and the New World* (Boston: Houghton Mifflin Company, 1992), 144-45.

44. Fuentes, 145-46. Similarly, Gerson and Bernardine of Siena promoted devotion to Joseph in the late Middle Ages, when plagues, famines, wars, economic troubles, and social upheavals threatened the welfare, and even the survival, of households. See David Herlihy, "The Making of the Medieval Family: Symmetry, Structure, and Sentiment," *Journal of Family History* 8 (1983): 116-30. Fuentes makes no mention of Joseph's historical role as a model to be imitated and as patron in Mexico. He proposes that Christ, hanging on the cross dead or in agony, became the father of the Indians, who saw in this figure the return of the gods (146).

(In 1585, the Third Provincial Council of Mexico renewed the Province's dedication to Joseph, noting, in its conciliar decrees, "the extraordinary devotion with which the most chaste Patriarch and lord St. Joseph, husband of the most holy Virgin Mary, is honored, courted, and revered in this ecclesiastical Province."[58] By this date, the archdiocese of Mexico City had twelve suffragan dioceses, the most recent addition being Manila in the Philippines). Thus, Mexico led the Universal Church in the establishment of widespread veneration of the earthly father of Christ. Europe lagged behind by several decades. By the time Teresa of Ávila began to popularize veneration of Joseph in Spain, his cult in Mexico was stronger than ever.[59]

Pope Gregory XV made the feast of St. Joseph a holy day of obligation for the Universal Church in 1621, sixty-six years after it had been so designated in Mexico. New France (Canada) followed Mexico's example and chose Joseph as its patron in 1624. Twentieth-century Canada is the site of the largest shrine in the world dedicated to St. Joseph: the basilica of the Oratory of St. Joseph, which had its origin in the simple faith of the Holy Cross lay brother, Blessed André Bessette (1845-1937). One of the first churches in the British Colonies was Old St. Joseph's in Philadelphia, founded in 1733 by the Jesuit Joseph Greaton. In both Europe and the Americas, the Jesuits were ardent advocates of veneration of Joseph, with the pattern being established in the New World by St. John de Brebeuf, who, in 1633, dedicated the first mission among the Hurons to Joseph. The Viceroyalty of Peru placed itself under Joseph's patronage in 1655.[60]

In the seventeenth century, Austria, Belgium, Bohemia, and Italy also selected Joseph as their national patron. On August 17, 1678, Pope Innocent XI approved the selection of Joseph as the patron and protector of the missions in China. The following year the same pontiff acceded to the petition of King Charles II of Spain that Joseph be designated the patron of Spain and of its European and overseas dominions. Although the same monarch subsequently had to ask the pope to nullify the brief granting his earlier request with regard to Spain itself, lest it prejudice the patronage of Spain's traditional patron, St. James the Greater, Joseph's patronage of the Spanish dominions remained intact.[61] Meanwhile, devotion to Joseph continued to grow in Mexico, as several recent studies have amply documented.[62]

John Sobieski's victory over the Turks at the battle of Vienna in 1683 was attributed to Joseph. In thanksgiving for this victory, Emperor Leopold of Austria petitioned the pope to add Joseph's name to the Litany of the Saints and to extend to the Universal Church the

45. The image of the Virgin Mary or of a saint enveloping a group of devotees with a large cloak often appears in religious art as an expression of special patronage. On such Marian images in Spanish art, see Manuel Trens, *María: Iconografía de la Virgen en el arte español* (Madrid: Editorial Plus Ultra, 1947), 255-364, *passim.* Patronage images of the Virgin and of the saints are abundant in Colonial Mexican art: see, e.g., Guillermo Tovar de Teresa, *Pintura y escultura en Nueva España (1557-1640),* Colección "Arte novohispano," vol. 4 (Mexico City: Grupo Azabache, 1992), 209, 245; Marcus Burke, *Pintura y escultura en Nueva España: El barroco,* Colección "Arte novohispano," vol. 5 (Mexico City: Grupo Azabache, 1992), 160, 176; Santiago Sebastián, *Iconografía e iconología del arte novohispano,* Colección "Arte novohispano," vol. 6 (Mexico City: Grupo Azabache, 1992), 66, 70-71, 74. There are some spectacular examples in Colonial Spanish art of such images of Joseph, whose gigantic cloak may protectively envelop a monastery, as in the eighteenth-century painting *St. Joseph and St. Teresa Protecting the Monastery,* attributed to the Colombian painter Joaquín Guitérrez (Usaquén, Colombia, Monastery of the

feast of the Patronage of St. Joseph that the Holy See had given permission three years earlier to the Carmelites to celebrate on the third Sunday after Easter.[63] Several decades passed before Joseph's name was added to the Litany of the Saints by Pope Benedict XIII on December 19, 1726. The feast of the Patronage was made universal by Pope Pius IX on September 10, 1847.[64]

On the basis of the Marian apparitions to St. Catherine Labouré (1831), to the children at La Salette (1846), and to St. Bernadette Soubirous at Lourdes (1858) and Pius IX's proclamation of the dogma of the Immaculate Conception (1854), the nineteenth century has been described as "the century of the Virgin Mary." This century was also that of the Virgin's spouse, Joseph.[65] As already mentioned, the feast of the Patronage of St. Joseph was extended to the Universal Church in 1847, in response to numerous petitions made to the Holy See. On March 9, 1870, during the First Vatican Council, three petitions signed by hundreds of Council Fathers asking that Joseph be declared Patron of the Universal Church were presented to the Holy See. Acceding to these petitions, Pius IX conferred this title upon Joseph on December 8, 1870. Subsequently, Pope Leo XIII issued the encyclical letter *Quamquam Pluries* on devotion to Joseph.[66] Shortly after the turn of the century, it was observed of the veneration of Joseph in the nineteenth century: "No devotion, perhaps, has grown so universal, none seems to have appealed so forcibly to the heart of the Christian people, and particularly of the laboring classes, during the nineteenth century, as that of St. Joseph."[67]

In the twentieth century, Joseph has continued to be the subject of papal decrees and documents. Joseph was chosen by Pope Pius XI, in his encyclical *On Atheistic Communism*, issued on March 19, 1937, as the Church's patron in the fight against atheistic Communism. Joseph has been consistently presented by modern popes as a role model for workers and laborers. In this connection, in 1955 Pope Pius XII suppressed the feast of the Patronage and instituted the feast of St. Joseph the Worker that was to be celebrated annually on May 1. Pope John XXIII named Joseph "Protector of the Second Vatican Council" (1961) and added his name to the Roman Canon (1962).[68] On August 15, 1989, Pope John Paul II issued the apostolic exhortation *Guardian of the Redeemer: On the Person and Mission of St. Joseph in the Life of Christ and of the Church* to commemorate the centenary of Leo XIII's encyclical on the saint. John Paul writes about Joseph with devotion, warmth, and insight, proposing him—much as Fray Pedro and his companions did—as a model accessible to Christians in every state of life: married people, parents,

Discalced Carmelites), or a large group of saints, ecclesiastical figures, and civil officials, as in eighteenth-century paintings of *The Patronage of St. Joseph* by the Mexican artist José de Ibarra (Tepotzotlán, Mexico, Church of St. Francis Xavier) and by the Bolivian artist Gaspar Miguel de Berrío (Potosí, Bolivia, Museo de la Moneda), or the members of a particular religious community, as in José de Alzíbar's *St. Joseph's Patronage of the Mexican Oratory* of 1767 (Mexico City, Pinacoteca de la Profesa). On Alzíbar's painting, see Jaime Cuadriello, "A propósito del ministerio de San José (Addenda)," *Memoria del Museo Nacional de Arte*, no. 4 (1991-92): 51-59, as well as his "San José en tierra de gentiles: Ministro de Egipto y virrey de Indias," which was published in the inaugural issue of *Memoria del Museo Nacional de Arte* and apparently sparked considerable controversy. For illustrations of the other works cited, see Joseph F. Chorpenning, O.S.F.S., *Just Man, Husband of Mary, Guardian of Christ: An Anthology of Readings from Jerónimo Gracián's Summary of the Excellencies of St. Joseph (1597)* (Philadelphia: Saint Joseph's University Press, 1993), 31, Plate 8; Burke, 152; Christopher C. Wilson, "St. Teresa of Ávila's Holy Patron: Teresian Sources for the Image of St. Joseph in Spanish American Art," in *Patron Saint of the New World: Spanish American Colonial*

workers, contemplatives, and those engaged in the apostolate.[69] Moreover, in the tradition of the missionaries who entrusted the evangelization of the Americas to Joseph, John Paul invokes the saint's patronage for the Church's work both of evangelization in regions where Christ and the Gospel are not yet known and of re-evangelization in those areas where large groups of Christians have lost a living sense of faith and no longer consider themselves members of the Church.[70]

ST. JOSEPH IN GOLDEN-AGE SPANISH, COLONIAL MEXICAN, AND *RETABLO* ART: AN OVERVIEW

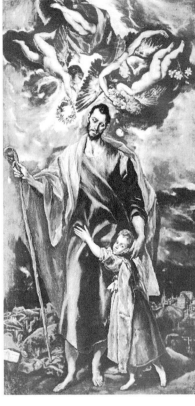

Plate 2. El Greco, Preliminary version of *St. Joseph and the Christ Child*, ca. 1597-1599. Toledo, Cathedral.

With the rise of devotion to St. Joseph in his own right in the sixteenth century, images of the saint alone with the Christ Child, heretofore non-existent, begin to appear. These images are a counterpart to the traditional image of the Madonna.[71] One of the oldest surviving statues of Joseph is that which Teresa of Ávila placed above the principal door of her first reformed monastery of St. Joseph's in Ávila.[72] Teresa also placed a statue of Joseph above the principal door of all the monasteries she founded. Subsequently, this became the standard practice of Carmelite monasteries both in Europe and in Spanish America.[73] In painting, El Greco (1541-1614) was one of the first artists to glorify Joseph in accordance with the cult of this saint that flourished in Spain after the Council of Trent (1545-1563), principally as a result of the efforts of Teresa of Ávila. El Greco's *St. Joseph and the Christ Child*, commissioned in 1597 for the main altar of the Chapel of St. Joseph in Toledo, represents the saint as a handsome man in his early thirties who, holds a shepherd's crook, instead of his usual attribute of the flowering staff, and protectively shepherds the boy Jesus, the Lamb of God (Plate 2).[74] Other masters quickly followed El Greco's example. Portrayals of Joseph walking with the Christ Child in a landscape and of the half-length figure of Joseph holding Jesus were painted by Francisco de Zurbarán (1598-1664), Bartolomé Esteban Murillo (1617-1682), and other artists. These two ways of portraying the saint grew in popularity during the seventeenth century in Spain and its colonies.[75]

Images of St. Joseph, edited by Joseph F. Chorpenning, O.S.F.S. (Philadelphia: Saint Joseph's University Press, 1992), 5-17, especially 15, Plate 13. On the European sources of these patronage paintings and on Ibarra as a patronage painter, see Burke, 153.

46. *The Collected Works of St. Teresa of Ávila*, 3 vols., translated by Otilio Rodriguez, O.C.D., and Kieran Kavanaugh, O.C.D. (Washington, D.C.: Institute of Carmelite Studies, 1976-85), 1:53-54. On the significance of Teresa's adoption of Joseph as her spiritual father, see Doze, 16.

47. See, e.g., León de San Joaquín, O.C.D., *El culto de San José y la Orden del Carmen*, translated by the Discalced Carmelite Friars (Barcelona: Juan Gili, 1905), 143-248; Fortunato de Jesús Sacramentado, O.C.D., "San José en el Carmen Descalzo español en su primer siglo," *Estudios Josefinos* 18, nos. 34-35 (1963-64): 355-408; Wilson, 7, 10, 12, 14-15. In fact, the Discalced Carmelites regarded Joseph as their founder and father. See Lucinio del Santísimo Sacramento, O.C.D., "La paternidad espiritual de San José en la Orden del Carmen," *Estudios Josefinos* 6 (1952): 80-108, and "Paternidad espiritual de San José en la espiritualidad contemplativa del Carmelo teresiano," *Estudios Josefinos* 18, nos. 34-35 (1963-64): 415-44; José Antonio Carrasco, "San José, fundador de la reforma teresiana," *Estudios Josefinos* 18, nos. 34-35 (1963-64): 339-53.

Santiago Sebastián notes that the image of St. Joseph abounds in Colonial Spanish America.[76] This is particularly true in Mexico. St. Joseph was depicted in two ways: first, walking with or holding the Christ Child; and, secondly, in narrative scenes that depicted the Holy Family and/or episodes in the saint's life, e.g., Joseph's espousal to the Virgin Mary, the angelic annunciation to Joseph, the Nativity of the Lord, the flight into Egypt, the rest on the flight into Egypt, the return from Egypt, the holy house at Nazareth, the finding of Jesus in the Temple, and the death of St. Joseph. Seventeenth-, eighteenth-, and nineteenth-century Mexican paintings of these subjects were often based on European paintings and engravings.[77] European and Mexican Colonial paintings, engravings, and statues provided the artistic inspiration for Mexican devotional *retablos*.[78]

In surveys of the most commonly represented subjects of Mexican *retablos* and of New Mexican *santeros* (saint-makers), Joseph always figures prominently. For example, a 1966 survey of a group of 341 Mexican *retablos* ranks the Holy Family as the third and Joseph as the fourth most popular subjects.[79] A survey of the subjects most often represented by New Mexican *santeros* puts Joseph even higher: he places third after the Crucified Christ and St. Anthony of Padua.[80] There is ample precedent in European and Colonial Mexican art for the principal ways in which Joseph is portrayed in Mexican devotional *retablos*. As Gloria Fraser Giffords emphasizes, predictability has always been an important aspect of religious art, and most people purchasing a *retablo* expected it to appear just as they had seen the image of the subject in question in church.[81]

Examination of Mexican *retablos* in which Joseph appears in The Peters Collection, in several private collections that I have viewed, and in the available books on the *retablo* art of Mexico reveals that there are a great variety of ways in which the saint is depicted. The principal ways in which Joseph is shown in *retablos* are the following: half-length figure, holding the Christ Child, in three-quarter view; full-length figure, holding the Christ Child, in an interior—a richly decorated room that includes drapery and a table upon which a book, fruit, a vase of flowers, or carpenter's tools rest; full-length figure, holding or walking with the Christ Child, in a landscape; full-length figure, holding the Christ Child, in an interior or in a landscape with carpenter's bench and tools; full-length figure as a member of the Holy Family; seated upon clouds in images of *La Mano Poderosa*, "The Powerful Hand," or *Los Cinco Señores*, "The Five Lords," together with Jesus, Mary, Anne, and Joachim; and in narrative scenes, such as the Espousal, the Flight into Egypt, and the House at Nazareth.

48. McAndrew, 393, 396.
49. This painting is illustrated in *Latin American Art* 5, no. 1 (1993): 74. On the advocation of the Virgin Mary under the title "Our Lady of Refuge," see Cataloge 18.
50. See Tovar de Teresa, 240. On the presence of the Holy Family in images of the Souls in Purgatory, see Santiago Sebastián, *El barroco iberoamericano: Mensaje iconográfico* (Madrid: Ediciones Encuentro, 1990), 241. On the pairing of St. Joseph and the *Mater Dolorosa*, see *Mexico: Splendors of Thirty Centuries* (New York: Metropolitan Museum of Art, 1990), Catalogue 146.
51. Carol M. Schuler, "The Seven Sorrows of the Virgin: Popular Culture and Cultic Imagery in Pre-Reformation Europe," *Simiolus* 21 (1992): 5-18, especially 14.
52. *Collected Works of St. Teresa of Ávila*, 1:54.
53. Patrignani, 44.

THE LITERARY CONTEXT FOR THE DEVELOPMENT OF ST. JOSEPH'S ICONOGRAPHY

In Europe as well as in the Americas, the iconography of Joseph developed in the context of a rich tradition of devotional literature about this saint. Three texts from this tradition have most often been cited by art historians in commenting on the portrayal of Joseph by Golden-Age and Colonial Spanish artists: *Summary of the Excellencies of St. Joseph* by the Discalced Carmelite friar Jerónimo Gracián de la Madre de Dios (1545-1614), who was Teresa of Ávila's religious superior, spiritual director, and closest friend and collaborator in the dissemination of her reform of Carmel; *The Life, Excellencies, and Death of the Most Glorious Patriarch and Husband of Our Lady, St. Joseph* by José de Valdivielso (1560?-1638), who was a prebendary of the cathedral of Toledo; and *The Mystical City of God and Life of the Virgin Revealed by Herself* by the Discalced Franciscan nun Venerable María de Jesús de Ágreda (1602-1655).[82]

The *editio princeps* of Gracián's *Summary* appeared in 1597, the same year the contract was signed for El Greco's *St. Joseph and the Christ Child* (Plate 2). The *Summary* quickly became a best-seller. An Italian translation appeared the same year as the first Spanish edition. In the seventeenth century, five Spanish, five Italian, two German, and two French editions were published. In the eighteenth century, two Spanish, one Italian, and one French edition appeared. In the nineteenth century, three Spanish and one French edition were published.[83]

The *Summary* is divided into five books, each of which is based on a Scriptural text about Joseph. In Gracián's own words, "The structure of my Summary is based on five things said in the Gospel about St. Joseph. . . . First, Joseph is called 'husband of Mary'; second, 'father of Jesus'; third, 'just'; fourth, it is said that angels appeared to him; and, fifth, that they spoke to him in dreams."[84] Modern scholarship assesses this work as being the best compendium of doctrine about Joseph produced up to that time. It attained an unprecedented circulation throughout Europe and had a decisive influence on the universal growth of devotion to Joseph.[85] Gracián's correspondence indicates that copies of the 1605 Toledo edition of the *Summary* were sent to the New World.[86]

In the *editio princeps* and in the first Italian translation of 1597, an engraving introduces each book; a sixth engraving precedes a litany of St. Joseph. These engravings, with their corresponding Latin inscriptions, visualize salient aspects of Gracián's doctrine, making manifest the work's intrinsic iconographic content. According to Alfonso E. Pérez Sánchez, the *Summary* offers one of the earliest and most successful formulations of the

54. *Collected Works of St. Teresa of Ávila*, 1:53.
55. Cifuentes, 287.
56. Juan Antonio Morán, M.J., "La devoción a San José en México en el siglo XVII," *Cahiers de Joséphologie* 29 (1981): 953-99, especially 959. On the history of the archdiocese of Mexico City, see Daniel T. Olmedo, S.J., "Mexico, Archdiocese of (Mexicanus)," *New Catholic Encyclopedia*, 1967.
57. McAndrew, 394; Rubén Sanabria, 672-73.
58. Quoted in Rubén Sanabria, 673.
59. McAndrew, 396.

iconography of Joseph as a strong and vigorous man who served as the earthly protector of the Virgin Mary and Christ Child.[87] Seventeenth-century evidence for the *Summary*'s formative influence on art is to be found in Francisco Pacheco's *Art of Painting* (begun ca. 1600; completed by 1638; published posthumously in 1649).[88] An artist and humanist, Pacheco was inspector for art for the Inquisition in Seville and the most important writer on art in Golden-Age Spain.

Like other Renaissance epics, Valdivielso's heroic poem on St. Joseph is divided into cantos—twenty-four in all. As its title suggests, it is a life of the saint. Valdivielso images Joseph variously as the seraphic guardian of the earthly paradise of the Virgin Mary, in which is planted the tree of life, Jesus; as crowned with lilies and roses; as the new Atlas who carries the heavenly God on his shoulders; as youthful and handsome; as the gardener whose soul enjoyed the first fruits of the restored earthly paradise; as an angelic man and a human angel; as a lover of poverty; as Jesus' Guardian Angel; as wounded by the Christ Child's flaming arrows of divine love; as the shepherd who tends the Lamb of God; as the new Adam who is ever obedient to the will of God; as the viceparaclete and shadow of the Holy Spirit who protects Mary and Jesus.[89] Several of these descriptions of the saint are also found in Gracián's *Summary*. First published in Toledo in 1604, Valdivielso's poem has gone through thirty-two editions.[90] The Hispanic Society of America has copies of twenty-three seventeenth-century editions. It was not unusual for two or three editions to be published in a single year, e.g., 1612, 1615, 1624, 1628, and 1659.[91]

The sumptuous imagery of Valdivielso's poem is the literary counterpart of the pictorial *detailisme* of the religious art of his day.[92] The graphic and the literary are brought together in the 1774 edition of the poem, in which twenty-five engravings illustrate the text. Recently, attention has been called to the influence of Valdivielso's poem on Jusepe de Ribera's *Holy Family in a Carpenter's Workshop* (ca. late 1630s-1640s, Rome, Sovrano Militare Ordine di Malta) and *The Holy Family with Sts. Anne and Catherine of Alexandria* (1648, New York, Metropolitan Museum of Art).[93] Conversely, Valdivielso's characterization of Joseph as the shepherd who tends the Lamb of God evokes El Greco's *St. Joseph and the Christ Child* (Plate 2) that antedates the poem; it is likely that the poet was familiar with this painting.

First published in 1670, five years after María de Ágreda's death, *The Mystical City of God*, like the *Summary* and Valdivielso's heroic poem, was very popular. Between 1670 and 1700, six editions were published. In the eighteenth century, at least another ten editions appeared.[94] There is iconographic evidence for the popularity of this work and its author

60. Filas, *The Man Nearest to Christ*, 155-60; and *Joseph Most Just: Theological Questions about St. Joseph* (Milwaukee: Bruce Publishing Company, 1956), 120-28; Rubén Sanabria, 675. There are ten holy days of obligation for the Universal Church, although certain countries, such as the United States, are exempt from the observance of some of these: Christmas (December 25), Mary, Mother of God (January 1), Epiphany (January 6), St. Joseph (March 19), Ascension, Corpus Christi, Sts. Peter and Paul (June 29), Assumption (August 15), All Saints (November 1), and Immaculate Conception (December 8).
61. Filas, *The Man Nearest to Christ*, 157-58, and *Joseph Most Just*, 114-16; Rubén Sanabria, 673-75.
62. See Morán; Carillo Ojeda, "San José en la Nueva España del siglo XVII," and "Presencia de San José en México en el siglo XVIII," *Cahiers de Joséphologie* 39 (1991): 637-64.
63. León de San Joaquín, 161, 199; Filas, *Joseph Most Just*, 114-15.
64. Filas, *The Man Nearest to Christ*, 196.

in Mexico: *St. John the Evangelist and Mother María de Jesús de Ágreda*, a magnificent oil-on-canvas painting by Cristóbal de Villalpando (ca. 1645-1714), one of the most important artists of the Baroque period in Mexico. Presently in the Museo Regional de Guadalupe in Zacatecas, this painting pictures the two visionaries—each with pen in hand and their respective book—in the foreground, and the mystical City of God and the Virgin of the Apocalypse in the background.[95]

The Mystical City of God has been described as a combination of novel, devotional book, pious legend, apocryphal history, Biblical truth, and mystical fantasy.[96] María recounts the entire life of the Holy Family in its most intimate details. Given that the author was a Discalced Franciscan, it is hardly surprising that one of the work's major themes is the Holy Family's poverty. María speaks of the voluntary poverty of Mary and Joseph, Joseph as a lover of poverty, Joseph's rejection of the devil's temptations against poverty, the poverty into which Jesus was born, the Holy Family as destitute and as masters of humility and poverty, the Magi's gifts being given to the poor, and the Holy Family in Egypt as the poorest of the poor and the recipient of alms.[97] The person of Joseph looms large in *The Mystical City of God*. The author treats Joseph's age and appearance, his vow of chastity and control of his passions, the martyrdom Joseph suffered when he saw that Mary was pregnant and before the mystery of the Incarnation was revealed to him, Joseph's obedience to God's will, his role as head of the Holy Family and as guardian of the Incarnation, the contemplation and mystical favors he enjoyed as well as miraculous powers he possessed, love as the cause of Joseph's death, the angelic consolation of Joseph on his deathbed, his privileges and powerful intercession.

ELEMENTS OF ST. JOSEPH'S ICONOGRAPHY COMMON TO MEXICAN DEVOTIONAL *RETABLOS*

There are three elements of the iconography of Joseph that virtually all *retablos* that represent this saint share in common. First of all, Joseph is consistently portrayed as a young man in the prime of life. During the patristic period and the Middle Ages, it was held that Joseph was of advanced age. For example, in the *Meditations on the Life of Christ*, Joseph is referred to as "a feeble old man" and as "the holy old man."[98] Some Fathers of the Church proposed that Joseph was a man of eighty years of age or more at the time of his espousal to the Virgin. The source for this belief was the apocryphal gospels that aimed to defend and to protect against heretics the dogma of Mary's virginal motherhood and of Jesus' divine origin. The image of an aged Joseph was adopted to symbolize his mortified passions and his absolute continence in his relationship with Mary.[99]

65. León de San Joaquín, 209-11.
66. Filas, *The Man Nearest to Christ*, 196-97.
67. Charles L. Souvay, "Joseph, Saint," *The Catholic Encyclopedia*, 1907-14.
68. Filas, *The Man Nearest to Christ*, 199, and *Joseph Most Just*, 130-32; Roland Gauthier, C.S.C., "Joseph (saint): Liturgie et documents pontificaux," *Dictionnaire de spiritualité*, vol. 8, 1316-21.
69. Vatican translation (Washington, D.C.: United States Catholic Conference, 1989), 35-36, 43, 45-46 (sections 24, 30-32).
70. *Guardian of the Redeemer*, 42 (section 29). On the Church's contemporary commitment to evangelization and re-evangelization, see Avery Dulles, S.J., "John Paul II and the New Evangelization," *America* 1 Feb. 1992: 52-59, 69-72.
71. John B. Knipping, *Iconography of the Counter-Reformation in the Netherlands: Heaven on Earth*, 2 vols. (Nieuwkoop: B. de Graaf/Leiden: A. W. Sijthoff, 1974), 1:118; Howard Hibbard, *Poussin: The Holy Family on the Steps* (London: Allen Lane, 1974), 63.

In the sixteenth century, the idea that Joseph was of advanced age was challenged by the Flemish theologian Johannus Molanus, in his treatise *On the History of Sacred Images*, first published in 1571 and reprinted many times until the eighteenth century. Molanus argued that Joseph must have been a strong, vigorous, young man for him to have supported Mary and Jesus by manual labor, to have travelled so extensively with them, and to have protected and defended them. The contrary opinion was held by the Jesuit St. Peter Canisius (1521-1597), who believed that Joseph should continue to be represented in art as aged because this was the image of the saint that was familiar to the faithful. Canisius' view did not prevail. The majority of theologians and devotional authors supported Molanus' position. Their consensus was that Joseph was thirty or, at the most, forty years old when he was espoused to Mary.[100] Some authors were even more specific. For example, in the *Mystical City of God*, María de Ágreda reports that Joseph was thirty-three at the time of the espousal.[101]

Whatever Joseph's specific age may have been, from this point on he was depicted in art as a handsome, young man. In Spain, the notion of a youthful Joseph was popularized by El Greco. Murillo, Zurbarán, and other Spanish artists followed his lead. El Greco's manner of representing Joseph has been related to the influence of Molanus' treatise in Spain.[102] The artist would have also been aware of the argument made by Alonso de Villegas (1534-1615), a prebendary of the Toledo cathedral, in his compendium of saints' lives, entitled *Flos Sanctorum* (first published between 1578 and 1589, and subsequently reprinted in numerous editions), that Joseph's youth and vigor would have been requisite for his marriage to the Virgin.[103] Undoubtedly, El Greco was familiar with this important work, a copy of which was listed in the 1621 inventory of his son's library.[104] The practice of representing Joseph as youthful was canonized by Pacheco, who, in his *Art of Painting*, prescribes that in portraying the espousal Mary should be depicted as being fourteen years of age and Joseph as a little more than thirty.[105] This image of Joseph was also ubiquitous in the New World. In Colonial Mexican art, as well as in the later devotional *retablos*, the saint is consistently rendered as mature but youthful and vigorous.

A second element that *retablos* of St. Joseph have in common is that the saint wears a green robe and a yellow cloak. This is in continuity with the practice of El Greco, Zurbarán, and Murillo, and numerous Colonial Mexican artists, including Andrés de Concha (1568-1612), Baltasar de Echave Orio (1582-1623), Baltasar de Echave Ibía (ca. 1583-1644), José Juárez (1617-1661), Baltasar de Echave Rioja (1632-1682), Villalpando, Juan Correa (ca. 1646-1716),

72. Mâle, 319.
73. Sebastián, *El barroco iberoamericano*, 200.
74. William B. Jordan, "Catalogue of the Exhibition," in Jonathan Brown et al., *El Greco of Toledo* (Boston: Little, Brown and Company, 1982), 240-41; David Davies, "El Greco and the Spiritual Reform Movements in Spain," *Studies in the History of Art* 13 (1984): 57-74, especially 67, and "The Relationship of El Greco's Altarpieces to the Mass of the Roman Rite," in *The Altarpiece in the Renaissance*, edited by Peter Humfrey and Martin Kemp (New York: Cambridge University Press, 1990), 212-42, especially 228-29.
75. Wilson, 11.
76. Sebastián, *El barroco iberoamericano*, 200.

Miguel Cabrera (1695-1768), and Antonio de Torres (1708-1754).[106] Recently, apropos of the painting *The Dream of St. Joseph* by the seventeenth-century Mexican artist José Rodríguez de los Santos (Tepotzotlán, Mexico, Museo Nacional de Virreinato), attention has been called to the custom of depicting Joseph in this manner in New Spain.[107]

During the Middle Ages, the members of the Holy Family were correlated with the theological virtues and the colors that correspond to these virtues. Jesus epitomized charity, symbolized by red, Mary exemplified faith, represented by blue, and Joseph, hope, signified by green. Joseph's hope is closely related to his constancy in the midst of adversity: travelling to Bethlehem for the imperial census at an inopportune moment since the time for Mary to give birth was imminent; being homeless and poor in Bethlehem; fleeing to save the Infant Jesus from harm by King Herod; living in exile in an alien and hostile country; diligently working to earn his living and to support his family.

Besides hope, several other, though not unrelated, meanings have also been associated with green. Green recalls the color and state of mind of the earthly paradise.[108] In this connection, green also connotes growth, fertility, and the triumph of spring over winter, or of life over death.[109] While devotional literature on Joseph does not explain the reason that the color green is associated with this saint, it does relate each of the symbolic meanings of this color to him.

At the outset of *The Names of Christ*, an elegant Platonic dialogue in which the names attributed to Christ in the Bible are explained, the Augustinian friar Luis de León (1527-1591), who was the premier Biblical exegete of the Spanish Golden Age, articulates the hermeneutic principle that informs his treatise: "All the names which are bestowed by God's command bear in them the meaning of some particular secret that the thing named contains in itself and in this meaning the name becomes similar to the thing."[110] This principle is also evident in explanations of the meaning of the name "Joseph" found in devotional literature. For example, in the *Summary*, Gracián cites St. Albert the Great's rendering of the Hebrew meaning of the name Joseph as "a son that grows."[111] Consonant with this meaning of the saint's name, the portrait of Joseph that unfolds in the *Summary* is that of a man whose life was a process of gradual and progressive growth in charity.[112] Similarly, Valdivielso explains that "the name Joseph means he who grows,"[113] specifying that Joseph grew throughout his life in virtue and in divine love.[114] María de Ágreda develops this notion even further by declaring that Joseph's love of God grew so intense that, finally, it caused his death, an idea that had been expressed earlier by the French devotional

77. On European paintings and engravings as sources for Colonial Mexican paintings, see Jorge Alberto Manrique, "Condiciones sociopolíticas de la Nueva España," José Guadalupe Victoria, "Un siglo de pintura en la Nueva España, 1521-1640," and Rogelio Ruíz Gomar, "La pintura de la Nueva España en la segunda mitad del siglo XVII y principios del XVIII," in *Pintura novohispana*, 21-23, 28-32, 33-37, respectively; Tovar de Teresa, 191-99; Burke, 57-61; Wilson, 14.
78. Giffords, *Mexican Folk Retablos*, 8-10, and "Retablos: Santos & Ex-Votos," *Latin American Art* 2, no. 3 (Fall 1990): 90-94, especially 92.
79. Giffords, *Mexican Folk Retablos*, 170-71.
80. Thomas J. Steele, S.J., *Santos and Saints: The Religious Folk Art of Hispanic New Mexico*, revised ed. (Santa Fe: Ancient City Press, 1982), 198.
81. Giffords, "*Retablos: Santos & Ex-Votos*," 92.

writer St. Francis de Sales (1567-1622).[115] Joseph's growth, then, is manifested by an increase of charity and virtue in his life, a spiritual fruitfulness and generativity so to speak, expressed visually by his green robe.

In devotional literature on Joseph, the saint is often associated with the earthly paradise or Heaven on earth. Biblical and patristic typology that identified the members of the Holy Family with the inhabitants of Eden provides the Scriptural foundation for this idea. The most well-known example of this identification was the typology Adam/Christ, developed by St. Paul in Romans 5:12-21, and Eve/Mary, put forth by the Fathers of the Church, principally on the basis of the remarkable parallel between the dialogue of Eve and the serpent in Genesis 3:1-7 and that of Mary and Gabriel in Luke 1:28-38.[116] Another typology found in the Fathers of the Church is Adam/Eve, Joseph/Mary. The *locus classicus* of this theme is the treatise *Against Heresies* of St. Irenaeus (died after 193): "[Eve], though wedded to Adam, was still a virgin . . . being disobedient, she became a cause of death to herself and to all mankind. So Mary, having a predestined husband, but none the less a Virgin, was obedient and became to herself and to the whole human race a cause of salvation."[117] This typology is repeated in medieval sermons and, more recently, in papal pronouncements by Paul VI and John Paul II.[118]

The paradisal theme stands out in Gracián's demonstration of how Joseph exercises the ministry of the Cherubim. In the Gospels, no word spoken by Joseph is recorded, and the only creatures who communicate with him are angels (Matthew 1:20-23; 2:13, 19-20). Consequently, Gracián and other devotional writers were fond of describing Joseph as a contemplative and as "an angel on earth" or "an angelic man," and of showing how he exercised the ministry of each of the nine choirs or orders of angels.[119] For example, after the expulsion of Adam and Eve, the Cherubim guarded the earthly paradise (Genesis 3:24). Likewise, Joseph, Gracián avers, was the guardian of the earthly paradise of the Virgin Mary, in which was planted the tree of life, Jesus.[120] According to Gracián, this is one of Joseph's fifty privileges: "St. Joseph merited to be the guardian of the earthly paradise like the Cherubim because he guarded the sovereign Virgin, who is the paradise of delights with the tree of life, Christ Jesus, planted within her."[121]

Nowhere is the association of Joseph with the earthly paradise or Heaven on earth stronger than in Valdivielso's poem. Like Gracián, Valdivielso regards Joseph as the guardian of the earthly paradise of the Virgin Mary, in which is planted Jesus, the tree of life. But Valdivielso goes on to develop new aspects of this theme. In Eden, humanity lived on

82. See, for example, Mâle, 316-23; Alfonso E. Pérez Sánchez, "On the Reconstruction of El Greco's Dispersed Altarpieces," and Jordan, in *El Greco of Toledo*, 149-76, especially 167, and 241, respectively; Gridley McKim-Smith, María del Carmen Garrido, and Sarah L. Fisher, "A Note on Reading El Greco's Revisions: A Group of Paintings of the Holy Family," *Studies in the History of Art* 18 (1985): 67-77, especially 74; Jeannine Baticle et al., *Zurbarán* (New York: Metropolitan Museum of Art, 1987), 149; Sebastián, *El barroco iberoamericano*, 200; Wilson, "St. Teresa of Ávila's Holy Patron," 10, and *St. Joseph in Spanish American Colonial Images of the Holy Family: Guardian of an Earthly Paradise* (Philadelphia: Saint Joseph's University Press, 1992), 8; Barbara von Barghahn, "From Prince to Sun King: The Image of St. Joseph in Spain and the New World," in *Patron Saint of the New World*, 31-39, especially 34; Alfonso E. Pérez Sánchez and Nicola Spinosa, *Jusepe de Ribera: 1591-1652* (New York: Metropolitan Museum of Art, 1992), 142, 155.

familiar and intimate terms with God and with the angels, who populated this paradise. With Jesus' birth, Valdivielso affirms, this state of intimacy with the divine is restored. At the moment of the Lord's nativity, a cold and frozen cave becomes Heaven on earth and, as Valdivielso's imagery suggests, the terrestrial paradise is recovered, for the icy earth is transformed into a flowering garden, night becomes day, and harsh winter is changed into mild spring.[122] Joseph is the minister of the Incarnation who guarded, supported, carried in his arms and on his shoulders, conversed with, and worshipped the Christ Child.[123] In his vocation as guardian of the Redeemer, Joseph is the wall that surrounds and defends the paradise that exists wherever God is present;[124] he is the Cherub who guards this new paradise.[125] Because God dwells in Joseph's house, it is Heaven on earth.[126] As husband of the new Eve, Joseph is the new Adam, whom, after God, the Virgin Mary loved more than she did anyone else.[127] Joseph is the gardener whose soul enjoys the first fruits of the restored earthly paradise.[128] As head of the Holy Family, Joseph forms with Jesus and Mary an earthly trinity that parallels the blessed Trinity in Heaven, a theme that will be discussed in detail below.[129]

In continuity with the tradition established by Gracián and Valdivielso, María de Ágreda declares that the house of the Holy Family at Nazareth was "a new Heaven."[130] Implicit in María de Ágreda's account of the history of Jesus, Mary, and Joseph is that the life of the Holy Family restored paradise on earth. As already noted, in Eden, God, angels, and humans dwelled together. For María de Ágreda, angels, who descended from Heaven in bodily form, participated in virtually every moment of the Holy Family's life, thus disclosing that the life of the God-Man Jesus, the Virgin Mary, and Joseph was paradise on earth. For example, angels help the Virign Mary to put the house at Nazareth in order and to prepare meals.[131] On journeys, the Holy Family is always accompanied by an guard of angels.[132] After helping Joseph to prepare the grotto where Jesus is born, angels adore and later hold the newborn Christ Child and venerate His mother.[133] As Mary and Joseph discourse about the name to be given to the Child at His circumcision, "innumerable troops of angels descended from Heaven in human form . . . They bore a device, upon which was engraved the name of Jesus. The two archangels, St. Michael and St. Gabriel, each held in their hands a luminous globe of wondrous beauty and splendor, within which was written the most holy name of Jesus."[134] After the circumcision, angels sing canticles composed by Mary and Joseph in praise of the name of Jesus.[135] On the flight into Egypt, angels strengthen Mary and Joseph for the journey, lead the Holy Family and form a luminous globe impenetrable to the

83. José Antonio Carrasco, "Fray Jerónimo Gracián de la Madre de Dios y su *Summario de las excelencias del glorioso S. Joseph, esposo de la Virgen María o Josefina* (1597)," *Cahiers de Joséphologie* 25 (1977): 295-322, especially 300-302.

84. Quoted in Chorpenning, 24. Subsequent references to Gracián's text in the anthology *Just Man, Husband of Mary, Guardian of Christ* will be to "Gracián"; those to the introductory essay preceding the anthology will be to "Chorpenning."

85. Carrasco, "Fray Jerónimo Gracián de la Madre de Dios y su *Summario*," 322.

86. Fortunato de Jesús Sacramentado, O.C.D., "Labor josefina del P. Jerónimo Gracián de la Madre de Dios," *Estudios Josefinos* 4 (1950): 69-88, 188-208, especially 73.

87. "On the Reconstruction of El Greco's Dispersed Altarpieces," 167.

88. Francisco Pacheco, *Arte de la pintura*, edited by F. J. Sánchez Canton, 2 vols. (Madrid: Instituto de Valencia de Don Juan, 1956), 1: 305; 2: 231, 235, 238, 240, 253, 255, 259, 264, 267.

weather around them, and nourish them with bread, fruit, and beverages.[136] On the return from Egypt, angels minister to the Holy Family in the desert.[137] Joseph is consoled by angels on his deathbed.[138]

To sum up: The green color of Joseph's robe, then, is rich in connotation. It suggests the saint's virtue of hope, the significance of the name "Joseph," his spiritual generativity, and his pivotal role in the restoration of paradise effected by the Incarnation.

Joseph's yellow cloak also evokes themes expounded in the devotional literature on this saint. One symbolic meaning of yellow is that it is the emblem of the sun and of divinity. For instance, the backgrounds of many Renaissance paintings glow with a golden yellow, symbolizing the sacredness of that which is depicted. Both St. Joseph and St. Peter are painted wearing a yellow mantle. It has been suggested that, in the case of Peter, yellow symbolizes revealed truth.[139] Joseph's yellow cloak may represent his divinely ordained, sacred vocation and privilege as husband of Mary and legal father of Christ: "'Joseph, son of David, do not be afraid to take Mary as your wife. . . . She will bear a son, and you are to name him Jesus'" (Matthew 1:20-21).[140] Yellow is also symbolic of the virtue of magnanimity.[141] In the case of Joseph, this virtue is manifest in the manner in which the saint lived out his vocation: "Joseph surrendered his whole existence to the demands of the Messiah's coming into his home."[142] This virtue is also evident in Joseph's response to those who invoke his patronage. As already noted, both Gerson and Teresa of Ávila had great confidence in the power of Joseph's heavenly intercession, insisting that God grants whatever Joseph asks. This was also the experience of the inhabitants of New Spain, for whom the saint's intercession was efficacious in averting natural disasters.[143]

The attributes of the flowering staff or rod and of the lily are a third element of Joseph's iconography observable in Mexican devotional *retablos*. The flowering staff or rod is derived from the legend of the espousal of Joseph and the Virgin Mary, found in the apocryphal gospels and repeated by numerous hagiographers and devotional authors, and represents Joseph's divine election as the husband of the Mother of God.[144] Gracián provides a synopsis of this legend: "When the Virgin Mary was fourteen years old, the age at which the virgins who were reared in the temple were married . . . God ordained that all the marrigeable young men of Mary's tribe who were in Jerusalem should come to the temple, and that He would miraculously make known to whom Mary should be given as wife. When the suitors came together, Joseph's staff flowered and a white dove appeared over him."[145] This legend was influenced by the story of Yahweh revealing his choice of Aaron

89. José de Valdivielso, *Vida, excelencias y muerte del gloriosísimo Patriarca y esposo de nuestra Señora, San Josef* in *Poemas épicos*, edited by Cayetano Rosell, Biblioteca de autores españoles, vol. 29 (Madrid: Ediciones Atlas, 1948), 139, 140, 162, 169 70, 180, 183, 193, 199, 215, 218-19, 221, 223, 231, 235, 238.
90. Laurentino M. Herrán, "El 'Maestro' José de Valdivielso, y su poema *Vida, excelencias y muerte del glorioso Patriarca y esposo de Nuestra Señora San Josef,*" *Cahiers de Joséphologie* 29 (1981): 421-88, especially 426, note 16.
91. Clara Louisa Penney, *Printed Books in the Hispanic Society of America: 1468-1700* (New York: The Hispanic Society of America, 1965), 576.
92. Frank Pierce, *La poesía épica del Siglo de Oro*, 2nd ed., translated by J. C. Cayol de Bethencourt (Madrid: Editorial Gredos, 1968), 292.
93. Pérez Sánchez and Spinosa, 142, 155.
94. Juan Luis Alborg, *Historia de la literatura española: Época barroca*, 2nd ed. (Madrid: Editorial Gredos, 1970), 936.

for the priestly office by making his rod blossom white almond flowers (Numbers 17:1-8), the reference to the shoot from the stump of Jesse in Old Testament prophetic literature (Isaiah 11:1), and the story in the canonical Gospels of the appearance of the dove of the Holy Spirit at Jesus' baptism to signal that He was the Son of God (Matthew 3:16; Mark 1:10; Luke 3:22) Underlying this legend is the conviction that God must have manifested His will about the marriage of Joseph and Mary in a special way.[146] This legend exerted a tremendous influence on Christian art: the flowering staff became Joseph's principal attribute. According to Valdivielso, Joseph's staff blossomed "white flowers with green leaves."[147] For Pacheco, the blossoms were "beautiful almond flowers," a motif clearly derivative of the story of Aaron's blossoming rod.[148] In the *retablo* art of Mexico, Joseph's staff either has white flowers or colorful hollyhocks, which in Spanish are called *varitas de San José*.

Besides divine election, the staff has other meanings in the Old Testament. For example, there is the shepherd's staff or crook, which signifies protection. The shepherd's staff could be used as a defensive weapon to ward away human or animal aggressors from the flock. With his staff, the shepherd also guided timid animals over terrain or streams that were difficult and/or dangerous to traverse. Hence, the shepherd's staff became a symbol of Yahweh's protection of His people (Psalm 23:4; Micah 7:14). Another meaning of the staff is that it identified the head of a particular household or tribe (Genesis 38:18, 25). In this instance, the staff was a symbol of patriarchal authority.[149]

When Joseph's attribute of the flowering staff is considered in light of this Old Testament background, the saint's unique ministry in salvation history stands out. As a symbol of protection, Joseph's staff emphasizes his role as defender and protector of Mary and Jesus. As a symbol of authority, Joseph's staff represents his divinely appointed position as head of God's household, the Holy Family.[150] Both of these roles flow from Joseph's divine election and are summed up by the titles that often precede the saint's name in the Spanish-speaking world: lord (*señor*) and patriarch. This cluster of meanings associated with Joseph's staff—divine election, protection, authority—is implicit in numerous European and Colonial Spanish images of the Holy Family, of narrative scenes such as the Flight into Egypt, and of the saint walking with or holding the Christ Child.

Sometimes artists make this symbolism explicit. For example, in his *St. Joseph and the Christ Child*, El Greco does this when he substitutes a shepherd's crook for the flowering staff and represents the saint protectively shepherding Jesus (Plate 2). Also evident in this painting is Jesus' submission to Joseph, which Molanus specified was to be represented by

95. *Mexico: Splendors of Thirty Centuries*, Catalogue 143.
96. Ludwig Pfandl, *Historia de la literatura nacional española en la Edad de Oro* (Barcelona: Juan Gili, 1933), 584.
97. Maria of Jesus of Ágreda, *The Admirable Life of the Glorious Patriarch St. Joseph: Taken from "The Mystical City of God"* (New York: Sadlier, 1859), 56, 68, 71-72, 110, 112, 115, 125, 129, 134, 148, 156, 159, 161, 169, 178-80, 187, 191, 201, 204.
98. *Meditations on the Life of Christ*, 59, 65.
99. Filas, *The Man Nearest to Christ*, 19-25, and *St. Joseph and Daily Christian Living: Reflections on His Life and Devotion* (New York: Macmillan, 1959), 14-19.
100. Mâle, 315-16. For discussion of resonances of the debate over Joseph's age in El Greco's art, see Jordan, 239; McKim Smith, Garrido, and Fisher, 68, 71, 73-74.
101. Maria of Ágreda, 50.

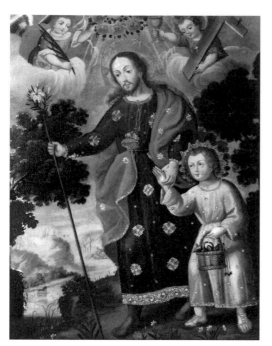

Plate 3.
School of Cuzco
(Peru),
*St. Joseph
Walking with
the Christ Child,*
18th c.
Private Collection.
(Photo: Jeffrey Blake)

showing the Christ Child at the hand of Joseph, as El Greco does here.[151] This portrayal highlights that Joseph's staff was also a symbol of authority. Similarly, the threefold symbolism of Joseph's staff stands out in an eighteenth-century School of Cuzco oil-on-canvas painting *St. Joseph Walking with the Christ Child* (Plate 3). With staff firmly in hand, Joseph guides the boy Jesus along rocky terrain and prepares to ford a stream, drawing attention to this staff as a symbol of protection. The staff as a symbol of authority is indicated by Joseph's leading Jesus by the hand. The flowers that blossom at the top of Joseph's staff are, as always, symbolic of his divine election as husband of Mary and, by virtue of his marriage to the Virgin, as legal father of Jesus.[152]

Although Giotto (ca. 1266 or 1276-ca. 1336) substituted the lily for the almond as the flower blossoming atop Joseph's staff, the use of the lily as the saint's attribute does not seem to have become widespread until the Counter-Reformation.[153] Scholars of this period reject the apocryphal legend of Joseph's flowering staff. Nonetheless, this attribute persists in art, and in this connection Molanus comments: "If we see St. Joseph represented with a flowering staff, it must be plainly understood that this flower symbolizes his virginity, since this story is apocryphal."[154] From this point on, the lily, the traditional symbol of chastity and of virginity, becomes Joseph's other principal attribute, and the saint's staff sometimes takes the form of a branch of lilies.[155] While this motif sometimes occurs in Colonial Spanish art, in the *retablo* art of Mexico, as in most Colonial Mexican art, the attributes of the flowering staff and of the lily remain distinct.[156] Occasionally, both attributes appear in a single *retablo* (Plate 9).

When, in Matthew 1:20-25, an angel reveals to Joseph that his espoused wife was to give birth to the Messiah, Joseph also learns about his own vocation. His mission was to be entrusted with Mary and her Child. Joseph was called to empty himself of the natural desire to have a wife who would give him a large family, and to be a biological father in a culture in which fatherhood defined a man's identity. He was to dedicate himself selflessly and generously to Mary's support and care as her husband, while respecting the fact that she

102. August L. Mayer, "Notas sobre la iconografía sagrada en las obras del Greco," *Archivo español de arte* 14 (1940-41): 164-68; Jordan, 241.
103. Laurentino M. Herrán, "San José en las vidas de Cristo y de María del siglo XVI," *Cahiers de Joséphologie* 25 (1977): 447-75, especially 461.
104. Richard L. Kagan, "The Toledo of El Greco," in *El Greco of Toledo*, 35-73, especially 49-50.
105. Pacheco, 2:228.
106. See, e.g., *Mexico: Splendors of Thirty Centuries*, Catalogue 128, 138, 139; Tovar de Teresa, 62, 113, 115, 153; Burke, 46-47, 49, 59, 117, 121. Sometimes Joseph's cloak is red in Colonial art: see Plate 1, and Tovar de Teresa, 53, 72, 139, 141, 148, 172. This color probably symbolizes Joseph's love. For example, Gracián portrayed Joseph as the recipient of the most sublime divine love, which the saint reciprocated by faithful and loving service to Jesus and Mary, thus becoming a model of paternal and con-

belonged exclusively to God. He was not to have marital relations with her. Joseph was also to care for the Child as if he were His father. The saint was to surrender to the Lord his potential fatherhood; Joseph's role was to be the shadow of God the Father.[157]

While Mary's perpetual virginity was virtually unanimously accepted early in Christian history, belief in Joseph's perpetual virginity underwent a longer period of development. The Greek Fathers of the Church tended to explain the reference in the Gospels to the "brothers of Jesus" by regarding them as Joseph's sons by a previous marriage. The source of this explanation is the apocryphal gospels. While numerous Church Fathers believed this legend, it was not generally accepted in the Western Church. Although the legends perpetuated by the apocryphal gospels on all other matters were accepted, on this point they were rejected. After 1100, Joseph's perpetual virginity was universally accepted by theologians and faithful alike.[158] For Gracián, Joseph's chastity made him greater than the angels, who because of their incorporeal nature are not able to sin against chastity: "Joseph was chaste by grace; the angels, by nature. Since grace is superior to nature, Joseph's chastity surpasses that of the angels."[159]

The attribute of the lily represents not only Joseph's virginity, but also one of his most important advocations that was closely related to his chastity: Refuge of Sinners. María de Ágreda makes known two instances in which the intercession of St. Joseph is most powerful: "The first is, to obtain the virtue of chastity, and to be withdrawn from the danger of losing it; the second, to receive powerful assistance to be freed from sin and to recover the grace of God."[160] As already noted, Morlete Ruiz visualizes this advocation in his painting that depicts Joseph, with his attribute of the lily and holding the Christ Child, and bears the inscription *Refugium peccatorum*. The lily was a visual reminder that Joseph, who, with the help of grace, was successful in surrendering himself to God's will, was someone to whom the faithful can turn, with confidence and trust, for assistance in times of temptation and spiritual peril. Since Christian Antiquity, Joseph of Egypt, who refused the sexual advances of Potiphar's wife (Genesis 39:6-10), was regarded as a type of the chaste and virginal Joseph of Nazareth.[161] During times of trouble, Pharaoh told the Egyptians: "'Go to Joseph'" (Genesis 41:55). With the rise of widespread public devotion to St. Joseph, this Old Testament text was applied to the saint explicitly to encourage Christians to turn to him for help in trials and temptations. The Latin version of this text, "'*Ite ad Joseph*,'" was often inscribed in a prominent place in chapels and on altars dedicated to this saint.[162]

jugal love. For an exposition of these themes in Gracián's *Summary*, see Chorpenning, 33-52. In European art, Joseph is some- times robed in regal purple, as in the *Mérode Triptych* (1425-1435; New York, Metropolitan Museum of Art, The Cloisters Collection). This color represents Joseph's affinity with God the Father, as well as his patriarchal dignity, prestige, and strength: see Marjory Bolger Foster, *The Iconography of St. Joseph in Netherlandish Art, 1400-1550*, Ph.D. diss., University of Kansas, 1978, 271; Cynthia Hahn, "'Joseph Will Perfect, Mary Enlighten and Jesus Save Thee': The Holy Family as Marriage Model in the Mérode Triptych," *Art Bulletin*, 68 (1986): 54-66, especially 64. This color may also allude to Joseph's position as a member of the royal house of David (Luke 2:4) and as husband of the Queen of Heaven.

107. Roberto M. Alarcón Cedillo in *Pintura novohispana*, 125.
108. A. Bartlett Giamatti, *The Earthly Paradise and the Renaissance Epic* (1966; Princeton: Princeton University Press pbk., 1969), 100.
109. George Ferguson, *Signs & Symbols in Christian Art* (1954; New York: Oxford University Press, 1973), 151. Cf. Giamatti, 115-16.

To summarize: The composite portrait of Joseph that emerges from these three elements common to Mexican devotional *retablos* is that which dominated European and Colonial Spanish art once Joseph was established as a saint in his own right. Joseph is pictured as the youthful but mature, gentle but vigorous, dignified but self-effacing protector of Mary and Jesus and patriarch of the Holy Family. We have come a long way from the medieval image of Joseph as an aged, sometimes comical, often ridiculous, background figure that prevailed in art until the Counter-Reformation. The *retablo* art of Mexico leaves no doubt that Joseph was a full-fledged and integral member of the Holy Family. Each of the various genres of *retablo* representations of Joseph enhance this well defined, positive image of the saint by adding the crown, book, carpenter's tools, and palm tree to his list of attributes. Each of these attributes visualizes ideas found in the tremendously rich devotional tradition that has developed around the person of Joseph.

RETABLO REPRESENTATIONS OF ST. JOSEPH

(1) HALF-LENGTH FIGURE IN THREE-QUARTER VIEW

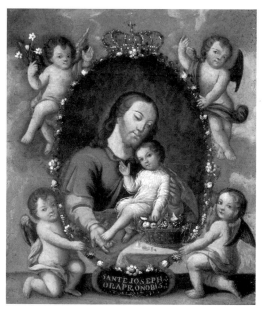

Plate 4.
Miguel Cabrera
(Mexico),
St. Joseph and the Christ Child,
1737.
(courtesy
Sotheby's,
New York).

Perhaps the most popular manner in which St. Joseph is depicted in *retablos* is as a half-length figure in three-quarter view holding the Christ Child. Models for this genre are plentiful in Colonial Mexican art. Examples include eighteenth-century oil-on-copper paintings by Miguel Cabrera (Plate 4) and Nicolás Enríquez (Plate 5) and an oil on panel attributed to Sebastián Salcedo (18th c., Collection of Dr. James F. Adams).[163] The works by Cabrera and Salcedo are *trompe l'oeil* images. A painting of Joseph with the Christ Child is contained within a painting: putti hold an oval painting of these sacred figures that is encircled by a garland of flowers surmounted by a gold crown. It has been suggested that the basic composition of Salcedo's painting (a bust-length figure in three-quarter view) is derived from a prototype established by Murillo.[164] Murillo painted several devotional works of a half-length figure of Joseph holding the Christ Child.[165] Earlier, the Flemish engraver Anton Wierix the Younger (ca. 1552-1624) produced a copper engraving of Joseph

110. Luis de Leon, *The Names of Christ*, edited and translated by Manuel Durán and William Kluback, The Classics of Western Spirituality (New York: Paulist Press, 1984), 48.
111. Gracián, 111.
112. See, e.g., Gracián, 95, 102-103, 121-23, 143-46, 169-70.
113. Valdivielso, 156.
114. See Valdivielso, 141, 156, 218.
115. Maria of Ágreda, 225, 232; St. Francis de Sales, *Treatise on the Love of God*, translated by Vincent Kerns, M.S.F.S. (Westminster, Maryland: Newman Press, 1962), 306-307. It is noteworthy that it was a commonplace in Teresian hagiography that divine love was the cause of the death of this saint who was so devoted to Joseph: see Irving Lavin, *Bernini and the Unity of the Visual Arts*, 2 vols. (New York: Pierpont Morgan Library and Oxford University Press, 1980), 1:114.

holding the Christ Child (ca. 1600) that was probably
also known and used in the colonies by artists (Plate 6).[166]
One of the oldest surviving examples of this manner of
portraying the saint from the Americas, antedating
Murillo, is an oval painting of *St. Joseph with the Christ
Child* executed ca. 1607-1612 by the Bolivian artist
Gregorio Gamarra (Plate 1). One of the most outstanding
of the early Colonial artists, Gamarra (1570?-1642) was
trained in one of the most important ateliers in the
Viceroyalty of Peru, the workshop headed by the skilled
team of the Jesuit lay brothers Bernardo Bitti (1548-1610)
and Pedro de Vargas (1553-ca. 1600).[167]

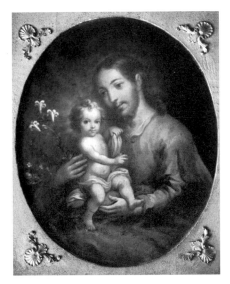

Plate 5.
Nicolás Enríquez
(Mexico),
*St. Joseph
and the
Christ Child,*
18th c.
Private Collection.

The flower garland "picture-within-the-picture"
composition of the paintings by Cabrera and Salcedo originates
with works by seventeenth-century Flemish artists, such
as Peter Paul Rubens (1577-1640), Jan Brueghel the Elder
(1568-1625), and the Jesuit lay brother Daniel Seghers (1590-
1661).[168] This form of composition served several purposes:
it emphasized the importance of the central image as an object
of veneration since any homage paid to the image passed to its
prototype; it was a symbolic and metaphorical extension of the

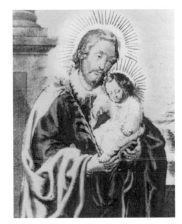

Plate 6.
Anton Wierix
the Younger,
*St. Joseph
with the
Christ Child,*
ca. 1600,
copper engraving.
(Photo: John B. Knipping)

contemporary practice of draping garlands of flowers around images for feast and holy days;
and it increased the value of the painting since, then as now, floral still lifes were among the
most costly and highly prized works of art.[169] By comparison, Enríquez's painting is
simpler—a straightforward oval painting.

A basket of fruit appears in all three paintings. In Cabrera and Salcedo, the basket
rests on the edge of a table, and the Christ Child fingers the fruit; in Enríquez, the basket is
in the background. In Flemish art, the basket of fruit in images of the Holy Family had a
precise Christo-Mariological significance. For example, Jan Baptist Bedaux has argued that
the bowl of fruit in a *Holy Family* by the Flemish artist Joos van Cleve (ca. 1513, New York,
Metropolitan Museum of Art) alludes to Mary's fertility: the fruit is shown in conjunction
with a text held by Joseph, the very text from the *Hail Mary* that refers to Christ as the fruit
of Mary's womb.[170] Fruit may have the same meaning when it appears as an element in

116. Michael O'Carroll, C.S.Sp., *Theotokos: A Theological Encyclopedia of the Blessed Virgin Mary* (Collegeville: Liturgical Press, 1982), 139-41.
117. Quoted in O'Carroll, 189.
118. See Bertrand, "Joseph (saint): Patristique et Haut Moyen Âge," 1306; *Guardian of the Redeemer*, 15 and note 17 on the same page (section 7).
119. See, e.g., Gracián, 189-96.
120. Gracián, 195.
121. Gracián, 260.
122. Valdivielso, 193, 199, 200. Flowers and springtime were constitutive elements of patristic and medieval descriptions of the earthly paradise: see Giamatti, 70, 72-73, 75.

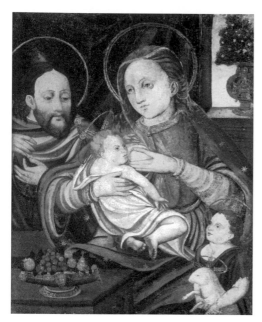

Plate 7.
The Holy Family,
Mexico,
late 17th c.
(courtesy
Sotheby's,
New York)

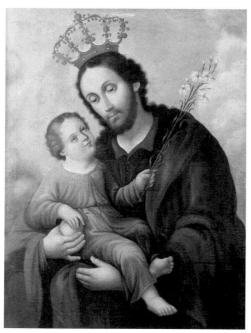

Plate 8.
Ramón Doblado
(Mexico),
*St. Joseph
and the
Christ Child*,
1826.
Philadelphia,
Saint Joseph's
University
Collection.
(Photo: Jeffrey Blake)

Colonial Spanish and *retablo* images of Joseph with Jesus. Paintings similar to Van Cleve's in composition (minus the text), and presumably significance, were produced in Colonial Mexico, as an anonymous late seventeenth-century oil on gessoed panel of *The Holy Family* attests (Plate 7). At the same time, the flower garlands, basket of fruit, and putti also have paradisal overtones.

European and Colonial Mexican images of the half-length figure of Joseph holding the Christ Child were models for *retablos* of this genre. Even after Mexico won its independence from Spain (1821), Mexican artists continued to portray Joseph according to the iconography firmly established by the European and Mexican Colonial tradition, as Ramón Doblado's oil-on-canvas painting *St. Joseph and the Christ Child* of 1826 indicates (Plate 8). Paintings like Doblado's would have also served as models for *retablo* artists. *Retablos* of this genre portray Joseph, who frequently wears a gold crown, affectionately holding the Christ Child, with either one or both of his attributes of the flowering staff and lily (Plate 9). The affinity between *retablos* and Colonial Mexican paintings is particularly evident when the figures of Joseph and Jesus are placed within an oval (Plate 10).

In these as in other *retablo* representations of Joseph, sometimes stars encircle Joseph and Jesus (Plates 10, 14), a motif that was probably borrowed from Marian iconography and may be related to some prayer form (see Catalogue 8, 9, 18). Sometimes Joseph's robe is adorned with stars (Plate 15), a decorative element also probably adopted from portrayals of the Virgin in Colonial Mexican paintings, such as Villalpando's *The Vision of St. Teresa* (Plate 11). The subject of this painting is Teresa's vision of August 15, 1561, recounted in her *Life*, chapter 33, of the Virgin Mary and Joseph

123. See, e.g., Valdivielso, 193.
124. Valdivielso, 184, 208. Valdivielso repeats almost verbatim the principle articulated by Teresa of Ávila in the *Way of Perfection*: "where the king is there is his court . . . wherever God is, there is heaven" (*Collected Works*, 2:140). For her part, Teresa probably adopted this principle from Francisco de Osuna's *Third Spiritual Alphabet*: "wherever God is and takes delight, there is paradise" (translated by Mary E. Giles, The Classics of Western Spirituality [New York: Paulist Press, 1981], 124).
125. Valdivielso, 242.
126. Valdivielso, 183, 184, 229, 230.
127. Valdivielso, 231.
128. Valdivielso, 235.
129. Valdivielso, 140, 229.

clothing her in "a white robe of shining brightness," indicating that she had been cleansed of her sins.[171] In Villalpando's impressive interpretation of this event, the Virgin's blue mantle is decorated with stars, while Joseph's golden yellow cloak is adorned with flowers, a motif that sometimes also appears in *retablos* of this saint (Plate 22).

The Christ Child, who sometimes is also crowned, often wears a reddish robe, symbolizing that He is divine love incarnate and/or the sacrificial Lamb of God (as in El Greco's *St. Joseph and the Christ Child*). In half-length representations, Jesus usually holds

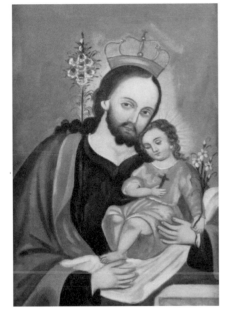

Plate 9.
St. Joseph with the Sleeping Christ Child,
Mexico,
19th c.
Private Collection.
(Photo: Jeffrey Blake)

a small cross, the instrument of human redemption; in full-length images, He holds either a cross or another attribute, such as a heart—an image of divine love—or an orb—a symbol of divine power (Catalogue 31, 32, 33; Plates 9, 10, 14, 16, 17).[172] The small cross may also reflect the legend, found in devotional literature, that the Christ Child made "little crosses, when He had time left after helping St. Joseph in his work, showing thus early His fervent longing for the work of our redemption."[173]

Another element of Joseph's iconography that often appears in *retablos* is the crown. There is ample precedent for this in Golden-Age Spanish and Colonial Mexican art. In his *St. Joseph and the Christ Child*, El Greco represents the saint being crowned with the victor's laurel by an angel (Plate 2). For David Davies, Joseph's crown represents the saint's reward for the "good works" he performed as Christ's guardian; this accords with the Council of Trent's decree *On Justification*.[174] Zurbarán makes this meaning of Joseph's crown explicit in his *The Coronation of St. Joseph* (1636, Seville, Museo Provincial de Bellas Artes): in a scene paralleling the coronation of the Virgin Mary, the victorious Redeemer rewards his earthly guardian with a crown of roses in the presence of God the Father and the dove of the Holy Spirit. This particular subject was a favorite of the

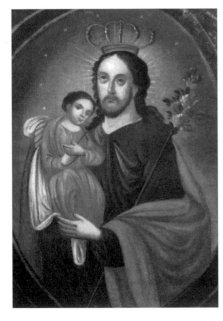

Plate 10.
St. Joseph with the Christ Child,
Mexico,
19th c.
Private Collection.
(Photo: Jeffrey Blake)

130. Maria of Ágreda, 194.
131. Maria of Ágreda, 71, 114.
132. Maria of Ágreda, 64, 86, 124-26, 160, 196.
133. Maria of Ágreda, 130, 132, 139.
134. Maria of Ágreda, 141-42.
135. Maria of Ágreda, 145.
136. Maria of Ágreda, 167, 172-73, 175.
137. Maria of Ágreda, 192.
138. Maria of Ágreda, 218.
139. Ferguson, 153.

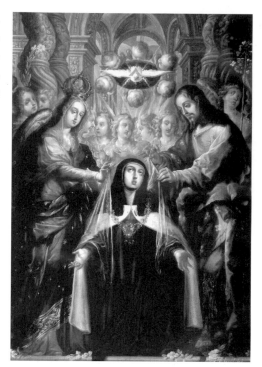

Plate 11.
Cristóbal de
Villalpando
(Mexico),
*The Vision
of St. Teresa,*
1680-1690.
Mexico City,
Pinacoteca
de La Profesa.

Jesuits, who did much to popularize it.[175] Angels hover above Joseph's head with a crown of lilies in Alonso Cano's *Holy Family* (1653-1657, Granada, Convento del Ángel Custodio), and with a crown of roses in Claudio Coello's *St. Joseph and the Christ Child* of 1666 (Plate 12).[176] In the Colonial Mexican paintings by Cabrera and Salcedo discussed above, Joseph's crown of flowers is replaced by a gold crown that appears above, rather than on, the saint's head. The converse is true in other images, such as Cabrera's *St. Joseph with the Christ Child* that shows the saint standing in an interior, wearing a gold crown, holding his attribute of the lily in his right hand and the Christ Child resting on his left arm; a basket of fruit rests on an adjacent table (Plate 13). In *retablos* of Joseph with the Christ Child, the saint almost always wears a gold crown.

As in the case of Joseph's other attributes, there are references in the literature about the saint to his crown. Gracián refers metaphorically to the crown of Joseph's virginity and chastity and to the saint's trials as the precious jewels of his crown.[177] The *Summary* also suggests another meaning implicit in Joseph's crown. As head of the Holy Family, Joseph carried out the ministry of Dominions, another of the nine choirs or orders of angels.[178] When Dominions are depicted in art, they are usually wear crowns.[179] Thus, Joseph's crown also evokes his role as Dominion.

Two meanings are ascribed to Joseph's crown in Valdivielso's heroic poem. First, after the Virgin Mary and Joseph renew their vow of chastity, following their espousal in the temple, Mary prays that God may send angels to bestow a garland of roses, marigolds, and orange flowers upon Joseph's head to crown his gracefulness, handsomeness, virtue, goodness, and purity.[180] Second, after his bodily assumption into Heaven, Joseph receives a crown of the rays of the sun as a reward for his purity that was so greatly admired by the angels, and he is seated at the side of Christ.[181]

In the nineteenth century—the period during which most Mexican devotional *retablos* were produced—there is an important reference to the crowned Joseph in a papal document.

140. According to Jewish law, Joseph's naming of Jesus made the saint His legal father. This is a more correct description of Joseph's role than adoptive or foster father. See Raymond E. Brown, S.S., "The Annunciation to Joseph (Matthew 1:18-25)," *Worship* 61 (1987): 482-92, especially 487-88. The angelic command to Joseph to name Jesus was also regarded as another example of the Adam/Joseph typology. In Eden, God brought all of the other creatures to Adam so that he could name them, thus expressing the dominion over the rest of creation that God entrusted to humanity (Genesis 2:19-20). Similarly, Joseph is commanded by God, through the agency of an angel, to name the Son of God, over whom he was given dominion. See, e.g., the court preacher Pierre de Besse's sermon for the feast of St. Joseph in the collection of his sermons for liturgical solemnities and the saints' feast days, *Conceptions theologiques sur toutes les festes des saincts & autres solemnelles de l'année* (Lyon: Simon Rigaud, 1629), 225-26.

141. J. E. Cirlot, *A Dictionary of Symbols*, 2nd ed., translated by Jack Sage (1971; New York: Dorset Press, 1991), 54.

On December 8, 1870, Pope Pius IX placed the entire Catholic Church under Joseph's patronage, conferring upon the saint the title "Patron of the Universal Church." On July 7, 1871, Pius IX issued a decree on the liturgical honors to be accorded Joseph. At the outset of this document, the Pope describes Joseph as "now crowned with glory and honor in Heaven."[182]

Crowned statues of Joseph parallel Colonial Mexican paintings of the crowned saint and also must have been a source for *retablos* depicting Joseph in this manner. The practice of crowning statues of Christ and the Virgin became popular in both the East and the West from the time of the Iconoclastic Controversy (ca. 725-842). The statues of saints, such as St. Anthony of Padua, were also sometimes crowned. The extension of this practice to images of Joseph corresponds to the period during which his cult began to flourish in Western Europe. In the early seventeenth century, the practice of crowning images of Joseph was already popular among the Discalced Carmelites. In the eighteenth century, this custom attained a canonical status within the Universal Church.[183]

Santa Fe de Bogotá in Colombia was the site of the first canonical coronation of an image of Joseph. In 1779, the Colombian layman Francisco de Vergara y Caicedo, a solicitor of the royal tribunal and the majordomo of a chapel adjacent to the cathedral of Santa Fe de Bogotá, petitioned the archbishop for permission to crown a statue of Joseph in the chapel under his charge. The archbishop secured the necessary

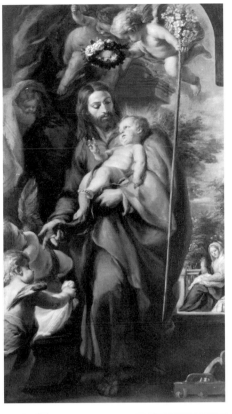

Plate 12.
Claudio Coello,
*St. Joseph
and the
Christ Child,*
1666.
The Toledo
Museum of Art,
Gift of Edward
Drummond Libbey.

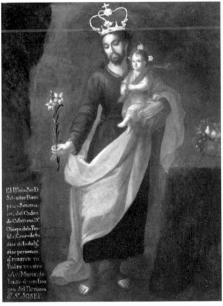

Plate 13.
Miguel Cabrera
(Mexico),
*St. Joseph
with the
Christ Child,*
18th c.
Private Collection.
(Photo: Jeffrey Blake)

authorization from the Holy See, and on November 19, 1779, the said statue was crowned on behalf of Pope Pius VI. Subsequently, numerous permissions were granted by the Holy See for coronations of statues of Joseph. Over the three-year period of 1788 to 1790, Pius VI

142. John Paul II, *Guardian of the Redeemer,* 37 (section 26).
143. See McAndrew, 394; Rubén Sanabria, 672.
144. Filas, *The Man Nearest to Christ,* 35-41; Jacobus de Voragine, *The Golden Legend: Readings on the Saints,* translated by William Granger Ryan, 2 vols. (Princeton: Princeton University Press, 1993), 2:153; Gracián, 73; Valdivielso, 152-53; Maria of Ágreda, 51.
145. Gracián, 73.
146. Filas, *St. Joseph and Daily Christian Living,* 52; Foster, 75; O'Carroll, 207.
147. Valdivielso, 153.
148. Pacheco, 2:229.
149. Madeleine S. Miller and J. Lane Miller, *Harper's Bible Dictionary,* 6th ed. (New York: Harper & Brothers, 1959), 619-20; John L. McKenzie, *Dictionary of the Bible* (Milwaukee: Bruce Publishing Company, 1965), 777-78, 845.

authorized eleven canonical coronations, ten of which took place in Mexico, e.g., Puebla (1788), Oaxaca (1788, 1789), Chipala (1789), San Luis Potosí (1789), Zacatecas (1790), Mexico City (1790), and Salvatierra (1790). Sometimes a city had two coronations in a single year, e.g., Oaxaca in 1789 and Zacatecas in 1790. In 1874-1875, another canonical coronation of Joseph took place in Mexico, in the Church of the Holy Family, entrusted to the Missionaries of St. Joseph, in Mexico City. From 1779 to 1963, the Holy See has authorized a total of thirty-two canonical coronations of images of Joseph in the following countries: Argentina, Belgium, Canada, Colombia, France, Great Britain, Italy, Malta, Mexico, Poland, Spain, and the United States. The rite of canonical coronation is carried out with great public pomp and ceremony.[184]

The custom of portraying the crowned Joseph was well established in Golden-Age Spanish and Colonial Mexican painting prior to these canonical coronations of the saint's image. For example, Salcedo's and Cabrera's paintings antedate the coronations that were celebrated in late eighteenth-century Mexico. Nonetheless, these artists may have been familiar with crowned statues of Joseph venerated by religious Orders, such as the Discalced Carmelites. Undoubtedly, canonically crowned images increased the popularity of this manner of depicting Joseph that is commonplace in Mexican devotional *retablos*. It is noteworthy that Vergara y Caicedo, whose petition set into motion the process that resulted in the first canonical coronation of a statue of the saint, also had a silver crown placed on a painting of Joseph, as well as commissioned an oil painting of the crowned Joseph for his own home.[185]

A variety of meanings are assigned to Joseph's attribute of the crown in connection with these canonical coronations. Among the reasons for crowning Joseph's statue that Vergara y Caicedo enumerated in his petition to the archbishop of Santa Fe de Bogotá were the following: the great devotion and cult rendered to this image; Joseph's royal descent from the house and family of David (Luke 2:4); and Joseph's right by marriage to share his wife's royal title and privileges.[186] Other meanings may be added to these. When on July 24, 1872, the bishop of Ghent crowned, with the permission of Pius IX, the statue of Joseph in the church of the Discalced Carmelite nuns of the same city, he specified in his sermon that the crown about to be placed on Joseph's head signified three things. First, it is a crown of glory that symbolizes the eternal glory that is Joseph's inheritance in the heavenly mansions. Second, for the faithful, it is a crown of recognition, an emblem of gratitude for the countless favors that Joseph has bestowed upon the Flemish people and Church. Finally, it is a ceaseless supplication and ardent prayer that Joseph will always be mindful of the needs

150. In this connection, Joseph of Egypt was considered a type of Joseph of Nazareth. The basis for this comparison was that just as Pharaoh put Joseph of Egypt in charge of his palace and kingdom (Genesis 41:39-41), God made Joseph of Nazareth the protector and lord of His house and family. See Gracián, 103; Filas, *The Man Nearest to Christ*, 173.
151. Mayer, 165.
152. Gracián, 95; Filas, *The Man Nearest to Christ*, 171; John Paul II, *Guardian of the Redeemer*, 31 (section 20).
153. Mâle, 318-19; Foster, 75-76; Louis Réau, *Iconographie de l'art chrétien*, 3 vols. (vol. 1, Introduction Générale; vol. 2, Iconographie de la Bible: part 1, Ancien Testament, part 2, Nouveau Testament; vol. 3, Iconographie des saints: part 1, A-F, part 2, G-O, part 3, P-Z, Répertoires) (Paris: Presses Universitaires de France, 1955-59), vol. 2, part 2, 172, and vol. 3, part 2, 757.
154. Quoted in Mâle, 355; Sebastián, *El barroco iberoamericano*, 133.
155. Ferguson, 33-34, 127; Réau, vol. 3, part 2, 757; Foster, 76.

and hopes of the faithful.[187] More recently, the Discalced Carmelite friar Isidoro de San José has pointed out that it is appropriate that Joseph be crowned, because he is the earthly father of the King of Heaven and earth and the husband of the Queen of the universe, and, in these roles, he cooperated with them in the work of redemption. According to Father Isidoro, canonical coronation is, on the part of the Church, an official recognition of popular piety and devotion to an image of Joseph, a way of exalting this saint, and a stimulus for invoking his intercession, honoring him, and better imitating him.[188] The significance of Joseph's crown, as explained by a late eighteenth-century Colombian layman, a Belgian bishop of the second half of the nineteenth century, and a Discalced Carmelite friar of our era, offers a valuable insight into some of the connotations that this attribute had at the level of popular piety.

(2) FULL-LENGTH FIGURE IN AN INTERIOR WITH DRAPERY AND TABLE

In his book *Landscapes of the Sacred: Geography and Narrative in American Spirituality*, Belden C. Lane points out that the Baroque spirituality and religious art of France and New France "breathed the same air of sovereign grandeur" as the court of Louis XIV, with its cult of majesty.[189] For example, images of royal majesty and sovereignty were used to speak of and to portray Jesus and Mary. Jesus was imaged as a Child King, and Mary as Queen of Heaven, exquisitely dressed and wearing a crown of jewels and gold.[190] Barbara von Barghahn has documented that a similar phenomenon is observable in Spain and in New Spain, specifically in the iconography of the Virgin Mary and of St. Joseph.[191] This is evident in Joseph's attribute of the crown. However, nowhere does the image of this saint assume the aura of regal majesty as when Joseph is represented as a full-length standing figure in an interior with crimson and gold drapery and a table covered with cloth of the same colors, on which rests a book, vase of flowers, fruit, or carpenter's tools (Plates 14, 15, 16, 17).

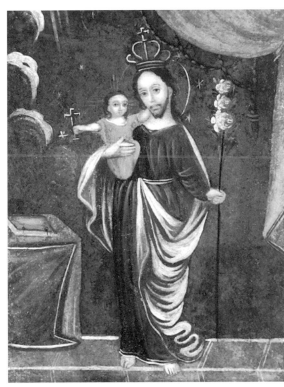

Plate 14.
St. Joseph with the Christ Child,
Mexico,
19th c.
Private Collection.
(Photo: Jeffrey Blake)

156. See Pál Kelemen, *Peruvian Colonial Painting: A Special Exhibition* (New York: The Brooklyn Museum, 1972), Catalogue 2, 9.
157. John Paul II, *Guardian of the Redeemer*, 29-32 (sections 19-20); Paul Molinari, S.J., and Anne Hennessy, C.S.J., *The Vocation and Mission of Joseph & Mary* (Dublin: Veritas Publications, 1992), 10-20; Ben Witherington, III, "Birth of Jesus," in *Dictionary of Jesus and the Gospels*, edited by Joel B. Green and Scot McKnight (Leicester, England: InterVarsity Press, 1992), 60-74, especially 62.
158. Filas, *The Man Nearest to Christ*, 25-35; O'Carroll, 359.
159. Gracián, 206.
160. Maria of Ágreda, 233-34. Cf. Réau, 755-56.
161. See Gracián, 162.
162. Mâle, 318-19.

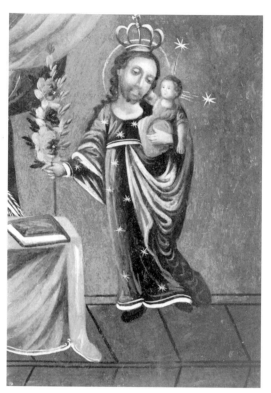

Plate 15.
St. Joseph
with the
Christ Child,
Mexico,
19th c.
Private Collection.
(Photo: Jeffrey Blake)

The prototype for this image of Joseph was Hapsburg royal portraiture. Many Spanish court portraits present the figure of the sovereign standing beside a table that often is draped in the colors of the Hapsburg kings, crimson and gold. This appointment is an emblem for the priestly role of the king as communicator of Christian ideology and defender of Catholic principles. In "dynastic" portraits, the table also drew an analogy between the king's consecration of his heir to God and Joseph's presentation of Jesus in the Temple in Jerusalem in accord with the prescription of the Mosaic law that every first-born son was to be consecrated to the Lord (Luke 2:22-24; Exodus 13:12). Numerous eighteenth- and nineteenth-century Mexican paintings portray the crowned figure of Joseph, holding the Christ Child and standing next to a table covered in the crimson and gold of the Hapsburg kings. This composition, which evokes the royal portrait, may be a legacy of the custom of blending the image of the Spanish king with that of the earthly father of Christ.[192]

Occasionally, the drapery and/or table covering is of colors other than crimson and gold. For example, in a *retablo* of Joseph illustrated in the catalogue of a recent exhibition, the drapery is green (one of the saint's particular colors) and gold, while the table cover is crimson and gold (Redlands, California, Collection of Joe and Rae Neumen).[193] Another color that appears, also with gold, is royal blue (Plate 17). (Joseph's monogram adorns the front of the table cloth.) While crimson and gold are the colors of the Hapsburg kings, blue and silver are those of the Hapsburg queens.[194] It is likely that this combination of blue and gold alludes to Joseph's role as husband of the Virgin Mary, who is the Queen of Heaven.

There are other elements of this *retablo* representation that require explanation. It has already been noted that the crowned Joseph may connote his exercise of the ministry of Dominions in his role as head of the Holy Family. Other angelic ministries are also suggested by these portraits. Joseph's holding the Christ Child, as he also does in the half-length figures, may allude to his ministry as Throne. When a book rests on the table beside Joseph,

163 Salcedo's painting is illustrated in Gabrielle Palmer and Donna Pierce, *Cambios: The Spirit of Transformation in Spanish Colonial Art* (Santa Barbara: Santa Barbara Museum of Art/Albuquerque: University of New Mexico Press, 1992), 92.

164. Pierce in *Cambios*, 93.

165. Wilson, "St. Teresa of Ávila's Holy Patron," 11.

166. Wilson, "St. Teresa of Ávila's Holy Patron," 14.

167. This information is drawn from the commentary, prepared by Barbara von Barghahn in March 1993, on this painting. This commentary is on file in the archives of Saint Joseph's University, Philadelphia. On Gamarra, also see José de Mesa and Teresa Gisbert, *Gregorio Gamarra* (La Paz, 1962), *Holguín y la pintura virreinal en Bolivia* (La Paz: Editorial Juventud, 1977), 231-40, and *Historia de la pintura cuzqueña*, 2 vols. (Lima: Fundación Augusto Wiese, 1962 and 1982), 1:69-70; Damián Bayón and Murillo Marx, *History of South American Colonial Art and Architecture*, translated by Jennifer A. Blankley, Angela P. Hall, and Richard L. Rees (New York: Rizzoli, 1992), 107, 245.

the saint's affinity with the Cherubim is highlighted. Gracián indicates that Joseph was like the Cherubim in two ways. First, as we have already seen, Joseph was akin to the Cherubim, who guarded Eden after the Fall, in that he was the guardian of the earthly paradise of the Virgin Mary. Secondly, Cherubim contemplate "the ineffable secrets of eternal wisdom," and Joseph was "wise in the things of God" by virtue of his practice of contemplation.[195] Joseph's attribute of the book represents the latter manner in which the saint shared in the ministry of the Cherubim, who are often depicted in art holding books.[196] This interpretation is corroborated by the presence of clouds, symbolic of divine wisdom, that frequently appear in this particular *retablo* representation of Joseph.[197] The clouds also signal the breakthrough of Heaven to earth and a theophany, as Joseph presents the God-Child to the viewer.[198] The dove of the Holy Spirit sometimes appears in this genre, alluding to the apocryphal legend of Joseph's divine election as husband of the Virgin and to his special relationship with the Holy Spirit, a topic discussed in detail below.

Among the objects found on the table in these images are a book, vase of flowers, fruit, or carpenter's tools. The significance of the book has just been explained; that of the fruit, as already expounded, is Christo-Mariological. Like the flower garlands in Colonial Mexican paintings, the vase of flowers may function on several levels: devotional, in that it emphasizes the importance of the image as an object of veneration and may reflect the custom of placing flowers before sacred images on feast and holy days; symbolic, in that it connotes the paradisal theme; and decorative, in that it enhances and balances the composition. The carpenter's tools refer to Joseph's trade as a carpenter, the means whereby he supported Jesus and Mary.

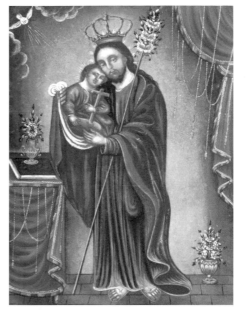

Plate 16.
*St. Joseph
with the
Christ Child,
Mexico,
19th c.*
Philadelphia,
Saint Joseph's
University
Collection.
(Photo: Jeffrey Blake)

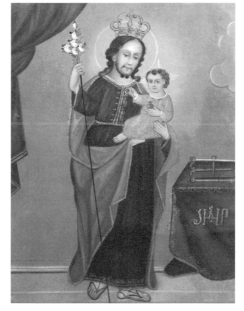

Plate 17.
*St. Joseph
with the
Christ Child,
Mexico,
19th c.*
Private Collection.
(Photo: Jeffrey Blake)

168. See David Freedberg, "The Origins and Rise of the Flemish Madonnas in Flower Garlands: Decoration and Devotion," *Münchner Jahrbuch der Bildenden Kunst* 32 (1981): 115-50. Also see Pamela M. Jones, *Federico Borromeo and the Ambrosiana: Art Patronage and Reform in Seventeenth-Century Milan* (New York: Cambridge University Press, 1993), 84-87. The influence of these Flemish compositions on Colonial Andean painting has been noted by Mesa and Gisbert, 1:289.
169. Freedberg, passim.
170. *The Reality of Symbols: Studies in the Iconology of Netherlandish Art 1400-1800* (The Hague: Gary Schwartz/SDU Publishers, 1990), 93.
171. *Collected Works of St. Teresa of Ávila*, 1:225-26.
172. cf. Valdivielso, 217.
173. *The Spiritual Conferences of St. Francis de Sales*, translated by F. Aidan Gasquet, O.S.B., and Henry Benedict Mackey, O.S.B. (1906; Westminster, Maryland: Newman Press, 1962), 53.

(3) FULL-LENGTH FIGURE HOLDING OR WALKING WITH THE CHRIST CHILD IN A LANDSCAPE

Plate 18.
Engraving from
Jerónimo
Gracián de la
Madre de Dios,
*Sommario
dell'eccellence
del glorioso
S. Josef
sposo della
Vergine Maria*
(Rome:
Luigi Zannetti,
1597).

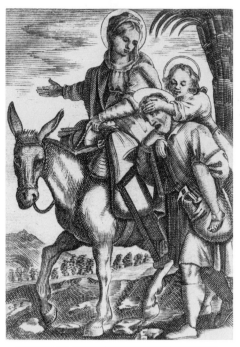

Plate 19.
Engraving from the
title-page of
José de Valdivielso,
*Vida, excelencias
y muerte del
gloriosísimo
Patriarca y esposo
de nuestra Señora
San Joseph*
(Alcalá?:
Baptista López,
1612).

References to Joseph carrying or walking with Jesus on the various journeys made by the Holy Family are frequent in devotional literature on the saint. Apropos of these journeys, Gracián explains: "And if they came upon some flat space or level and dry ground, Joseph would let the Child walk holding His hand; when Joseph saw that Jesus was tired or when they were on rocky ground and near a mud hole, he would carry Him on his shoulders, thus becoming a divine Atlas, and with no little fatigue and labor, Joseph would walk with this divine cargo."[199] Gracián also describes how Joseph carried Jesus in his arms: "When St. Joseph would enter a place with the Christ Child in his arms, all Heaven would become a window, with the angels in awe at God being carried in the arms of a carpenter and at such great humility on the part of the Creator and so great a favor bestowed on a creature."[200]

In Greek mythology, Atlas was a Titan who was forced by Zeus to support the Heavens on his shoulders. Like Gracián, Valdivielso regards Joseph as a new and divine Atlas because he supports God, who sustains Heaven and earth, holds Him in his arms, and carries Him on his shoulders.[201] Valdivielso also refers to Joseph walking with Jesus, while holding His hand.[202] Certain editions of the works of Gracián and Valdivielso may have also served as artistic sources for representations of Joseph carrying or walking with the Christ Child. For example, the 1597 Spanish and Italian editions of the *Summary* are illustrated with an engraving showing Joseph carrying the boy Jesus on his shoulders (Plate 18). The inscription beneath the image reads: *Athlas, dux, custos gestat, regit atque tuetur coelum humeris, matrem voce, et utrumque fide*, "Atlas, leader, guardian carries, rules, and protects Heaven (God) on his shoulders, His mother by his voice, and both by his faith." An

174. Davies, "El Greco and the Spiritual Reform Movements in Spain," 67, and "The Relationship of El Greco's Altarpieces to the Mass of the Roman Rite," 228.
175. Mâle, 320; Réau, 759.
176. Harold E. Wethey, *Alonso Cano: Painter, Sculptor, Architect* (Princeton: Princeton University Press, 1955), Figure 101; Edward J. Sullivan in Edward J. Sullivan et al., *Painting in Spain 1650-1700 from North American Collections* (Princeton: The Art Museum, Princeton University, 1982), 71-72, Catalogue 14; Edward J. Sullivan, *Baroque Painting in Madrid: The Contribution of Claudio Coello, with a Catalogue Raisonné of His Works* (Columbia: University of Missouri Press, 1986), 111.
177. Gracián, 206, 213.
178. Gracián, 194.
179. Ferguson, 97.
180. Valdivielso, 162.

important engraving also appears on the title-page of the 1612 (Alcalá?) edition of Valdivielso's poem: in a landscape, Joseph walks with the boy Jesus, who carries a basket, holding His hand (Plate 19). These literary and artistic sources must have contributed to the popularity of the subject of Joseph holding or walking with the Christ Child in a landscape in Golden-Age and Colonial Spanish art.

Plate 20. Juan Correa (Mexico), *St. Joseph Walking with the Christ Child*, 18th c. Querétaro, Museo Regional.

In the mid-1630s, Zurbarán painted *St. Joseph Walking with the Child Jesus* (ca. 1636, Paris, Saint-Medard) for the high altar of the church of the monastery of the Discalced Mercedarians in Seville.[203] Several decades later, Murillo painted *St. Joseph Walking with the Christ Child* (ca. 1670, Lima, Peru, Monastery of the Discalced Franciscans), which was exported to the New World. Many copies were made of this particular painting, thus contributing to the subject's popularity in the Andean region.[204] Prior to Murillo, Alonso Cano (1601-1667) did a pen and wash drawing of this subject that is now in the Prado Museum.[205]

Variations on this portrayal of Joseph became extremely popular in the Spanish colonies. One of the oldest surviving examples is the Italian Jesuit artist José Avitavilli's *St. Joseph Walking with the Christ Child and St. Catherine of Alexandria* (ca. 1597, Cuzco, Convento de la Recoleta).[206] Avitavilli arrived in Peru in the early 1590s and was a pupil of Bitti. This painting, contemporaneous with El Greco's *St. Joseph and the Christ Child* (Plate 2), is thought to be a copy of an earlier composition which Bitti painted in 1595 for the college of the Society of Jesus in Cuzco, at the request of the Jesuit Manuel Vázquez.[207] Another outstanding Andean example of this subject is an eighteenth-century School of Cuzco *St. Joseph Walking with the Christ Child* (Plate 3) that follows the iconography of Murillo's painting in Lima, but reveals that the European Baroque tendency towards naturalism, correct anatomy, and perspective was less important than the creation of brilliantly colored, monumental figures strolling through a beautiful paradisal landscape.[208]

This subject also enjoyed great popularity in Mexico. Juan Correa's *St. Joseph Walking with the Christ Child* is an outstanding example of this genre (Plate 20). In a lush paradisal landscape, the majestic figure of Joseph looks lovingly at the Christ Child, who carries a basket and whose hand the saint holds. Overhead putti bear two of the *arma Christi* (the weapons with which Christ conquered sin and death), the cross and the crown of thorns.

181. Valdivielso, 243. On the question of Joseph's assumption, see Filas, *Joseph Most Just*, 70-77, and *St Joseph and Daily Christian Living*, 170-71. Joseph's assumption was put forth as a probable theological opinion, on the basis of fitness or appropriateness, by Gerson, Bernardine of Siena, Francisco Suárez, Gracián, Valdivielso, and Francis de Sales.
182. Quoted in Filas, *The Man Nearest to Christ*, 165.
183. Fortunato de Jesús Sacramentado, "San José en el Carmen Descalzo español en su primer siglo," 369; Isidoro de San José, O.C.D., "Las coronaciones canónigas de las imágenes de San José," *Estudios Josefinos* 18, nos. 34-35 (1963-64): 893-905.
184. Isidoro de San José, 895-98; Carrillo Ojeda, "Presencia de San José en México en el siglo XVIII," 638-39; León de San Joaquín, 233-41. The text of the rite of canonical coronation of an image of Joseph may be found in Isidoro de San José, 904-905.
185. Isidoro de San José, 895.
186. Isidoro de San José, 900.
187. León de San Joaquín, 241.

Plate 21.
St. Joseph
Walking
with the
Christ Child,
ca. 1800,
engraving.

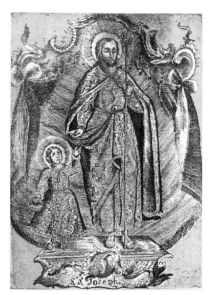

Another Mexican example is a late eighteenth- or early nineteenth-century copper engraving of a statue of St. Joseph walking with the Christ Child (Plate 21).

Images of Joseph walking with Jesus while holding His hand, as well as of the saint holding the Christ Child in his arms, also evoke another of his angelic ministries, namely, his role as Jesus' Guardian Angel. Concerning Joseph's exercise of this ministry, Gracián explains: "The principal office of Angels, which is the lowest choir, is to guard human beings, according to these words of the psalmist: 'For to His angels He has given command about you, that they guard you in all your ways; upon their hands they shall bear you up, lest you dash your foot against a stone' (Psalm 91:11-12). Learned authors say that Jesus had no Guardian Angel but many angels who served and ministered to Him, and that the office of Jesus' Guardian Angel was entrusted to St. Joseph."[209] Among the many ways that Gracián specifies that Joseph fulfilled this ministry was that he carried Jesus in his arms and on his shoulders on journeys, so that He would not stumble or hurt His foot on a stone, and that "if they came upon some flat space or level and dry ground, Joseph would let the Child walk holding His hand."[210] Devotion to the Guardian Angels became popular during the Counter-Reformation. An iconographic formula for representing the Guardian Angel was developed from earlier images of the Archangel Raphael accompanying the young Tobias: a beautiful angel leading a child by the hand or wrist.[211] This is precisely the manner, in Golden-Age and Colonial Spanish art, in which Joseph was usually shown walking with the Christ Child.[212]

Mexican devotional *retablos* sometimes show the full-length figure of Joseph, often crowned, holding the Christ Child and his attribute of the flowering staff, standing outdoors. With his cloak or another piece of fabric draped over his arm, Joseph makes what is in effect a throne for Jesus, thus exercising the angelic ministry of Thrones (Catalogue 31; Plate 22).[213] Joseph and Jesus may stand on the top of a mountain or in a landscape that includes greenery, flowers, mountains, and/or the ocean (Catalogue 33; Plate 22). These settings recall the earthly paradise, which, according to Christian tradition, was located high on a mountain.[214] The landscape of these *retablos* highlights Joseph's role in the restoration of paradise, a point that is underscored by the flowers that occasionally adorn the saint's robe. The practice of

188. Isidoro de San José, 902-903.
189. (New York: Paulist Press, 1988), 87.
190. Lane, 88-89. Lane notes that even the titles of spiritual works in this era disclose the prevalence of these motifs. The examples he cites are works on Christ and the Virgin (87-88). The same tendency is also evident in works on Joseph: see, e.g., Gauthier, "Joseph (saint) dans l'histoire de la spiritualité," 1311-12. The language of royalty and majesty also pervades Spanish spirituality of the period, as the works of St. Ignatius Loyola and Teresa of Ávila attest. See *The Spiritual Exercises of St. Ignatius*, translated by Louis J. Puhl, S.J. (Westminster, Maryland: Newman Press, 1951), 43-45; Nicole Pélisson "Les noms divins dans l'oeuvre de Sainte Thérèse de Jésus," in Robert Ricard and Nicole Pélisson, *Études sur Sainte Thérèse* (Paris: Centre de Recherches Hispaniques, n.d.), 57-197, especially 169-74.
191. "Imaging the Cosmic Goddess: Sacred Legends and Metaphors for Majesty," in *Temples of Gold, Crowns of Silver: Reflections of Majesty in the Viceregal Americas*, edited by Barbara von Barghahn (Washington, D.C.: George Washington University, 1991), 93-115, and "From Prince to Sun King," 31-39.

decorating Joseph's clothing with flowers is derived from portrayals of the saint in Colonial Mexican paintings, such as Villalpando's *The Vision of St. Teresa* (Plate 11). Sometimes there are clouds above and around Joseph and Jesus, emphasizing, as already explained, divine wisdom, the breakthrough of Heaven to earth, and theophany.

Retablo images of Joseph walking with the Christ Child are rare. However, one such representation, entitled *St. Joseph Walking with the Holy Child of Atocha*, blends tradition and innovation (Plate 23). Joseph's iconography is traditional. However, the Christ Child is depicted, not in the usual manner, but as *El Santo Niño de Atocha*, "The Holy Child of Atocha," i.e., with a brimmed hat with a plume and carrying a basket of flowers. The source for this image is a legend that dates to the period of the Moorish occupation of Spain (711-1492). In the town of Atocha, the Moors imprisoned many Christians, and all persons, with the exception of little children, were forbidden to enter the prison on errands of mercy. The mothers and wives of the prisoners prayed incessantly for their loved ones, knowing that they lacked sufficient food and water. One day a child, dressed like pilgrims of that era, entered the prison. In one hand, he carried a basket, and, in the other, a staff with a gourd full of water at its tip. To the Moors' astonishment, even after all the prisoners had been served (and blessed) by the child, the basket and gourd were still full. The child was Christ Himself, who came in answer to the prayers of the women of Atocha. During the Colonial era, this advocation of the Christ Child was exported to Mexico, where a famous shrine was established in Plateros, near Fresnillo, in Zacatecas.[215]

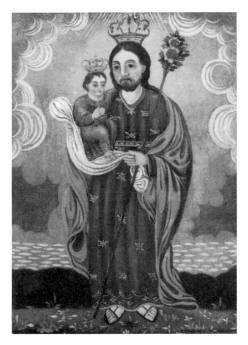

Plate 22.
St. Joseph Holding the Christ Child in a Landscape, Mexico, 19th c. Private Collection. (Photo: Jeffrey Blake)

Plate 23.
St. Joseph Walking with the Holy Child of Atocha, Mexico, 19th c. Private Collection.

192. von Barghahn, "From Prince to Sun King," 32. Cf. Giffords' remarks on the "grand manner" setting of some *retablos santos*: *Mexican Folk Retablos*, 7.
193. *The Art of Private Devotion*, 29.
194. Barbara von Barghahn kindly shared this information with me.
195. Quoted in Chorpenning, 62, note 65; Gracián, 195.
196. Ferguson, 97.
197. This is the meaning assigned to clouds in Cesare Ripa's *Iconologia*, a sourcebook for symbolism used by Renaissance and Baroque painters: see Hibbard, 102, note 69.
198. Frederick Hartt, *Love in Baroque Art* (Locust Valley, New York: J. J. Augustin, 1964), 5-6; Pierce, "New Spain," in *Cambios*, 74-83, especially 80.
199. Gracián, 191.

A palm tree, another of Joseph's attributes, is in the background of this *retablo*. The Gospel of Matthew describes Joseph as a "just man" (1:19). In the introit or entrance antiphon for the Mass of his feast day, taken from Psalm 92:13, an equivalence is established between Joseph the just man and the palm tree: "The just man shall flourish like the palm tree." This equation was explored by devotional writers like Francis de Sales, whose writings enjoyed considerable popularity in Colonial Mexico.[216] On the basis of ideas about the palm found in the writings on natural history of Aristotle, Pliny, and other classical authors, Francis demonstrates, in a sermon preached on the feast of St. Joseph in 1622, that the saint and the palm share in common the virtues of virginity, humility, courage, constancy, and strength.[217]

The dove of the Holy Spirit appears in the *retablo*'s upper left corner. This probably alludes to the legend in the apocryphal gospels about Joseph's staff blossoming with flowers and the dove of the Holy Spirit appearing over him to signal his divine election as husband of the Virgin Mary. Later devotional authors believed that there was a special relationship between Joseph and the Holy Spirit. Following Isidore of Isolanis, Gracián demonstrated that Joseph was the recipient of the seven gifts of the Holy Spirit.[218] Valdivielso calls Joseph "the viceparaclete" and "shadow" of the Holy Spirit.[219] Although the Incarnation was the "work" of all three persons of the blessed Trinity, it is especially attributed to the Holy Spirit (Luke 1:35). As husband of Mary and putative father of Jesus, Joseph safeguarded the honor of Mary and of the Holy Spirit. Valdivielso further explains Joseph's role as viceparaclete and shadow of the Holy Spirit by applying to him the functions attributed to the third person of the Trinity in the medieval hymn *Veni Sancte Spiritus*, which is sung as the Sequence during the liturgy of the Word on Pentecost. Joseph is the "comforter" of the newborn Son of God, who trembled from the cold. He is the "gift of God" given to Mary and Jesus as the shadow of the mystery of the Incarnation. With respect to Jesus and Mary, Joseph brings "ease" in toil and "sweet refreshment" in weariness. The saint is "the soul's most welcome guest" who lodges the King of Heaven, and the "father of the poor" who shelters Mary and Jesus in his home and in his heart.[220]

Sor Juana Inés de la Cruz (1648-1695), the premier female author of Mexican letters, synthesizes these topoi in a sonnet to the saint. This poem was composed for a literary competition, which required contestants to employ the following comparisons: the rose as the Virgin Mary, a bee as Jesus Christ, and a palm tree as the Holy Spirit and as St. Joseph. Sor Juana draws on an idea found in the writings of Pliny, Aristotle, and Virgil as the basis for

200. Gracián, 113.
201. Valdivielso, 140, 193, 219, 223.
202. Valdivielso, 217, 219.
203. Wilson, "St. Teresa of Ávila's Holy Patron," 11.
204. Wilson, "St. Teresa of Ávila's Holy Patron," 14. Also see Gisbert and Mesa, 1:117.
205. Wethey, 9, Figure 5.
206. For a discussion of the circumstances in which this painting was executed and of its iconography, see Wilson, "St. Teresa of Ávila's Holy Patron," 13-14.
207. Mesa and Gisbert, 1: 62, 66.
208. Wilson, "St. Teresa of Ávila's Holy Patron," 14.
209. Gracián, 190.

her poem. According to these authors, bees were generated from flowers. Sor Juana's sonnet begins with the story of how a gallant palm tree offers the protection of its shade to a bee that has just been given birth by a dew-drenched rose. Next, she expounds her allegory. The rose is Mary, who conceives Jesus. When the Child begins to grow within her womb, Joseph becomes suspicious, and the shadow of the Holy Spirit shields the Virgin from suspicion. When Herod intends to do the Christ Child harm, the shadow of Joseph protects Him.[221] This *retablo* images the themes of Joseph as the palm tree that shades and protects the Christ Child and of the saint's special relationship with the Holy Spirit.

(4) JOSEPH AND THE CHRIST CHILD, WITH CARPENTER'S BENCH AND TOOLS

Plate 24.
St. Joseph with the Christ Child, Mexico, 19th c. Private Collection.
(Photo: Edna A. Martin)

Retablos of Joseph with the Christ Child in arms and the saint's attributes of a carpenter's bench and tools may be set either indoors or outdoors (Catalogue 32; Plate 24).[222] The foremost example of this subject in Golden-Age Spanish art is Alonso Cano's *St. Joseph with the Infant Christ* (ca. 1645, Madrid, Gullón Collection).[223] Cano's representation was also disseminated by an engraving based on this painting, such as the one that appears as the frontispiece of the 1780 Madrid edition of Gracián's *Summary* (Plate 25). The attribute of the carpenter's bench and tools also appears in three drawings of Joseph and the Christ Child by Vicente Salvador Gómez (ca. 1637-ca. 1680).[224]

The Gospels indicate that during His adult life, Jesus was referred to as "the carpenter's son" (Matthew 13:55; cf. Mark 6:3), thereby making known Joseph's means of livelihood. This is the reason that, since the Middle Ages, Joseph has been regarded as patron of carpenters and all manual workers.[225] It is to this aspect of the saint's life and patronage that the attributes of the carpenter's bench and tools draw attention. However, these attributes also have a deeper spiritual meaning: they reveal the special relationship that existed between Joseph of Nazareth and God the Father.

Many Fathers of the Church and later theologians believed that Joseph the earthly artisan was the image of God the Father, the heavenly maker of all things. This view was

210. Gracián, 191.
211. Mâle, 305-306; Knipping, 1:126-27.
212. Cf. Réau, 757.
213. cf. Gracián, 195; Valdivielso, 221.
214. Giamatti, 56, 80.
215. Giffords, *Mexican Folk Retablos*, 24, and *The Art of Private Devotion*, 91; Steele, 109.
216. See Winifred Corrigan, "The Bishop and the Woman: 'Sor Filotea' and Sor Juana Inés de la Cruz," *Studia Mystica* 15, nos. 2 & 3 (Summer/Fall 1992), 71-84.
217. Joseph F. Chorpenning, O.S.F.S., "Just Man, Husband of Mary, and Guardian of Christ: St. Joseph's Life and Virtues in the Spirituality of St. Francis de Sales," in *Patron Saint of the New World*, 19-29, especially 21-25.
218. Gracián, 169-76.

Plate 25.
Engraving after
Alonso Cano
from the
title-page of
Jerónimo Gracián,
La Josefina
(Madrid:
Antonio
de Sancha,
1780).

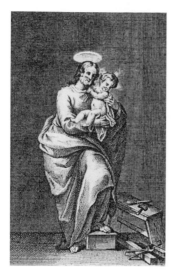

Plate 26.
Engraving
from Gracián,
*Sommario
dell'eccellence
del glorioso
S. Josef
sposo della
Vergine Maria.*

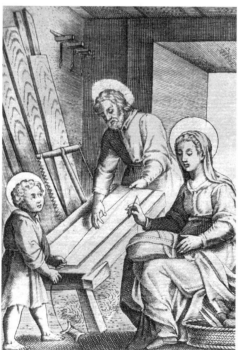

held by, among others, St. Hilary (ca. 315-367), St. Ambrose (339-397), St. Maximus of Turin (ca. 380-ca. 470), St. Peter Chrysologus (ca. 400-ca. 450), St. Bede the Venerable (ca. 673-735), Rabanus Maurus (ca. 784-856), St. Thomas Aquinas (1225-1274), and Isidore of Isolanis.[226] Gracián sets forth this idea in his *Summary*. For the Carmelite friar, Joseph's exercise of the trade of carpentry expresses a "most sublime mystery."[227] God the Father was the first to practice the trade of carpentry when He created the universe. Now, as the new creation is being brought into existence by His Son Jesus Christ, Joseph "a mature and experienced carpenter" is chosen as "the advisor for the building of the Church," to help "to draw up the model, plans, and design of the new Jerusalem."[228]

This affinity between God the Father and Joseph is poignantly expressed in one of the engravings that appears in the 1597 *editio princeps* and Italian translation of the *Summary* (Plate 26). While the Virgin Mary works at her sewing, the Child Jesus helps Joseph with his carpenter's work. The inscription beneath the engraving makes its meaning clear: *Terrarum caelique, faber pater unus Iesu est. Ecce pater Ch(rist)i nunc faber alter adest*, "The Artisan of lands and sky is the one Father of Jesus. Behold, the father of Christ, another artisan is here present!" Salvador Gómez's drawings dramatically draw attention to this same idea. In all three, the carpenter's bench and tools appear at the right. In two of the drawings, God the Father from above views Joseph holding or adoring the Christ Child; in a third, God the Father from on high entrusts the Infant Christ to the open arms of the saint.[229]

(5) THE HOLY FAMILY

Paintings and prints of the subject technically known as "The Heavenly and Earthly Trinities" are the prototype for *retablos* of the Holy Family.[230] It has been suggested that

219. Valdivielso, 139, 229, respectively.
220. Valdivielso, 229; Herrán, "El 'Maestro' José de Valdivielso," 479-80. On this hymn, see Michael O'Carroll, C.S.Sp., *Veni Creator Spiritus: A Theological Encyclopedia of the Holy Spirit* (Collegeville: Liturgical Press, 1990), 227-28.
221. Fernando Martín del Campo, M.J., "Sor Juana Inés de la Cruz nos habla de San José," *Cahiers de Joséphologie* 29 (1981): 489-534, especially 491-93.
222. Also see Giffords, *The Art of Private Devotion*, 113-14; *Images of Faith*, 27.
223. Wethey, 169-70, Figure 71.
224. Gridley McKim Smith, *Spanish Baroque Drawings in North American Collections* (University of Kansas Museum of Art, 1974), 64-65, Plates 13, 14, Catalogue 39.
225. Filas, *The Man Nearest to Christ*, 117; Keith P. Luria, "The Counter-Reformation and Popular Spirituality," in *Christian Spirituality: Post-Reformation and Modern*, edited by Louis Dupré and Don E. Saliers, World Spirituality: An Encyclopedic History of the Religious Quest, vol. 18 (New York: Crossroad, 1989), 93-120, especially 113-14.

the idea of the Holy Family as an earthly trinity that reflects the blessed Trinity in Heaven originated with St. Augustine (354-430);[231] however, from the time of Augustine, the word "trinity" was used to refer only to the three divine persons.[232] Gerson is the theologian who is usually credited with the origin of the theme of the two trinities. Until the seventeenth century, the word "family" in Western Europe was understood to mean "extended family," or all those living under the authority of the *paterfamilias*. Gerson chose the word "trinity" to express the concept of the "nuclear family" of Jesus, Mary, and Joseph.[233]

The correspondence between the Holy Family and the blessed Trinity is more than simply numerical. According to Gerson, the common denominator was that each was a community of love, as one of his short poems discloses: *O veneranda trinitas Jesus, Joseph et Maria, quam coniunxit divinitas, Charitatis concordia!* "Oh, venerable trinity Jesus, Joseph and Mary, which divinity has joined, the concord of love!"[234] The theme of the two trinities was disseminated among the faithful by liturgical hymns, devotional literature, and preaching. The following passage from a sermon by the sixteenth-century Augustinian friar Balthasar Boehem serves to illustrate one way in which this theme was presented to the faithful: "Three persons possess the one Jesus as their son: God the Father sent the Divinity of the Son from Heaven; the virgin mother Mary contributed His holy body; and venerable Joseph supported His noble humanity by the work of his hands. This is, so to speak, the all-blessed new trinity which has appeared on this earth—Jesus as son, Mary as mother, and Joseph as father."[235] Numerous seventeenth-century spiritual authors popularized this theme, including Valdivielso, Francis de Sales, the Observant Franciscan Andrés de Soto (1552-1625), and the Oratorian François Bourgoing (1585-1662).[236] This theme not only draws out the profound theological significance of the life of the Holy Family, but also highlights Joseph's privileges.[237]

Fray Pedro de Gante may have been familiar with the theme of the two trinities and introduced it to the Americas. Another missionary who certainly played a pivotal role in this theme's dissemination in New Spain was the Spanish Jesuit Pedro Morales (ca. 1537-1614). Sent as a missionary to Mexico in 1576, he taught moral theology and canon law at the Jesuit college in Puebla, where he served four terms as rector.[238] In his *Commentary on the First Chapter of Matthew's Gospel,*

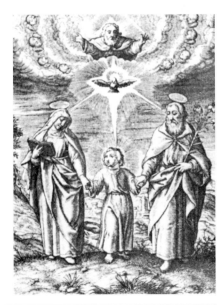

Plate 27. Christopher van Sichem after Hieronymus Wierix, *The Heavenly and Earthly Trinities,* ca. 1620, copper engraving. (Photo: John B. Knipping)

226. Bertrand, "Joseph (saint): Patristique et Haut Moyen Âge," 1307; Hahn, "'Joseph Will Perfect, Mary Enlighten and Jesus Save Thee,'" 58-59, and "Joseph as Ambrose's 'Artisan of the Soul' in the *Holy Family in Egypt* by Albrecht Dürer," *Zeitschrift für Kunstgeschichte,* 47 (1984): 515-22.

227. *Obras de Jerónimo Gracián de la Madre de Dios,* edited by Silverio de Santa Teresa, O.C.D., 3 vols. (Burgos: Monte Carmelo, 1933), 2:412. The Vulgate uses the word *faber* to describe Joseph's trade (Matthew 13:55; Mark 6:3). This was the common name for "craftsman of iron" or blacksmith and for "craftsman of wood" or carpenter. Gracián does not agree with those Fathers of the Church, such as Venerable Bede and St. Isidore of Seville (ca. 560-636), who held that Joseph had been a smith. Rather, Gracián argues that Joseph was a carpenter, supporting his position with the authority of St. Justin Martyr (died ca. 165), Ambrose, Thomas Aquinas, Ludolph of Saxony (ca. 1300-1378), and other theologians (see *Obras,* 2:410-12).

228. *Obras de Jerónimo Gracián de la Madre de Dios,* 2:413; Gracián, 257.

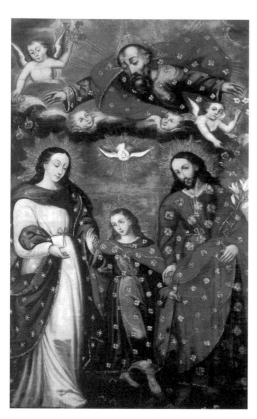

Plate 28.
School of Cuzco
(Peru),
*The Heavenly and
Earthly Trinities,*
18th c.
Philadelphia,
Saint Joseph's
University
Collection.
Gift of
Katherine A.
Hillman '74.
(Photo: Jeffrey Blake)

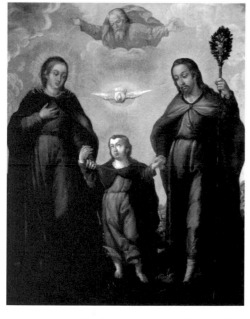

Plate 29.
Juan Correa
(Mexico),
*The Heavenly
and Earthly
Trinities,*
1679.
Private Collection.

published at Lyon in 1614, Morales explains that Christ instituted an earthly trinity that is similar to that in Heaven: "Just as in the heavenly Trinity there are three distinct Persons and only one essence, so also, in this admirable earthly trinity, there are three persons and, with one incomparable love, only one heart and only one soul."[239] Jesus, Mary, and Joseph were so closely united, Morales avers, that Matthew does not even place a comma between their names, and their names have the same number of letters and syllables in Greek. He also indicates various correspondences among Jesus, Mary, and Joseph and the three Persons of the blessed Trinity.[240]

In images of the two trinities, the pictorial space is divided into a heavenly realm, where God the Father, the dove of the Holy Spirit, and angels dwell, and an earthly realm, where the Child Jesus stands in the center, flanked by Mary and Joseph. The vertical and horizontal trinities intersect in the God-Man Jesus, who unites Heaven and earth.[241] Images of this subject were plentiful in Europe and in Colonial Spanish America. An engraving by the Flemish engraver Hieronymus Wierix (ca. 1553-1619) seems to be one of the earliest illustrations of this theme, and probably served as the prototype for subsequent images (Plate 27).[242] Given the vigor and popularity of the devotional tradition of the two trinities, the theme of the Holy Family as the earthly trinity that reflects the heavenly Trinity may have been implicit even in

images in which God the Father and the Holy Spirit are not pictured, such as paintings of *The Return of the Holy Family from Egypt* by Rubens (1613, Hartford, Wadsworth Atheneum) and by Jacob Jordaens (ca. 1615-1616, Providence, Museum of Art, Rhode Island School of Design).[243]

229. An eighteenth-century Mexican oil-on-canvas painting of *St. Joseph and the Christ Child* is similar in composition (although it omits the carpenter's bench and tools) to Salvador Gómez's drawing. God the Father from above views Joseph holding the Christ Child. The painting bears the inscription *Refugium agonizantium,* "Refuge of the Dying." (For an illustration of this painting, see *Churubusco: Colecciones de la Iglesia y Ex-Convento de Nuestra Señora de los Ángeles* [Mexico City: Instituto Nacional de Antropología e Historia, 1981], 59.) This expresses another of Joseph's advocations, patron of the dying. The reason for this patronage is clear: "No man or woman ever had such a privilege as that of dying in the company of Jesus and Mary. No deathbed scene could ever have been attended by witnesses who were more consoling. It has been logical, then, to ask [Joseph] to intercede for us that we, too, might imitate his death by breathing our last in the friendship of Jesus and Mary" (Filas, *St. Joseph and Daily Christian Living,* 125). This advocation was popularized largely through the efforts of the Jesuits. Images of Joseph's peaceful death and of his reception by Jesus in Heaven sought to offer comfort to the dying. See Mâle, 320, 322-25; Réau, vol. 3, part 2, 758-59; Luria, 114.

The premier Spanish example of the subject of the two trinities is Murillo's *Heavenly and Earthly Trinities* (ca. 1640-1645, Stockholm, Nationalmuseum).[244] In the Americas, this theme enjoyed tremendous popularity, both in the Andean region (Plate 28) and in New Spain. There are several outstanding Mexican examples of this subject. Baltasar de Echave Ibía's seventeenth-century oil on wood of *The Holy Family* (Mexico City, Iglesia de la Profesa) presents a graceful interpretation of the theme, with angels holding jewelled crowns over the heads of the Virgin and Joseph and a crown of thorns floating in midair, directly in front of the dove of the Holy Spirit, over the Christ Child.[245] Juan Correa's *Heavenly and Earthly Trinities* of 1679 treats this subject in more conventional terms (Plate 29). The iconography of an early eighteenth-century *Holy Family* by Villalpando (Puebla, Guadalupe Chapel of the Cathedral) is similar to Echave Ibía's painting in that two putti hold jewelled gold crowns over Mary and Joseph, while over the Christ Child and directly in front of the Holy Spirit is a crown of thorns.[246] Interestingly, in this composition crowded with hosts of angels in the background and putti overhead, Villalpando pictures the dove of the Holy Spirit, but not God the Father. In addition to Colonial paintings, engravings and woodcuts provided models for

Plate 30.
The Heavenly and Earthly Trinities,
Mexico, 1819,
woodcut.

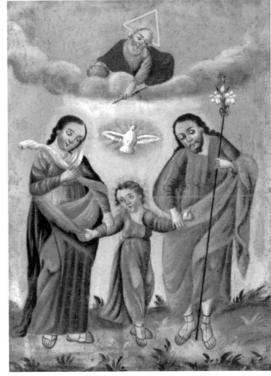

Plate 31.
The Holy Family,
Mexico,
19th c.
Private Collection.
(Photo: Edna A. Martin)

retablo representations of this subject (Plate 30). In continuity with established iconographic tradition, *retablos* depict the subject of the two trinities principally in two ways: first, with God the Father and the dove of the Holy Spirit above the standing figures of Jesus, Mary, and Joseph (Plate 31); and, second, with simply the dove of the Holy Spirit above the standing figures of the Holy Family (Catalogue 44). In either instance, Jesus, Mary, and Joseph exemplify what every family is to make present in human society: a community of life and love that is an earthly counterpart or reflection of the blessed Trinity in Heaven.

230. For an overview of the historical development of the iconography of the Holy Family, see Mâle, 309-313; Réau, vol. 2, part 2, 146-50.
231. Ks. Tadeusz Fitych, "Bernard Rosa, Abbé de Krzeszow, et la dévotion à Saint Joseph," *Cahiers de Joséphologie* 29 (1981): 378-402, especially 399.
232. Irénée Noye, "Famille (Dévotion à la sainte Famille)," *Dictionnaire de spiritualité*, vol. 5 (Paris: Beauchesne, 1964), 84-93, especially 85.
233. Noye, 85.
234. Quoted in Herlihy, 128.
235. Quoted in Filas, *The Man Nearest to Christ*, 53.
236. Noye, 85-86.
237. This is especially observable in Valdivielso, who speaks of Joseph's prenatal sanctification in connection with the saint's participation in the earthly trinity of the Holy Family (140). Herrán ("El 'Maestro' José de Valdivielso," 436) has called attention to this aspect of Valdivielso's poem.

(6) *LA MANO PODEROSA* OR *LOS CINCO SEÑORES*

Another group representation in which Joseph appears is *La Mano Poderosa* or *Los Cinco Señores* (The Powerful Hand or The Five Lords). The *retablo* of this title in The Peters Collection is an exceptionally fine example of this subject (Catalogue 43). The setting is undetermined. A hand bearing the stigmata appears from the midst of clouds. Five figures—Jesus, His parents, and His maternal grandparents—appear above the hand, corresponding to the thumb and four fingers. From left to right, these figures are St. Anne (ear finger), the Virgin Mary (ring finger), the Christ Child (middle finger), St. Joseph (forefinger), and St. Joachim (thumb). From the wound in the hand, blood flows into a chalice, which becomes a fountain whence seven lambs drink. At the left and bottom are the instruments of the Passion or *arma Christi* that represent Jesus' sufferings: the pillar, scourge, lance, rod with sponge attached, nails, and crown of thorns. To these are added the cock, betrayer's black hand, hammer, and pliers.

In *Mexican Folk Retablos*, Giffords explains that this subject is an unidentified allegory. The "blue Franciscan robe clothing the arm" and "the stigmata of St. Francis" lead Giffords to suggest that this subject may have originated with the Franciscan Order. She also notes a similarity between this subject and that of the Eucharistic Man of Sorrows (*El Varón Eucarístico de Dolores*), since occasionally in this theme lambs are pictured at the bottom to catch the precious blood in their mouths.[247] In her subsequent *The Art of Private Devotion*, Giffords traces the symbolism of the Powerful Hand to the introduction of the cult of St. Anne by crusaders returning from the Holy Land, noting that relics of Anne included a hand-shaped, jewelled reliquary known as the Anne-hand. Moreover, through an evolution of ideas, another element was added to this cult, the hand of Christ.[248]

According to Juárez Frías, the Powerful Hand is an allegory of the blood of Christ, and he identifies the hand as that of Christ. His interpretation is corroborated by a *retablo* of *Los Cinco Señores* in which the bleeding Heart of Christ, encircled with the crown of thorns and placed atop a chalice, is substituted for the hand (Zacatecas, Museo Zacatecano). Seven lambs, symbolic of the seven sacraments, drink the blood that flows from the Heart.[249]

Apropos of a sixteenth-century painting *Los Cinco Señores*, attributed to the Master of St. Cecilia, in the cathedral in Mexico City, Amada Martínez Reyes points out that this theme has its roots in late medieval Flemish and German representations of the Virgin Mary's genealogy, known as the Holy Kinship or the Lineage of the Virgin Mary, and in the

238. André Derville, "Morales (Pierre)," *Dictionnaire de spiritualité*, vol. 10 (Paris: Beauchesne, 1980), 1719.
239. Sebastián Bartina, S.J., "Pedro de Morales, S.J., (1538-1614) y su tratado *In caput primum Matthaei*," *Cahiers de Joséphologie* 29 (1981): 85-92, at 91, note 5. Valdivielso also speaks of the union of the hearts of Jesus, Mary, and Joseph (229).
240. Bartina, 91, note 5.
241. Foster, 235.
242. Knipping, 1:114; Nora de Poorter in R.-A. d'Hulst et al., *Jacob Jordaens (1593-1678)*, 2 vols. (Brussels: Gemeentekrediet, 1993), 1:46.
243. This suggestion is made by de Poorter in *Jacob Jordaens*, 1:46. On the Rubens painting, see *Wadsworth Atheneum Paintings, Catalogue I: The Netherlands and the German-Speaking Countries, Fifteenth-Nineteenth Centuries*, edited by Egbert Haverkamp-Begemann (Hartford: Wadsworth Atheneum, 1978), 178-82. Rubens' painting was the inspiration for Jordaen's, as well as numerous other paintings, including a School of Cuzco *Return from Egypt* (18th c., New Orleans Museum of Art). The

cult of St. Anne. It was not unusual for paintings of the Holy Kinship to include as many as twenty-three persons—most of whom were derived from apocryphal legends about St. Anne. After the Council of Trent, the Church eschewed these legends, and, as a result, the number of figures in depictions of the Lineage of the Virgin Mary was dramatically reduced. When the subject of the Holy Kinship or Lineage of the Virgin Mary was transplanted to the New World, it became known there as *Los Cinco Señores*. Among the Colonial Mexican artists who painted this subject are Juan Correa (Guatemala City, Museo de Antigua Guatemala), Villalpando (Toluca, Mexico, Museo de Bellas Artes), and Nicolás Rodríguez Juárez (Querétaro, Museo Regional, and Guadalajara, Church of Santa Ana).[250]

A similar, though less developed, hypothesis has also been put forward by Juárez Frías. In commenting on a rare Mexican devotional *retablo* of the genealogical tree of Christ (Zacatecas, Museo Zacatecano), Juárez Frías suggests that the theme of the Five Lords may originate with this subject. The *retablo* in question shows King David as the trunk of the tree. Jesus is seated in the center of the tree, with His maternal grandparents, Joachim and Anne, located below Him and the Virgin Mary and Joseph slightly above Him.[251]

It should also be noted that the names of the Five Lords are also explicitly linked with devotion to the Sacred Heart. This is in evidence in the image of the Sacred Heart that was executed according to the specifications of St. Margaret Mary (1647-1690), a Visitation nun of the monastery of Paray-le-Monial who was the recipient of a number of private revelations by the Lord over a period of eighteen months, from December 1673 to June 1675. Jesus' Heart, with the word *Caritas* inscribed at its center, is pierced by nails, surmounted by a cross amidst flames, and encircled with a crown of thorns; the names of Jesus, Mary, Joseph, Anne, and Joachim surround the Heart.[252] During the Baroque era, the Sacred Heart devotion, and its iconography, was introduced to New Spain, where it enjoyed great popularity.[253] The *retablo* of *Los Cinco Señores* with the Sacred Heart in the Museo Zacatecano offers concrete evidence of the association of these sacred figures with this devotion in Mexico, as does another in which the Powerful Hand and the Five Lords (minus the chalice, lambs, and *arma Christi*) appear in tandem with both the Sacred Heart of Jesus and the pierced heart of the Virgin Mary (San Francisco, The Mexican Museum).[254]

A Netherlandish woodcut, entitled *The Hand as the Mirror of Salvation* and dated 1466 (Washington, D.C., National Gallery of Art), offers another perspective on the subject of the Powerful Hand. This image was intended to be used as an aid in the teaching and the memorization of Christian doctrine. A hand occupies the center of the pictorial space. Four

latter replicates in reverse many elements of a painting by the seventeenth-century Flemish painter Willem van Herp that was based on an engraving of Rubens' *Return of the Holy Family from Egypt* by the seventeenth-century Flemish engraver Lucas Emil Vosterman: see Wilson, *St. Joseph in Spanish American Colonial Images of the Holy Family*, 11-12.

244. See Jonathan Brown, *The Golden Age of Painting in Spain* (New Haven: Yale University Press, 1991), 244, Plate 225.
245. Tovar de Teresa, 147-48.
246. Burke, 117.
247. Giffords, *Mexican Folk Retablos*, 29. On the blue Franciscan habit in *retablo* art, see Giffords, *Mexican Folk Retablos*, 81. Cf. Larry Frank, *New Kingdom of the Saints: Religious Art of New Mexico 1780-1907* (Santa Fe: Red Crane Books, 1992), 300.
248. Giffords, *The Art of Private Devotion*, 83.
249. Juárez Frías, 64-67. Cf. Giffords, *Mexican Folk Retablos*, 31.

sayings of Jesus from the Gospels appear above the hand: "'But strive first for the kingdom of God and His righteousness, and all these things will be given to you as well'" (Matthew 6:33); "'What does it profit a man if he gains the whole world, but loses or forfeits himself?'" (Luke 9:25); "And he said to them, 'You also go into the vineyard, and I will pay you whatever is right'" (Matthew 20:4); "'I am the true vine'" (John 15:1). Each finger, knuckle, and joint of the hand is labelled, and the meaning is set forth in explanatory verses on either side of the hand. For example, the thumb signifies God's will; the forefinger, examination; the middle finger, repentance; the ring finger, confession; and the ear finger, satisfaction. Above and to the left of the hand is Mary Magdalen, the symbol of self-knowledge, contrition, and confession. To the right is Mary/Martha, symbol of prayer, the elmination of greed, and charity. Below the wrist, seven long lines explicate the image's meaning.[255]

Like this Netherlandish woodcut, *La Mano Poderosa* in The Peters Collection is also a mirror of salvation, or, more precisely, an allegory of grace. The *retablo* presents an allegorical tableau of the doctrine of grace by showing that Christ's passion and death is the source of grace, which is imparted to the faithful by the sacraments. This allegory is a variation on the subject of the Fountain or Well of Life, which was often combined with that of Christ Treading the Winepress. These late medieval allegorical images of Christ's passion enjoyed renewed popularity in the Counter-Reformation, both in Europe and in the New World. European engravings and paintings of these subjects served as compositional sources for Colonial Andean and Mexican artists. The Fountain or Well of Life typically represents Christ shedding His blood into a chalice or basin that functions as a fountain or well from which seven jets of blood either shoot into the mouths of seven lambs or irrigate the earth or the souls of kneeling mortals.[256]

In *La Mano Poderosa*, the blood that flows from the wounded hand of Christ denotes the grace poured forth on humanity by His redemptive passion and death. As in images of the Fountain or Well of Life, the seven lambs into whose mouths Christ's blood shoots from the chalice/fountain symbolize the seven sacraments that impart this grace. The *arma Christi*, which are emblematic of each of Jesus' sufferings, underscore the centrality of His passion and death as the source of grace. As one of the Five Lords, Jesus is depicted as *Salvator mundi*, "Savior of the World": with His foot resting on the globe, Jesus holds a small cross, the instrument of redemption, in His left hand, while He raises His right hand in benediction. The purpose of the genealogies of Jesus in the Gospels (Matthew 1:1-17; Luke 3:23-38) is to establish "the human reality of Christ . . . that Jesus, the Son of God, was

250. Amada Martínez Reyes, "Los Cinco Señores: Una pintura del siglo XVI en la catedral de México," in *Estudios acerca del arte novohispano: Homenaje a Elisa Vargas Lugo* (Mexico City: Universidad Nacional Autónoma de México, 1983), 77-82, especially 77-78. On the subject of the Holy Kinship or Lineage of Mary, see Trens, 108-114; Réau, vol. 2, part 2, 141-46; Foster, 198-206.
251. Juárez Frías, 28. Cf. Giffords, *The Art of Private Devotion*, 18, 82.
252. See Émile Bougaud, *The Life of St. Margaret Mary Alacoque*, translated by a Visitandine of Baltimore (1890; Rockford, Illinois: Tan Books, 1990), 288, Plate 7.
253. For further discussion of the Sacred Heart devotion and iconography, see Catalogue 4.
254. *Colonial Mexican and Popular Religious Art*, 33.
255. See Richard S. Field, *Fifteenth-Century Woodcuts and Metalcuts from the National Gallery of Art* (Washington, D.C.: Publications Department of the National Gallery of Art, n.d.), Catalogue 269. This woodcut seems to anticipate the meditative technique of the *chiropsalterium* or psalmodic hand invented by John Mombaer (ca. 1460-1501), a writer of the *devotio*

indeed a man of human stock."[257] The genealogical subject of the Five Lords fulfills a similar purpose by portraying the final generations of Jesus' family tree, affirming, as the Universal Church prays in the third Christmas preface to the Eucharistic Prayer, "that in Christ man restores to man the gift of everlasting life."[258]

Unlike the woodcut of *The Hand as the Mirror of Salvation*, *La Mano Poderosa* has no text that explains its meaning. Nonetheless, this *retablo* also functions as an instructional, memory, and meditative aid. By its riveting and unforgettable imagery, it instructs the viewer in the doctrine of grace, fixes it in the spectator's memory, and assists in prayer and meditation on the passion and death of Christ and its salvific effects in accord with the sensible, affective, Christocentric meditative techniques propagated by the religious Orders, such as the Franciscans, Jesuits, and Carmelites. The correlation of the Five Lords with the thumb and four fingers of the Powerful Hand suggests that it was a memory aid for the recitation of a series of standard prayers, such as the *Hail Mary* and the *Our Father*, to honor and/or to invoke the special intercession and protection of Jesus, His parents, and His maternal grandparents.

Juárez Frías points out that the Church must have certainly disapproved of popular devotion to the Powerful Hand because it was directed to the Hand itself, rather than to the Five Lords symbolized by the five fingers of the Hand. Nonetheless, to the present day this devotion flourishes in the Spanish-speaking world.[259] Inexpensive, mass-produced chromolithographs (or what Catholics call "holy cards") of the image of the Powerful Hand, accompanied by a prayer for divine mercy and guidance so that a painful dilemma with which the petitioner is struggling may be resolved, are readily available in Mexico as well as in the American Southwest and in California.

In Mexican devotional *retablos* of the Powerful Hand, Joseph is seated upon a lily or clouds, as are Joachim, Anne, the Virgin, and Jesus. Joseph wears his customary green robe and yellow cloak and holds his attribute of the flowering staff. Sometimes he is crowned.

(7) NARRATIVE SCENES

Another *retablo* representation in which Joseph appears is the narrative, which depicts scenes from the saint's life, such as the Espousal of Joseph and the Virgin, the Flight into Egypt, and the Holy Family at Nazareth. These episodes were the subject of numerous European prints that served as artistic sources for Colonial Spanish paintings. In turn, these prints and paintings inspired *retablo* artists. For example, an engraving of the *House of Nazareth* by Hieronymus Wierix has been identified as the compositional source of a

moderna, "Modern Devotion," movement: see P. Debongnie, *Jean Mombaer de Bruxelles, abbé de Livry: Ses écrits et ses réformes* (Louvain/Toulouse, 1927), 172-87; R. R. Post, *The Modern Devotion: Confrontation with Reformation and Humanism* (Leiden: E. J. Brill, 1968), 544. One of the hallmarks of this late medieval movement, which shaped Catholic and Protestant piety in the early modern era and thereafter, was its emphasis on techniques of meditative prayer for the working classes. For an excellent, up-to-date introduction to the *devotio moderna*, see *Devotio Moderna: Basic Writings*, translated by John van Engen, preface by Heiko A. Oberman, The Classics of Western Spirituality (New York: Paulist Press, 1988).

256. Knipping, 2:466-73; Gertrud Schiller, *Iconography of Christian Art*, translated by Janet Seligman, 2 vols. (Greenwich: New York Graphic Society, 1971-72), 2:228-29; von Barghahn, "Imaging the Cosmic Goddess: Sacred Legends and Metaphors for Majesty," 96-97; Sebastián, *Iconografía e iconología del arte novohispano*, 34-35, *Contrarreforma y barroco: Lecturas iconográficas e iconológicas*, 2nd ed. (Madrid: Alianza, 1985), 161-72, and "Diffusion of Counter-Reformation Doctrine," in *Temples of Gold, Crowns of Silver*, 57-79, especially 62-63.

painting of the same title by the Colonial Colombian artist Gregorio Vázquez Ceballos (1678, Bogotá, Museo de Arte Colonial).[260] In the foreground of this painting, angels assist the Virgin Mary and Christ Child with household chores, while Joseph works in his carpenter's shop in the background. An engraving in the 1597 editions of Gracián's *Summary* presents a more sober interpretation of domestic life at Nazareth: Mary works at her sewing, while the Child Jesus helps Joseph with his carpentry work (Plate 26). Juárez Frías illustrates a *retablo*, presently in the Museo Zacatecano in Zacatecas, that is close in spirit to this engraving. Entitled *La Familia de Nazaret*, "The Family of Nazareth," this *retablo* bears the inscription *Sr. San José obrero*, "Lord St. Joseph the Worker," one of Joseph's most popular advocations.[261] The figure of Joseph dominates this *retablo*. While the Virgin sews in the background, the carpenter shop—where Joseph, assisted by Jesus, saws a beam of wood—occupies the foreground. The saint wears a green robe; his yellow cloak and a hat are hung on a hook on the wall behind him. While some carpenter's tools are hung in an orderly fashion in a holder on the back wall, others are scattered on the floor and on a plank resting on two sawhorses.

Like *retablos* in which Joseph is shown with his attributes of a carpenter's bench and/or tools (Catalogue 32; Plates 17, 24), *La Familia de Nazaret* exalts Joseph the worker. Lynn White, Jr., has suggested that there is a connection between the rise of the cult of Joseph and the emphasis on hard work as a virtue in the early modern era.[262] Similarly, Luis Weckmann points out that propagation of devotion to Joseph in the Renaissance and Baroque parallels the growth of devotion to the Virgin Mary in the High Middle Ages, with an important difference: the cult of the Virgin arose and was fomented in a courtly atmosphere as a reflection of feudal values, whereas that of Joseph was fostered by the nascent bourgeoisie that was composed of merchants and artisans.[263] Teresa of Ávila, who did so much to popularize devotion to Joseph in early modern Europe, came precisely from this sort of middle class background.[264] In *La Familia de Nazaret*, the image of Joseph the worker is complemented by the figures of Mary and Jesus, thus offering a complete picture of the working family, an image that would have clearly resonated in the life-experience of this *retablo*'s original owner(s).[265]

Just as images of the House of Nazareth extolled Jesus, Mary, and Joseph as models for family life, those of the Espousal of Joseph and the Virgin promoted the saint and his spouse as models for married couples. According to Jewish custom, there were two stages to marriage. The first stage was the "betrothal" or "espousal," a formal exchange of consent before witnesses that constituted a legally ratified marriage. Henceforth, the woman was

257. René Laurentin, *The Truth of Christmas: Beyond the Myths. The Gospels of the Infancy of Christ,* translated by Michael J. Wrenn et al. (Petersham, Massachusetts: St. Bede's Publications, 1986), 357.
258. *The Roman Missal: The Sacramentary,* translated by the International Commission on English in the Liturgy (New York: Catholic Book Publishing Company, 1974), 383.
259. Juárez Frías, 66.
260. Sebastián, "Diffusion of Counter-Reformation Doctrine," 74.
261. Juárez Frías, 32.
262. "The Iconography of *Temperantia* and the Virtuousness of Technology," in *Action and Conviction in Early Modern Europe: Essays in Memory of E. H. Harbison,* edited by Theodore K. Rabb and Jerrold E. Seigel (Princeton: Princeton University Press, 1969), 197-219, especially 200-201.

considered the man's wife, and any infringement on the husband's marital rights could be punished as adultery. The second stage was the subsequent taking of the bride to the groom's home, where, under ordinary circumstances, the marriage was consummated.[266] Marriage scenes of Joseph and Mary in Western art always portray their espousal, as in the *retablo* of *Los Desposorios de San José y la Virgen*, "The Espousal of St. Joseph and the Virgin" (Catalogue 42), in The Peters Collection. The Jewish rite of espousal came to be equated with the Christian marriage ceremony.[267]

The Fathers of the Church and the scholastics believed that marriage was based on the contractual agreement voluntarily made by man and wife, not on physical consummation, and consequently that the marriage of Joseph and Mary was a true one. Augustine demonstrated that each of the three "goods" of marriage—offspring, loyalty, and the sacrament—were fulfilled in that of Joseph and Mary: "We recognize the offspring in Our Lord Jesus Christ Himself; the loyalty, in that no adultery occurred; and the indissolubility, because of no divorce. Only conjugal intercourse did not take place."[268] Similarly, Thomas Aquinas held that the twofold perfection of marriage was present in this sublime union: consent to the nuptial bond, but not expressly that of the flesh, unless it was pleasing to God; and the upbringing of the Child, even though procreation was not by carnal intercourse.[269]

The canonical Gospels do not provide an account of the betrothal of Joseph and Mary. The apocryphal gospels, and the hagiographic and devotional texts that repeated the legends of the apocrypha, were the literary sources for artists. The legend of Joseph's miraculous selection has been discussed above. Molanus and other theologians rejected this legend. Nonetheless, it was repeated by the devotional authors Gracián, Valdivielso, and María de Ágreda, and the iconographer Pacheco.[270]

The Espousal did not become a popular subject in European art until the fourteenth century. During the Renaissance and Baroque periods, it was rendered by many well-known artists, including Giotto, Fra Angelico (1378-1455), Raphael (1483-1520), El Greco, Rubens, Seghers, Nicolas Poussin (1594-1665), and Murillo. The Espousal was always found in series of images of the life of the Virgin. For example, Albrecht Dürer (1471-1528) included a woodcut of the Espousal (ca. 1504) in his *Life of the Virgin* (1500-1505). This was also the practice in Spain, as evidenced by a group of early sixteenth-century Castilian polychrome wood relief panels, presently in the Indiana University Art Museum in Bloomington, and by eighteenth-century altarpieces in the Cathedral Chapel of the Immaculate Conception and in the Church of St. Michael in Teruel (Spain). In the mid-eighteenth century, the German

263. *The Medieval Heritage of Mexico*, translated by Frances M. López-Morillas (New York: Fordham University Press, 1992), 206.
264. See Jodi Bilinkoff, *The Ávila of St. Teresa: Religious Reform in a Sixteenth-Century City* (Ithaca: Cornell University Press, 1989), 64-68, 109-16.
265. Cf. Hahn, "Joseph Will Perfect, Mary Enlighten and Jesus Save Thee," 64.
266. Foster, 74; Raymond E. Brown, S.S., *The Birth of the Messiah: A Commentary on the Infancy Narratives in the Gospels of Matthew and Luke*, updated ed. (New York: Doubleday, 1993), 123-24. In parts of Judea, interim marital relations were not absolutely condemned; however, in Galilee no such leniency was tolerated, and the wife had to be taken to her husband's home as a virgin.
267. Foster, 74.
268. Quoted in O'Carroll, *Theotokos*, 234.

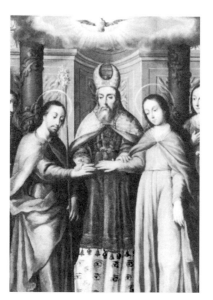

Plate 32.
Luis Berrueco
(Mexico),
*Marriage of
the Virgin*,
ca. 1730.
The Denver
Art Museum.

engraver Gottfried Bernhard Goetz (1708-1774) did a set of engravings of the life of the Virgin that in the 1780s became the compositional source for a group of paintings of the same theme executed by the three Ecuadoran Cortés brothers (Antonio, Nicolás, and Francisco Javier) or by their workshop (Popayán, Colombia, Archepiscopal Palace). The Espousal appears as a subject both in Goetz's engravings and in the Cortés' paintings. Sebastián maintains that the Espousal is the scene from Joseph's life that was most commonly portrayed in Colonial Spanish art. The subject of the Espousal was very popular in Colonial Mexican art during the seventeenth and eighteenth centuries, being painted by all the major artists of the period.[271]

An element common to all representations of the Espousal is that the composition is centered on three figures—the high priest, Mary, and Joseph—who generally are arranged so that they form a pyramid. The setting is either in the open air, in front of the temple where the Virgin was raised, or inside the temple. Sometimes only the high priest, Mary, and Joseph are present; sometimes more figures are added, such as other priests, disappointed suitors, Sts. Joachim and Anne, witnesses. Joseph holds his flowering staff, above which the dove of the Holy Spirit sometimes hovers. Sometimes the dove of the Holy Spirit or the tetragrammaton (the four Hebrew letters, usually transliterated YHWH or JHVH, that form the proper name of God) appear in a radiating aureole, above the high priest.

The ceremony is depicted in two different manners. In the first, Joseph places the wedding ring on the Virgin's finger. In the second, the high priest either joins the hands of Joseph and Mary or blesses their joined hands. The first prevailed in Italy. A factor that undoubtedly influenced this artistic practice was that among the relics venerated in the cathedral of Perugia was the Virgin Mary's wedding ring. The second was what was called in Roman law *dextrarum junctio* or *conjunctio manuum*, a gesture symbolizing conjugal union. In the case of the Espousal, it signifies the mutual consent of Joseph and Mary to the marriage. This was the preferred manner of representing the Espousal in France. It was also popular among Golden-Age Spanish artists, such as El Greco, Juan de Roelas (ca. 1560-1625), Antonio de Pereda (1611-1678), and Murillo. Both representations are found in Colonial Spanish art.[272]

269. O'Carroll, *Theotokos*, 234.

270. Gracián, 73; Valdivielso, 152-53; Mary of Ágreda, 51; Pacheco, 2:229-30. Also see Mâle, 355-57.

271. Mâle, 356-57; Miguel Ángel García-Guinea, "Los Desposorios de San José en el arte," *Estudios Josefinos* 9 (1955): 38-59; Réau, vol. 2, part 2, 170-73; Sebastián, *Contrarreforma y barroco*, 215-18, 224-25, *El barroco iberoamericano*, 217, and "Diffusion of Counter-Reformation Doctrine," 71, 78; María Teresa Velasco de Espinosa, "Los Desposorios de la Virgen en la pintura novo-hispana de los siglos XVII y XVIII y los tratadistas españoles," *Cuadernos de arte colonial* no. 2 (1987): 37-53; *Spanish Polychrome Sculpture 1500-1800 in United States Collections*, edited by Suzanne L. Stratton (New York: The Spanish Institute, 1993), 160-61.

The *retablo* of the Espousal in The Peters Collection shows only the three figures of the high priest, the Virgin, and Joseph. The high priest's vestments include those specified in Exodus 28:4 and in Pacheco's *Art of Painting*: a miter, mantle, tunic, alb, and breastpiece that has chains of gold and is set with precious stones.[273] The peacock eyes that decorate the bottom of the high priest's alb are of special interest, because the same decorative motif occurs in Luis Berrueco's *Marriage of the Virgin* (ca. 1730, The Denver Art Museum), suggesting that the *retablo* artist was familiar with this painting (Plate 32).[274] Joseph wears his customary green robe and yellow cloak and holds his flowering staff. The Virgin is represented as she often is in *retablo* art, wearing a red robe and blue cloak (see, e.g., Catalogue 17, 18, 33, 44), the colors that Pacheco prescribes for her.[275]

In Berrueco's painting, the high priest joins the hands of Joseph and Mary. This *retablo* is in the same tradition, showing the high priest blessing the joined hands of the couple. However, the *retablo*'s plain maroon drapery tied back with gold cord simplifies the usually elaborate architectural or decorative settings, replete with clouds and/or angels, of Colonial Mexican paintings of the Espousal. The green semicircular ornament, offset by a flower on each side, where the drapery meets in the center, substitutes for either the dove of the Holy Spirit or the tetragrammaton in radiating aureole that usually appears in Colonial paintings.

One factor that contributed to the popularity of the Espousal in art was the promotion and eventual institution of a feast celebrating this event. In 1413, Gerson initiated a private campaign to secure the adoption of a votive feast of the Espousal. He argued that the most suitable day for this celebration was Thursday of the third week of Advent, because it would fit appropriately between Wednesday's Gospel of the Annunciation and Friday's Gospel of the Visitation. Gerson proposed this celebration in honor of the virginal marriage of Joseph and Mary to invoke their heavenly intercession to heal the disunity that afflicted the Church of his day, when one pope and two anti-popes were claiming the papal throne. His efforts were unfruitful.[276]

When the Council of Constance convened (1416), Gerson, who represented the king of France and the University of Paris of which Gerson was the chancellor, placed his proposal before this holy synod. The reason he put forth for the institution of the feast of the Espousal was that "[in] order that through the merits of Mary and through the intercession of so great, so powerful, and in a certain way so omnipotent an intercessor with his bride . . . the Church might be led to her only true and safe lord, the supreme pastor,

272. Pacheco, 2:230; Anna Jameson, *Legends of the Madonna*, edited by Estelle M. Hurll (Boston: Houghton, Mifflin, and Company, 1897), 202-208; Mâle, 356-57; García-Guinea, 55-56 (Figures 14, 15, 16, 17, 18); Réau, vol. 2, part 2, 171; Kelemen, Catalogue 2, 3; Sebastián, *Contrarreforma y barroco*, 216-17 (Plate 62), and *El barroco iberoamericano*, Plates 66, 67; Velasco de Espinosa, 42-51; Burke, 46-47; *Patron Saint of the New World*, 47, Catalogue 8.
273. Pacheco, 2:227.
274. I owe this observation to Bettina Jessell, who recently did conservation work on the *retablo* of the Espousal, and Barbara von Barghahn.
275. Pacheco, 2:225.
276. Filas, *The Man Nearest to Christ*, 145-46.
277. Quoted in Filas, *The Man Nearest to Christ*, 147.
278. Filas, *The Man Nearest to Christ*, 153-54; Gauthier, "Joseph (saint): Liturgie et documents pontificaux," 1317-18.

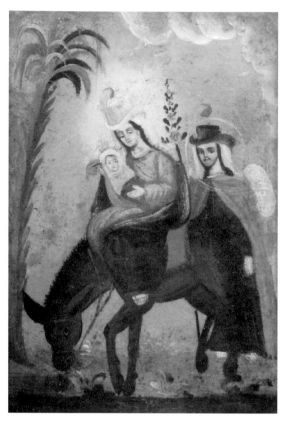

Plate 33.
*The Flight
into Egypt,*
Mexico,
19th c.
Private Collection.
(Photo: Jeffrey Blake)

her spouse in place of Christ."[277] While Gerson's proposal was favorably received, no direct action was taken on it, due to other pressing business. However, Gerson's dream was not completely unrealized.

The feast of the Espousal appears in several late fifteenth-century missals: Chartres, 1482, 1490; Saintes, ca. 1490; Autun, 1493. In the sixteenth century, several religious Orders adopted this feast. The Franciscans did so in 1537. The Servites and the Dominicans followed the same course. In their general chapter of 1567, the Carthusians chose the feast of the Espousal as a special means of obtaining God's help to ward off the dangers of the times and to repopulate their monasteries with worthy aspirants. While this feast was never added to the calendar of the Universal Church, the Holy See granted permission for the Espousal to be celebrated annually on January 23 in Austria (1678), Germany (1680), Spain and its dominions (1680), and the Holy Land (1689). In 1682, the feast was transferred to November 26 in Spain and its dominions because the feast of St. Ildephonsus of Toledo was observed on January 23. Subsequently, the feast of the Espousal was conceded to the Cistercians (1702), Tuscany (1720), and the Papal States (1725). It was suppressed in 1961.[278]

A *retablo* of the Flight into Egypt directs attention to Joseph's advocation as patron of travellers (Plate 33).[279] Fray Pedro and his fellow friars surely invoked Joseph's protection as they crossed the Atlantic to the New World. Early in the Colonial period, the miraculous rescue of two Franciscan friars from shipwreck was attributed to Joseph.[280] Joseph was also Teresa of Ávila's protector on the many long, arduous, and perilous journeys that she made throughout Spain to found monasteries of the reformed Carmel.[281] Gracián reports that on these journeys Teresa always carried a statue of Joseph with her.[282] When the Discalced Carmelites travelled across the sea from Spain to New Spain, they must have invoked Joseph's protection as well as carried with them images of the saint, just as the Mother of Carmel did on all her journeys to new foundations. This aspect of Joseph's patronage is the

279. Also see Juárez Frías, 31; *Colonial Mexican and Popular Religious Art,* 31
280. Carrillo Ojeda, "San José en la Nueva España del siglo XVII," 631.
281. Wilson, "St. Teresa of Ávila's Holy Patron," 11.
282. Gracián, 242.
283. Wilson, "St. Teresa of Ávila's Holy Patron," 12.
284. Larry M. Toschi, O.S.J., "St. Joseph, Father of the Birth of Christianity in Alta California," *Cahiers de Joséphologie* 39 (1991): 705-724, especially 715-19.

subject of a seventeenth-century painting from the School of Cuzco, entitled *The Allegorical Flotilla of Salvation* (Lima, Colección Guillermo Boza Vega León). Three ships are depicted. Each contains a radiant passenger: Teresa of Ávila on the far left, the crucified Christ in the center, and the Virgin Mary with the Christ Child on the right. The presence of Teresa implies the many journeys that she made mystically to the Americas, as her writings and reform were transported across the sea. In the sky above, overseeing the entire enterprise of the sea journey, is the figure of Joseph embracing the Christ Child. Joseph is the patron and protector of this important voyage, both the allegorical voyage of the Catholic Church, with its members, to the port of salvation, and also the voyage of Christianity to a new land.[283] In fact, it was in the Americas, where, on November 21, 1768, Joseph was officially decreed as patron of travel both on land and on sea, as Blessed Junípero Serra (1713-1784) embarked on the expedition to begin the evangelization of Alta California. Joseph's patronage was not invoked in vain. At one point, this expedition was on the verge of having to be abandoned because of perilously low food supplies. However, on March 19, 1770, the feast of St. Joseph, ships arriving with much needed supplies were sighted.[284]

The predominance of travel during the Colonial period—voyages back and forth from Europe to the New World, travel within the colonies to major centers and also to more remote regions for the purpose of evangelization—clearly contributed to the popularity of the subjects of the Flight into Egypt, the Rest on the Flight into Egypt, and the Return from Egypt.[285] In these images, Joseph appears as the youthful, strong, but gentle, guardian and protector of Jesus and Mary. Joseph is presented in this way in the *retablo* of the Flight into Egypt. He is clothed in his usual green robe and yellow cloak and carries his attribute of the flowering staff. He walks on foot, while the Virgin, with the Christ Child in arms, rides on a donkey. The palm tree is a conventional element of the landscape of this subject, as well as one of Joseph's attributes. The pilgrim hats that Joseph and Mary wear, reminiscent of the hat with which Teresa of Ávila is outfitted in Juan Correa's *St. Teresa as Pilgrim* (ca. 1690-1700, Mexico City, Museo del Carmen),[286] highlight Joseph's role as the protector of this particular journey and as the patron of all travellers.

CONCLUSION

Mexico is the first country in Christendom where devotion to Joseph became widespread among the faithful. Introduced by the Franciscans during the first decade of the evangelization of New Spain, veneration of Joseph grew in popularity until the First

285. Barbara von Barghahn, *Temples of Gold, Crowns of Silver: Reflections of Majesty in the Viceregal Americas.* **Exhibition Guide** (Washington, D.C.: George Washington University, 1991).
286. See Christopher Wilson, "Beyond Strong Men and Frontiers: Conquests of the Spanish Mystics," in *Temples of Gold, Crowns of Silver*, 116-27, especially 116-17.

Provincial Council of Mexico chose him as the patron of the ecclesiastical Province of Mexico City in 1555. Joseph's patronage of Mexico was reinforced when Pope Gregory XV made Joseph's feast day a holy day of obligation for the Universal Church in 1621, sixty-six years after it had been so designated in Mexico, and when Pope Innocent XI granted the Spanish monarchy's request that Joseph be declared patron of Spain and its dominions in 1679. In view of this tradition of veneration of Joseph, it is not surprising that this saint, either alone with the Christ Child or in his capacity as the head of the Holy Family, was a frequent subject in Colonial Mexican art. Even after Mexico won its independence from Spain in 1821, devotion to Joseph did not diminish. The number and variety of ways in which Joseph is depicted in *retablos* testifies to the intense interest in, and devotion to, this saint that flourished unabated in Mexico since the 1520s. The rich iconography of Joseph in *retablo* art, derived from the abundant devotional literature on this saint and from European and Colonial Mexican art, expresses the manifold roles he played in the devotional life of the Mexican people as protector of the nation, patron of the evangelization of the Americas, role model, father of the conquered and oppressed, powerful intercessor, safe refuge in times of physical and spiritual danger.

I am indebted to Barbara von Barghahn, Carmen R. Croce, and Christopher C. Wilson for reading a draft of this study and for offering suggestions for its improvement, and to Patrick T. Brannan, S.J., and Frederick Homann, S.J., for their assistance in transcribing and translating into English the Latin inscriptions of the engravings in the 1597 Spanish and Italian editions of Jerónimo Gracián's Summary of the Excellencies of St. Joseph.

CATALOGUE OF THE EXHIBITION

JOSEPH F. CHORPENNING, O.S.F.S. (JFC)

CHRISTOPHER C. WILSON (CCW)

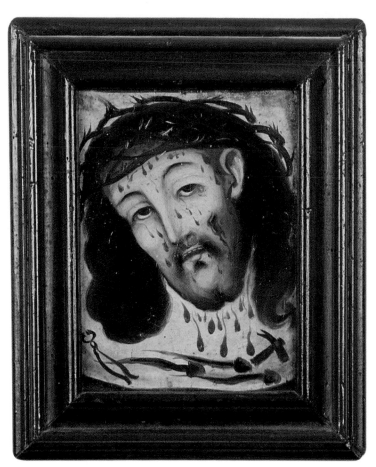

1. **El Divino Rostro**
 (The Divine Face), 6 ³/₄" x 5"

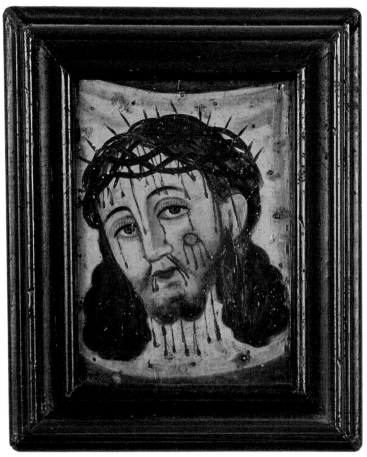

2. **El Divino Rostro**
 (The Divine Face), 7" x 5"

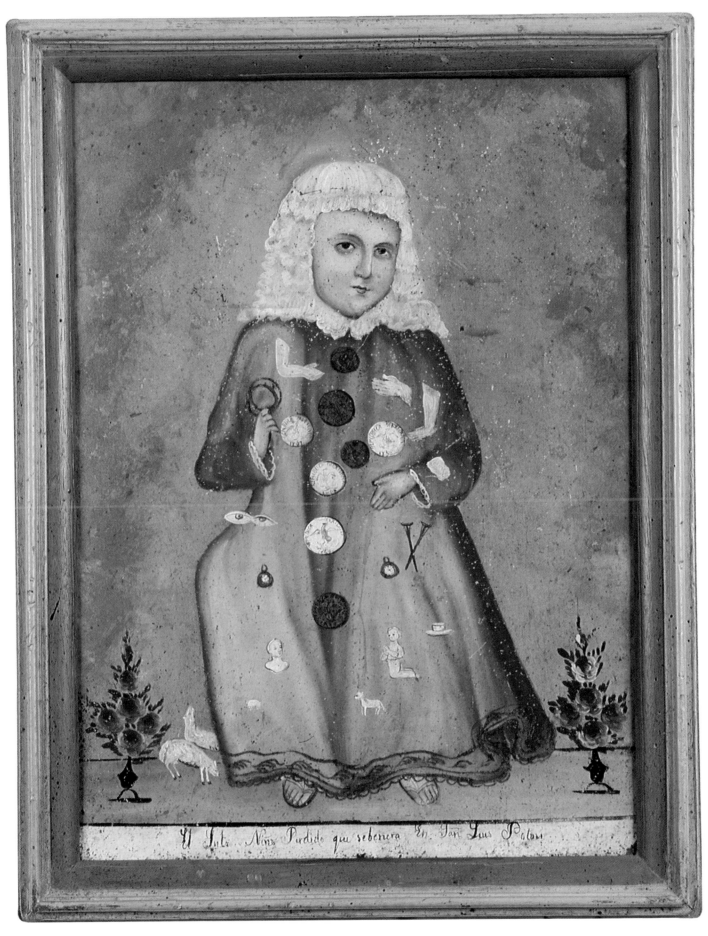

3. **EL SANTO NIÑO PERDIDO**
 (The Holy Lost Child), 18 ¹/₂" x 13 ¹/₄"

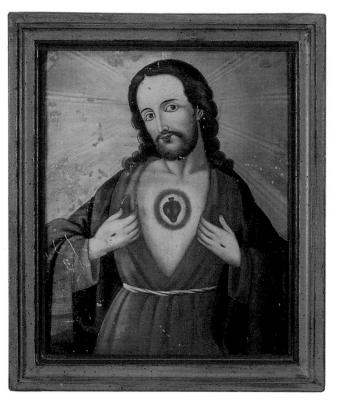

4. **EL SAGRADO CORAZÓN DE JESÚS**
 (The Sacred Heart of Jesus), 14" x 10"

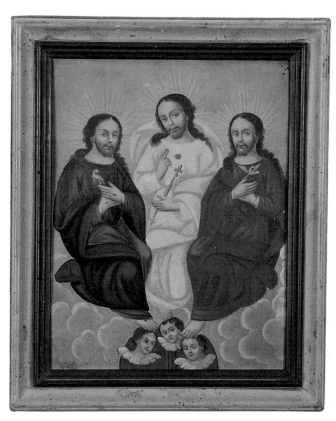

5. **LA SANTÍSIMA TRINIDAD**
 (The Most Holy Trinity), 13 1/4" x 10"

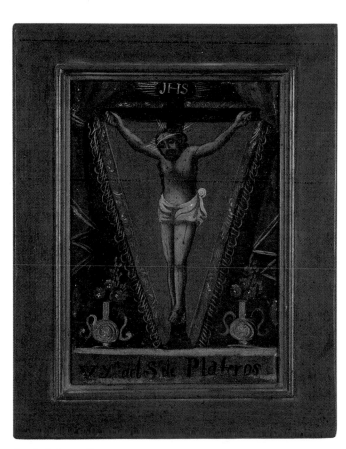

6. **EL SEÑOR DE PLATEROS**
 (The Lord of Plateros), 10 1/2" x 7 1/2"

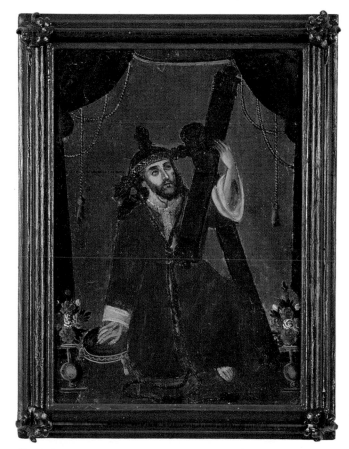

7. **EL SEÑOR DE LAS PENAS**
 (The Lord of Suffering), 14" x 10"

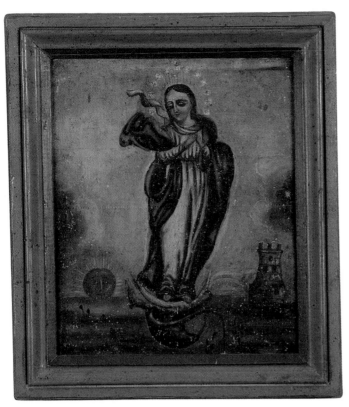

8. **LA INMACULADA**
(The Immaculate Conception), 12 ¹/₂" x 10"

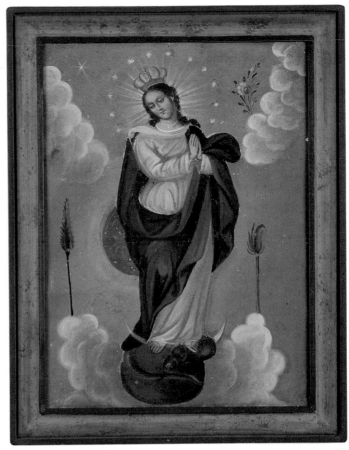

9. **LA INMACULADA**
(The Immaculate Conception), 14" x 10"

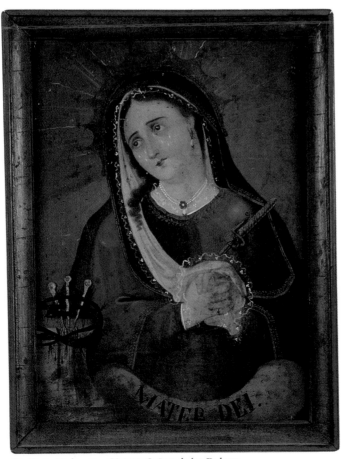

10. **Mater Dolorosa** or **Nuestra Señora de los Dolores**
(Sorrowful Mother or Our Lady of Sorrows), 14" x 10"

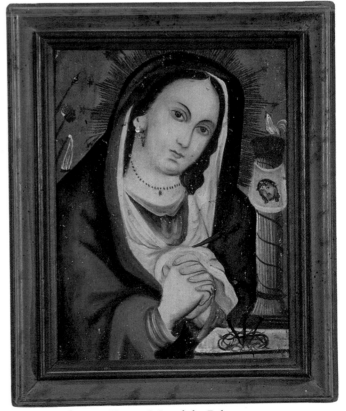

11. **Mater Dolorosa** or **Nuestra Señora de los Dolores**
(Sorrowful Mother or Our Lady of Sorrows), 12 ¹/₂" x 9 ³/₄"

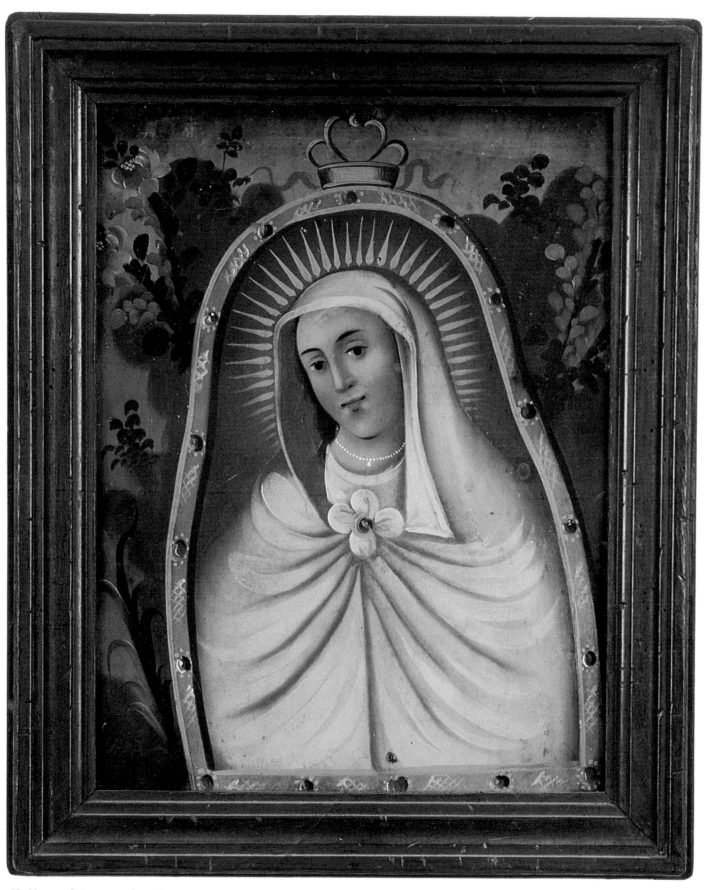

12. **NUESTRA SEÑORA DE LA CUEVA SANTA**
 (Our Lady of the Sacred Cave), 12" x 9"

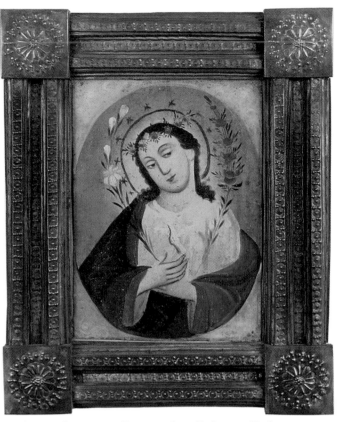

13. **Nuestra Señora de la Encarnación** or **El Alma de María**
(Our Lady of the Incarnation or The Soul of Mary), 14" x 10"

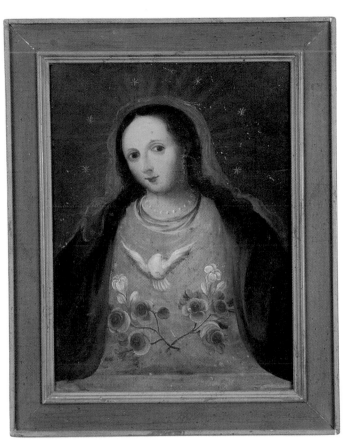

14. **Nuestra Señora de la Encarnación** or **El Alma de María**
(Our Lady of the Incarnation or The Soul of Mary), 14" x 10"

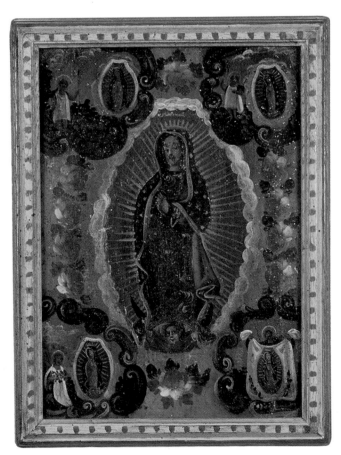

15. **Nuestra Señora de Guadalupe**
(Our Lady of Guadalupe), 14" x 10"

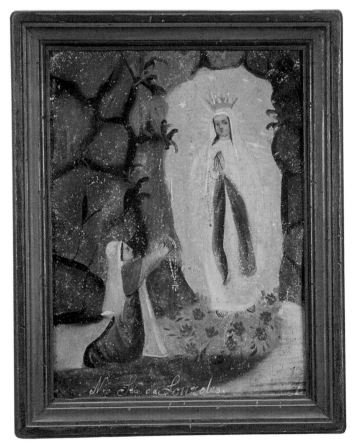

16. **Nuestra Señora de Lourdes**
(Our Lady of Lourdes), 14" x 10"

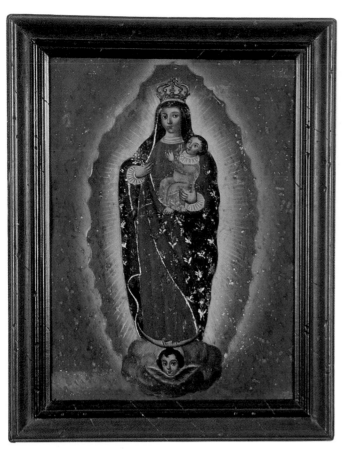

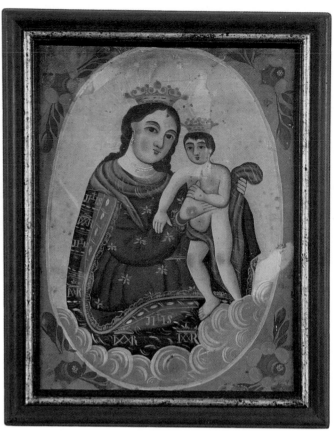

17. **Nuestra Señora del Patrocinio de Zacatecas**
(Our Lady of the Patronage of Zacatecas), 14" x 10"

18. **Nuestra Señora, Refugio de Pecadores**
(Our Lady, Refuge of Sinners), 14" x 10"

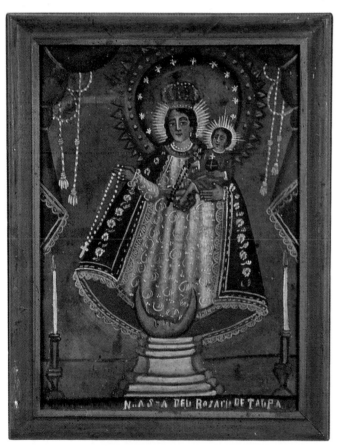

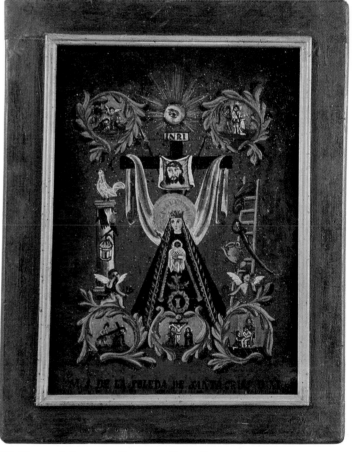

19. **Nuestra Señora del Rosario de Talpa**
(Our Lady of the Rosary of Talpa), 14" x 10"

20. **Nuestra Señora de la Soledad de Santa Cruz**
(Our Lady of Solitude of Santa Cruz), 14" x 10"

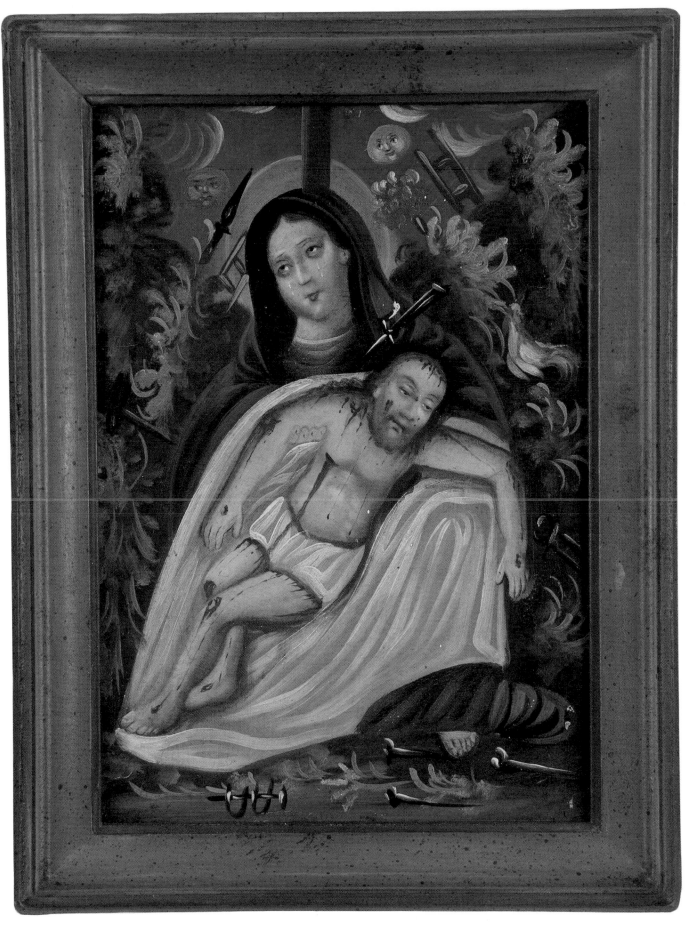

21. **LA PIEDAD**
(THE *PIETÀ*), 10" x 7"

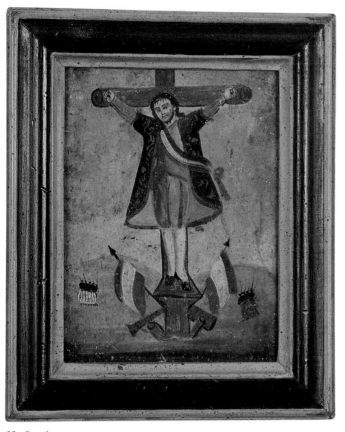

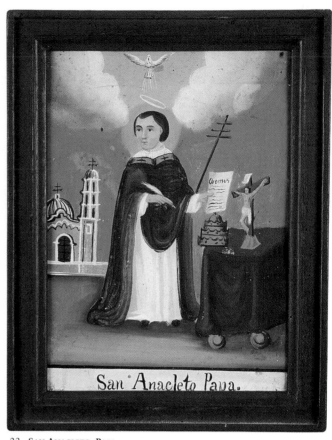

22. **San Acacio**
(St. Acacius), 10" x 7"

23. **San Anacleto, Papa**
(St. Anacletus, Pope), 10" x 7"

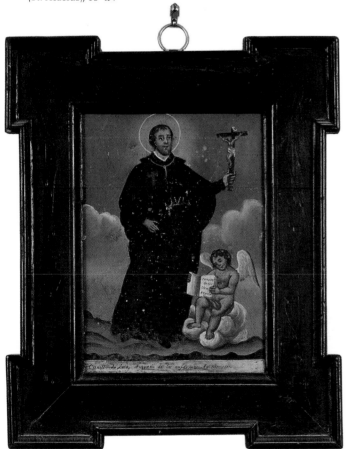

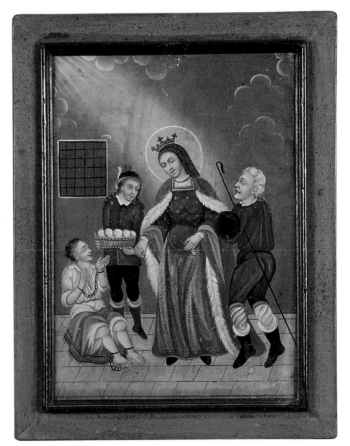

24. **San Camilo de Lelis**
(St. Camillus de Lellis), 10 ¹⁄₂" x 7 ¹⁄₂"

25. **Santa Eduviges**
(St. Hedwig), 14" x 10"

26. **SANTA ELENA**
(St. Helena), 13 1/4" x 10"

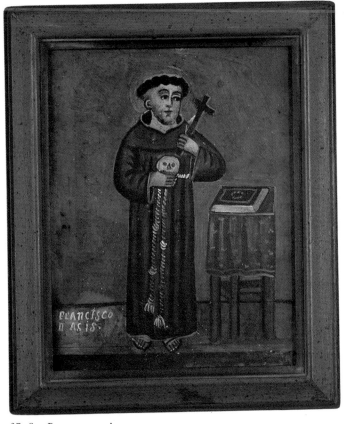

27. **SAN FRANCISCO DE ASIS**
(St. Francis of Assisi), 9 1/2" x 7"

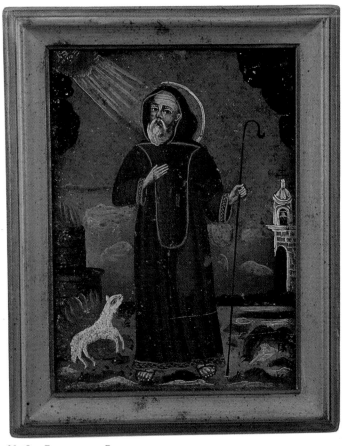

28. **SAN FRANCISCO DE PAULA**
(St. Francis of Paola), 11" x 8"

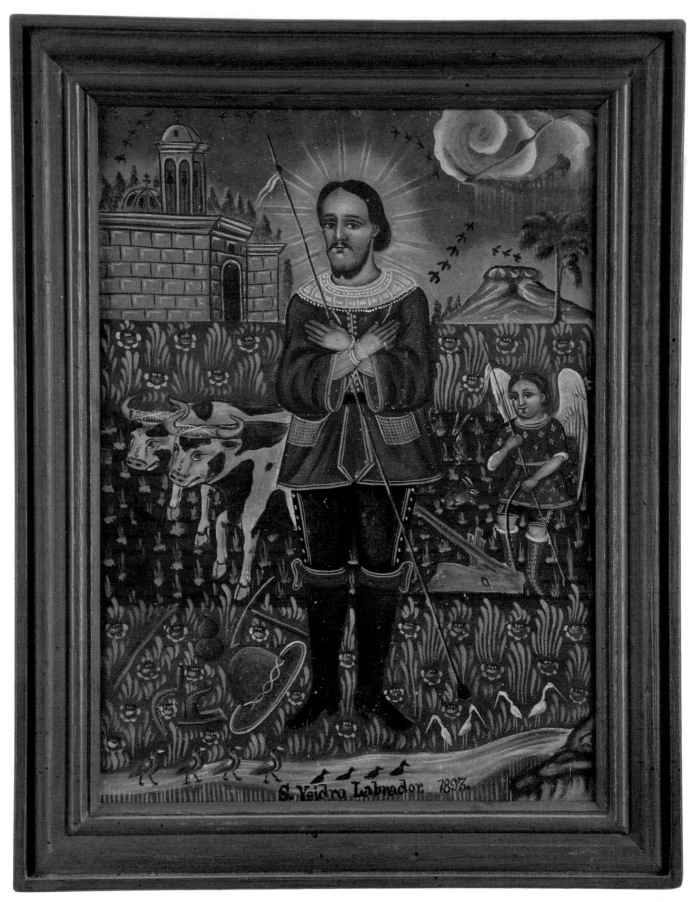

29. **San Isidro Labrador**
 (St. Isidore the Farmer), 1893, 14" x 10"

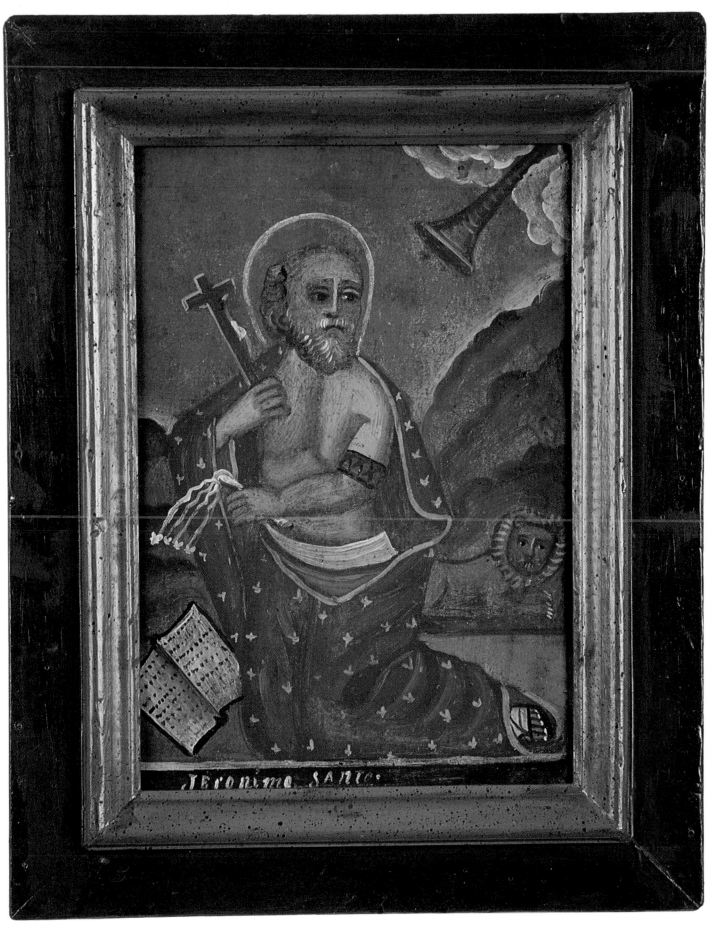

30. SAN JERÓNIMO
(St. Jerome), 10" x 7"

31. SAN JOSÉ
 (St. Joseph), 14" x 10"

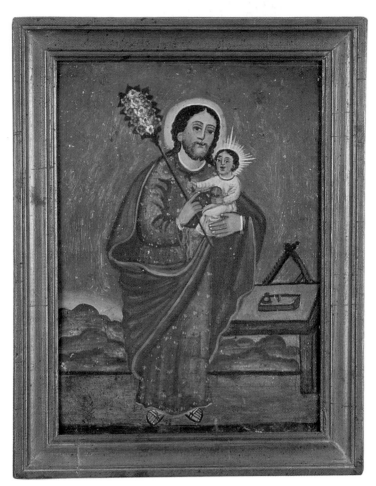

32. **SAN JOSÉ**
(St. Joseph), 14" x 10"

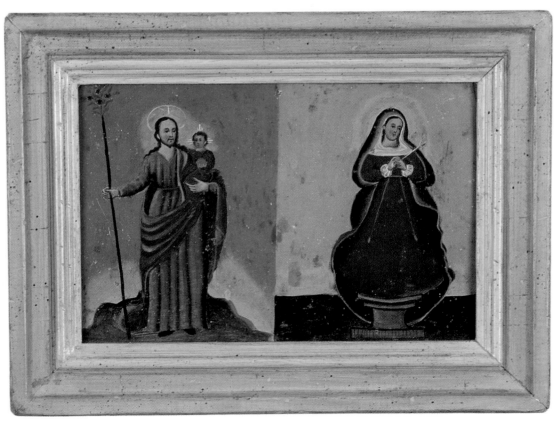

33. **SAN JOSÉ**
(St. Joseph)
MATER DOLOROSA OR **NUESTRA SEÑORA DE LOS DOLORES**
(Sorrowful Mother or Our Lady of Sorrows)
7" x 10"

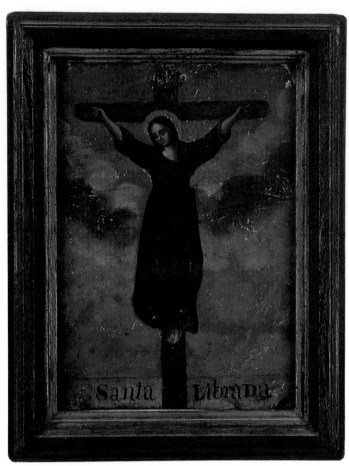

34. **SANTA LIBRADA**
 (St. Wilgefortis), 9 ¹/₂" x 6 ¹/₂"

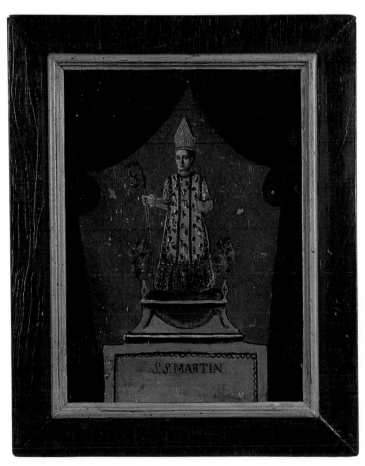

35. **SAN MARTÍN**
 (St. Martin), 14" x 10"

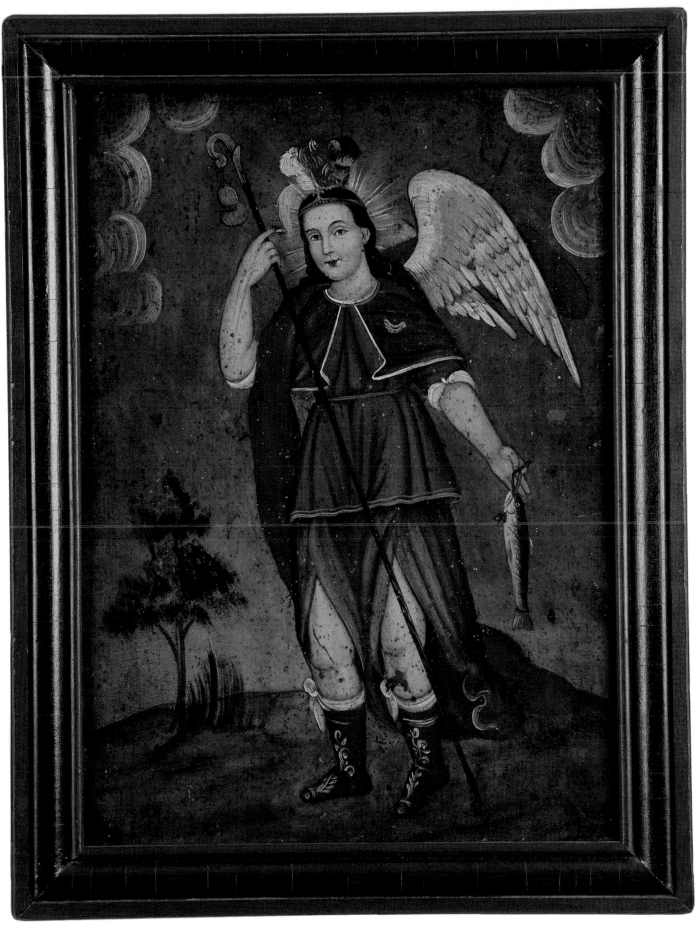

36. **SAN RAFAEL**
(St. Rafael), 14" x 10"

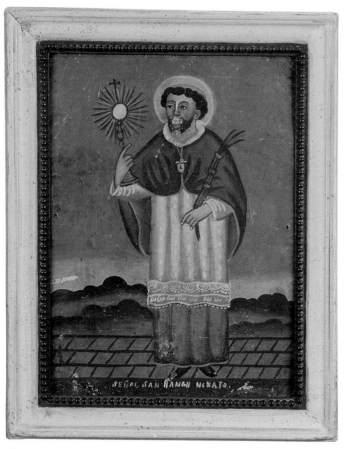

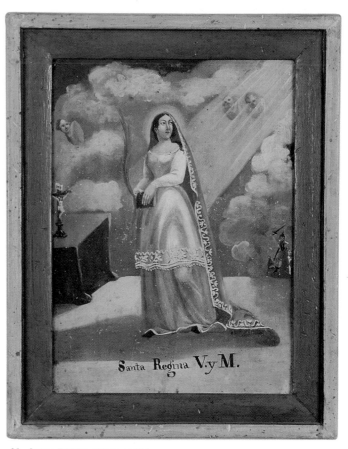

37. **SAN RAMÓN NONATO**
(St. Raymond Nonnatus), 14 ¹/₄" x 10"

38. **SANTA REGINA, VIRGEN Y MÁRTIR**
(St. Regina, Virgin and Martyr), 14" x 10"

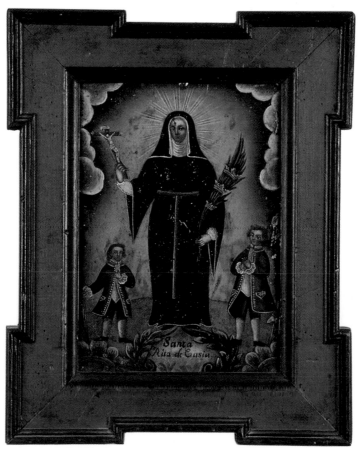

39. **SANTA RITA DE CASIA**
(St. Rita of Casia), 10 ¹/₂" x 7 ¹/₂"

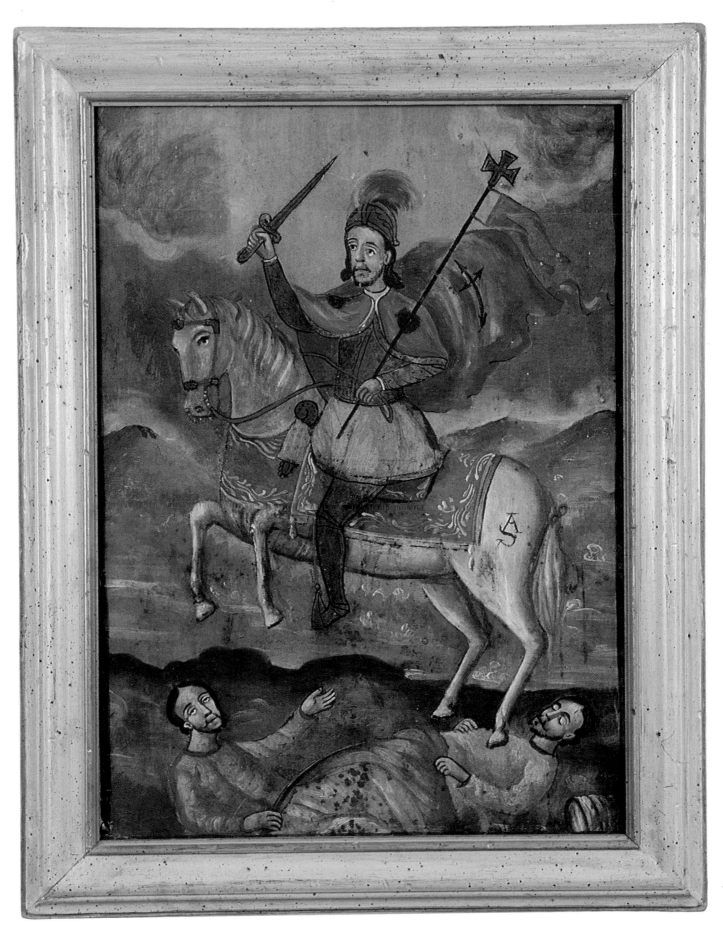

40. SANTIAGO
 (St. James the Greater), 17 ¹/₂" x 12 ¹/₂"

111

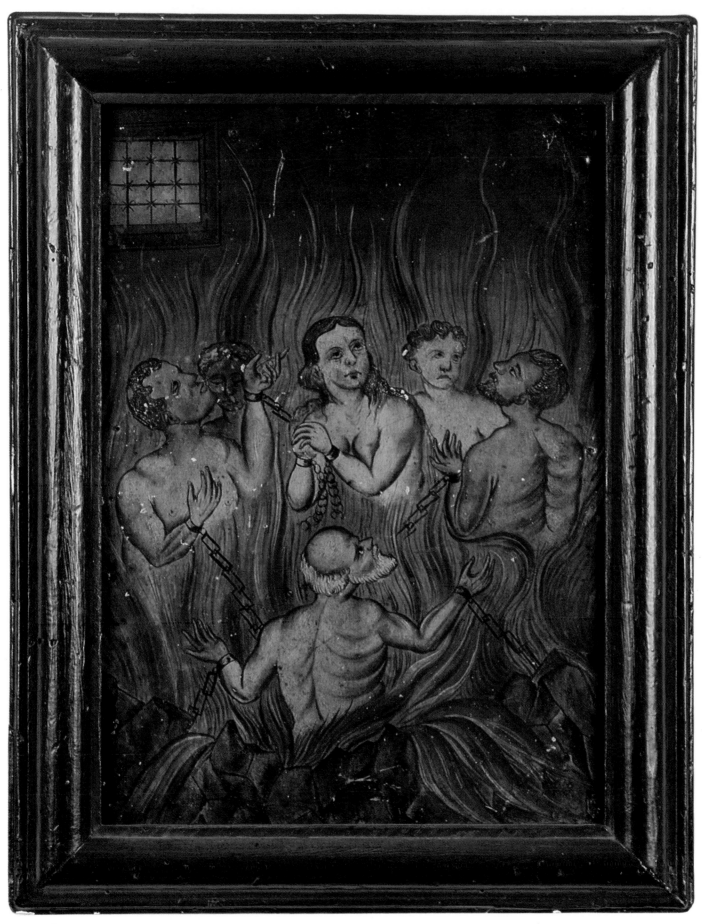

41. LAS ÁNIMAS
(The Souls in Purgatory), 14" x 9 ¹/₂"

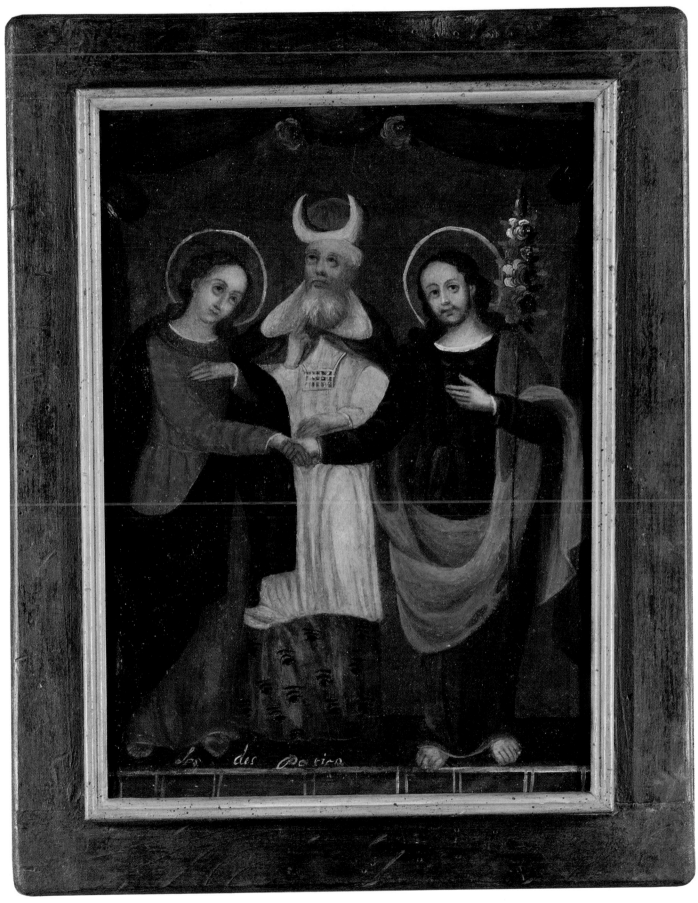

42. **LOS DESPOSORIOS DE SAN JOSÉ Y LA VIRGEN**
(The Espousal of St. Joseph and the Virgin), 14" x 10"

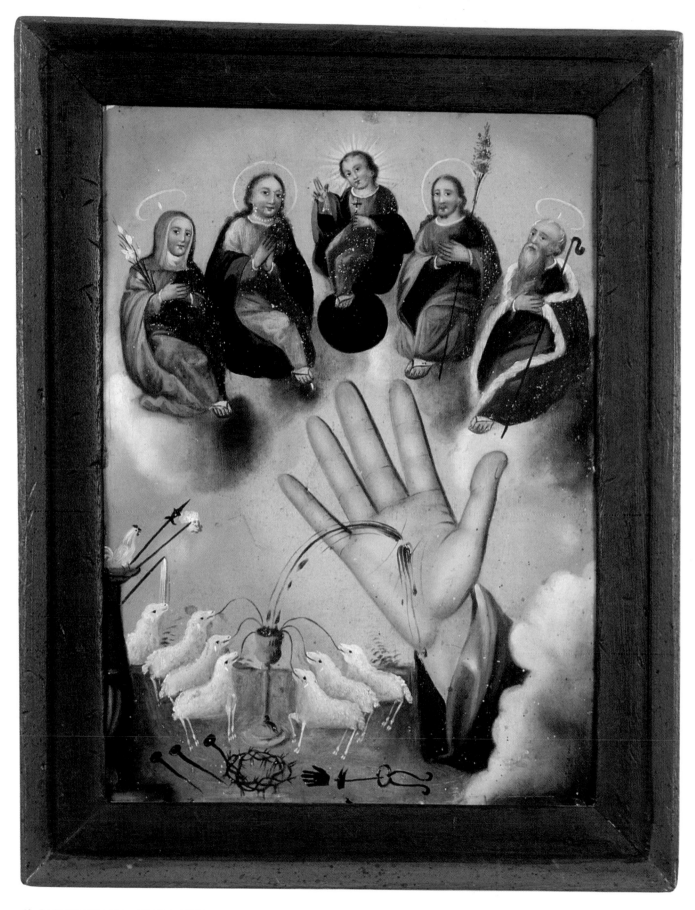

43. **LA MANO PODEROSA** or **LOS CINCO SEÑORES**
 (The Powerful Hand or The Five Lords), 14" x 10"

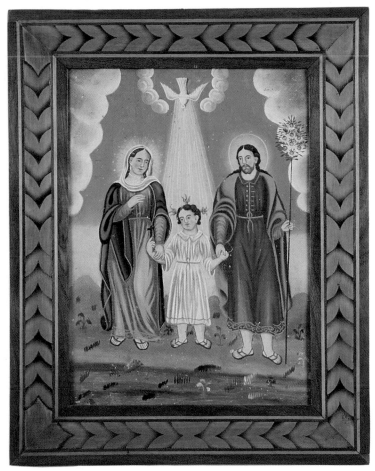

44. La Sagrada Familia
(The Holy Family), 14" x 10"

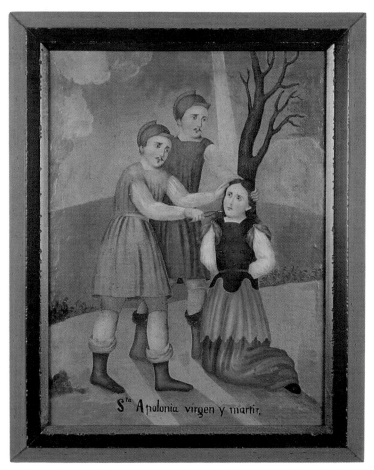

45. Santa Apolonia, Virgen y Mártir
(St. Appolonia, Virgin and Martyr), oil on canvas, 24 1/2" x 18"

115

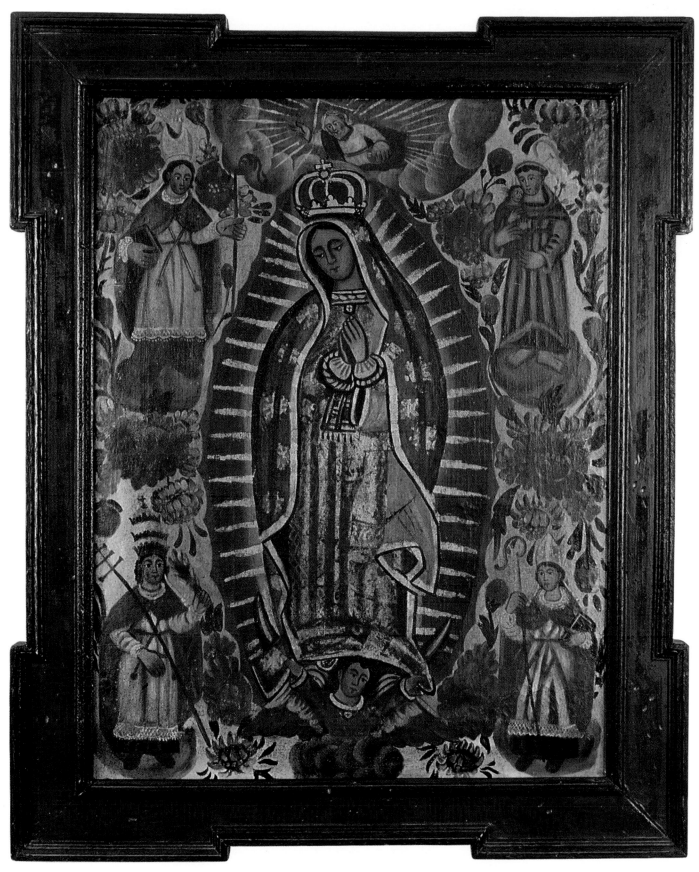

46. Nuestra Señora de Guadalupe
(Our Lady of Guadalupe), oil on canvas, 25" x 19"

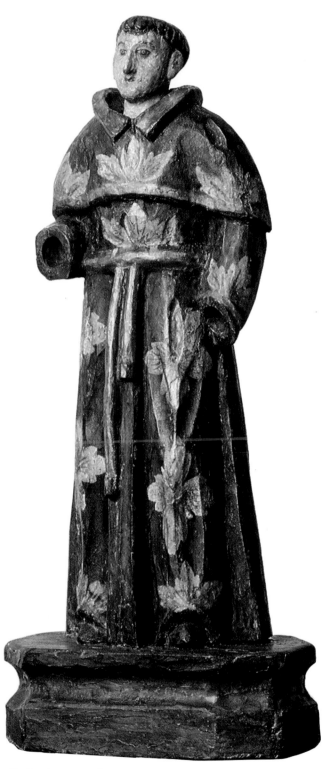

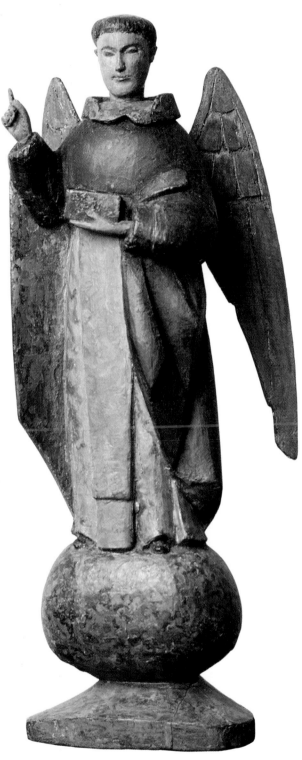

47. **San Antonio de Padua**
(St. Anthony of Padua), 13" (Philippines)

48. **San Vicente Ferrer**
(St. Vincent Ferrer), 14" (Philippines)

1. **EL DIVINO ROSTRO**
 (The Divine Face), 6 $^3/_4$" x 5"

2. **EL DIVINO ROSTRO**
 (The Divine Face), 7" x 5"

El Divino Rostro, also known as Veronica's Veil, is a miraculous image, like that of the Virgin of Guadalupe (Catalogue 15 and 46), made without the intervention of human hands. According to legend, a compassionate woman named Veronica met Christ on His way to Calvary and offered Him a cloth with which to wipe the sweat and blood from His face. When Christ returned the cloth to Veronica, she found that His image had been miraculously imprinted upon it. There is evidence that a cloth bearing Christ's image was venerated at St. Peter's in Rome as early as the end of the tenth century, and during the High Middle Ages there was great devotion to the *Vera Icon*, "True Image," from which Veronica's name probably derived. The cloth is still preserved among the relics of St. Peter's, though the image has faded away and become indiscernible.

Late medieval artists removed Veronica from the passion narrative and portrayed her alone, holding the cloth by the edges so that the Divine Face is turned toward the viewer. This type of depiction continued during the fifteenth and sixteenth centuries, until the subject was further reduced. In an engraving of 1513, Albrecht Dürer omitted the figure of Veronica, choosing instead to show two angels holding the veil. The image of the *Divino Rostro* was treated by several Spanish masters, including El Greco (Madrid, Private Collection), who included a panel painting of *Veronica's Veil* in the main altarpiece (now dispersed) of Santo Domingo el Antiguo in Toledo (1577-79). The painted image, representing the veil nailed to a dark background, was inserted into a gilded wooden cartouche, creating the impression that the cloth is hanging within a reliquary. Francisco de Zurbarán continued the Spanish practice of portraying the veil fastened by nails to a dark background (ca. 1635, Stockholm, Nationalmuseum).

Spanish Colonial artists followed the precedents of El Greco and Zurbarán in portraying Veronica's Veil, focusing their compositions on the image of the Divine Face, staring out toward the viewer. The Mexican master Ildephonsum López de Herrera painted a particularly magnificent example in 1624, showing the head of Christ, with the crown of thorns, surrounded by a golden aureole of light (Tepotzotlán, Museo Nacional del Virreinato). A popular subject of Mexican devotional *retablos*, images of the *Divino Rostro* sometimes include instruments of the passion at the bottom of the composition, such as a hammer and nails, as in Catalogue 1.

CCW

BIBLIOGRAPHY
Alarcón Cedillo and García de Toxqui, 104; Brown, *Zurbarán*, 112; Farmer, 422; Giffords, *The Art of Private Devotion*, 86, and *Mexican Folk Retablos*, 20-21; Jordan, 229-30; Juárez Frías, 35-38; Meagher.

3. EL SANTO NIÑO PERDIDO
(The Holy Lost Child), 18 ½″ x 13 ¼″

While living in Nazareth, the Holy Family observed the feast of Passover each year by travelling to Jerusalem. When Jesus was twelve, the family made this journey. On their way back to Nazareth, Joseph and Mary realized that the Child was not with them. They looked among their relatives and acquaintances, but, unable to find Him, they returned to Jerusalem. After three days, they discovered Jesus in the Temple, surrounded by the doctors, with whom He was in deep discussion (Luke 2:41-52). The three-day loss of the Child Jesus is one of the Seven Sorrows of Mary (see Catalogue 10, 11, and 33).

Though the scene of Christ among the Doctors was often represented in the art of Spain and the New World, as in an eighteenth-century work by the Mexican painter Juan Rodríguez Juárez (Tepotzotlán, Museo Nacional del Virreinato), the single figure of the lost Christ Child is a less common subject. Catalogue 3 depicts a dressed statue of the Lost Child which, according to an inscription at the bottom of the *retablo*, is venerated in San Luis Potosí. Statue paintings were produced with great frequency in the Colonial Americas, and the practice of representing miraculous statues in two-dimensional compositions continued in Mexican devotional *retablos*. Typically, a statue painting reproduces the appearance of a sculpted image as it stands on the altar, flanked by vases of flowers or candlesticks. In Catalogue 3, the Christ Child, with vases of roses set up on either side of him, wears a pink gown and ruffled white cap. Pinned to the statue's garment are coins, several of which have legible dates (e.g., 1850, 1869, 1889), and silver replicas of body parts, such as an arm, a hand, and a pair of eyes. Known as *ex-votos*, these offerings of gratitude were placed by individuals cured of various ailments as a result of the Lost Christ Child's intervention.

CCW

BIBLIOGRAPHY
Giffords, *The Art of Private Devotion*, 90.

4. EL SAGRADO CORAZÓN DE JESÚS
(The Sacred Heart of Jesus), 14" x 10"

Three principal phases are discernible in the historical development of devotion to Jesus' physical Heart of flesh. This devotion, which probably originated from the cult of the wound in the side of the crucified Christ (John 19:34), first appears in the Middle Ages. Its nature was personal and private. Representative of this phase are the writings of St. Anselm (ca. 1033-1109), of St. Bernard of Clairvaux (1090-1153), and of St. Bonaventure (1221-1274) and the visionary experiences of St. Mechtilde of Hackeborn (ca. 1241-1298) and of St. Gertrude the Great (ca. 1256-1302). Beginning in the sixteenth century, this devotion moved into a second phase of development. It was disseminated among the laity and religious by, among others, the Carthusians, the Society of Jesus, which counted among its members the most ardent advocates of this devotion, St. Francis de Sales (1567-1622), who imbued the Order of the Visitation of Holy Mary, which he co-founded with St. Jane Frances de Chantal (1572-1641), with it, and St. John Eudes (1601-1680), who worked zealously to promote it. This devotion became liturgical and ever more public in its third phase, in which St. Margaret Mary Alacoque (1647-1690) played a pivotal role.

A Visitation nun of the monastery of Paray-le-Monial, Margaret was the recipient of a number of private revelations by the Lord over a period of eighteen months, from December 1673 to June 1675. The Lord told Margaret Mary that the love of His Heart must spread and be made manifest to humanity by means of her, and that He would reveal the treasures of its graces through her, His chosen instrument and the disciple of His Sacred Heart. Jesus further instructed the saint that His Heart was to be honored under the form of a heart of flesh, and that she was to make reparation for the ingratitude of the human race by frequent Holy Communion, especially on the first Friday of each month and by an hour's vigil every Thursday night in memory of His agony and desertion in the garden of Gethsemane; this, of course, is the origin of the devotions of the Nine First Fridays and of the Holy Hour. The Sacred Heart is the symbol of Jesus' ardent love for humanity. Margaret Mary reports that, in the final revelation of 1675, the Lord declared to her: "'Behold this Heart which has so loved men, that it has spared nothing, to exhausting and consuming itself to testify to this love for them, and in return I receive from most ingratitude, by their irreverence and sacrileges, and by the disregard and coldness they have for Me in the sacrament of love [the Eucharist]. What wounds me still more is that it is hearts consecrated

to Me who behave like this'" (quoted by O'Carroll, *Verbum Caro*, 107). He then asked that a feast of reparation be instituted for the Friday after the octave of Corpus Christi (now the feast of the Sacred Heart). The apparitions at Paray-le-Monial gave a great impetus to publicizing this devotion and to shaping its practices. Margaret Mary was greatly assisted in her mission as the apostle of the Sacred Heart by the Jesuits, three of whom deserve special mention: St. Claude de la Colombière (1641-1682), the saint's confessor; Jean Croiset (1656-1738), author of the first theological treatise on the devotion; and Joseph François de Gallifet (1663-1749), promoter of this cause in Rome.

The iconography of the Sacred Heart, properly speaking, does not appear in Christian art until the late seventeenth century. It takes two principal forms. One is the Heart, depicted with a wound, encircled by a crown of thorns, and a small cross above, the whole radiating light and/or flames. The first such depiction was a pen drawing done, according to Margaret Mary's specifications, in 1685, by a novice at Paray-le-Monial: Jesus' Heart, with the word *Caritas* inscribed at its center, is pierced by nails, surmounted by a cross amidst flames, and encircled with a crown of thorns; the names of Jesus, Mary, Joseph, Anne, and Joachim surround this image. Subsequently, a second representation developed: the Sacred Heart on the breast of the person of Christ. In 1780, the Italian artist Pompeo Batoni painted an image of the Sacred Heart of Jesus for the Queen of Portugal. Batoni showed Christ holding in His left hand an enflamed Heart that had a little cross at its top and was encircled with a crown of thorns. The Congregation of Rites in Rome, in a directive of 1878, disapproved this form of representation; the visible figure of the Heart was required to be represented exteriorly on Christ's breast. A further clarification (1891) permitted images of the Heart alone for private devotion, but these were not to be displayed for public veneration. Images of the Sacred Heart became tremendously popular among the faithful, who often displayed them in their homes, mindful of one of the Lord's promises made at Paray-le-Monial: "'I will bless every dwelling in which an image of My Heart shall be exposed and honored'" (quoted by Bainvel, 49).

From Europe, devotion to the Sacred Heart was introduced to New Spain at the height of the Baroque era. This devotion enjoyed great popularity in Mexico, as did its iconography. The first place of worship dedicated to the Sacred Heart in Mexico was constructed in the eighteenth century in Mexitacán, Jalisco. Often the Heart alone was portrayed, as in an eighteenth-century Mexican oil painting on canvas, entitled *El Divino Corazón de Jesús*, "The Divine Heart of Jesus" (offered for sale at auction in Mexico City in

July 1993). The Divine Heart, against the background of the cross, encircled with the crown of thorns, and radiating light is surrounded by God the Father at the top and by two Jesuit saints on each side: Ignatius Loyola (1491-1556), Francis Borgia (1510-1572), Francis Xavier (1506-1552), and John Francis Regis (1597-1640). There is documentation that in eighteenth-century Mexico some artists became renowned for producing images of this kind. Even more interesting is the set of Stations of the Cross, in which the person of Christ is replaced by a large representation of His Heart, that was commissioned by Pedro Nolasco Leonardo for the Santuario de Jesús Nazareno de Atotonilco (1773). Nolasco was a vigorous promoter of the Sacred Heart devotion in the tradition of Margaret Mary, with whose writings he was quite familiar.

The second form of representing the Sacred Heart also appears in New Spain. For example, an early nineteenth-century Guatemalan tabernacle door by an unknown artist depicts this subject (Santa Fe, Collection of the International Folk Art Foundation at the Museum of International Folk Art, Museum of New Mexico). Executed in high relief in silver and silver gilt, the image of Jesus, showing His Sacred Heart on His breast, floats over puffy clouds. Jesus' hands bear the marks of the nails. The Heart has a small cross above it, is encircled with a crown of thorns, and emanates flames. Similarly, Catalogue 4 shows a half-figure of Christ, whose hands bearing the nail wounds draw back His robe to reveal His Heart that burns with love for humanity.

JFC

BIBLIOGRAPHY
Bainvel; *Butler's Lives of the Saints*, 4:134-38; *El corazón sangrante/The Bleeding Heart*; David-Danel; de Guibert, 392-402; Hamon; Juárez Frías, 62-63; Knipping, 1:119-20; de Margerie; Moell; Morris; O'Carroll, *Verbum Caro*, 107-108, 158-61; Palmer and Pierce, 123; Réau, vol. 2, part 2, 47-49, 51; Sebastián, *Arte iberoamericano*, 1:173-75, and *Contrarreforma y barroco*, 326-27;

5. LA SANTÍSIMA TRINIDAD
(The Most Holy Trinity), 13 1/4" x 10"
See Wilson, "Art and the Missionary Church in the New World," 18-26.

6. EL SEÑOR DE PLATEROS
(The Lord of Plateros), 10 1/2" x 7 1/2"

The inscription at the bottom of this *retablo* identifies it as *V. Yn.* [=Verdadera Imagen] *del Sr. de Plateros*, "True Image of the Lord of Plateros." *The Lord of Plateros* is a statue of the crucified Christ, carved in the late sixteenth century, that is venerated in the Mexican town of Plateros. According to legend, in the early seventeenth century there was an Indian uprising in northern Mexico. Consequently, a group of Christians, including Spaniards and Indians, who had settled near the silver mines fled to the south. A family of Spanish Christians carried with them a sculpted crucifix. One night, when the family had set up camp near the mine of Plateros, a group of mules became greatly agitated and stirred up a thick cloud of dust. Believing that they were being ambushed by Indians, the Spaniards fled in terror, without time to gather their belongings. The crucifix was abandoned and came into the possession of the parish priest. He placed it in a church in Plateros, where it remains today.

During the Colonial period, Mexican crucifixes were created from wood or *caña de maíz* (see Catalogue 19) and painted in flesh tones, known as *encarnación*. Christ's wounds were articulated with red paint that was periodically reapplied in order to maintain the vivid blood-like color. Human hair and glass eyes were often added, and a loincloth was wrapped around the waist of the figure, endowing the image with a stirring naturalism. Miracles were attributed to some images of the Crucifixion, and these statues were subsequently represented in Colonial Spanish paintings and in Mexican devotional *retablos*. *The Lord of Plateros* is distinguished by a triangular piece of red drapery, adorned with golden trim, that is attached to the crucifix.

CCW

BIBLIOGRAPHY
von Barghahn, "Colonial Statuary"; von Barghahn and Figueroa; Juárez Frías, 49; Stroessner, 25.

7. EL SEÑOR DE LAS PENAS
 (The Lord of Suffering), 14″ x 10″

This statue painting depicts a carved and dressed image of Christ Carrying the Cross. Curtains are pulled back to reveal the figure as it stands on an altar, flanked by two vases of flowers. Christ wears the scarlet robe that was thrown upon Him when Pilate's soldiers mockingly hailed Him as King of the Jews (Matthew 27: 28-29). A rope hangs around His neck, a detail often seen in Spanish and Latin American paintings of this subject, as in Alonso Cano's *Christ on the Road to Calvary* (1637, Worcester, Art Museum). In some Colonial Spanish paintings, and occasionally in Mexican devotional *retablos*, Christ is shown struggling to carry the cross as His persecutors lead Him by a rope, tied either around His neck or waist. Christ kneels on one leg, having fallen under the weight of the cross. Only the Evangelist John writes that Christ was forced to carry His own cross: "And He bearing His cross went forth into a place called the place of a skull, which is called in Hebrew Golgotha" (John 19:17). The statue seen in this painting is also portrayed on another Mexican *retablo* (see Giffords, *The Art of Private Devotion*, Catalogue 10), where the figure is identified by an inscription as *Vo. Ro.* [=Verdadero Retrato] *del Señor de las Penas*, "True Image of the Lord of Suffering."

The subject of Christ Carrying the Cross was frequently portrayed in Colonial Spanish painting and sculpture. The statues were carried on platforms through the city streets during Holy Week processions, when the events of Christ's Way to Calvary were reenacted. During the rest of the year, statues of the persecuted Christ, dressed in costumes that changed with the church calendar, remained within the churches. A fundamental purpose of these representations was to bring the viewer into an intimate and emotional dialogue with Christ. The spiritual value of looking upon the suffering Christ is perhaps best expressed in the writings of St. Teresa of Ávila (1515-1582), the extraordinary Spanish mystical author and reformer of the Carmelite Order. In her book *The Way of Perfection*, Teresa counsels the reader who feels despondent or experiences trials to picture Christ being persecuted: "Behold Him burdened with the cross, for they didn't even let Him take a breath. He will look at you with those eyes so beautiful and compassionate, filled with tears; He will forget His sorrows so as to console you in yours, merely because you yourselves go to Him to be consoled, and you turn your head to look at Him" (*Collected Works*, 1:134-135). Artistic depictions of Christ Carrying the Cross elicit an emotional response from the viewer, initiating the kind of exchange recommended by St. Teresa. Such images also provide visual material that could be stored in the memory and recalled later during periods of meditation.

CCW

BIBLIOGRAPHY
Alarcón Cedillo and García de Toxqui, 97-99, 102; Juárez Frías, 44; Martin, 54-57; Sebastián, "Diffusion of Counter-Reformation Doctrine," 75-76.

8. LA INMACULADA
(The Immaculate Conception), 12 ½" x 10"

9. LA INMACULADA
(The Immaculate Conception), 14" x 10"

The Immaculate Conception was solemnly defined as a dogma of faith by Pope Pius IX, in the Papal Bull *Ineffabilis Deus*, on December 8, 1854. The dogmatic formula was the following: that "the most Blessed Virgin Mary, in the first instant of her Conception, by a singular grace and privilege granted by Almighty God, in view of the merits of Jesus Christ, the Savior of the human race, was preserved free from all stain of original sin" (quoted by O'Carroll, *Theotokos*, 179). This definition was preceded by several centuries of vigorous promotion of this doctrine and of intense pressure on the Papacy to define it as dogma by religious Orders, such as the Franciscans, Carmelites, Mercedarians, and Jesuits, as well as by the Spanish monarchy, which in 1760 had placed Spain and its dominions under the protection of the Virgin Mary under her title of the Immaculate Conception. Defenders of this doctrine produced an enormous body of literature. The Jesuits alone wrote 300 works on the Immaculate Conception.

Numerous images of the Immaculate Conception were produced in Spain during the sixteenth and seventeenth centuries as part of a campaign to instruct the populace in this doctrine. This was done to establish the widespread support of the faithful that was required for the proclamation of this doctrine as dogma. In these images, the Virgin, depicted as the apocalyptic woman who is "clothed with the sun, with the moon under her feet, and on her head a crown of twelve stars" (Revelation 12:1) and who crushes the serpent's head, occupies the center of the pictorial space. To her right and left in the clouds and also in the landscape beneath her are depicted various symbols from the Old Testament that were applied to Mary. This genre is referred to as *tota pulchra*, an expression taken from Song of Songs 4:7, which in the twelfth century Abelard (1079-1142) identified with this Marian doctrine: *Tota pulchra es, amica mea, et macula non est in te*, "You are all-beautiful, my beloved, and there is no blemish in you." In Spain, the Valencian artist Juan de Juanes (ca. 1510-1579), in his painting *The Virgin "Tota Pulchra"* (ca. 1576-77), done for the Iglesia de la Compañía in Valencia, gave definitive and canonical form to this manner of representing the Virgin, at times placing the Biblical quotations that inspired the symbols alongside them. Francisco de Zurbarán's *Virgin of the Immaculate Conception* (1630), presently in the Museo Diocesano de Arte in Sigüenza (Spain), is the premier seventeenth-century Spanish example of this

genre. The subject of the *Tota pulchra* was tremendously popular in New Spain, where painters such as the Spaniard Alonso Vázquez (1605-1607, Mexico City, Hospital de Jesús) and the Mexican Baltasar de Echave Ibía (1622, Mexico City, Pinacoteca Virreinal de San Diego) rendered impressive interpretations of this theme.

Catalogue 8 and 9 conform to the *tota pulchra* iconographic formula. In both, the Virgin is the apocalyptic woman who is crowned with twelve stars, has the moon under her feet, and crushes the serpent. In Catalogue 8, the Virgin is flanked by two Marian symbols: the sun (Song of Songs 6:10) and the tower (Song of Songs 4:4). These symbols allude to the Virgin's epithets in the Marian litanies, such as that attributed to St. Turibius (1538-1606), archbishop of Lima, who is, equally with St. Rose of Lima (1586-1617), the first known saint of the New World: *Ut Sol electa, Turris David.* In Catalogue 9, several other Marian symbols appear: the cedar (Ecclesiasticus 24:13), star (derived from a medieval liturgical hymn), rose (Song of Songs 2:1), and palm tree (Song of Songs 7:7). These also refer to Mary's epithets from her litanies: *Cedrus fragrans, Stella maris, Rosa sine spina, Rosa puritatis, Palma virens gratiae.* Of importance in both *retablos* are the twelve stars that encircle the Virgin's head. These not only were part of the standard iconography of the Immaculate Conception but also served a devotional and mnemonic purpose. From the Middle Ages on, these stars were related to an abbreviated form of the rosary known as the *Stellarium.* This devotion became popular in the seventeenth century, due to the efforts of the religious Orders, most especially the Jesuits. The twelve stars represented variously Mary's virtues, her privileges, and the most important events of her life. These were accompanied by the recitation of prayers in tandem with the virtues or privileges or events to be contemplated. For example, the Flemish Jesuit Cornelius à Lapide (1567-1637), in his commentary on Revelation (1627), specified this format for this devotion: an *Our Father* in honor of God the Father, followed by four *Hail Marys* for the first four stars in honor of the Virgin's faith, hope, charity, and piety; an *Our Father* in honor of God the Son, followed by four *Hail Marys* for the second four stars in honor of Mary's humility, virginity, fortitude, and poverty; and an *Our Father* in honor of God the Holy Spirit, followed by four *Hail Marys* for the final four stars in honor of the Virgin's love of neighbor, obedience, compassion, and purity.

JFC

BIBLIOGRAPHY
Giffords, *Mexican Folk Retablos*, 46-47; Hamilton, "Virgin Mary," 5-6; Juárez Frías, 96-97; *Mexico: Splendors of Thirty Centuries*, Catalogue 130; O'Carroll, *Theotokos*, 179-82; Réau, vol. 2, part 2, 75-83, 126-27; Sebastián, *El barroco iberoamericano*, 140-41; Stratton; Trens, 149-90; Vargas Ugarte, 1:64-68.

10. **MATER DOLOROSA** or **NUESTRA SEÑORA DE LOS DOLORES**
(Sorrowful Mother or Our Lady of Sorrows), 14″ x 10″

11. **MATER DOLOROSA** or **NUESTRA SEÑORA DE LOS DOLORES**
(Sorrowful Mother or Our Lady of Sorrows), 12 ½″ x 9 ¾″

Also see Catalogue 33.

The roots of the veneration of the Virgin Mary's Seven Sorrows are to be found in the medieval movement of affective, meditative devotion to Christ's passion. Biblical evidence for Mary's participation in the passion is meager. Of the four evangelists, only John mentions Mary's presence at the foot of the cross (John 19:25). Consequently, Simeon's prophecy to Mary during Jesus' presentation in the temple provided the Scriptural foundation for her sufferings: "'This child is destined for the falling and the rising of many in Israel, and to be a sign that will be opposed so that the inner thoughts of many will be revealed—and a sword will pierce your own soul too'" (Luke 2:34). This "sword" was interpreted by medieval commentators on Scripture variously as a symbol of Mary's pain at the passion, as the counterpart of the lance used to pierce Christ's side, and as the embodiment of Christ's pain shared by His mother. Identification with Mary was regarded by theologians like St. Anselm (ca. 1033-1109) as a way of entering into the tragedy of Christ's sufferings. According to this view, the passion was meditated upon by imagining the Virgin's reactions: Mary's sufferings were used to arouse the meditator's own emotions by re-creating her pains to stimulate an affective response. By the late thirteenth century, affective descriptions of Mary's sorrows had been popularized by passion tracts and plays, sermons, hymns, and theological treatises. By the end of the Middle Ages, the figure of the suffering Virgin had evolved from a vehicle for empathetic understanding of Christ's passion to an independent object of veneration that offered the opportunity to venerate and to obtain the favors of a sympathetically inclined mother. Mary was someone with whom the faithful could readily identify. The Virgin's sufferings were immediately comprehensible as the anguish of a mother enduring the horrors inflicted on a beloved child, a figure perhaps easier to identify with than the suffering Christ Himself. Here as elsewhere in medieval Christianity, Mary could bridge the gulf between humanity and God, and make the mysteries of a remote divinity comprehensible in human terms. Moreover, Mary's suffering with her Son was taken as indicative of her compassion for all humanity; her ordeal had earned her tremendously efficacious intercessory power. Thus, her assistance was sought for adversities suffered in this life, as well as for personal salvation after death.

One way in which this devotion to Mary asserted itself as independent from that to Christ was in its numerical form. Like the Five Wounds or the Fourteen Stations of the Cross, Mary's Sorrows were enumerated. The Sorrows varied in number from five to 150, but the number that became canonical was seven. They were specified by the responsories at Matins of the feast of the Seven Sorrows that was commemorated on two separate days (the Friday after the fifth Sunday of Lent [made of universal observance by Pope Benedict XIII in 1727] and September 15 [first granted to the Servite Order, the principal devotion of which was to the Mother of Sorrows, in 1668, and extended to the Universal Church by Pope Pius VII in 1814]): the prophecy of Simeon, the flight into Egypt, the three-day loss of the twelve-year-old Jesus in the temple, Mary meeting Jesus on the way to Calvary, her standing at the foot of the cross, the taking down of Christ from the cross, and His burial.

Devotion to the Seven Sorrows was probably transplanted to the Americas from Andalusia, where it was extremely popular. In the New World, this devotion was zealously propagated by the Servites and by the Jesuits. The latter often commissioned altarpieces depicting the Mother of Sorrows. For example, in 1678 the Jesuit priest José Vidal, who was the author of several devotional works on the Virgin of Sorrows, commissioned an altarpiece of this subject from the Mexican artists Juan Correa, Tomás Juárez, and Alonso de Jerez for the Society's Church of San Pedro and San Pablo in Mexico City. An altarpiece of Our Lady of Sorrows was also produced ca. 1690 for the chapel of the Jesuit hacienda of Santa Lucía near Mexico City (Cuernavaca, Jorge Alberto Borbolla Villamil and Angela Malo de Borbolla Collection). Images of the *Mater Dolorosa* were also venerated elsewhere in Mexico. Since the early seventeenth century, an oil painting on linen of the Virgin of Sorrows was venerated in the parish church of Acatzingo in the archdiocese of Puebla. According to tradition, this image was left in the town ca. 1609 by a traveller, who never returned to reclaim it. Annually, on September 5, the feast of the *Sudor* (literally "sweat" or "perspiration") that commemorated Jesus' agony in the garden when "His sweat became like drops of blood falling on the ground" (Luke 22:44), the face of the Virgin would miraculously perspire. As many times as the perspiration was wiped away, it would reappear. In 1693, the Confraternity of the Virgin of Sorrows of Acatzingo was founded. Devotion to the Virgin of Sorrows flourished throughout the archdiocese of Puebla, as well as in Cajamarca in Peru, in Guatemala City, in Manare in Venezuela, and in Santiago de Cuba.

The symbolic sword piercing the Virgin's heart, rather than her soul, makes its first appearance in art in Germany in the thirteenth century. It provides a concrete image of

suffering that would be easily comprehensible to an unlearned audience; its purpose is to present vividly the torments of Christ and His mother, in order to enhance the emotional impact of the passion and to provoke the viewer's empathies. In Catalogue 10 and 11, the sword is replaced by a dagger that pierces the Virgin's heart. In these *retablos*, Mary, adorned with jewelry, is shown mourning, with her head veiled, hands clasped, and tears running down her face. Adjacent to her are the instruments of the passion or *arma Christi* (the weapons with which Christ conquered sin and death): the scourge, pillar, crown of thorns, nails, rod with sponge attached, and lance. To these are added the cock and Veronica's veil. These objects probably served as memory and meditative aids, being focal points for the worshipper's prayer since they recall Christ's specific sufferings. At the bottom of Catalogue 10 is a scroll that identifies the Virgin as *Mater Dei*, "Mother of God." Catalogue 33, an example of a statue painting, offers a simpler interpretation of this subject.

JFC

BIBLIOGRAPHY

Alarcón Cedillo and García de Toxqui, 84-85; *Butler's Lives of the Saints*, 3.554-55; Giffords, *The Art of Private Devotion*, 95, and *Mexican Folk Retablos*, 44-45; Hamilton, "Virgin Mary," 3; Juárez Frías, 75, 86; *Mexico: Splendors of Thirty Centuries*, Catalogue 146; Réau, vol. 2, part 2, 108-110, 128; Schiller, 2:184-86; Schuler; Trens, 223-32; Vargas Ugarte, 1:280-83, 300, 323-24, 417-18, 2:120-21.

12. NUESTRA SEÑORA DE LA CUEVA SANTA
 (Our Lady of the Sacred Cave), 12" x 9"

The province of Valencia in Spain is the place of origin of this subject. At the base of a high mountain in the diocese of Segorbe, there is a cave in which an image of the Virgin Mary is venerated under the title of "Our Lady of the Sacred Cave." The chapel is protected from the water that constantly drips from the cave's ceiling by a roof. This image is sculpted out of plaster and shows the Virgin in half-length. How the image came to this place is unknown. It is believed that it was the work of a Carthusian monk from the nearby monastery of Val de Cristo. The artist is identified as Fray Bonafacio Ferrer, who was a skilled sculptor. The monk gave this image as a gift to some local shepherds, who placed it in the cave that served as shelter for their flocks. Subsequently, as a result of landslides, the image remained buried in the cave and forgotten until the fifteenth century, when the Virgin appeared to a shepherd in the region, revealing to him where he would find her image, which she wished to be venerated in that very place. Once the image was discovered, the Virgin began to be honored at this site under the title of "Our Lady of the Sacred Cave." September 8 was observed as her feast day.

This Marian devotion was transplanted to Mexico in the eighteenth century. In 1741, the Virgin was already venerated there under this title. In that year, a novena in honor of Our Lady of the Sacred Cave was published, and a painting of her image hung in one of the principal churches of Mexico City. A lithograph of the original image venerated in Spain was also produced. In the next century, the presence of an image of this subject in the church of the Colegio de Propaganda Fide in Querétaro, where this devotion was promoted by Fray Miguel de Zavala, is documented. Subsequently, Fray Miguel received permission from the local bishop to build a chapel in honor of this image. This chapel was blessed on November 28, 1824. In the late nineteenth century, a larger sanctuary was constructed, where this image is venerated to the present day.

A late eighteenth-century Quitenian polychrome wood sculpture of Our Lady of the Sacred Cave (Milwaukee Public Museum) indicates that this advocation of the Virgin was also known in Ecuador. In the nineteenth century, it was introduced to Colombia, where in Bochalema there is a copy of the image venerated in Querétaro. A devout Catholic gentleman, Luis Eusebio González, was granted an extraordinary favor through the intercession of Our Lady of the Sacred Cave. González was afflicted with a sharp pain in his

face. A travelling salesman offered to sell him, among other things, an image of Our Lady of the Sacred Cave. González allegedly responded, "If this Virgin cures me of this pain that I'm suffering, I will not only purchase this image but I will also become her devotee." The salesman told González to take the image, and if on his return González had not been cured, he could return it to him. González was healed, and in thanksgiving he built a chapel in Bochalema for the Virgin under this title. This Marian devotion flourished and spread throughout the region.

Catalogue 12 is an especially fine rendering of this subject. A beautiful Virgin Mary appears in an elegantly ornamented bell-shaped grotto, atop of which is placed a crown. Mary's veiled cloak is joined by a lovely white flower. The Virgin is adorned with a necklace. In the background are rock formations and beautiful wild roses, perhaps a reference to her epithets *Rosa sine spina* and *Rosa puritatis* in the Marian litanies.

JFC

BIBLIOGRAPHY
Giffords, *The Art of Private Devotion*, 99, and *Mexican Folk Retablos*, 50-51; Hamilton, "Marian Subjects," 4; Juárez Frías, 92; Palmer, 107, 135; Vargas Ugarte, 1:66, 401.

13. NUESTRA SEÑORA DE LA ENCARNACIÓN or EL ALMA DE MARÍA
 (Our Lady of the Incarnation or The Soul of Mary), 14″ x 10″

14. NUESTRA SEÑORA DE LA ENCARNACIÓN or EL ALMA DE MARÍA
 (Our Lady of the Incarnation or The Soul of Mary), 14″ x 10″

Juárez Frías identifies some late eighteenth-century paintings, entitled *Imagen de la Virgen*, by the Mexican artist Manuel Caro as the prototype for this subject. This *retablo* subject is an allegory of the Incarnation: the dove of the Holy Spirit rests upon the breast of the Virgin in accord with the Archangel Gabriel's words to Mary in Luke 1:35: "'The Holy Spirit will come upon you, and the power of the Most High will overshadow you; therefore the Child to be born will be holy; He will be called Son of God.'" Mary is usually portrayed as a young girl wearing a white robe, a blue cloak, and a crown of roses. Her hands are crossed over her breast, as if pressing the dove toward her. She holds a staff of lilies in one arm, and roses in the other. The symbols of the lily among thorns and of the rose without thorns, derived from the Old Testament (Song of Songs 2:1-2), were applied to the Virgin Mary to refer to her sinlessness and virginity. They correspond to epithets in the Marian litanies: *Lilium castitatis, Rosa sine spina, Rosa puritatis*.

As St. Bernard of Clairvaux (1090-1153) observed, Mary's lily is not one that is carefully cultivated and nurtured in a garden, but a lily that buds and flowers in the wild without human intervention. Consequently, the lily is rarely absent in paintings of the Annunciation, whether it be in a vase or in the hands of Gabriel or of Mary, to indicate that Christ will be born of a virgin. This convention may be observed in numerous European and Colonial Mexican paintings of the Annunciation. The crown of roses may reflect the Virgin's advocation as Our Lady of the Rosary. The rose was also adopted as an emblem by numerous confraternities of Our Lady of the Rosary, and the presence of this flower in images of the Virgin may be an allusion to these pious societies. It has been noted that the Virgin's garland of roses in these *retablos* is akin in style to those worn by nuns on the day of their religious profession. Likewise, during the Romantic period in Mexico, portraits of deceased children often depicted them wearing a crown of roses and holding a lily, symbolizing their innocence and angelic nature. Twelve stars encircle the Virgin's head, and undoubtedly are related to the abbreviated form of the rosary known as the *Stellarium* (see Catalogue 8, 9).

Catalogue 13 and 14 offer contrasting interpretations of this subject. Catalogue 13 conforms closely to the conventional iconographic formula. In Catalogue 14, there are several departures from standard iconography: Mary wears no crown, the number of stars is reduced to six, and her hands are not shown. Lilies and roses are present, but float in midair. Nonetheless, stylistically Catalogue 14 is more refined and sophisticated than Catalogue 13.

JFC

BIBLIOGRAPHY
Giffords, *The Art of Private Devotion*, 92, and *Mexican Folk Retablos*, 40-41; Hamilton, "Virgin Mary," 2; Juárez Frías, 98; Trens, 296-99, 555-62; Vargas Ugarte, 1:66

15. Nuestra Señora de Guadalupe
(Our Lady of Guadalupe), 14″ x 10″
Also see Catalogue 46.

In December 1531, an Indian convert named Juan Diego was walking to hear Mass at Tlatelolco, just north of Mexico City. As he approached the hill of Tepayac, a site where the Aztec Mother Goddess Tonantzin had been venerated at the time of the Conquest, he heard a beautiful voice singing. He went up the hill to investigate and saw before him a young girl, around fourteen years of age, whose resplendence made the rock on which she stood and the surrounding mesquite trees and prickly pears seem like precious jewels. She told Juan Diego that she was the Virgin Mary, and that she wished to help him and his brethren. She instructed him to visit the local bishop, Fray Juan de Zumárraga, and request that a temple be erected in her honor on the hill of Tepayac.

The bishop listened to Juan Diego's story but turned him away, not believing the Indian's testimony. Juan Diego went back to the hill and told the Virgin what had happened, suggesting that she choose a more influential representative. The Virgin replied that she had chosen him. She sent him again to the bishop's house, and again the bishop rejected him, demanding proof of the Virgin's apparition. During Juan Diego's next meeting with Mary, she told him to climb to the top of the hill, gather the flowers there, and take them to the bishop. Though it was winter, Juan Diego found the hilltop covered with roses in full bloom. He collected them in his *tilma*, a cactus-fiber cloak, and set off for the bishop's house. When he opened his cloak to pour out the roses, a beautiful image of the Virgin looking just as she did when she appeared to Juan Diego, was imprinted onto the *tilma*. The bishop was convinced and immediately ordered that a shrine be constructed on the hill of Tepeyac. The miraculous apparition became known as the Virgin of Guadalupe, and Juan Diego's *tilma* bearing her image is today preserved in the Basilica of Guadalupe at Tepeyac.

Numerous miracles have been attributed to the Virgin of Guadalupe throughout Mexico's history. She saved Mexico City from a flood in 1621, and delivered it from an epidemic in 1737. She was named Patroness of Mexico City in 1737, and nine years later was declared Patroness of the Viceroyalty of New Spain. In 1747, Pope Benedict XIV granted an Office and Mass for the feast of Our Lady of Guadalupe. For the people of Mexico, she became a symbol of national identity. During the struggle for independence, rebels went into battle under banners of the Virgin of Guadalupe.

Colonial Spanish paintings of Our Lady of Guadalupe reproduce the miraculous image imprinted on Juan Diego's *tilma*. Enveloped in a golden mandorla, the Virgin wears a red gown and a blue mantle decorated with gold stars. She stands on a crescent moon, a feature that is seen in portrayals of the Virgin as the apocalyptic woman (see Catalogue 8, 9). An angel with outstretched arms grasps the hem of Mary's gown and mantle. Mary's figure is usually painted against a neutral background, creating the impression that she floats in an undefined space. In the corners of the composition, many Colonial artists inserted tiny scenes documenting the Virgin's apparitions to Juan Diego, and the episode of Juan Diego unfolding the *tilma* at the bishop's house. This feature is included in Catalogue 15. Our Lady of Guadalupe was portrayed by Mexican masters of the Colonial period such as Miguel González (1692, Madrid, Museo de América), Juan Correa (17th c., El Paso, Private Collection), Francisco Antonio Vallejo (1777, Seville, Collection Carlos Serra Pablo Romero), and Sebastián Salcedo (1779, The Denver Art Museum). She is a favorite subject of Mexican devotional *retablos*. Catalogue 46, a nineteenth-century oil painting on canvas, reproduces the image of Our Lady of Guadalupe as she is commonly seen in Colonial Mexican paintings and in *retablos*. In the corners, however, the artist has replaced the usual narrative vignettes with depictions of St. Anthony of Padua (upper right; see Catalogue 47) and three of the Latin Fathers of the Church: St. Ambrose and St. Augustine, who are both dressed as bishops, and Pope St. Gregory the Great, who wears the papal tiara.

CCW

BIBLIOGRAPHY
Alarcón Cedillo and García de Toxqui, 86; von Barghahn, "From the Tower of David to the Citadel of Solomon," 159-61; *Butler's Lives of Patron Saints*, 327-28; Giffords, *The Art of Private Devotion*, 22-23, 96-97, and *Mexican Folk Retablos*, 52-55; Gutiérrez Zamora; *Imágenes guadalupanos*; Juárez Frías, 24, 70-71; Pierce and Palmer, 90-92; Sebastián, *El barroco iberoamericano*, 165-66; Steele, 98-109.

16. NUESTRA SEÑORA DE LOURDES
(Our Lady of Lourdes), 14" x 10"

Between February 11 and July 16, 1858, four years after the definition of the dogma of the Immaculate Conception, the Virgin Mary appeared eighteen times to the fourteen-year-old Bernadette Soubirous (1844-1879), eldest daughter of an impoverished miller. These apparitions took place in the grotto of a rocky cliff that skirts the Gave de Pau River near Lourdes, a town at the foot of the Pyrenees in southwest France. Bernadette described the appearance of the Lady whom she saw as very beautiful: she was clad in white, with a blue sash, and a rosary hung over her arm. After calling for penance on February 24, the following day the Lady directed Bernadette to drink and to wash at a spring which came forth from the grotto as soon as Bernadette dug. Subsequently, some of the sick who took water from this spring were restored to health. During the apparition of March 25, the solemnity of the Annunciation, Bernadette asked the Lady who appeared to her: "'Would you kindly tell me who you are?'" At this, the apparition smiled but made no reply. Bernadette repeated her question two more times. The Lady, joining her hands on her breast and raising her eyes to Heaven, responded in the dialect of Lourdes: "'I am the Immaculate Conception.'"

Reports of the favors received in the sacred grotto quickly spread, and the faithful began to flock to Lourdes. In 1862, after a formal canonical inquiry into these events, the local bishop authorized veneration of the Virgin under the title of "Our Lady of Lourdes" to be held in the grotto itself. Before long, a Gothic church, which became a basilica in 1870, was built above the grotto. Adjacent to it, the magnificent Rosary Basilica was completed in 1901. Millions of pilgrims have visited the shrine, where a medical bureau of physicians investigates the character of the cures. Pope Leo XIII sanctioned a local feast of the apparition of Our Lady of Lourdes (February 11) in 1891, and Pope St. Pius X extended it to the Universal Church in 1907. Our Lady of Lourdes is patroness of Portugal and of the Philippines.

Bernadette entered the Sisters of Charity and Christian Instruction at Nevers in 1866. She died in 1879. She was beatified in 1925 and canonized in 1933. Bernadette took no part in the development of Lourdes as one of the greatest pilgrim shrines in the history of Christendom; she sought to live a completely self-effaced life. She was canonized not for her visions, but for the humble simplicity and trust in God that characterized her whole life.

Devotion to Our Lady of Lourdes was introduced to Mexico during the reign of the Emperor Maximilian of Hapsburg (1864-67). It was most popular at the imperial court.

It also flourished in Venezuela and in Chile. Catalogue 16 depicts the apparition of the Virgin to Bernadette. The Mother of God is dressed exactly as Bernadette described; a crown and a ring of stars are added. The Virgin appears in a grotto, whence a rosebush bloomed in winter as a miraculous sign of her presence, and water flows, a reference to the healing spring. Bernadette prays the rosary, as she often did during the apparitions.

JFC

BIBLIOGRAPHY
Attwater, 62; *Butler's Lives of the Saints*, 1:298-302; Farmer, 43-44; Hamilton, "Virgin Mary," 8; Juárez Frías, 94; Vargas Ugarte, 1:440, 2:400; Zimdars-Swartz, 43-67.

17. **NUESTRA SEÑORA DEL PATROCINIO DE ZACATECAS**
(Our Lady of the Patronage of Zacatecas), 14" x 10"

Spanish *conquistadores* founded the city of Zacatecas in 1546, and since that time the city's inhabitants have venerated a dressed statue of the Virgin, produced in Spain, that is now housed in the eighteenth-century Sanctuary of Our Lady of Patronage. The statue, as it is represented in this *retablo*, wears a gold crown and stands on a crescent moon, in accordance with images of the Virgin as the apocalyptic woman (see Catalogue 8, 9). She supports the Christ Child with her left arm, and in her right hand holds a cluster of roses (today the actual statue holds a golden scepter instead of roses). The figure is enveloped in a mandorla of golden rays. In the painting, the base of the statue has been transformed into a cloud, adorned with the winged head of a Cherub. Unlike most statue paintings, this *retablo* does not attempt to portray the carved image standing on an altar. Instead, the figure of the Virgin is shown floating against a neutral background, like many images of the *Virgin of Guadalupe* (see Catalogue 15, 46).

Our Lady of the Patronage of Zacatecas, as the statue is named, has been invoked to ward off various calamities throughout the city's history. A number of painted *ex-votos*, housed within the Sanctuary, document requests for her intervention. One such image, dated 1879, begs her to save the city from a plague, and another, dated 1892, invokes her to bring an end to a long drought.

CCW

BIBLIOGRAPHY
Juárez Frías, 74, 195-97.

18. **NUESTRA SEÑORA, REFUGIO DE PECADORES**
(Our Lady, Refuge of Sinners), 14″ x 10″

An early eighteenth-century image of the Virgin Mary, venerated in Poggio (Italy), is the prototype for this subject, the title of which corresponds to an epithet in the Marian litanies (*Refugium peccatorum*). In 1709, a copy of this image was brought to Mexico by the Jesuit Blessed Anthony Baldinucci (1665-1717). This image became the object of great devotion by the faithful and was credited with the conversion of numerous sinners, hence it began to be called "Refuge of Sinners." On July 4, 1717, the image of Our Lady, Refuge of Sinners was, with papal approbation, canonically crowned. In 1744, a copy of this image made in Mexico City was placed in the chapel of the Franciscan Colegio de Guadalupe de Propaganda Fide in Zacatecas. Images of Our Lady, Refuge of Sinners were also venerated in Puebla and in Guatemala City. The image that Baldinucci carried to the New World is presently preserved in the cathedral in Frascati (Italy).

The subject of Our Lady, Refuge of Sinners enjoyed great popularity throughout Mexico, accounting for approximately twenty-five percent of the entire production of *retablos*. Besides paintings, prints of this subject, such as the 1798 engraving that Romero de Terreros y Vinent illustrates, were artistic sources for *retablo* artists. The Franciscans of the Colegio de Guadalupe widely disseminated this Marian advocation. The devotion became so popular that in 1832 Pope Gregory XVI acceded to a petition by the Mexican hierarchy and instituted an annual feast of Our Lady, Refuge of Sinners (July 4), with a proper Mass and Office. The image of Our Lady, Refuge of Sinners is found even in the most humble homes in Mexico. After Our Lady of Guadalupe, it is considered the "most Mexican" Marian image.

In Catalogue 18, the figures of the Virgin and Christ Child appear in an oval, with colorful flowers decorating the outer corners. This composition derives from Colonial Mexican flower garland "picture-within-the-picture" paintings, which were inspired by the works of seventeenth-century Flemish artists, such as Peter Paul Rubens, Jan Brueghel the Elder, and the Jesuit lay brother Daniel Seghers (see Chorpenning, "The Iconography of St. Joseph in Mexican Devotional *Retablos*," 62-63). This manner of presenting the image of Our Lady, Refuge of Sinners emphasizes its importance as an object of veneration, since any homage paid to the image passed to its prototype. It may also reflect the practice of draping garlands of flowers around religious images for feast and holy days. In almost all other respects, this representation of this subject is standard. Mary appears as a half-length figure

seated, and Jesus as a full-length figure standing upon clouds. The Virgin wears a red dress decorated with flowers and a blue cloak that is ornamented with her monogram (MAR), as well as that of Jesus (IHS). Although the Christ Child often wears a transparent robe in *retablos* of this subject, here He is barely covered with a scarf like that which Mary wears around her neck. The Child rests His right hand on Mary's right arm and grasps her right thumb in His left hand. The Virgin is adorned with jewelry, and both she and the Child are crowned. Thirteen stars visibly encircle the Virgin and Child; there seems to have been an additional star at the top of the *retablo* where the paint has slightly flaked. Again, these are probably related to the devotion of the *Stellarium* (see Catalogue 8, 9).

JFC

BIBLIOGRAPHY
Alarcón Cedillo and García de Toxqui, 87; *Butler's Lives of the Saints*, 4:292-93; Freedberg; Giffords, *The Art of Private Devotion*, 93-95, and *Mexican Folk Retablos*, 62-64; Hamilton, "Virgin Mary," 3; Juárez Frías, 72-73; Romero de Terreros y Vinent, 65; Tylenda, *Jesuit Saints & Martyrs*, 399-401; Vargas Ugarte 1: 256-59.

19. NUESTRA SEÑORA DEL ROSARIO DE TALPA
(Our Lady of the Rosary of Talpa), 14" x 10"

This *retablo* portrays a miraculous statue of Our Lady of the Rosary that dates from the seventeenth century and is venerated in the town of Santiago de Talpa. The carved figure of the Virgin holds a white rosary in one arm, and with the other supports the Christ Child, who also clutches a rosary. She stands on a crescent moon, and her head is surrounded by a golden halo and twelve stars, in accordance with the prescribed iconography of the Immaculate Conception (see Catalogue 8, 9). Painted and sculpted images of the Virgin of the Rosary were propagated in the New World by members of the Dominican Order, because the founder of the Order, Santo Domingo de Guzmán (St. Dominic), was credited with instituting the devotion of the rosary. Accounts of St. Dominic's life affirm that in the year 1208 the saint implored the Virgin to save the Church. She appeared to Dominic and presented him with the rosary, commanding him to go forth and preach. Arriving in the Viceroyalty of New Spain in 1526, the Dominicans played a major role in the process of evangelization.

During the Colonial period, images of the Virgin were carved from wood or, in the case of Our Lady of the Rosary of Talpa, *caña de maíz* (corn stem). The technique of *caña de maíz* involved constructing a corn stem frame, onto which the artist molded a figure, using a mixture of corn paste, paper, and glue. A layer of gesso was applied, and once the figure was carved to a desired shape, it was painted and costumed in elaborate brocades, silks, or embroidered fabrics. Since the statues were dressed, usually only the face, hands, and feet were carved and painted to simulate flesh; the rest of the statue consisted of beams and supports, hidden beneath the costume. Glass eyes and human hair were often added to heighten the naturalistic effect. The statues were further adorned with gold or silver crowns and jewelry. Clothes and jewels used for dressing the statues were often kept in a special room behind the altar called a *camarín*. Throughout the year, the Virgin's costume would be changed. In this *retablo*, the statue of Our Lady of the Rosary of Talpa is shown wearing a triangular-shaped gown and mantle decorated with roses, a gold crown, earrings, rings, and a pearl necklace.

The history of Our Lady of the Rosary of Talpa is recorded in an account compiled by the seventeenth-century priest Pedro Rubio Félix and is preserved in the sanctuary of Talpa, where the statue is now housed. This chronicle states that in the year 1644, on the occasion of the feasts of St. James the Greater and the Immaculate Conception, villagers gathered at

the local church for vespers. When Father Rubio arrived, he found that some statues of Christ, the Virgin, and saints, kept on the altar, were so worm-eaten and deteriorated that they did not inspire devotion. After celebrating the feasts, he ordered that the images be wrapped in some old altar cloths and buried in a hole in the sacristy, so that they would not have an adverse effect on the piety of the villagers. On September 19 of that same year, a young woman named María came to the church and proceeded to remove the statue of Our Lady of the Rosary. This image was one of the most disfigured, since it was very old and made from cane. When María picked up the statue, a great radiance suddenly burst forth from the image, blinding the young woman and throwing her down, so that she fell, as if dead, onto the statue's pedestal.

When a group of villagers, who were sweeping out the church, rushed over to see what had happened, María declared to them that the deteriorating statue of the Virgin had been transformed, so that it sent out rays of fire surrounded by clouds. The villagers approached the altar to look at the statue, and they too witnessed the same miraculous phenomenon. Other inhabitants of the village came running to the church. Two candles of medium size were set up to burn near the statue. When Father Rubio himself arrived at the church four days later, he found that these candles, miraculously, had not burned down. He took a deposition of the unusual events, gathering testimony from both Indians and Spaniards who had been present. While collecting information, he investigated the origin of the statue, and found that it had originally belonged to an Indian named Diego Felipe, who had kept it in his house for many years. Diego's son donated it to the church, where it had been kept on the altar and had deteriorated over time.

In 1901, the local bishop, D. Ignacio Díaz, named Our Lady of the Rosary patroness of the town of Santiago de Talpa. In 1921, Bishop Manuel Azpeitia y Palomar, at the insistence of devotees of Our Lady of the Rosary of Talpa, obtained permission from the Holy See for a canonical coronation of the statue. This ceremony was held on May 12, 1923.

<div style="text-align: right">CCW</div>

BIBLIOGRAPHY
von Barghahn, "Colonial Statuary"; von Barghahn and Figueroa, 147-49; Duncan; Giffords, *The Art of Private Devotion*, 98; Vargas Ugarte, 1: 286-89.

20. **NUESTRA SEÑORA DE LA SOLEDAD DE SANTA CRUZ**
 (Our Lady of Solitude of Santa Cruz), 14" x 10"

Like Catalogue 19, this *retablo* depicts a dressed statue of the Virgin, identified by an inscription as *N. S. de la Soleda de Santa Crus D.M.*, "Our Lady of Solitude of Santa Cruz of Mexico." Statues of Our Lady of Solitude show Mary, dressed in mourning, sorrowfully contemplating the events of the passion and holding a white cloth with which to wipe the tears from her eyes. In this painting, the carved figure of the Virgin, dressed in black, stands in front of a cross, and with clasped hands mourns the death of her Son. A single dagger pierces her heart, as in the portrayal of the *Mater Dolorosa* in Catalogue 33. The statue is surrounded by medallions portraying the five Sorrowful Mysteries of the rosary (clockwise from upper left): the Agony in the Garden, the Scourging at the Pillar, the Crowning with Thorns, the Crucifixion, and the Carrying of the Cross. Flanking the figure of the Virgin are instruments of the passion: on the viewer's left are the cock, the column of flagellation, the hand of the betrayer, the money pouch, the hammer, the lantern (carried by the soldiers and police in the garden of Gethsemane), and an angel holding three nails. On the viewer's right are the ladder, Christ's robe, the sword (with which Peter cut off Malchus' ear), and the pitcher of water (used to wash Pilate's hands of Christ's blood). Above the statue's head, nailed to a cross, is the veil of Veronica (see Catalogue 1, 2) and on either side of the veil is the spear and the sponge soaked with vinegar. The eye of God hovers above the cross.

Statues of Our Lady of Solitude were carved from wood or *caña de maíz* and dressed in richly embroidered or brocaded black fabrics. Crystal teardrops were sometimes applied to the Virgin's face to heighten the emotional impact of the image upon the viewer. The limbs of the statues were usually fastened to moveable joints, so that the figure could assume various postures during reenactments of the passion and during processions, when the image would be carried on a platform through the streets of the city by members of *cofradías*, or religious brotherhoods. During the ceremony of the *Descendimiento y Sepulcro*, "Descent from the Cross and Burial," held in some Mexican churches on Good Friday, a carved image of Christ is lowered from a cross, while a statue of Our Lady of Solitude stands nearby. The priest ceremoniously hands the instruments of the passion, one by one, to the statue of the mourning Virgin, who holds each object in the white cloth in her hands and bows her head. Our Lady of Solitude is then carried in a funereal procession, as the body of Christ is taken to the sepulcher.

Statue paintings of Our Lady of Solitude were produced in Mexico, as well as in Central and South America during the Colonial period. In the nineteenth century, this practice continued in Mexican devotional *retablos*. Usually, the dressed statue is shown standing on an altar and flanked by burning candles, but in this *retablo* an altar is not articulated, and the statue is integrated into a more emblematic composition in which space is not clearly defined. *Our Lady of Solitude of Santa Cruz* was also depicted in nineteenth-century Mexican prints (see Wroth, 88), one of which may have served as the immediate source for this *retablo*.

CCW

BIBLIOGRAPHY
von Barghahn, "Colonial Statuary," 79; von Barghahn and Figueroa, 147-48; Giffords, *The Art of Private Devotion*, 10; Juárez Frías, 77-78; Palmer and Pierce, 31; Wroth, 21-23.

21. LA PIEDAD
(The *Pietà*), 10" x 7"

Pietà is the Italian name for an image of the Mother of God holding the dead Christ in her lap. This image first appeared in the late thirteenth century in German convents of contemplative nuns. Its origin lies in medieval meditative devotion to Christ's passion. The primary focus of veneration in these images was not Mary's grief, but the redemptive wounds of the dead Christ as He lay in His mother's lap. For example, St. Mechtilde of Hackeborn (ca. 1241-1298), Benedictine nun, mystic, and mentor of St. Gertrude the Great (ca. 1256-1302), records in her *Book of Special Graces* that, while at prayer before a *Pietà* one Good Friday afternoon, she was graciously requested by the Virgin herself to meditate not on Mary's lamentation but on the adoration of the Redeemer. Such images, in churches usually placed on secondary altars in close proximity to the faithful, were often venerated for their miraculous effects.

The *Pietà* is not to be confused with the Lamentation, the main theme of which is mourning of the dead Christ. By contrast, the *Pietà* is imbued with the spirit of medieval German mysticism, which emphasized self-surrender, trust, and union with the divine. In the *Pietà*, the mystery of the Incarnation of God and that of His sacrificial death stand face to face. Rather than truly grieving, Mary is depicted as moved and thoughtful as she holds the dead Christ with the five wounds. Sometimes Mary looks at her dead Son, other times she looks heavenward or at the viewer. In any event, she exhibits Christ's body for the worshipper's adoration. The five "redemptive" wounds are always visible: that in Christ's side is especially deep, and blood drips from all five wounds. In the *Pietà*, the grief characteristic of the Lamentation is transfigured in Mary's rapturous and pensive expression. The *Pietà* is a pendant to the image of the Mother of God in whose lap the Christ Child sits or lies as she either presents Him for adoration or gazes reflectively at Him.

The subject of the *Pietà* appears after 1400 in Italy, where it was rendered in sculpture three times by Michelangelo Buonarroti (1475-1564). France adopted it a little earlier, but there the *Not Gottes* or *Pitié de Nostre-Seigneur*, which portrays God the Father's presentation or exhibition of His dead Son, a pictorial parallel to the *Pietà*, was more common. In Spain, there are examples of the *Pietà* that go back to the fourteenth century. The *Pietà* was a popular subject in Spanish painting of the Golden Age. It was painted more than once by masters such as El Greco (1541-1614), Bartolomé Esteban Murillo (1617-1682), and Jusepe

de Ribera (1591-1652). For example, El Greco's first *Pietà* (ca. 1574-1576, New York, Hispanic Society of America) combines elements from two of Michelangelo's sculptures of this subject; his later *Pietà* (ca. 1580-1590, London, Stavros S. Niarchos Collection) reveals the dramatic change that occurred in El Greco's style after his arrival in Spain. One of the most outstanding Spanish examples of this subject is Luis de Morales' *Pietà* (1560-70), originally executed for the Jesuit church in Córdoba, but now in the Real Academia de Bellas Artes in Madrid. It has been suggested that, in his interpretation of devotional subjects, Morales, known as "El Divino," may have been influenced by the mystical writings of St. John of Ávila (1500-1569) and of the Dominican friar Luis de Granada (1505-1588). This literature was particularly popular in the region around Badajoz, where Morales spent his working life. In fact, Morales' *Pietà* has been related to a passage from Granada's *Book of Prayer and Meditation*, which was first published in 1554 and became the number one best-seller of the Spanish Golden Age. This link serves as a reminder of the fundamentally mystical nature of the *Pietà*. Given the importance of this subject in Spain, its appearance in the art of New Spain is hardly surprising.

Catalogue 21 depicts the *Pietà* against the background of the cross in a dense lush landscape, alluding to the garden in the place where Christ was crucified (John 19:41). Mary's eyes look away from the viewer and are cast heavenward in rapture. The dagger that pierces her heart is an evident reminder of her suffering (see Catalogue 10, 11). The Virgin presents the dead Christ, whose wounds are clearly visible and bleeding, for the contemplation and adoration of the worshipper. Around the figure of Mary and the dead Jesus are the instruments of the crucifixion and deposition, together with other objects associated with the passion: the nails, lance, ladders, pliers, rod with sponge attached, cock. The dark sky with the sun and the moon evokes the darkness that the Synoptics report came over the earth at Christ's death (Matthew 27:45; Mark 15:33; Luke 23:44).

JFC

BIBLIOGRAPHY
Brown, *The Golden Age of Painting in Spain*, 49-52, 70, 190-91, 264, and "El Greco and Toledo," 88; Esteban and Gaya Nuño, 99, 117; Giffords, *The Art of Private Devotion*, 92, and *Mexican Folk Retablos*, 42-43; Hamilton, "Virgin Mary," 3, 4-5; Jordan, 235; Juàrez Frías, 87; Pérez Sánchez and Spinosa, 21, 27; Réau, vol. 2, part 2, 103-108, 128; Schiller, 2:179-81; Trens, 204-22; Whinnom, 194.

22. SAN ACACIO

(St. Acacius), 10" x 7"

There is disagreement about the dates and details of the martyrdom of St. Acacius. Most scholars regard Acacius as a legendary second-century saint, who, together with 10,000 Roman soldiers under his command, suffered martyrdom. According to this legend, Acacius and 9,000 soldiers had been dispatched to subdue a large force of Syrian rebels. Outnumbered, Acacius and his company were told by an angel that if they converted to Christianity, they would be victorious. Afterward, the angel led the new converts to Mt. Arrat in Armenia, where they were eventually tracked down by the imperial army and martyred. Acacius and his soldiers were flogged, crowned with thorns, and stoned. However, the hands of those stoning the martyrs withered, and the stones they threw boomeranged. These miraculous occurrences moved 1,000 more soldiers to join Acacius and his companions in martyrdom. Finally, all were crucified or impaled. After languishing for six hours, the martyrs asked God to grant health of mind and body to anyone who venerated their memory. A voice from Heaven assured the martyrs that their prayers were heard. Their bodies were buried by angels.

The information on Acacius provided in *Butler's Lives of the Saints* differs significantly from that offered by other scholars. According to Butler, Acacius was a centurion from Cappadocia in the Roman imperial army who suffered martyrdom ca. 303-305, and one of two genuine ancient martyrs of Byzantium. Details of the saint's martyrdom are found in the *Acts of Acacius* that were originally composed in Greek, but also exist in an ancient Syriac version. This text specifies that after Acacius was denounced by the tribune Firmus at Perinthus in Thrace, he was cruelly tortured under the judge Bibienus. Subsequently, Acacius was taken to Byzantium, where he was suspended from a walnut tree and publicly flogged before being beheaded.

Several churches in Constantinople are dedicated to Acacius. One of these was constructed by Constantine and nicknamed "the Walnut" since built into its structure was the walnut tree from which Acacius was hung for scourging. In the Middle Ages, Acacius and his companions were proposed to the crusaders as models of courage and faith in God. Acacius' cult thrived in Switzerland and Germany, as is evidenced by several notable works of art executed between the thirteenth and the sixteenth centuries, including a fifteenth-century stained-glass window at Berne that provides a complete pictorial account of his

martyrdom. Relics of Acacius were claimed by Cologne, Prague, and other towns. In the late fifteenth century, the Spanish artist Francisco Gallego painted *The Martyrdom of St. Acacius and the 10,000 Martyrs of Mt. Arrat* (ca. 1490, Dallas, The Meadows Museum, Southern Methodist University). Gallego ignores the Roman setting and dresses the martyrs in the courtly fashions of Spain of the Catholic Monarchs (as Ferdinand and Isabella were designated by Pope Alexander VI in 1494), perhaps even of Salamanca, where the artist often worked and whence this painting originally came.

Acacius was often included among the so-called "Fourteen Holy Helpers," a group of saints who enjoyed a collective cult in the Rhineland from the fourteenth century because of the efficacy of their intercession against various diseases (Acacius was invoked to cure headaches) and for salvation at the hour of death. This devotion was widespread in Germany, Hungary, and Sweden. It reached its apogee in the fifteenth century. In the sixteenth century, the cult was attacked by the Protestant reformers and discouraged by the Council of Trent (1545-1563), but it enjoyed a revival during the Baroque period.

Catalogue 22 depicts Acacius much as he is in the *retablo* of the saint illustrated in Juárez Frías (113). Acacius is shown wearing a crown of thorns and crucified, after having been defeated in battle. His clothing and insignia are those of the French occupation forces, which set up Maximilian of Hapsburg as emperor in Mexico in 1864 and provided the necessary military support for his brief three-year reign. At the base of the cross are two Mexican flags; Acacius' sash also bears the colors of the Mexican flag. Juárez Frías suggests that the figure of Acacius alludes to the Emperor Maximilian, who, after the withdrawal of French troops in 1867 (due to opposition in the French press and parliament to this Mexican venture) and the defeat of his own small army, was executed by Mexican republican forces on June 19, 1867.

JFC

BIBLIOGRAPHY
Butler's Lives of the Saints, 2:250-51; Burke, 4; Farmer, 2, 167; Giffords, *The Art of Private Devotion,* 103, and *Mexican Folk Retablos,* 76-77; Juárez Frías, 113; Réau, vol. 3, part 1, 13-15; Steele, 180; Wilder and Breitenbach, Plate 1.

23. SAN ANACLETO, PAPA
(St. Anacletus, Pope), 10" x 7"

St. Anacletus or Cletus was born in Athens. He was pope from ca. 79 to ca. 91, when he probably died as a martyr during the reign of Domitian (81-96). In the Roman Canon of the Mass, Cletus is named as the third pope, being preceded by Peter (died ca. 64) and Linus (died ca. 79). Little is known about Cletus for certain. The division of Rome into twenty-five parishes is dubiously attributed to him. Cletus' feast day is April 26.

Catalogue 23 portrays Cletus vested in an alb and a Roman purple conical-style chasuble, edged at the neck with gold galloon decorated with two small crosses. In his right hand, the saint holds a quill; in his left, a scroll with the word *Oremus*, "Let us pray," perhaps a reference to his name being included in the Canon of the Mass. The dove of the Holy Spirit hovers overhead, amidst clouds. In this context, the Spirit's presence refers to His role as the Advocate sent to guide and direct the Church (cf. John 14:15-31). Not only does Cletus have a halo, but also a nimbus of light. A standing crucifix and the papal tiara rest upon a table draped with a crimson cloth. To Cletus' left is a crosier with the Greek cross with three transverse bars. A Greek cross with two transverse bars appears at the top both of the dome and of the tower of the basilica in the background. Undoubtedly, these crosses allude to Cletus' Greek origin.

JFC

BIBLIOGRAPHY
Attwater, 87; *Butler's Lives of the Saints*, 2:163; Farmer, 92; Juárez Frías, 142; Réau, vol. 3, part 1, 70.

24. SAN CAMILO DE LELIS
(St. Camillus de Lellis), 10 1/2" x 7 1/2"

Born in 1550 at Bucchianico in the Abruzzi region in central Italy, St. Camillus de Lellis was an exceptionally tall man (6' 6"). At age seventeen, he joined the Venetian army to fight aganist the Turks. However, he contracted an ulcer on his right foot that afflicted him for the rest of his life. In 1571, he was dismissed from the San Giacomo hospital for incurables in Rome for his quarrelsomeness. He spent the next four years in the Venetian army (1571-1574). Addicted to gambling, Camillus was subsequently reduced to indigence and was forced to work as a builder's laborer at a Capuchin monastery in Manfredonia in Apulia in southeast Italy. A sermon by a Capuchin friar was the catalyst for his conversion in 1575. He entered the Capuchin novitiate as a coadjutor brother, but soon left because his foot became ulcerated once more. Camillus returned to San Giacomo, where, after his foot healed, he remained for almost three years working with the sick. He then returned to the Capuchins (1579), but his wound opened again and he was forced to leave. Camillus' own sufferings drew his attention to those of others, and he now decided to dedicate his life to the care of the sick. He returned to San Giacomo, where he was asked to serve as the hospital's superintendent. In this position, Camillus diligently strove, despite obstacles and opposition, to improve physical and spiritual conditions.

On the advice of his spiritual director, St. Philip Neri (1515-1595), Camillus had begun studies for the priesthood and was ordained in 1584. He gathered others around him who wanted to share his work and founded a congregation of priests and lay-brothers, the Order of the Servants of the Sick, devoted to offering physical and spiritual assistance to the plague-stricken, the sick in hospitals or in their own homes, prisoners, galley-slaves, and especially the dying. Camillus and his Order, which received papal approbation in 1591, served the sick with so much affection and diligence that it was evident to all who witnessed their ministry that they considered Christ Himself as lying sick or wounded in His members. During his lifetime, Camillus oversaw the foundation of fifteen houses of his Servants and of eight hospitals. He also sent out the first recorded "military ambulance unit," when, in 1595 and 1601, some of his religious cared for the wounded and dying on battlefields in Hungary and in Croatia. Camillus was a pioneer in the field of health care, insisting on such innovations as open windows, suitable diets, and isolation of contagious cases. His priests were always prepared to minister to the dying, and experience had taught

Camillus the need for special precaution, lest patients be buried while still alive. God acknowledged Camillus' zeal and selflessness by bestowing on him the gifts of prophecy and of miracles, as well as numerous divine communications and favors.

Camillus resigned the canonical leadership of his Order in 1607. Although his health deteriorated, he continued to visit his hospitals and care for patients almost until the day of his death. The saint died in Genoa, on July 14, 1614, at the age of sixty-four. Canonized a saint by Pope Benedict XIV in 1746, Camillus was proclaimed patron of the sick and of hospitals by Pope Leo XIII in 1886, and of nurses and nursing associations by Pope Pius XI in 1930. He is the patron of the city of Rome and is also invoked for a happy death. His feast day is July 14. Camillus' cult was particularly popular in nineteenth-century Mexico. Often lacking any medical care, the inhabitants of isolated *pueblos* particularly suffered from the disastrous effects of the numerous civil wars that ravaged the country and from epidemics. Confronted by sickness and death on all sides, the faithful often invoked the intercession of Camillus de Lellis.

A frequent subject in *retablo* art, Camillus usually appears ministering to a dying man. By contrast, Catalogue 24 depicts Camillus as a tall, imposing, full-length figure. He holds a crucifix and wears the habit of the Servants of the Sick, with its characteristic red cross on the right breast. To the saint's left, an angel, seated upon clouds, holds the open book of the rule of Camillus' Order, as the inscription reveals: *Consti[tuciones] de los Cléi[igos] Regular[es]*, "Constitutions of the Clerks Regular." The term "Clerks Regular" refers to certain Orders of Roman Catholic priests who live in community and engage in active pastoral work. The Servants of the Sick were reckoned as Clerks Regular once they received papal approbation. At the bottom of the *retablo* is an inscription that discloses Camillus' principal advocation: *Camillo de Lelis, Avogado de los enfermos [y] agonisantes*, "Camillus de Lellis, advocate of the sick and dying."

JFC

BIBLIOGRAPHY
Attwater, 75; *Butler's Lives of the Saints*, 3:134-36; Farmer, 70-71; Ferrando Roig, 67-68; Giffords, *The Art of Private Devotion*, 106, and *Mexican Folk Retablos*, 88-89; Juárez Frías, 164-65; Réau, vol. 3, part 1, 256-57; Steele, 182; Tylenda, *Saints of the Liturgical Year*, 84-85.

25. Santa Eduviges
(St. Hedwig), 14″ x 10″

St. Hedwig, Duchess of Silesia (a region in eastern central Europe that formerly was part of Germany but is now chiefly in northern Czechoslovakia and southwest Poland), was born in Andechs in Bavaria ca. 1174. The daughter of Berthold IV, Count of Andechs, Hedwig was, through her sister, an aunt of St. Elizabeth of Hungary (1207-1231). After spending her childhood in a monastery, the saint was married at age twelve to Henry, Duke of Silesia, who was then eighteen. They had seven children, some of whom were the cause of considerable distress to their parents. Only one, Gertrude, who became abbess of the Cistercian monastery of nuns at Trzebnica, survived Hedwig. The saint admirably fulfilled the duties of wife and mother. With her husband, she constructed the first convent of religious women in Silesia (the Cistercian monastery at Trzebnica), as well as founded and supported houses of Augustinian canons, Cistercian monks, and Dominican and Franciscan friars. After the birth of their last child, Hedwig and Henry made a vow of mutual continence. When her husband died in 1238, Hedwig retired to the Cistercian convent at Trzebnica. Although she wore the Cistercian habit, she did not take vows, so that she might be free to administer her estate for the relief of the poor and suffering. Hedwig died on October 15, 1243, at Trzebnica, where she is buried. She was canonized by Pope Clement IV in 1267. Her feast day is October 16. Hedwig is the patroness of Poland, of Silesia, and of Wroclaw, the capital of Silesia. The principal centers of her cult are Andechs, Trzebnica, and Wroclaw.

The saint was renowned for her generosity and charity toward the poor and suffering. She tirelessly dedicated herself to the temporal and spiritual welfare of her subjects, using her personal fortune to alleviate poverty and suffering. Her own lifestyle was austere. At the convent at Trzebnica, Hedwig slept in the dormitory and complied with all the religious exercises of the community. She wore the same cloak and tunic summer and winter, and underneath them a hair shirt with sleeves of white serge so that it would not be seen. She walked to church barefoot over ice and snow, but carried shoes under her arm to put on if she met anyone. Hedwig often worked to make peace among her quarreling children and between her husband and his enemies. She was honored by God with the gift of miracles. Several miraculous cures were attributed to the saint during her lifetime, including a blind nun recovering her sight after Hedwig blessed her with the sign of the cross. She also had the gift of foreknowledge, specifically of the death of her son and of her own death.

In Catalogue 25, Hedwig's serene face is radiant with celestial light. Her full-length figure is regally attired. She wears a crown, and her royal red cloak is trimmed in white fur. The saint is depicted practicing one of the corporal works of mercy: ministering to the imprisoned. The saint brings food and gives alms from her purse. While the shackled prisoner smiles at his saintly visitor, the figures to Hedwig's right and left look upon her with veneration. While the figure to the saint's right is her servant who assists her by carrying a basket of bread, the man on her left, with hat in hand, may be the jailer or a man begging for alms. The staff refers to Hedwig's role as the foundress of the convent at Trzebinca, as well as of other religious houses. The clouds give this scene of Hedwig's practical charity an atmosphere of transcendence.

JFC

BIBLIOGRAPHY
Attwater, 162-63; *Butler's Lives of the Saints*, 4:124-25; Farmer, 201; Ferrando Roig, 91-92; Giffords, *The Art of Private Devotion*, 107; Juárez Frías, 158; Réau, vol. 3, part 2, 632-33; Tylenda, *Saints of the Liturgical Year*, 140-41.

26. SANTA ELENA
(St. Helena), 13 1/4" x 10"

St. Helena (ca. 250-330), born at Drepanum in Bithynia, may have been an innkeeper's daughter. She married the Roman General Constantius Chlorus, who divorced her when he became emperor in 292. Helena's son, Emperor Constantine I, greatly honored his mother, naming her Augusta at the beginning of his reign (306). She converted to Christianity after Constantine's victory over Maxentius. During this battle, her son beheld a vision of the cross with a banner that read "By this sign thou shalt conquer."

In 324, Helena made one of the first pilgrimages to the Holy Land and is said to have directed excavations at Mount Calvary. There, she unearthed three crosses and the inscription, "Jesus of Nazareth, King of the Jews," that Pilate had ordered nailed to the cross of Christ. In order to determine which of the three crosses was the one upon which Christ died, Helena directed that a man who was very ill be placed on each of the crosses. He was miraculously cured when he touched the wood of the True Cross. During further excavations, Helena discovered the nails of the crucifixion which were said to shine like gold. She gave two of these to Constantine. The best known artistic portrayals of the Vision of Constantine, the Battle of Constantine and Maxentius, and the Recognition of the True Cross are those executed by Piero de la Francesca for his monumental fresco cycle (1452-57), dealing with the Legend of the True Cross, in the Church of San Francesco, Arezzo. In Colonial Spanish art and Mexican devotional *retablos*, St. Helena is shown in elegant royal costume, wearing a crown and holding her attribute, the True Cross. In this *retablo*, she also holds one of the nails of the crucifixion.

CCW

BIBLIOGRAPHY
von Barghahn, "Imaging the Cosmic Goddess," 100-101; *Butler's Lives of the Saints*, 3:346-48; Farmer, 201-202; Ferguson, 122-23, Geiger; Giffords, *The Art of Private Devotion*, 108, and *Mexican Folk Retablos*, 94-95; Juárez Frías, 149.

27. SAN FRANCISCO DE ASIS
(St. Francis of Assisi), 9 ½" x 7"

The son of a wealthy cloth merchant, St. Francis was born in Assisi in central Italy ca. 1181. After a brief military career, which ended when he heard a heavenly voice tell him "to serve the master rather than the man," Francis turned to Christ in solitary prayer. One day, while praying for guidance in the dilapidated Church of San Damiano in Assisi, Christ spoke to him through a crucifix, saying, "'Francis, go and repair My Church which, as you see, is falling into ruins.'" Interpreting the words to mean that he should refurbish the deteriorated San Damiano, Francis sold some of his father's cloth to buy building materials. He also developed the habit of giving money, and sometimes even his own clothing, to the poor. Exasperated by his son's generosity and peculiar vocation, Francis' father called him before the bishop of Assisi and demanded the return of the money that had been given away. Francis responded by stripping off his clothes, saying that these too belonged to his father. With that dramatic act, the twenty-five-year-old Francis left everything to follow Christ.

A few years later, after being joined by a dozen companions, Francis drew up a religious rule, based on the Gospel counsels on perfection, that was approved by Pope Innocent III. Dedicated to imitating the way of life of Christ and His apostles, Francis and his companions went on preaching tours, and when the tours were over, lived within their convent practicing prayer and embracing a life of poverty. In 1212, Francis gave the habit of the newly-founded Franciscan Order to St. Clare, who was thereby the foundress of the second Order of cloistered nuns (the Benedictines being the first). Having done all out of love for the crucified Christ, Francis in 1224 received the *stigmata*, the five wounds of Christ, on his hands and feet, and in his side. These wounds remained until his death in 1226. Francis was canonized by Pope Gregory IX two years later. The saint's relics are now housed in the Basilica of San Francesco in Assisi.

One of the religious Orders most important for the missionary effort in the New World, the Franciscans first arrived in Mexico in 1523. The Franciscans propagated the image of their founder, and commissioned numerous paintings and sculptures dealing with his life for the decoration of their churches and monasteries in the colonies. In Spanish art, St. Francis was often depicted in prayer, with a crucifix (because of his devotion to the crucified Christ), and a skull (a reminder of the brevity of earthly existence). El Greco painted a magnificent example of this subject ca. 1585-90 (Barcelona, Torelló Collection). This composition continued in Colonial Spanish painting and sculpture, and in Mexican devotional *retablos*. In Catalogue 27, Francis holds a crucifix and a skull. The saint wears a blue habit. This reflects the practice of the Spanish Franciscans, who adopted the blue habit because of their special devotion to the Immaculate Conception. Brown did not become the universal color for the Franciscan habit until a decree by Pope Leo XIII in 1897.

CCW

BIBLIOGRAPHY
Raphael Brown, 13-17; *Butler's Lives of the Saints*, 4:22-32; Farmer, 167-70; Giffords, *Mexican Folk Retablos*, 81; Jordan, 236-37; Juárez Frías, 122; Sebastián, *El barroco iberoamericano*, 294-317.

28. SAN FRANCISCO DE PAULA
(St. Francis of Paola), 11" x 8"

St. Francis of Paola was born to devout and hardworking parents on March 27, 1416, at Paola, a small town in Calabria, in southern Italy. He was named for St. Francis of Assisi (Catalogue 27), to whom his childless parents had earnestly prayed for a child. When Francis was twelve, he was placed in the Franciscan friary at San Marco, in fulfillment of a promise his parents had made to St. Francis of Assisi. After a year at the friary, Francis accompanied his parents on a pilgrimage to Rome, Assisi, and Loreto. Upon returning to Paola, he embraced the eremitical life. Within a few years, he was joined by some other young men.

The year 1452 is reckoned as that of the foundation of Francis' Order, known until 1492 as the Penitent Hermits of St. Francis of Assisi. The Order was approved by the Holy See in 1474, and, at the founder's request, its name was changed in 1492 to Minims because Francis wished his friars to be considered the least (*minimi*) in the household of God. To the three traditional vows of poverty, chastity, and obedience, Francis added a fourth of humility. He also imposed the obligation of observing a perpetual Lent that included fasting and abstinence not only from meat but also from eggs and anything made with milk. *Caritas*, "Charity," was the motto Francis chose for his Order.

During his lifetime, Francis was renowned as a holy man, miracle worker, and prophet. Francis' reputation spread throughout Italy and even into France. When, in 1482, King Louis XI of France (reigned 1461-1483) was slowly dying after an apoplectic fit, he asked Francis to come and cure him. Francis was disinclined to go, until Pope Sixtus IV urged him to do so. However, rather than restoring the king to health, Francis prepared him for death. The saint spent the rest of his life in France, where he and his friars were greatly esteemed and favored by Louis' son, Charles VIII (reigned 1483-1498). He died on Good Friday, April 2, 1507, at the age of ninety-one, near Tours. He was canonized by Pope Leo X in 1519, at the request of King Francis I of France (reigned 1515-1547), and his feast day is April 2.

A popular saint in Italy, France, and Mexico, Francis is often invoked for protection from fire (from the effects of which he enjoyed miraculous immunity), childlessness, and shipwreck (several of his miracles were associated with the sea). He is patron of Calabria and of Tours. A brief prayer that is popular in Mexico makes known the favors that were most often sought from the saint in that country: *San Francisco de Paula, tres cosas pido: salvación y dinero y un buen marido*, "St. Francis of Paola, three things I ask: salvation, money, and a good husband."

The most accurate likeness of Francis was a posthumous portrait, based on the saint's death mask, by the French artist Jean Bourdichon (1513) that was commissioned by King Louis XII of France (reigned 1498-1515). Bourdichon personally knew Francis, and even gave testimony at his canonization process. King Francis I of France sent this portrait as a gift to the pope on the occasion of the saint's canonization. Although this painting is now lost, copies of it are in the Church of Santa Maria della Pace in Rome and in the orphanage of Montalto, near Cosenza, in Calabria. Several engravings of Bourdichon's portrait also survive.

Francis' cult was also popularized by numerous other works of art. The Flemish engraver Hieronymus Wierix (ca. 1553-1619) executed an engraving of Francis. The Spanish master Bartolomé Esteban Murillo (1617-1682) painted several images of Francis, usually in prayer. Various series of paintings of Francis' life and miracles, most of which are now lost or have been destroyed, were done for the churches and monasteries of the Minims in Flanders, Italy, France, and Spain. A marble statue of Francis was added in 1733 to the series of founders of religious Orders in St. Peter's Basilica in Rome. Francis was also a popular subject in Colonial Spanish art, the premier example being the painting of the saint as a hermit by the Bolivian artist Melchor Pérez de Holguín (1660-1724) that is presently in Buenos Aires. Several fine polychrome sculptures of Francis also survive. The most beautiful is that executed by the Asturian artist Juan Alonso Villabrile in the first quarter of the eighteenth century (Cali, Colombia, Colección Soffy Arboleda).

Francis of Paola is a very popular subject in *retablo* art. Images of this saint may account for as much as five percent of the production of Mexican *retablo* artists. Francis is usually portrayed as he is in Catalogue 28. He is represented as an old man with a long gray beard. He wears sandals and the dark brown Minim habit. The Minim habit consists of a tunic, the cord of St. Francis of Assisi, and a short scapular hanging down in front a little below the waist and rounded off at the ends, to the back of which is sewn a small round hood that is frequently drawn over the head. Francis holds a rosary in his right hand and a staff, symbolic of his role as a monastic founder, in his left hand. In the upper left corner, the word *Caritas*, Francis' motto for the Minims, appears in an aureole emitting rays of light toward the saint. The building on the right represents the monasteries that Francis built during his lifetime. The fiery red horizon and black clouds allude to Francis' immunity to the effects of fire, and hence also to his being invoked for protection from fires. The lamb emerging from the fiery oven refers to one of Francis' miracles. During the construction of Francis' first monastery, hungry workmen caught, slaughtered, and roasted in a kiln the

saint's pet lamb Martinello. While they were eating, Francis approached them, looking for his lamb. They confessed to Francis that they had killed and eaten the lamb because they had no other food. Francis inquired as to the whereabouts of the fleece and bones, and the workers replied that they had thrown them into the furnace. Francis walked over to the furnace, looked into the fire, and called "'Martinello, come out!'" The lamb jumped out of the furnace, completely unharmed, bleating happily at the sight of his saintly master.

JFC

BIBLIOGRAPHY
Attwater, 136; *Butler's Lives of the Saints*, 2:10-13; Esteban and Gaya Nuno, 104, 115; Farmer, 170, Ferrando Roig, 116-17; Fiot, 1042; Giffords, *The Art of Private Devotion*, 107, and *Mexican Folk Retablos*, 98-99; Jameson, 334-37; Juárez Frías, 128; Knipping, 1:172; Mâle, 498-99; Réau, vol. 3, part 1, 535-38; Sebastián, *El barroco iberoamericano*, 318 and Plate 192; Simi and Segreti, 26; Tylenda, *Saints of the Liturgical Year*, 35-36.

29. SAN ISIDRO LABRADOR
(St. Isidore the Farmer), 1893, 14″ x 10″

St. Isidore the Farmer was born, ca. 1080, of poor but devout parents in Madrid. He was named after St. Isidore of Seville (ca. 560-636), the famous archbishop and Doctor of the Church. Isidore's parents inculcated in him a hatred of sin and a love of prayer. As soon as he was old enough to work, he entered the employment of Juan de Vargas, a wealthy landowner. The saint remained in Vargas' service for his entire life, working as a farm laborer on Vargas' estate outside Madrid. Isidore married María de la Cabeza, a woman as holy as he was. After the death of their only son as an infant, Isidore and María made a vow of perfect continence. Isidore's life was a model of Christian perfection lived in the world. He attended Mass daily and prayed continually to God, the saints, and his Guardian Angel while he worked plowing. Isidore's generosity was legendary. He shared his own meals with the poor, often keeping for himself only the scraps that were left over. The saint died on May 15, 1130.

Great impetus was given to Isidore's cult by the report of many miracles worked through his intercession. He is credited with King Alfonso VIII of Castile's defeat of the Moors in a crucial battle of the Reconquest in 1211. King Philip III of Spain (reigned 1598-1621), who attributed his recovery from a serious illness to Isidore's intercession, vigorously promoted his cause for canonization. On March 12, 1622, Isidore was canonized a saint by Pope Gregory XV, together with his fellow Spaniards Ignatius Loyola (1491-1556), Francis Xavier (1506-1552), and Teresa of Ávila (1515-1582), and the Italian Philip Neri (1515-1595). He is the patron of farmers, workers, and the city of Madrid, and is often petitioned for rain. His feast day is May 15. Isidore's wife María is popularly honored as a saint in Spain.

In Catalogue 29, Isidore wears a laborer's clothing and holds an ox-goad, an instrument the saint once used to work a miracle. His broad-brimmed hat lies on the ground. Isidore appears in the foreground in larger scale than the angel and oxen in the middle ground. These figures and the church in the background allude to a particular episode in the saint's life. Isidore's fellow laborers complained to Vargas that the saint's attendance at Mass each morning before he came to work caused him to be late. To verify this allegation, one day Vargas hid himself to see when Isidore arrived. Vargas saw that Isidore was late in arriving. However, as he approached Isidore to upbraid him, Vargas saw Isidore's ploughing team of oxen being driven along the furrows by an angel. Others also reported that they saw angels helping Isidore. Vargas, like many others, came to revere Isidore.

Other elements of this *retablo* can also be related to incidents in Isidore's life. For example, the stream and Isidore's ox-goad refer to the occasion when, to satisfy his master's thirst, Isidore struck the earth with his ox-goad, and a spring of pure water burst forth from the ground. The many birds in the *retablo* evoke one of the numerous stories that illustrate Isidore's love of animals. One snowy winter's day, as Isidore carried a sack of corn to be ground, he saw a number of birds perched disconsolately on the bare branches of a nearby tree, obviously unable to find anything to eat. Isidore opened the sack, and, despite his companion's protests, poured out half its contents on the ground for the birds. When Isidore and his fellow worker reached their destination, the sack was found to be full, and the corn, when ground, produced double the usual amount of flour. The rain clouds in the upper right corner allude to the practice of seeking Isidore's intercession when rain is needed. This is one of the reasons that great devotion to Isidore flourishes in Zacatecas, known for its arid land. Annually, on May 15, the saint's image is carried in procession, and the faithful fervently pray: *San Isidro labrador, pon el agua y quita el sol*, "St. Isidore the Farmer, make it rain and take away the sun." Isidore was certainly one of the most popular saints among the common people. In a sense, he may also be considered as representative of the class of people for whom Mexican devotional *retablos* were intended.

JFC

BIBLIOGRAPHY
Attwater, 177; Boyd; *Butler's Lives of the Saints*, 2:323-24; Ferrando Roig, 142-43; Giffords, *The Art of Private Devotion*, 108, and *Mexican Folk Retablos*, 140-41; Juárez Frías, 168-70; Steele, 187; Tylenda, *Saints of the Liturgical Year*, 51-52.

30. **SAN JERÓNIMO**
(St. Jerome), 10" x 7"
See Wilson, "Art and the Missionary Church in the New World," 19-26.

31. **SAN JOSÉ**
(St. Joseph), 14" x 10"
See Chorpenning, "The Iconography of St. Joseph in Mexican Devotional *Retablos*," 45, 72-77.

32. **SAN JOSÉ**
(St. Joseph), 14" x 10"
See Chorpenning, "The Iconography of St. Joseph in Mexican Devotional *Retablos*," 77-78.

33. **SAN JOSÉ**
(St. Joseph)
See Chorpenning, "The Iconography of St. Joseph in Mexican Devotional *Retablos*," 45-46, 72-77.

MATER DOLOROSA or **NUESTRA SEÑORA DE LOS DOLORES**
(Sorrowful Mother or Our Lady of Sorrows)
See Catalogue 10 and 11.
7" x 10"

34. **SANTA LIBRADA**
(St. Wilgefortis), 9 1/2" x 6 1/2"

The development of the cult of the fictitious saint known variously as Wilgefortis (derived from the Latin *Virgo fortis*, "Strong Virgin") and Uncumber in England, Ontkommer in Holland, Liberata in Italy, and Librada in the Spanish-speaking world is a bizarre chapter in the annals of hagiography. The Bollandist Hippolyte Delehaye traces the origin of the legend of Wilgefortis to the explanation of the iconographical peculiarity of crucifixes showing the bearded Christ wearing a long tunic, the most well-known example being the *Volto Santo* in Lucca in central Italy. The crucified person dressed in a long robe was thought to represent an unidentified woman saint. The legend of Wilgefortis originated in fourteenth-century Flanders to explain the identity of this female saint.

According to this legend, Wilgefortis' father, the king of Portugal, wanted her to marry the king of Sicily. However, Wilgefortis had made a vow of virginity. She prayed for divine assistance to extricate her from this predicament, and her prayers were answered when a beard grew upon her face. The king of Sicily withdrew his marriage proposal, and

Wilgefortis' outraged father had her crucified. While she hung dying on the cross, Wilgefortis prayed that all who remembered her passion should be liberated from all difficulties and troubles.

In Dutch, this saint was called Ontkommer, "Uncumber." From Flanders, her cult spread throughout Europe. On the authority of St. Peter Canisius (1521-1597), the Flemish theologian Johannus Molanus included this saint in his edition of the *Martyrology* (1568), from which it made its way into the *Roman Martyrology* (1583). The latter still refers to St. Wilgefortis, Portuguese virgin martyr, under July 20. Molanus also latinized the Dutch name Ontkommer to Liberata. The Spaniards and Portuguese were greatly flattered that the cult of a saint from the Iberian Peninsula flourished elsewhere. The miracle of the beard, however, was never fully accepted in Iberia. According to the version of the legend of this saint that was popular there, she was martyred by beheading. Nonetheless, crucifixion became a permanent element of Librada's legend. From the seventeenth century on, Librada was represented in Spanish art in this manner. The cult of Librada was also exported to the New World, where even today Colombia counts her among its patron saints.

The names "Ontkommer," "Uncumber," "Liberata," and "Librada" denote deliverance or liberation. In England, St. Uncumber was invoked by women who needed relief from troublesome husbands or unwanted suitors. In Mexico, Santa Librada was invoked in times of trouble and as a helper in distress. In both Spain and Mexico, Librada was considered one of the Fourteen Holy Helpers (see Catalogue 22) and, like St. Acacius, invoked against headaches.

Artists and devotional authors disseminated Wilgefortis' legend and iconography. The Flemish artist Hans Memling (ca. 1440-1494) included the image of the crucified Wilgefortis on the outer wing of one of his retables (Bruges, Hôpital de Saint-Jean). A wood engraving of the crucifed saint (ca. 1502) by the German engraver, miniaturist, and painter Hans Burgkmair the Elder (ca. 1473-ca. 1553), who was a disciple of Albrecht Dürer (1471-1528), bears the inscription *Bildnis zu Luca*, "Likeness of Lucca," proving that the image of this saint is derived from the *Volto Santo* in Lucca. The saint's legend is recounted in a book by the Brussels court orator Biverus, entitled *Sacrum Sanctuarium Crucis* (*The Holy Sanctuary of the Cross*), published at Antwerp in 1634. This book is a compendium of the stories of those who suffered martyrdom by crucifixion and includes an engraved illustration of Wilgefortis' crucifixion. A quarter of a century earlier, Wilgefortis' crucifixion was the subject of a print that appeared in the 1608 Plantin edition of Bartholomew Ricci's

Triumphus Jesu Christi Crucifixi (Triumph of Jesus Christ Crucified). Several important Spanish images of this saint also survive, including a retable by Juan de Pereda in the cathedral in Sigüenza (1515) and wooden statues from the sixteenth and eighteenth centuries (Valladolid, Museo Provincial, and Museo, respectively). Frank notes that even today chromolithographs of Librada are readily available in the Spanish-speaking world.

Catalogue 34 is in the tradition of the two statues of Librada in Valladolid, in that all these images depict the saint crucified but without a beard. Compared with other *retablo* images of the saint that often include palm branches and Librada being crowned with roses, this one is rather plain. Also unlike other *retablos* of this subject, Librada is nailed, rather than tied, to the cross.

JFC

BIBLIOGRAPHY
Attwater, 330; *Butler's Lives of the Saints*, 3:151-52; Delehaye, 31-32, 87-88, 155, 158; Farmer, 437-38; Ferrando Roig, 170-71; Frank, 304; Giffords, *The Art of Private Devotion*, 115, and *Mexican Folk Retablos*, 116-17; Juárez Frías, 150; Knipping, 1:130, 2:242-43; Réau, vol. 2, part 2, 24-25, 27, and vol. 3, part 3, 1342-45; Steele, 194; Wilder and Breitenbach, Plate 7.

35. San Martín
(St. Martin), 14" x 10"

One of the most popular saints in Christendom, St. Martin of Tours was born of pagan parents in Sabaria, Pannonia (present-day Hungary), ca. 316. His father was an officer in the Roman army and moved his family to Pavia (Italy), where Martin grew up and became a catechumen. At age fifteen, Martin was forced to enter military service. While he was serving near Amiens (France), an incident occurred that tradition and art have made famous: "Once, in the wintertime, [Martin] was passing through the city gate of Amiens when a poor man, almost naked, confronted him. No one had given him an alms, and Martin understood that this man had been kept for him, so he drew his sword and cut the cloak he was wearing in two halves, giving one half to the beggar and wrapping himself in the other. The following night he had a vision of Christ wearing the part of his cloak with which he had covered the beggar, and heard Christ say to the angels who surrounded Him: 'Martin, while still a catechumen, gave Me this to cover Me'" (Jacobus de Voragine, *The Golden Legend*, 2:292). Martin had himself baptized at once. Although Martin came to be looked on as a "soldier saint," he became convinced that his commitment to Christ prevented his serving in the military. Martin made a protest to the authorities that could be considered an early example of "conscientious objection" to military service: "'I am a soldier of Christ, and I am not allowed to fight'" (see Attwater, 227; *Butler's Lives of the Saints*, 4:310). Martin was imprisoned and eventually discharged (356). He placed himself under the direction of St. Hilary of Poitiers (ca. 315-ca. 368), and later founded a monastery at Ligugé, near Poitiers, that is considered the first such institution established in Gaul. At the acclamation of the clergy and people, Martin was made bishop of Tours in 371. As bishop, Martin continued to live a monastic life and became renowned as a monastic founder, evangelizer, vigorous opponent of heresy, and miracle worker. He died while on a pastoral visit to Candes on November 8, 397, and was buried in Tours on November 11, the day of his feast in the Roman calendar. His successor, St. Brice (died 444), built a chapel over his tomb; later, it was replaced by a magnificent basilica.

Martin was one of the first holy people who was not a martyr to be venerated publicly as a saint. His tomb quickly became an important place of pilgrimage. His cult spread rapidly not only because of his reputation as a wonder-worker in life and after death, but also because of the biography written by his friend Sulpicius Severus (ca. 363-ca. 420)

that became a model for medieval hagiographers. In France, 500 villages and 4,000 parish churches are dedicated to Martin. He is also widely venerated in Italy, Spain, Germany, the Low Countries, and England.

In art, Martin is represented either as a Roman soldier on foot or on horseback, or as a bishop with miter and crosier. The former depiction predominates, the premier example in Spanish art being El Greco's *St. Martin and the Beggar* (ca. 1597-1599, Washington, D.C., National Gallery of Art). St. Martin and the Beggar was also a popular subject in Colonial Spanish art, as the Mexican artist Cristóbal de Villalpando's *St. Martin of Tours Sharing His Cloak with a Beggar* (ca. 1690, The Denver Art Museum) and the Peruvian artist Marcos Rivera's *St. Martin and the Beggar* (ca. 1690-1704, The Denver Art Museum) attest. This image of the saint is also that which is usually portrayed in the *retablo* art of Mexico. (Although Martin was a popular saint in nineteenth-century Mexico, *retablos* of him are uncommon.) Catalogue 35, however, presents the alternative representation. A statue painting with a grand manner setting, this *retablo* portrays Martin vested in an alb with a fine lace skirt, a chasuble beautifully decorated with flowers, miter, crosier, and pectoral cross.

JFC

BIBLIOGRAPHY
Attwater, 227-28; *Butler's Lives of the Saints*, 4:310-13; Farmer, 287-88; Ferrando Roig, 193; Giffords, *The Art of Private Devotion*, 116, and *Mexican Folk Retablos*, 120-21; Jordan, 241; Juárez Frías, 146; Réau, vol. 3, part 2, 900-917; Steele, 189; Tylenda, *Saints of the Liturgical Year*, 152-53; Voragine, 2:292-300.

36. SAN RAFAEL
(St. Raphael), 14″ x 10″

Raphael is one of three archangels mentioned by name in the Bible, the other two being Michael and Gabriel. He appears only in the Book of Tobit. The name Raphael means "God heals," and appropriately, in the Book of Tobit, Raphael reveals that God commissioned him to cure Tobit's blindness (12:14). He also discloses that he is "one of the seven angels who enter and serve before the Glory of the Lord" (12:15), and that he was sent to guide Tobias on his journey to Rages to collect money owed his father and to teach Tobias how safely to enter into wedlock with Sarah. Because of the healing performed by Raphael in this story and the significance of his name, the archangel has sometimes been identified with the angel who moved the waters of the healing pool of Bethesda in Jerusalem (John 5:1-9).

Veneration of Raphael in the East antedates that in the West. In the Western Church, his cult did not become widespread until the Counter-Reformation, when devotion to the angels became popular. The impetus for the rise of the cult of the archangels was the discovery of a fresco of the seven archangels, probably of late Byzantine origin, at Palermo (Sicily) in 1516. This image attracted the devotion of Christians throughout Europe. The Flemish engraver Hieronymus Wierix executed an engraving of it (ca. 1610) that was copied and widely circulated in Europe and in the Americas, serving as a source for artists. Wierix's engraving establishes the essential elements of the archangels' iconography. Raphael, for example, holds an ointment ampulla close to his chest with his left hand, and the hand of Tobias, who stands at his side holding a fish, with his right hand. The fish refers to Raphael's healing office since he instructed Tobias to rub fish gall on his father's eyes to remove the cataracts that blinded him (Tobit 6:9; 11:8). Prior to Wierix's engraving, copies of this fresco were made for several churches in Rome. Books about, and numerous engravings of, the archangels and their attributes contributed to the dissemination of their cult.

The Hapsburgs actively promoted this cult in Spain, as series of paintings of the archangels in the vestibule of the Royal Discalced Convent, founded by Juana of Austria (1535-1573), the daughter of Charles V, and in the Church of the Incarnation adjoining the Augustinian convent founded in 1611 by Margarita of Austria, the wife of King Philip III (reigned 1598-1621), both in Madrid, affirm. Series of the archangels were also produced in the Sevillan workshops of Francisco de Zurbarán (1598-1664) and of Juan de Valdés Leal (1622-1690). The Jesuits not only supported Juana of Austria's efforts to disseminate the cult

of the archangels in Spain, but also became this devotion's most ardent champions in the Americas, a role memorialized by a seventeenth-century Mexican oil-on-canvas painting, entitled *Allegory of the Archangels and the Society of Jesus* (Tepotzotlán, Museo Nacional del Virreinato). The Spanish artist Bartolomé Román (1596-1659), who executed the series of the archangels for the royal convents in Madrid, also painted a series for the Jesuit Church of San Pedro in Lima. Beginning ca. 1680, the custom of painting series of angels became widespread in the Andean region of the Viceroyalty of Peru. Archangels are also a popular subject in Colonial Mexican art, both in painting and in sculpture. For example, an exquisite eighteenth-century Mexican wood polychromed and gilded sculpture, with glass eyes, shows Raphael clad in a floral-patterned cloak, cape, tunic, and skirt, with his left arm upraised (originally holding a staff), holding his attribute of the fish with his right arm, and standing on carved, painted clouds (sold at auction at Sotheby's, New York, November 1993).

Several religious Orders had special devotion to Raphael. The Brothers Hospitallers, who claimed St. John of God (1495-1550) as their founder, was one such group. John of God placed all the hospitals he founded under Raphael's patronage and hung the archangel's image in a place of prominence in these institutions. The Minims, founded by St. Francis of Paola (see Catalogue 28), were another Order that promoted Raphael's cult. In 1602, the Minims were granted a proper Mass and Office for Raphael by the Holy See. Rome extended similar favors to the Mercedarians in 1671 and to Spain and its dominions in 1683. Although the feast of Raphael appears in several missals and books of hours (Bordeaux, 15th c., July 8 and October 13; Rome, 16th c., October 2; Grasse, 16th c., October 6) and was celebrated in Italy (May 10) and in Spain and elsewhere (October 24), it was not added to the Roman calendar until 1921, when Pope Benedict XV assigned this feast to October 24. In the reform of the liturgical calendar after the Second Vatican Council, the three archangels Michael, Gabriel, and Raphael are commemorated together on September 29, because on that day, according to the *Hieronymian Martyrology* (ca. 450), the basilica of St. Michael on the Salarian Way, north of Rome, was dedicated. In Mexico, Raphael, together with Michael, enjoyed great popularity. He was invoked for safe journeys and against eye ailments, plagues, and malaria.

The subject of Raphael serving as a guide for the young Tobias became especially popular in Renaissance and Baroque art. Numerous European artists rendered this subject, including Titian (ca. 1540, Venice, San Marziale) and Rembrandt (17th c., Vienna, Albertina). In early eighteenth-century Mexico, Juan Correa (ca. 1646-1716), one of the most important

artists of the Colonial period, painted this subject. Mexican devotional *retablos*, however, seldom portray it. Images of Raphael accompanying Tobias, usually walking through a landscape, on the return journey home from Rages, became the prototype for depictions of the Guardian Angel, a devotion that also became popular in the Counter-Reformation. This equation was supported by the devotional literature of the period. For example, in his *Introduction to the Devout Life* (1609), St. Francis de Sales directs his reader, in a meditation on the election and choice of Heaven: "Imagine yourself to be in an open field, alone with your guardian angel, like young Tobias on his way to Rages" (67).

The other principal way in which Raphael is depicted is alone, as a full-length figure, holding a traveller's staff with gourd and a fish. This is the way in which he is usually represented in Mexican devotional *retablos*, an excellent example being Catalogue 36. European and Mexican images of the Colonial period and thereafter, such as a hand-tinted engraving of the Seven Archangels printed in San Luis Potosí in 1841, were artistic sources for this *retablo* representation of Raphael. In addition to the elements of his iconography already discussed, in Catalogue 36 Raphael wears pilgrim's garb, with a cockle shell adorning his cape. On his head is a diadem with feathers of white, red, and green, the colors of the Mexican flag. The archangel's robe is cut away so that his legs and boots are visible, a stylistic aspect this *retablo* subject shares in common with images of Michael.

JFC

BIBLIOGRAPHY
Alarcón Cedillo and García de Toxqui, 53-55, 60-65; Attwater, 237-38; von Barghahn, "A Crucible of Gold," 39-48; *Butler's Lives of the Saints*, 4:188-89; Duhr, 608, 614, 622; Farmer, 367; Ferrando Roig, 235-36; Francis de Sales, 67; Giffords, *The Art of Private Devotion*, 102, 118-19, and *Mexican Folk Retablos*, 128-29; Gisbert; Hamilton, "Angels in *Retablos*," 3-4; Juárez Frías, 106; Knipping, 1:123-27; Mâle, 297-309; *Mexico: Splendors of Thirty Centuries*, Catalogue 142; Palmer and Pierce, 42-47, 87, 98, 104-105, 109-111; Sebastián, *El barroco iberoamericano*, 194-98, and *Contrarreforma y barroco*, 315-20; Steele, 180; Tylenda, *Saints of the Liturgical Year*, 129-30.

37. SAN RAMÓN NONATO
(St. Raymond Nonnatus), 14 ¹/₄" x 10"

Information about St. Raymond Nonnatus is a blending of history and legend. Born in 1204 at Portello in Catalonia (Spain), Raymond was called *non natus*, "not born," because he was taken from his mother's womb after her death in labor. With his father's permission, he entered the Order of Our Lady of Mercy (the Mercedarians), founded in Barcelona in 1218 by St. Peter Nolasco (ca. 1189-1258) for the purpose of ransoming Christian captives from the Moors, who then occupied much of Spain. Within two or three years of making religious profession, Raymond succeeded Peter himself as ransomer. After purchasing the liberty of a number of slaves in Algiers, he voluntarily sold himself into slavery to save others. During his captivity, Raymond not only gave spiritual comfort to his fellow Christian prisoners, but also sought to convert his captors to Christianity. The latter activity was proscribed by Islamic law, and as a punishment the saint was whipped at the corners of all streets in the city, his lips were pierced with a red-hot iron, and his mouth shut with a padlock, the key to which was kept by the governor, who gave it to the jailer only when Raymond was to be fed. Eight months later, he was ransomed, leaving Algiers only under obedience. On his return to Spain in 1239, Raymond was named a cardinal by Pope Gregory IX. The following year he died en route to Rome, at Cerdagne, about six miles from Barcelona, of a fever, at the age of thirty-six. He is buried in the chapel of St. Nicholas at Portello, and his name was inscribed in the *Roman Martyrology* in 1657. His feast day is August 31. Because of his cesarean birth, he is the patron of midwives. He is also venerated as the patron of pregnant women, women in childbirth, the unborn, and secrecy. He is invoked for protection from gossip, slander, and curses.

When the Mercedarians arrived in New Spain in 1594, they introduced devotion to their patroness, *Nuestra Señora de la Merced*, "Our Lady of Mercy," and to the Order's principal saints, Peter Nolasco and Raymond Nonnatus. Raymond became one of the most popular saints in Mexico. In *retablo* art, he is usually portrayed as he is in Catalogue 37. The saint is vested in a cassock, rochet, and prelate's mozetta. His padlock seems to clasp the front of his mozetta. His mouth is rubbed away from the practice of rubbing the saint's mouth to eliminate gossiping or someone's continuous talking. Raymond holds a palm ringed with three crowns. The palm is the customary attribute of a martyr. Although the saint did not die as a martyr, he fervently wished to do so and suffered excruciating torture

at the hands of his captors. The three crowns have been interpreted as symbolizing chastity, eloquence, and martyrdom, or as being the three crowns of martyrdom: one for the saint's offering himself as ransom to save others, another for being chained for continuing to preach the Gospel while in captivity, and a third for having his lips pierced and padlocked. The monstrance or ostensorium refers to Raymond's receiving Holy Communion on his deathbed from Christ or an angel.

JFC

BIBLIOGRAPHY
Attwater, 271-72; *Butler's Lives of the Saints*, 3:449-50; Ferrando Roig, 236; Frank, 305-306; Giffords, *The Art of Private Devotion*, 120, and *Mexican Folk Retablos*, 130-31; Juárez Frías, 121; Réau, vol. 3, part 3, 1138; Sebastián, *El barroco iberoamericano*, 343-44; Steele, 191.

38. Santa Regina, Virgen y Mártir

(St. Regina, Virgin and Martyr), 14" x 10"

See Wilson, "Art and the Missionary Church in the New World," 34-38.

39. SANTA RITA DE CASIA

(St. Rita of Casia), 10 ¹/₂" x 7 ¹/₂"

St. Rita was born in the town of Roccaporena near Casia in 1377. Beginning in childhood, Rita was filled with the desire to become a nun, but in deference to her parents' wishes she married a man who became violent and was unfaithful. She endured his abusive behavior for eighteen years, until the day her husband was brought home dead, having been murdered in an altercation. Her two sons vowed to avenge their father's murder, but Rita prayed that her children would die before committing murder. Rita's prayer was answered, and both sons were struck with fatal illnesses before carrying out their retaliation. Around 1407, after the deaths of her husband and children, Rita entered the Augustinian convent of Santa Maria Maddalena in Casia, at last fulfilling her wish to become a nun. She devoted herself to constant prayer and mortification. Her meditation on the passion of Christ was so intense that a wound appeared in her forehead as though pierced by a crown of thorns. The wound remained in Rita's forehead for fifteen years and could not be healed. She meanwhile cared for sick nuns within the convent and also counseled sinners until her death from tuberculosis in 1447.

In the year 1457, as a result of Rita's growing reputation for sanctity, her incorrupt body was transferred to an elaborately decorated tomb that still survives. The sarcophagus also contains the local bishop's approval of Rita's cult written in 1457. There survives an authentic fifteenth-century portrait of Rita, as well as an account of her life, written in verse on the sarcophagus. She was beatified in 1626 and canonized in 1900.

A popular subject of Mexican devotional *retablos*, Rita is portrayed wearing the black habit of the Augustinian Order. A thorn is shown embedded in her forehead, and she usually holds a crucifix. She is often flanked by the figures of her two sons. Rita has traditionally been invoked as patron of desperate cases, particularly marital difficulties.

CCW

BIBLIOGRAPHY
Bruni; *Butler's Lives of the Saints*, 2:369-70; Farmer, 370-71; Giffords, *The Art of Private Devotion*, 30, 121, and *Mexican Folk Retablos*, 133; Juárez Frías, 157; Roth.

40. SANTIAGO
(St. James the Greater), 17 $\frac{1}{2}$" x 12 $\frac{1}{2}$"

St. James the Apostle, brother of St. John the Evangelist and son of Zebedee, is called the Greater to distinguish him from the other apostle of the same name, St. James the Lesser, who was his junior. St. James the Greater lived in Galilee and was a fisherman by trade with his father and brother. When Christ was walking by the sea of Galilee, He saw two brothers, Peter and Andrew, fishing and called them to follow Him, saying that He would make them fishers of men. Walking further along the shore, he came upon two other brothers, James and John, in a ship with their father, mending their nets. Christ called them, and the two brothers left their nets and their father and followed Him (Matthew 4:21-22; Mark 1:19-20; Luke 5:10-11). Jesus gave the brothers James and John the name "Sons of Thunder" (Mark 3:17), connoting impetuous character and fiery temper. Together with Peter, James and John were present at Christ's Transfiguration, and He took them to the garden of Gethsemane, to keep watch while He endured His night of agony (Matthew 17:1-9, 26:36-46; Mark 9:2-13, 14:33-42; Luke 9:28-36).

According to Spanish tradition, after the crucifixion James made an evangelizing visit to the Iberian Peninsula, where he became known as Santiago. He later returned to Jerusalem, where in 44 A.D. he was beheaded under King Herod Agrippa I (Acts 12:1-2). James was buried in Jerusalem but, again according to Spanish tradition, his body was brought to Spain, first laid to rest at Irio Flavia (now El Padrón in Galicia) and then transferred to Compostella. During the Middle Ages, the shrine of Santiago de Compostella became one of the greatest of all Christian pilgrimage sites. James' relics are still housed in the cathedral, and in a bull of 1884 Pope Leo XIII referred to their authenticity.

St. James the Greater is the patron saint of Spain. That country's military order, the Order of Santiago, founded in 846, was also placed under his patronage. The iconography of James as a warrior originated with the numerous stories of his intervention during the Christian reconquest of Spain from the Moors. For example, during the ninth-century battle of Clavijo, Santiago *Matamoros*, "Killer of Moors," miraculously appeared and aided King Ramírez of Castile against the Muslims. During the Spanish conquest of the Americas, Santiago was invoked to assist in the subjugation of the Native American population. When rushing into battle against the Indians, Spanish soldiers cried "Santiago!," beseeching the saint to help them conquer the pagan enemy, just as he had helped Spaniards defeat the

Moorish infidels. Numerous Mexican churches were dedicated to the saint during the sixteenth and seventeenth centuries, such as Santiago de Tlatelolco, Santiago Atzacoalco, Santiago del Tepalcatlapán, and Santiago de Zapotitlán.

In Colonial Spanish art and in Mexican devotional *retablos*, James is depicted as Santiago *Matamoros*, dressed in armor, riding a white horse and brandishing a sword, as he slays Moorish infidels who wear turbans and exotic costumes. In Catalogue 40, James carries a long staff with the cross of the Order of Santiago at its tip. He tramples over two Moors lying in a heap at the bottom of the composition. A turban rests at the lower right corner of the image, having rolled off the head of one of the defeated figures. Santiago's monogram "SA" is branded on the horse's flank.

CCW

BIBLIOGRAPHY
von Barghahn, *Temples of Gold* Exhibition Guide; *Butler's Lives of the Saints*, 3:182-83; Farmer, 222; Giffords, *The Art of Private Devotion*, 109, and *Mexican Folk Retablos*, 136-37; Juárez Frías, 162-63; Palmer and Pierce, 26; Sebastián, *El barroco iberoamericano*, 192-93; Steele, 110-115.

41. LAS ÁNIMAS
(The Souls in Purgatory), 14″ x 9 ½″

According to the teachings of the Roman Catholic Church, Purgatory is the place, state, or condition where departed souls, who have died in the state of grace but are not entirely free of imperfection, are purified of their sins, through punishment, before entering Heaven. While the Church has not come to a consensus on the nature and intensity of the punishment, the Latin Church has generally held that fire is imposed on souls in Purgatory. Some theologians have maintained that actual flames are present, while others, such as St. Catherine of Genoa (1447-1510), have written that the soul in Purgatory experiences a desire for God that is an ardent fire, more devouring and painful than any earthly fire. The Church asserts that works of piety practiced by the faithful on earth, such as prayer, indulgences, almsgiving, fasting, and sacrifices, can help souls in Purgatory. Prayers can be directed for the benefit of an individual soul in Purgatory, in the hope that God will hear these petitions and accelerate the soul's final entry into Heaven.

In Colonial Spanish art, depictions of the souls in Purgatory are commonly seen in compositions of *Our Lady of Mount Carmel* and *Our Lady of the Rosary*. The iconography of *Our Lady of Mount Carmel*, as revealed in an eighteenth-century work by Mauricio García y Delgado, an artist of the Cuzco School of Peru (Albuquerque: International Institute of Iberian Colonial Art, University of New Mexico) shows the Virgin, dressed in the habit of the Carmelite Order, extending a scapular to the souls in Purgatory. Portrayed in half-length, the suffering figures are engulfed in flames at the bottom of the canvas. An eighteenth-century Mexican portrayal of *Our Lady of the Rosary* (Santa Fe, Palace of the Governors, International Institute of Iberian Colonial Art) depicts the Virgin holding a rosary toward the burning souls, one of whom is bound in shackles. Both compositions imply that devotional practices of individuals on earth, such as the rosary and the scapular, can assist souls in Purgatory.

Painters of Mexican devotional *retablos* isolated the souls in Purgatory from larger scenes, such as those mentioned above, choosing instead to fill the composition with a group of burning souls, as in Catalogue 41, or only one soul. Some *retablos* show a single burning figure, with the name of the deceased written beneath the composition. These paintings remind relatives to pray for the release of the soul from Purgatory, so that the faithful departed may enter Heaven more quickly.

CCW

BIBLIOGRAPHY
Bastian; Giffords, *The Art of Private Devotion*, 100-101; Palmer and Pierce, 40, 94; Sebastián, *El barroco iberoamericano*, 225, 241.

42. **Los Desposorios de San José y la Virgen**
(The Espousal of St. Joseph and the Virgin)
See Chorpenning, "The Iconography of St. Joseph in Mexican Devotional *Retablos*," 86-90.

43. **La Mano Poderosa or Los Cinco Señores**
(The Powerful Hand or The Five Lords), 14" x 10"
See Chorpenning, "The Iconography of St. Joseph in Mexican Devotional *Retablos*," 82-85.

44. **La Sagrada Familia**
(The Holy Family), 14" x 10"
See Chorpenning, "The Iconography of St. Joseph in Mexican Devotional *Retablos*," 78-81.

45. **Santa Apolonia, Virgen y Mártir**
(St. Appolonia, Virgin and Martyr), oil on canvas, 24 ¹/₂" x 18"
See Wilson, "Art and the Missionary Church in the New World," 34-38.

46. **Nuestra Señora de Guadalupe**
(Our Lady of Guadalupe), oil on canvas, 25" x 19"
See Catalogue 15.

Philippine *Bultos*

During the Colonial period, the Viceroyalty of New Spain was a vast region that comprised not only present-day Mexico and Central America, but also stretched across the Pacific Ocean to include the Philippine Islands. The Philippines were an especially valuable possession of the Spanish crown, because their strategic position off the Asian mainland allowed for a flourishing trade exchange between the Far East and the New World. From 1565 to 1815, ships known as the Manila Galleons sailed from Manila to the Port of Acapulco, loaded with precious Asian cargo. Some of the most lovely objects to arrive in the New World were Philippine statues of Christian subjects, usually carved in ivory. The earliest Christian images were produced in the late sixteenth century by Chinese artists living in Manila. Using religious engravings as models, the artists showed remarkable skill in creating statues of Christ, the Virgin, and saints. In 1591, the bishop of Manila, Domingo de Salazar, wrote to King Philip II of statues of the Christ Child, carved in ivory, comparing their beauty to that of Flemish images.

Artists working in the Philippines were also adept at producing wooden images of Christian figures, known as *bultos*. Like their counterparts in Colonial Mexico, the Philippine artists carved *bultos* from wood that was subsequently polychromed. Before its completion, a statue usually passed through the hands of several different artists. First, an *imaginero* prepared the wood and carved the image in the round. Next, an *encarnador* applied the flesh tones, or *encarnación*, over a gesso surface. Then, several artists painted garments onto the statue, using the technique of *estofado*. In this procedure, a *dorador* (gilder) first applied a layer of gold leaf to the statue's surface. The gilding was then completely covered with oil paints in various colors. Finally, an artist etched designs into the outermost layers of polychrome, revealing the gold underneath and creating a decorative effect that resembles gold brocade. During the nineteenth century, Manila and Paete were the Philippines' two most important sculptural centers. *Santeros* (saint-makers) produced statues for churches and for private devotion, as in the case of the two *bultos* in The Peters Collection.

CCW

BIBLIOGRAPHY
von Barghahn, "Colonial Statuary"; Bunag Gatbonton, *Philippine Religious Carvings In Ivory*, and *A Heritage of Saints*; White, 11.

47. SAN ANTONIO DE PADUA
(St. Anthony of Padua), 13" (Philippines)

St. Anthony of Padua (1195-1231) was born in Lisbon, although his surname derives from the Italian city where he spent the last years of his life and where his relics are still venerated. At the age of fifteen, he joined the regular canons of St. Augustine and resided for several years at Coimbra, devoting himself to prayer and to the study of Sacred Scripture. He was living in that Portuguese city when in 1220 Don Pedro of Portugal brought from Morocco the relics of some Franciscan friars who had recently been martyred. Anthony was deeply moved and became filled with the desire to lay down his life for Christ. He expressed his desires to some Franciscans who were visiting his monastery, and in 1221 was admitted to the Order founded by St. Francis of Assisi.

Shortly after entering the Order, Anthony was permitted to travel to Morrocco, where he intended to preach the Gospel. On account of a severe illness, however, he was forced to return to Europe. The ship on which he sailed was driven off course, and Anthony landed in Sicily. He travelled to Assisi in order to participate in the 1221 general chapter, and it was there that Anthony first met St. Francis of Assisi. The Italian Franciscans soon discovered that Anthony had a natural talent for preaching. He was sent to spread the Gospel in various regions of Romagna. With his remarkable knowledge of Scripture, his fervent desire to save souls, and his power of persuasion, he enjoyed great success, attracting large crowds wherever he went and converting heretics. After the death of St. Francis, he was appointed minister provincial of Emilia or Romagna. In 1226, he acted as an envoy from the general chapter to Pope Gregory IX, and on that occasion Anthony obtained from the pope his release from office so that he could devote himself to preaching. Anthony then settled in Padua, where he was greatly loved and where his ministry made a profound effect on the population. He died in 1231, at the age of thirty-six. His reputation for sanctity was so great that he was canonized within a year of his death.

Because of his skill at preaching and his renown for converting heretics, Anthony was viewed as a model for members of the religious Orders who came to the New World for the purpose of winning souls to God. The Franciscans first arrived in Mexico in 1523 and expanded the Order to the Philippines in 1577, playing a major role in converting the indigenous populations to Christianity. The friars propagated the iconography of their founder, St. Francis of Assisi, and of the second most important member of their Order,

St. Anthony of Padua. In Colonial Spanish painting and sculpture, St. Anthony was most often portrayed holding a book on which the Christ Child is supported. This iconography derives from the story that on one occasion, when Anthony was staying at a friend's house in Padua, his host saw a brilliant light coming from under the door of the saint's room. The man looked through the keyhole and saw the Christ Child, standing on top of a book on a table, with his arms placed around Anthony's neck. Catalogue 47 must have originally depicted Anthony holding a book, with the Christ Child seated on it, but the figure's arms have not survived.

CCW

BIBLIOGRAPHY
Butler's Lives of the Saints, 2:534-37; Farmer, 23-24; Sebastian, El barroco iberoamericano, 31.

48. SAN VICENTE FERRER
(St. Vincent Ferrer), 14" (Philippines)

Like St. Anthony of Padua, the Dominican St. Vincent Ferrer (ca. 1350-1419) was regarded as a model to be imitated by members of the religious Orders because of his skill at converting individuals to Christianity. Born in Valencia, Vincent entered the Order of St. Dominic at the age of eighteen. He soon became known for his preaching ability, being renowned for rousing sinners to repentance and converting Jews to Christianity. He devoted his life to preaching, travelling throughout Spain, France, Italy, and, according to one biographer, England and Scotland, spreading the Gospel with considerable success. In Spain, he preached in the open air because no church was large enough to hold the crowds who flocked to hear his sermons. He spent the last few years of his life in France and died at Vannes on April 5, 1419. Vincent was canonized in 1455.

Vincent is portrayed in art wearing the black and white habit of the Dominican Order, pointing to Heaven with one arm and holding a book in the other. In many Italian Renaissance images, as in a late fifteenth-century Milanese engraving (London, British Museum), the book is open to the following passage, spoken by an angel in the Book of Revelation, "'Fear God, and give glory to Him; for [the hour of His judgment] is come'" (14: 7). This apocalyptic warning came to be associated with St. Vincent because he once quoted it while delivering a sermon at Salamanca, stressing the need for repentance and the coming of the Last Judgment, and proclaimed to his listeners that he himself was the angel of the Book of Revelation. Because of this episode, Vincent, also known as the "Angel of Judgment," is commonly portrayed with angel wings in Mexican devotional *retablos* and in Philippine *bultos*, as in Catalogue 48. The iconography of St. Vincent Ferrer was popularized in the Philippines by members of the Dominican Order, who first arrived in the islands in 1587.

CCW

BIBLIOGRAPHY
Butler's Lives of the Saints, 2:31-34; Farmer, 425-26; Zucker.

WORKS CITED IN
CATALOGUE BIBLIOGRAPHIES

Alarcón Cedillo, Roberto M., and Ma. del Rosario García de Toxqui. "Catálogo." *Pintura novohispana: Museo Nacional del Virreinato, Tepotzotlán, Tomo 1: Siglos XVI, XVII, y principios del XVIII.* Tepotzotlán, México: Asociación de Amigos del Museo Nacional del Virreinato, 1992.

Attwater, Donald. *The Penguin Dictionary of Saints.* 2nd edition. Revised and updated by Catherine Rachel John. New York: Penguin Books, 1983.

Bainvel, S.J., J. V. *Devotion to the Sacred Heart: The Doctrine & Its History.* Translated by E. Leahy. Edited by George O'Neill, S.J. London: Burns Oates and Washbourne, 1924.

Barghahn, Barbara von. "Colonial Statuary of New Spain." *Latin American Art* 4, no. 4 (Winter 1992): 77-79.

————. "A Crucible of Gold: The 'Rising Sun' of Monarchy in the Blending of Cultures." *Temples of Gold, Crowns of Silver: Reflections of Majesty in the Viceregal Americas.* Edited by Barbara von Barghahn. Washington, D.C.: The George Washington University, 1991. 34-56.

————. "From the Tower of David to the Citadel of Solomon: Mirrors of Virtue for a Viceregal Silver Age." *Temples of Gold, Crowns of Silver.* 154-179.

————. "Imaging the Cosmic Goddess: Sacred Legends and Metaphors for Majesty." *Temples of Gold, Crowns of Silver.* 93-115.

————. *Temples of Gold, Crowns of Silver: Reflections of Majesty in the Viceregal Americas.* Exhibition Guide. Washington, D.C.: The George Washington University, 1991.

————, and Evelyn Figueroa. "Colonial Centers for Devotional Sculpture: Artists and Techniques." *Temples of Gold, Crowns of Silver.* 136-153.

Bastian, R.J. "Purgatory." *New Catholic Encyclopedia.* 1967.

Boyd, E. "*Santos* of San Ysidro Labrador." *El Palacio* 63, no. 4 (1956): 99.

Brown, Jonathan. *Francisco de Zurbarán.* New York: Harry N. Abrams, 1974.

————. *The Golden Age of Painting in Spain.* New Haven: Yale University Press, 1991.

————. "El Greco and Toledo." *El Greco of Toledo* by Jonathan Brown et al. Boston: Little, Brown and Company, 1982. 75-147.

Brown, Raphael. Introduction. *The Little Flowers of St. Francis.* Garden City: Image Books, 1958.

Bruni, G. *Vita de santa Rita de Cascia.* Rome, 1941.

Bunag Gatbonton, Esperanza. *A Heritage of Saints: Colonial Santos in the Philippines.* Manila: Editorial Associates, 1979.

————. *Philippine Religious Carvings in Ivory.* Manila: Intramuros Administration, 1983.

Burke, Marcus B. *A Selection of Spanish Masterworks from The Meadows Museum.* Dallas: The Meadows Museum, Southern Methodist University, 1986.

Butler's Lives of Patron Saints. Edited and supplemented by Michael Walsh. San Francisco: Harper & Row, 1987.

Butler's Lives of the Saints. Edited, revised, and supplemented by Herbert Thurston, S.J., and Donald Attwater. 4 vols. 1956. Westminster, Maryland: Christian Classics, 1987.

The Collected Works of Saint Teresa of Ávila, I: The Book of Her Life, Spiritual Testimonies, Soliloquies; II: The Way of Perfection, Meditations on the Song of Songs, The Interior Castle; III: The Book of Her Foundations, Minor Works. Translated by Kieran Kavanaugh, O.C.D., and Otilio Rodríguez, O.C.D. Washington, D.C.: Institute of Carmelite Studies Publications, 1976-85.

El corazón sangrante/The Bleeding Heart. Edited by Elisabeth Sussman. Boston: Institute of Contemporary Art, 1991.

David-Danel, M.-L. "Sacré-Coeur: Iconographie." *Catholicisme,* vol. 13, fasc. 60.

Delehaye, Hippolyte. *The Legends of the Saints.* Translated by Donald Attwater. New York: Fordham University Press, 1962.

Duhr, Joseph. "Anges." *Dictionnaire de spiritualité,* vol. 1. Paris: Beauchesne, 1937. 560-625.

Duncan, Barbara. "Statue Paintings of the Virgin." *Gloria in excelsis: The Virgin and Angels in Viceregal Painting of Peru and Bolivia.* New York: Center for Inter-American Relations, 1986. 32-57.

Esteban, Claude, and Juan Antonio Gaya Nuño. *Tout l'oeuvre peint de Murillo.* Translated by Simone Darses and Annie Cloulas. Paris: Flammarion, 1980.

Farmer, David Hugh. *The Oxford Dictionary of Saints.* 2nd edition. New York: Oxford University Press, 1991.

Ferguson, George. *Signs and Symbols in Christian Art.* 1954. New York: Oxford University Press, 1961.

Ferrando Roig, Juan. *Iconografía de los santos.* Barcelona: Ediciones Omega, 1950.

Fiot, Robert. "François de Paule (sainte)." *Dictionnaire de spiritualité,* vol. 5. Paris: Beauchesne, 1964. 1040-1051.

Francis de Sales, St. *Introduction to the Devout Life.* Translated and edited by John K. Ryan. Garden City: Image Books, 1972.

Frank, Larry. *New Kingdom of the Saints: Religious Art of New Mexico 1780-1907.* Santa Fe: Red Crane Books, 1992.

Freedberg, David. "The Origins and Rise of the Flemish Madonnas in Flower Garlands: Decoration and Devotion." *Münchner Jahrbuch der Bildenden Kunst* 32 (1981): 115-50.

Geiger, J. H. "Helena, St." *New Catholic Encyclopedia.* 1967.

Giffords, Gloria Fraser. *Mexican Folk Retablos.* Revised edition. Albuquerque: University of New Mexico Press, 1992.

————, et al. *The Art of Private Devotion: Retablo Painting of Mexico.* Fort Worth: InterCultura/Dallas: The Meadows Museum, Southern Methodist University, 1991.

Gisbert, Teresa. "The Angels." *Gloria in excelsis.* 58-63.

Guibert, S.J., Joseph de. *The Jesuits: Their Spiritual Doctrine and Practice: A Historical Study.* Translated by William J. Young, S.J. Edited by George E. Ganss, S.J. Chicago: Institute of Jesuit Sources, 1964.

Gutiérrez Zamora, Ángel Camiro. *La imagen histórica de la Virgen de Guadalupe.* Mexico City: Editorial Diana, 1990.

Hamilton, Nancy. "Angels in *Retablos.*" *Retablo Newsletter* 17 (March/April 1993): 1-5.

—————. "Marian Subjects Very Popular in *Retablos*." *Retablo Newsletter* 21 (September 1993): 2-5.

—————. "Virgin Mary: Popular Subject." *Retablo Newsletter* 22 (October/November 1993): 2-10.

Hamon, Auguste. "Coeur (Sacré)." *Dictionnaire de spiritualité*, vol. 2. Paris: Beauchesne, 1953. 1023-46.

Imágenes guadalupanos: Cuatro siglos. Mexico City: Centro Cultural/Arte Contemporáneo, 1987.

Jameson, Anna. *Legends of the Monastic Orders as Represented in the Fine Arts*. 2nd edition. London: Longman, Brown, Green, and Longmans, 1852.

Jordan, William B. "Catalogue of the Exhibition." *El Greco of Toledo*. 225-63.

Juárez Frías, Fernando. *Retablos populares mexicanos: Iconografía religiosa del siglo XIX*. Mexico City: Inversora Bursatil, 1991.

Knipping, John B. *Iconography of the Counter-Reformation in the Netherlands: Heaven on Earth*. 2 vols. Nieuwkoop: B. de Graaf/Leiden: A. W. Sijthoff, 1974.

Mâle, Émile. *L'art religieux de la fin du XVIe siècle, du XVIIe siècle et du XVIIIe siècle: Étude sur l'iconographie après le Concile de Trente*. 2nd edition. Paris: Librairie Armand Colin, 1951.

Margerie, B. de. "Sacré-Coeur (Dévotion au)." *Catholicisme*, vol. 13, fasc. 60.

Martin, John Rupert. *Baroque*. New York: Harper & Row, 1977.

Meagher, P.K. "Veronica." *New Catholic Encyclopedia*. 1967.

Mexico: Splendors of Thirty Centuries. New York: Metropolitan Museum of Art, 1990.

Moell, C.J. "Sacred Heart, Devotion to." *New Catholic Encyclopedia*. 1967.

Morris, J. U. "Sacred Heart, Iconography of." *New Catholic Encyclopedia*. 1967.

O'Carroll, C.S.Sp., Michael. *Theotokos: Theological Encyclopedia of the Blessed Virgin Mary*. Collegeville: Liturgical Press, 1982.

—————. *Verbum Caro: An Encyclopedia on Jesus, the Christ*. Collegeville: Liturgical Press, 1992.

Palmer, Gabrielle G. *Sculpture in the Kingdom of Quito*. Albuquerque: University of New Mexico Press, 1987.

—————, and Donna Pierce. *Cambios: The Spirit of Transformation in Spanish Colonial Art*. Santa Barbara: Santa Barbara Museum of Art/Albuquerque: University of New Mexico Press, 1992.

Pérez Sánchez, Alfonso E., and Nicola Spinosa. *Jusepe de Ribera: 1591-1652*. New York: Metropolitan Museum of Art, 1992.

Réau, Louis. *Iconographie de l'art chrétien*. 3 vols. (vol. 1, Introduction Générale; vol. 2, Iconographie de la Bible: part 1, Ancien Testament, part 2, Nouveau Testament; vol. 3, Iconographie des saints: part 1, A-F, part 2, G-O, part 3, P-Z, Répertoires). Paris: Presses Universitaires de France, 1955-59.

Romero de Terreros y Vinent, Manuel. *Grabados y grabadores en la Nueva España*. Mexico City: Ediciones de Arte Mexicano, 1948.

Roth, F. "Rita of Casia, St." *New Catholic Encyclopedia*. 1967.

Schiller, Gertrud. *Iconography of Christian Art*. Translated by Janet Seligman. 2 vols. Greenwich: New York Graphic Society, 1971-1972.

Schuler, Carol M. "The Seven Sorrows of the Virgin: Popular Culture and Cultic Imagery in Pre-Reformation Europe." *Simiolus* 21 (1992): 5-18.

Sebastián, Santiago. *Arte Iberoamericano desde la colonización a la independencia*. 2 vols. Colección "Summa Artis," 28 and 29. Madrid: Espasa-Calpe, 1985.

—————. *El barroco iberoamericano: Mensaje iconográfico*. Madrid: Ediciones Encuentro, 1990.

—————. *Contrarreforma y barroco: Lecturas iconográficas e iconológicas*. 2nd edition. Madrid: Alianza Editorial, 1985.

—————. "The Diffusion of Counter-Reformation Doctrine." *Temples of Gold, Crowns of Silver*. 57-79.

Simi, Gino J., and Mario M. Segreti. *St. Francis of Paola: God's Miracle Worker Supreme (1416-1507)*. Rockford, Illinois: Tan Books, 1977.

Steele, S.J., Thomas J. *Santos and Saints: The Religious Folk Art of Hispanic New Mexcio*. Santa Fe: Ancient City Press, 1982.

Stratton, Suzanne. *La Inmaculada Concepción en el arte español*. Translated by José L. Checa Cremades. Madrid: Fundación Universitaria Española, 1989. (An English translation of this important study will be published by Cambridge University Press in 1994.)

Stroessner, Robert J. "Beyond the Pillars of Hercules: Spanish Colonial Painting from the New World." *Temples of Gold, Crowns of Silver*. 16-33.

Trens, Manuel. *María: Iconografía de la Virgen en el arte español*. Madrid: Editorial Plus Ultra, 1946.

Tylenda, S.J., Joseph N. *Jesuit Saints & Martyrs: Short Biographies of the Saints, Blessed, Venerables, and Servants of God of the Society of Jesus*. Chicago: Loyola University Press, 1984.

—————. *Saints of the Liturgical Year: Brief Biographies*. Washington, D.C.: Georgetown University Press, 1989.

Vargas Ugarte, S.J., Rubén. *Historia del culto de María en Iberoamerica y de sus imágenes y santuarios más celebrados*. 3rd edition. 2 vols. Madrid, 1956.

Voragine, Jacobus de. *The Golden Legend: Readings on the Saints*. Translated by William Granger Ryan. 2 vols. Princeton: Princeton University Press, 1993.

Whinnom, Keith. "The Problem of the 'Best-Seller' in Spanish Golden-Age Literature." *Bulletin of Hispanic Studies* 57 (1980): 189-98.

White, Roberto. "Historical Preface: Viceregal Mexico." *Spain and New Spain: Mexican Colonial Arts in Their European Context*. Corpus Christi: Art Museum of South Texas, 1979.

Wilder, Mitchell, and Edgar Breitenbach. *Santos: The Religious Folk Art of New Mexico*. Colorado Springs: Taylor Museum, 1943.

Wroth, William. *Images of Penance, Images of Mercy: Southwestern Santos in the Late Nineteenth Century*. Norman: University of Oklahoma Press, 1991.

Zimdars-Swartz, Sandra L. *Encountering Mary: Visions of Mary from La Salette to Medjugorje*. New York: Avon Books, 1991.

Zucker, Mark. "Problems in Dominican Iconography." *Artibus et Historiae* 13 (1992): 181-193.